ZBRUSH®

CHARACTERS & CREATURES

PROJECTS, TIPS & TECHNIQUES FROM THE MASTERS

ZBRUSH®
CHARACTERS & CREATURES

PROJECTS, TIPS & TECHNIQUES FROM THE MASTERS

3DTOTALPUBLISHING

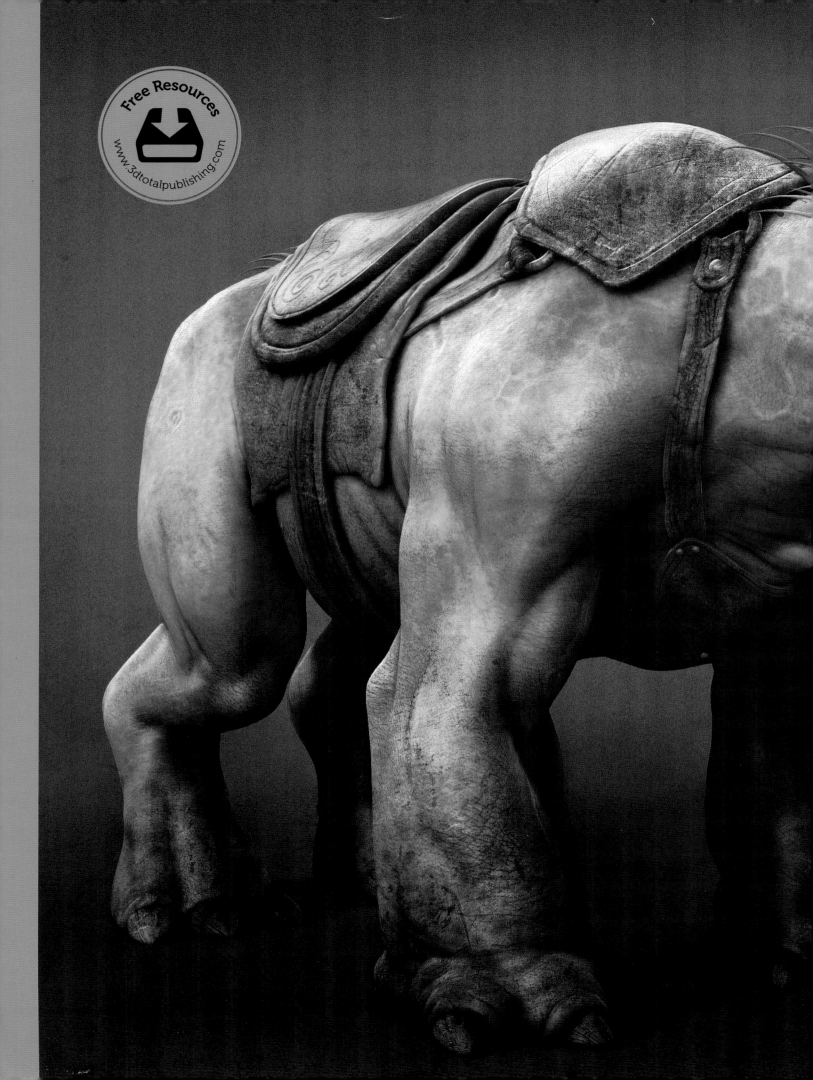

3DTOTAL PUBLISHING

Correspondence: publishing@3dtotal.com

Website: www.3dtotal.com

ZBrush Characters & Creatures: Projects, Tips & Techniques from the Masters. © 2014, 3dtotal Publishing. All rights reserved. No part of this book can be reproduced in any form or by any means, without the prior written consent of the publisher. All artwork, unless stated otherwise, is copyright © 2014 3dtotal Publishing or the featured artists. All artwork that is not copyright of 3dtotal Publishing or the featured artists is marked accordingly.

Every effort has been made to ensure the credits and contact information listed are present and correct. In the case of any errors that have occurred, the publisher respectfully directs readers to the **www.3dtotalpublishing.com** website for any updated information and/or corrections.

First published in the United Kingdom, 2014, by 3dtotal Publishing. 3dtotal.com Ltd, 29 Foregate Street, Worcester WR1 1DS, United Kingdom.

Soft cover ISBN: 978-1909414136

Printing and binding: Everbest Printing (China)

www.everbest.com

Visit **www.3dtotalpublishing.com** for a complete list of available book titles.

Junior editor: Jenny Newell

Proofreader: Melanie Smith

Lead designer: Imogen Williams

Cover and template design: Matthew Lewis

Designers: Matthew Lewis, Aryan Pishneshin, Cameron Dallimore

Managing editor: Lynette Clee

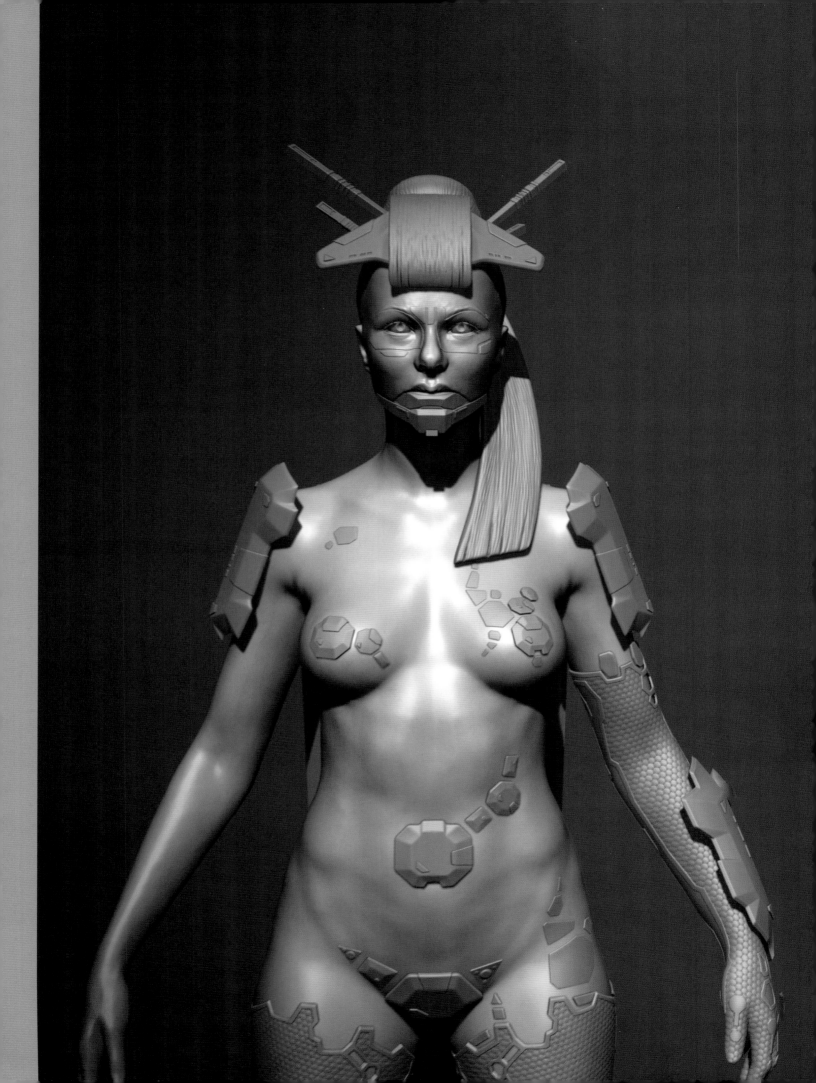

CONTENTS

Free Resources
www.3dtotalpublishing.com

INTRODUCTION

Whether you're a budding concept designer looking to learn new skills, or an established industry professional seeking inspiration and pro tricks, *ZBrush Characters & Creatures* is designed to equip you with all the knowledge you'll need to create truly magnificent models.

The applications of ZBrush are endless, and it's been credited as a key sculpting tool in some of the biggest games and films in recent years. From the wrinkles on the characters' cloaks in *Assassin's Creed*, to the surface detail on the horses of Rohan in the *The Lord of the Rings: The Return of the King*, ZBrush has firmly established its industry-wide reputation as one of the best programs for versatile character and creature creation.

So how do artists go about creating these mighty movie characters and game personalities? This is where our ZBrush guide to creating characters and creatures comes in! We asked some of the best ZBrush users in the CG industry to break down the most efficient and effective practices for creating amazing characters and creatures in this versatile software.

To ease you into the standard industry workflows practiced in this sculpting software, we begin with a section on speed sculpting to help you sculpt as fast as you think. Then from there, our experts will launch you into a mass of mini projects covering all manner of beasts, monsters, animals, aliens – and perhaps even the odd mech! Each project comes from the mind of a top CG character and creature designer, such as Bryan Wynia, Glauco

Longhi, and Justin 'Goby' Fields, who in turn work through the complete creature creation process.

From there, Freelance Concept Artist at Bad Robot, Kurt Papstein, and Freelance Character and Games Artist, Piotr Rusnarczyk, each take you deeper into the more complex workings of ZBrush. In their six-part series, Kurt and Piotr take you through the more in-depth tools and functions of ZBrush, such as topology brushes, Alpha textures, and Polypainting, and respectively reveal the complete creation of a fantasy 'Harpie Queen' and a sci-fi soldier.

Each tutorial gives a complete overview of the ZBrush workflow involved in realizing convincing creature concepts and extraterrestrial entities – so read on, and discover how to think and sculpt like a true pro!

The tutorials in this book will reveal workflows used in ZBrush 4, with the tools and methods taught compatible with Release 7. While the artists featured in this book have sculpted using various releases of ZBrush 4, all the features in 4R6 and before continue to work in 4R7 – that's the beauty of ZBrush, after all!

Happy sculpting!

Jenny Newell,
Junior Editor,
3dtotal Publishing

Free Resources
www.3dtotalpublishing.com

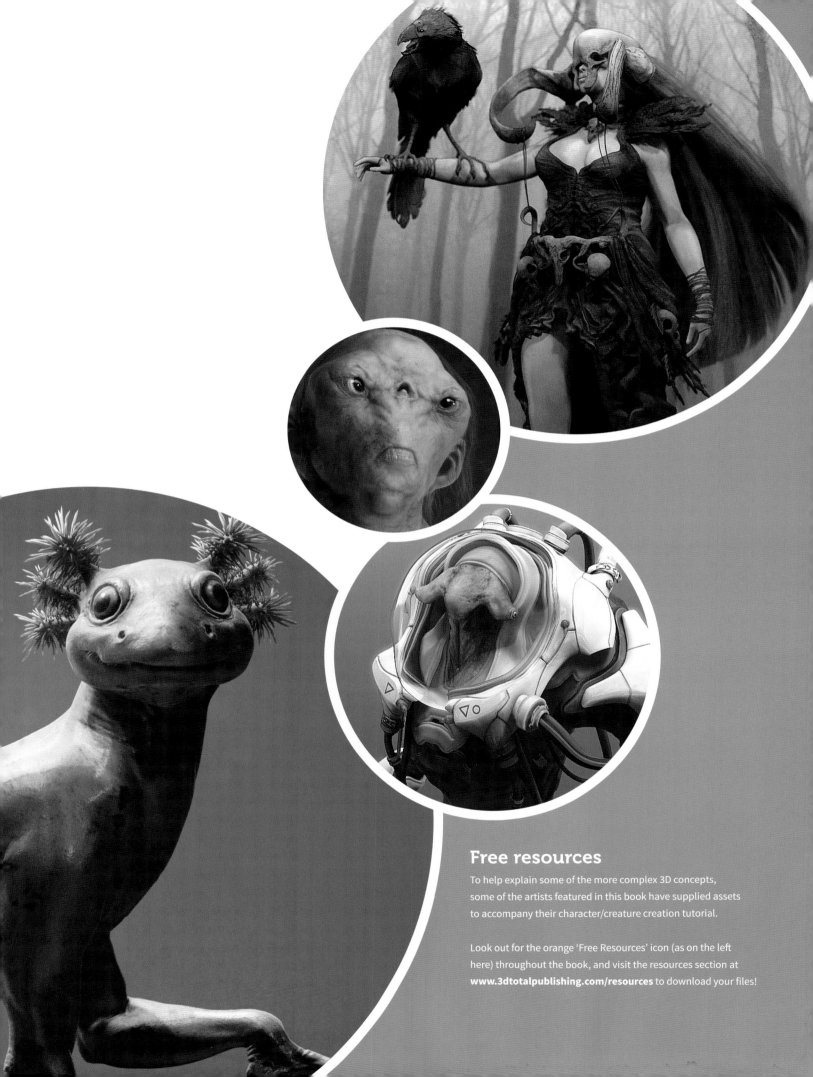

Free resources

To help explain some of the more complex 3D concepts, some of the artists featured in this book have supplied assets to accompany their character/creature creation tutorial.

Look out for the orange 'Free Resources' icon (as on the left here) throughout the book, and visit the resources section at **www.3dtotalpublishing.com/resources** to download your files!

Speed sculpting

Learn how to create quick character and creature speedsculpts

We start off our ZBrush guide with a series of quick warm-up tutorials on creating a realistic character or creature-based speedsculpt. The following tutorials will cover the best techniques to use when creating your own 3D speedsculpts within a set time limit, from concept to post-production. With tips from top artists such as Bruno Jiménez and Mathieu Aerni, you'll be able to follow the entire sculpt creation process and be producing perfect portfolio pieces in no time at all!

Chapter 01
Speed sculpting
Part 01: Fine-detail your speedsculpt

By Daniel Bystedt

Lead Modeler and Project Manager at Milford Film
& Animation

When doing a speedsculpt it's important to
work on the big shapes and be loose and
experimental. This allows you to make a
whole bunch of character or creature concepts
for a client (or yourself) in a short period of
time, without getting stuck on details.

For this image, even though it wasn't important
to add details such as small wrinkles and
pores, I found that I had the time to do so
later on in my three-hour time limit. The
majority of time (2hrs 45mins) was spent
on modeling; the rest, and more, was spent
on the render (1hr 10mins; see image A).

01 Rough modeling

I start by loading the DefaultSphere from LightBox
(hotkey ','). I pull this sphere a little with the Move
brush, just to get a basic shape to start off with.
To avoid stretching, I convert the image to a
DynaMesh at a fairly low resolution (40), as I only
want to work on the big forms at the beginning.

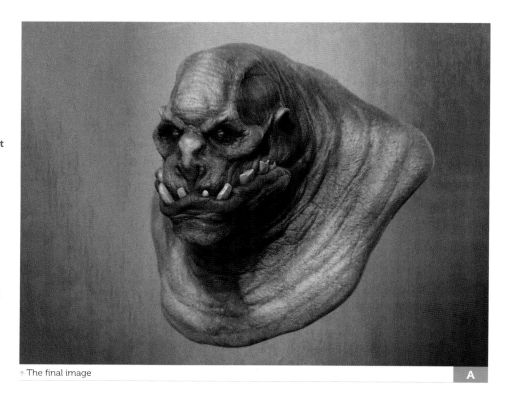

↑ The final image

A

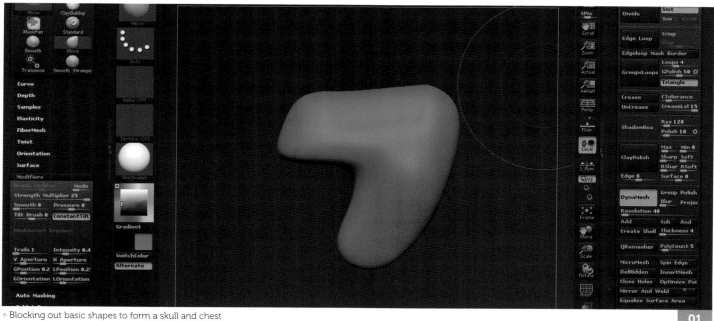

↑ Blocking out basic shapes to form a skull and chest

01

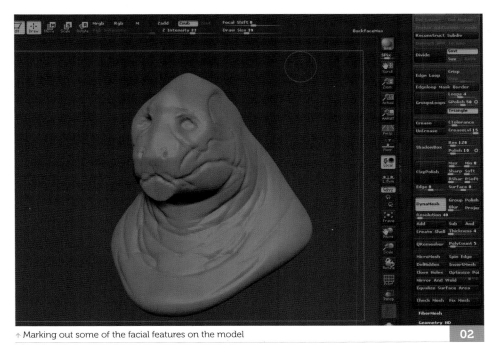

↑ Marking out some of the facial features on the model

02

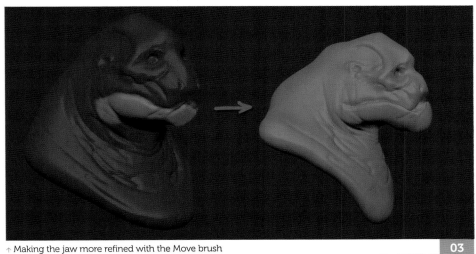

↑ Making the jaw more refined with the Move brush

03

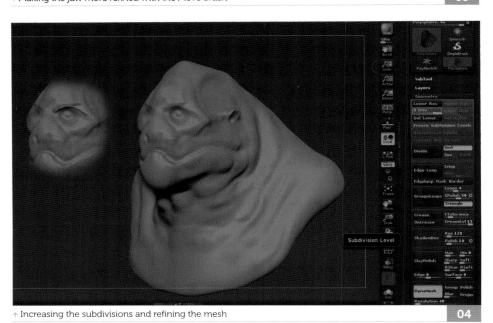

↑ Increasing the subdivisions and refining the mesh

04

"Don't forget that you can move the faces in the brush's direction by pressing the Alt button while moving"

I start blocking out something that resembles a humanoid skull and chest. I find it useful to use the TrimDynamic and Clip brushes at this early stage to get some coarse features into the model.

02 Making the face

I now start scribbling out some features on the face with the Dam_Standard brush. These are used as a kind of sketch just to get my ideas flowing. I don't intend for these sketch carvings to stay there forever, so I can smooth them out later with the Smooth brush. I also find it helpful to suggest the eye sockets and the cheekbones early on. When I started I didn't really have any idea of what kind of character I wanted, but now the idea that he should be an ogre-like brute is in my head.

03 Refining features

I continue working on the profile of the character with the Move brush. In order to make his lower jaw stand out, I mask it off with the MaskLasso brush while looking at the model from the side. I then pull out the jaw with the Move brush. Don't forget that you can move the faces in the brush's direction by pressing the Alt button while moving. I do this quite often as you don't have to rotate the model around when using this feature. It's also good to work with the Standard brush at a low Z Intensity.

04 Subdivisions

At this time, I feel that I have the general form of the character pretty much complete, so I want to develop the subdivisions a little. First, I re-DynaMesh the model (Ctrl+drag on the document) and subdivide it into three sections. When working with DynaMesh, I usually set Blur to zero in order to keep the texture of the model fairly rough.

Here, I have marked the 'T' overlap in the upper part of the eye socket in red. This is something easily overlooked as the fat and tissue in this area hide the bone structure; I find it useful to exaggerate this at the start of a model though, in order to get the correct proportions. I also add a small ear and more fat hanging from the jaw.

In ZBrush 4R7, take advantage of the Dynamic Subdivision function that allows you to work on high subdivision levels in real time.

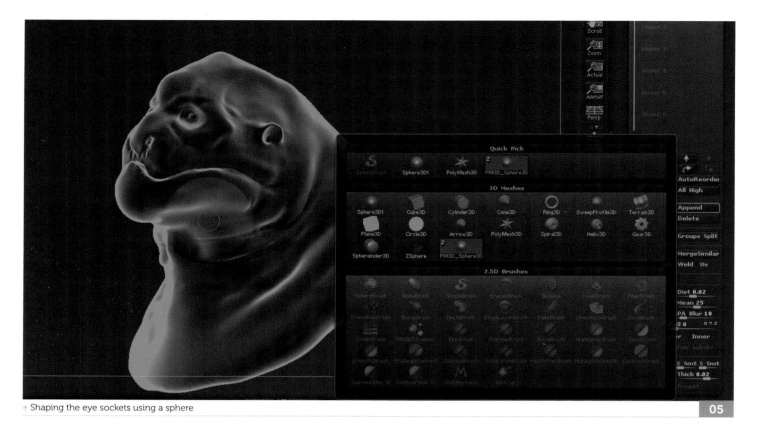

↑ Shaping the eye sockets using a sphere

`05`

05 Eyes

In order to sculpt the area around the eye, I always bring a sphere in to help me get the correct shape. I add the Sphere3D (Tool > SubTool > Append) into the model, scale it down, and then place it on the figure correctly. It's helpful to activate Transparency when doing this. The Transparency button can be found in the lower-right side of the document.

06 Eyelids

When the eyeball is in place, it is easier to sculpt the eyelids. Image 06 shows the highest and lowest point of the upper and lower eyelids (marked with arrows). I use the SubTool Master (ZPlugin > SubTool Master > Mirror) to mirror the eye to the other side of the face.

07 Facial features

I continue to refine some of the details. Image 07 shows a few of the bone structure adjustments:

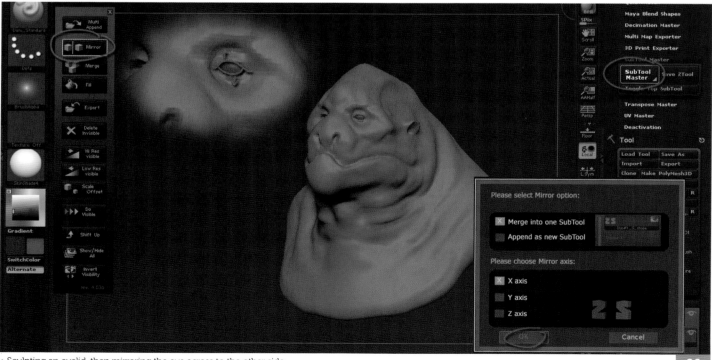

↑ Sculpting an eyelid, then mirroring the eye across to the other side

`06`

1. The flat part of the frontal bone.

2. A simplified diagram of the nose.

3. Fat pockets above the upper eyelid that I sculpt with the ClayBuildup brush.

4. Wrinkles radiating from the mouth; these can be found above and below the mouth on an old human being, but here I've only sculpted them above the mouth.

5. Wrinkles going around the mouth; these are mostly seen on the lower jaw but can also be found less pronounced above the mouth.

6. Fat that builds up on the neck; this tends to create folds that encircle the neck. These are created when a person tilts their head.

I think that the character's face feels a little bit empty at this point in the process, so I decide to give him a bit more character by adding some teeth. For this I use the CurveTubes brush. You are only able to work with the Insert brushes on a SubTool with a single subdivision in ZBrush, so I therefore switch to the eye SubTool when I add the teeth.

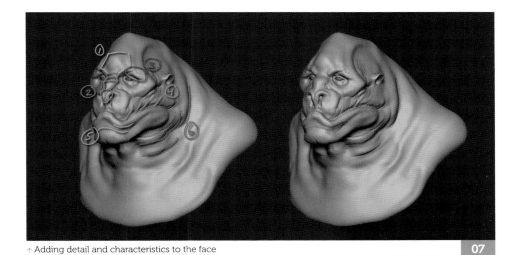

↑ Adding detail and characteristics to the face
07

08 Teeth and wrinkles

After the base geometry is in place, I start pushing the teeth around with the Move brush to get a better shape. You can also mask off one tooth at a time and use the Scale Transpose line (hotkey S) to flatten them. To get a sharper look, I add some finish with the TrimDynamic brush.

As I'm feeling indecisive about how I should tackle the big features of the face, I decide to add some more wrinkles with the Dam_Standard brush. I always do this on a separate layer so I can turn the layer off and protect the wrinkles when I want to work on the basic shape. It's also good practice to add a new layer, sculpt, and then merge with your old layer if the sculpting turns out well. This is an excellent way to give yourself more scope to experiment and correct your work.

After adding all of the wrinkles to the model, I start to add volume to the area between the wrinkles to give them a much fleshier feel. This is easily achieved using the Standard brush on a low Z Intensity.

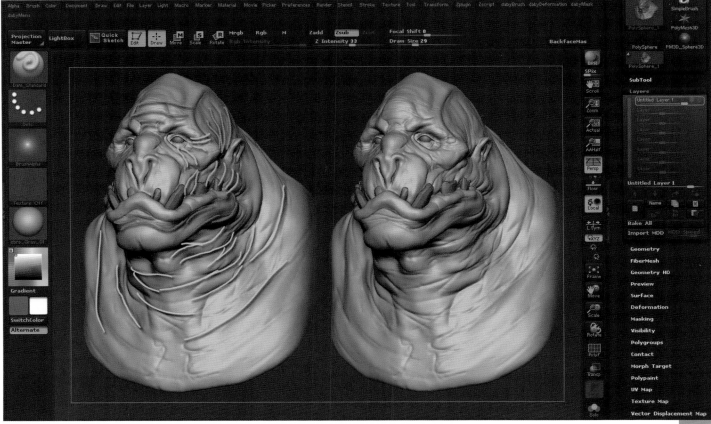

↑ Working on the wrinkles using the Dam_Standard brush
08

"When posing any kind of head I usually just use the MaskLasso tool to mask off the head and rotate it with the Rotate Transpose line"

09 Posing

I want to create a quick pose for my character in order to break up the symmetry. To do this, I use the Transpose Master and activate Layer, so that the new pose will be put on a separate layer for each SubTool. I go to ZPlugin > Transpose Master and press TPoseMesh to create a new tool for posing.

When posing any kind of head I usually just use the MaskLasso tool to mask off the head and rotate it with the Rotate Transpose line (hotkey R). I drag out a Transpose line from the middle of the head and then move the Transpose line by dragging the line (not the white or red rings) to the position where the head meets the neck. Now I can rotate the head by dragging the white ring on the transpose line that is in front of the head.

When I am done with posing, I select TPose > SubTool (ZPlugin > Transpose Master) to transfer the pose to the model. After the pose is done, I add some asymmetry to the face with the Move brush.

10 Adding the detail

Since I have some time left on my three-hour limit, I decide to do some skin detail.

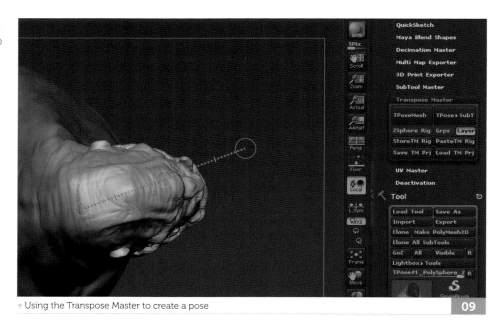

↑ Using the Transpose Master to create a pose **09**

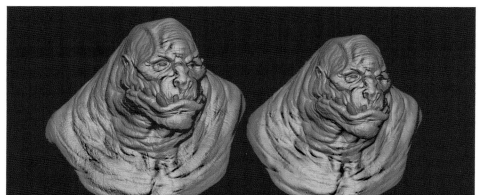

↑ Two versions of the model with different skin detail **10**

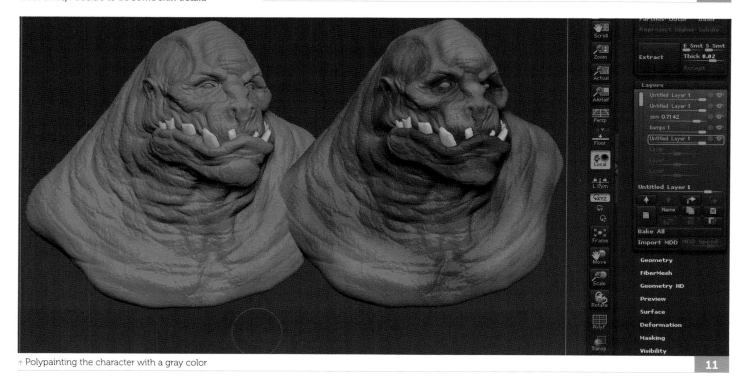

↑ Polypainting the character with a gray color **11**

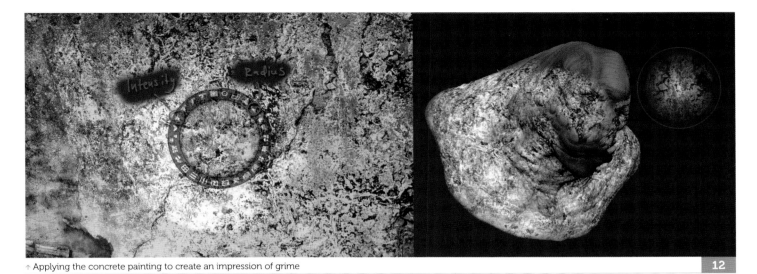

↑ Applying the concrete painting to create an impression of grime

12

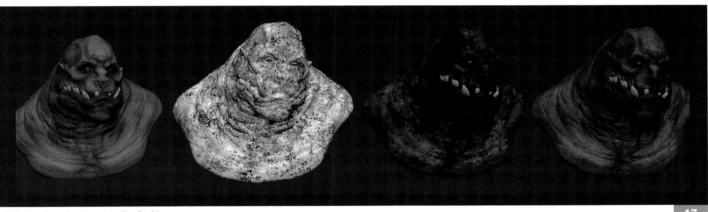

↑ Refining the color to create the final image

13

I create two separate passes on two different layers that I will later combine.

The left-hand figure in image 10 shows the skin wrinkles on the character. I do a new version of the Standard brush (Brush > Clone) and use Alpha 58 for the alpha slot. I then set the Stroke to Spray with a low value on Stroke > Flow and set the Brush > Orientation > Spin Rate to 10. I use this brush to sculpt the small skin wrinkles. It's a pretty fast way of adding skin structure, but you should make sure that you apply this effect evenly.

The right-hand figure in image 10 shows some skin bumps. To make these, I create a new version of the Standard brush (Brush > Clone) with Alpha 47 in the Alpha slot. I set the Stroke to Spray with a low value on Stroke > Flow and a high or top value for the Stroke > Placement.

Adding color

Now that the sculpting is done, I want to do a quick Polypainting on the character. I change my brush to Standard, turn off Zadd and turn on Rgb.

"As my version of ZBrush only has Normal blending mode on Polypaint layers, I need to create a mask based on my concrete layer and paint the darker color on a new layer"

These buttons can be found in the middle-upper part of the UI. I create a new layer and paint it with a gray color. After that I switch to black and start to add some value to different parts of the face.

12 Skin detail

To add some grime in the skin, I import a concrete texture (Texture > Import) and bring it into a Spotlight (Texture > Add to Spotlight). Before I start painting, I increase the Spotlight radius to make it easier to see my model when painting. After that, I increase the contrast in the image by dragging the Contrast icon on the Spotlight wheel.

In order to go into Paint mode in Spotlight, I press the Z key on the keyboard and then paint the concrete on a new layer.

13 Base color

After doing the concrete painting, I turn off Spotlight (Shift+Z) and return to my base layer. Now I change Brush > Alpha and Texture > Polypaint mode to 2 (Colorize), and paint the base paint layer with color.

As my version of ZBrush only has Normal blending mode on Polypaint layers, I need to create a mask based on my concrete layer and paint the darker color on a new layer. To do this, I turn on the eye icon on the concrete layer, click Tool > Masking > Mask By Intensity, and create a new layer. The masking will be on the new layer.

After this is done I turn off the concrete layer, activate Rec on the new layer with the intensity mask, and paint it in a dark color. I fine-tune this tone by dialing down the layer opacity until I find a level I like. At this stage, I'm now happy to call the project complete.

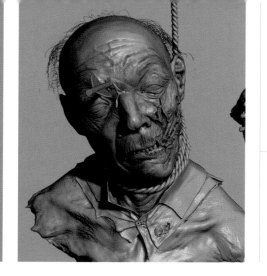

Speed sculpting

Part 02: Adding story to your speedsculpt

By Mariano Steiner

3D Character Artist and Digital Sculptor

Videos for this tutorial are available from www.3dtotalpublishing.com/resources. Downloading all six videos before reading will make it easier to understand the entire process.

01 Creating the bust

When modeling a bust, I find that starting with a sphere is the easiest, as half the head shape is already created for you. I mask the bottom of the sphere off to act as the base, and then pull the neck and upper torso upward from it.

"My initial base will be a basic human in form: After this, I can get creative and begin to imagine how this human was transformed into a zombie"

02 Refining polygons

After pulling out the basic head, neck and upper torso shapes, I find that the mesh becomes a little disjointed; so I use DynaMesh to redistribute my polygons.

I then start to fill out the main shape of the character. At the moment, I am not too worried about topology as I will later use QRemesher to even it all out.

My initial base will be a basic human in form: After this, I can get creative and begin to imagine how this human was transformed into a zombie. In this example, I use a picture of a Japanese man with an interesting 'scream' expression.

As soon as I achieve a good base sculpt, I use QRemesher to improve the poly distribution in the model. To do this, I duplicate my model, delete the subdivision levels, and draw a few edge loops with the QRemesher Guides brush. I then mask the main portion of the face and ears to specify my priority points and let QRemesher do the rest.

↑ Pulling out the basic head and shoulder shapes

01

↑ Preparing to use QRemesher to refine the mesh

02

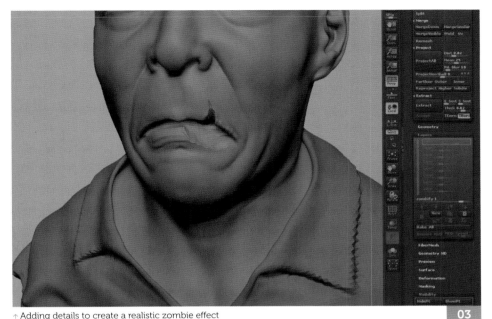
↑ Adding details to create a realistic zombie effect

03

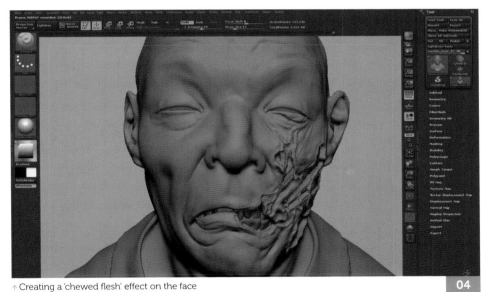
↑ Creating a 'chewed flesh' effect on the face

04

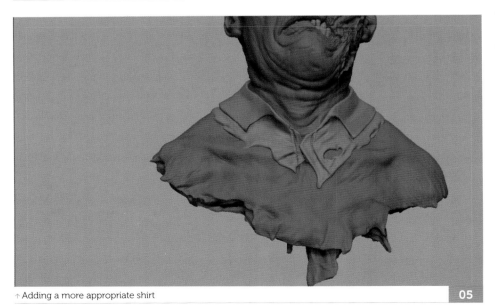
↑ Adding a more appropriate shirt

05

03 Zombification

Now that I have established a good base mesh with better flow and distribution on the edge loops, I can start the real sculpting process.

Using Transpose, I rotate the torso a little to reduce the T-pose look, and extract a mesh for his shirt from the torso. At this point, I am simply experimenting with forms to see what kind of zombie I want to create.

With the basic forms and expression blocked, I create a new layer to begin the zombification process! As this is a bust, I had the idea to sculpt it as a half-eaten corpse. But this is just the start…

I carve the mouth and the left cheek to give the impression that someone has bitten him on the face, and add some teeth to complete the mouth structure. I've noticed that zombies are usually depicted with very bony faces that emphasize the fact that they are corpses, so I make the bone structure in the model's face more prominent.

> "To make this even more realistic, I decide to add some bones and organs protruding from the mass. This was done by transforming them in DynaMesh and blocking the forms up"

04 Skin texture

With these basic details in place, I now start changing the texture of the character's skin. I begin by cracking and detaching the skin from some areas in his face, and then add some wrinkles and different zombie volumes to the face.

As I had the idea of making the bust appear as if it is a half-eaten chunk of flesh, I define the cut and add some hanging skin pieces. To make this even more realistic, I decide to add some bones and organs protruding from the mass. This was done by transforming them in DynaMesh and blocking the forms up.

05 The shoulders

I now decide to redo the shirt, as the old one would have covered up too much of the body. I extract a little fabric wire to put on the holes and the ripped areas of the shirt to make it appear suitably damaged. With UV Master, I unwrap the shirt so I can have a decent pattern distribution with the Surface Noise modifier.

06 Cause of death

It's now time to decide how my model died. I finally decide that his main cause of death will be an arrow to the brain. I use ShadowBox to create the arrow details, and radial symmetry to model the arrow pointer. I also extract a mesh from the arrow to create some blood streaming from the wound.

07 Finer details

By randomly masking the head area, I generate some fibers. Once I have achieved a certain amount, I can tweak the settings and groom the hair to create a nice tousled, zombie haircut.

With the zombie almost finished, I can start to do the finer detail. I use the Dam_Standard and Clay brushes, with some Alpha variations, to create the wrinkles, veins, and skin textures.

The trick is to pay attention to the bump variations on the human face. The secret for a realistic face is the bump map. Most beginners use one or two Alphas to texture the face, but in fact there are many pattern variations on it.

08 The background story

To finish, I paint gray color variations using Mask By Cavity and Mask PeaksAndValleys.

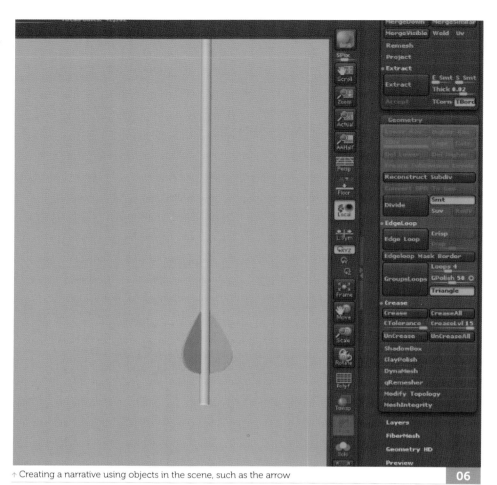

↑ Creating a narrative using objects in the scene, such as the arrow

06

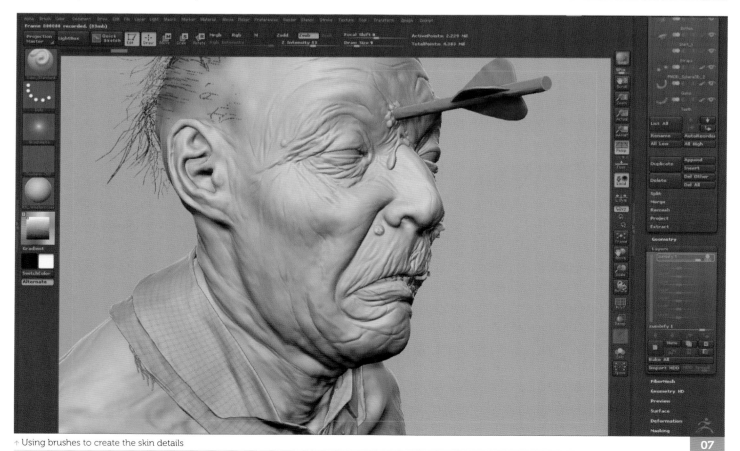

↑ Using brushes to create the skin details

07

While doing this, I have a few brainwaves about the story behind the character. This is always useful as it guides my decisions on using certain features. My final story is as follows:

1. He has been bitten on the face by a crazy zombie.

2. He tries to end his life with the rope, not realizing that the zombie virus is triggered by death.

3. Zombies continue eating his body, and he wakes up as a mutilated zombie.

4. A kind stranger takes pity on him and ends his life with an arrow to the head.

09 The final image

Now the character has a background, I can make those final decisions on the details – such as the rope around his neck – and add them in. Image 09 shows the model from different angles.

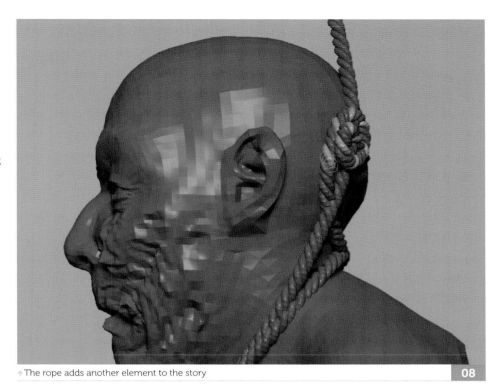

↑ The rope adds another element to the story

08

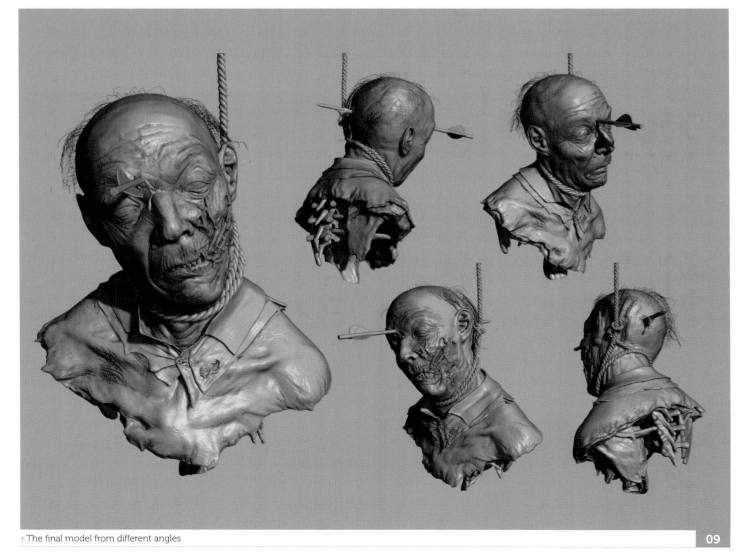

↑ The final model from different angles

09

Speed sculpting

Part 03: Manipulate your speedsculpt mesh

By Bruno Jiménez

Freelance CG Artist

This project is about creating the bust of a boxer. I often use fighters as my subject as they have strong facial features due to their countless hours of fighting.

We'll create a head protector so we can see some very handy techniques for creating models from other meshes. To do this, we'll extract meshes from masks painted on the main objects (the bust and the protector). Later, we'll add details such as stitches and folds over the protector, using standard brushes. Most of the project is done using DynaMesh and ZRemesher to maintain clean topology, which makes everything easy to handle.

We'll finish by working with 3ds Max and V-Ray to set up the lighting in the scene, so we'll also see how to take objects done within ZBrush to 3ds Max in order to make a fast lighting setup.

In addition, we'll take a look at Photoshop in order to add those extra touches to the image to make it look really finished.

"Proportion is a difficult subject to summarize, but if you can retain these basic guidelines, you should be able to create a well-proportioned face"

01 ZSpheres base mesh

I start working on the basic volumes after placing the ZSpheres. First, I add the main ZSphere at the base of the neck, and then I activate symmetry to create the shoulders, neck, and head.

The next step is to put everything in place. At this point I try to work quickly and don't waste time adding lots of ZSpheres. It doesn't matter if the silhouette doesn't seem right at this stage, as this will only be the base of the mesh.

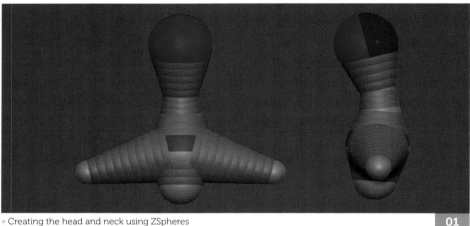

↑ Creating the head and neck using ZSpheres **01**

↑ Some of the face proportion rules **02**

02 Face proportions

Before I start modeling, let's take a look at some basic proportion rules.

1. From the front view, the head can be divided into thirds and halves (image 02).

2. The eyes are in the middle of the face.

3. You can divide the face into three equal parts, from the start of the front, down to the chin.

4. The face is five 'eyes' wide.

↑ Defining the basic volumes of the character **03**

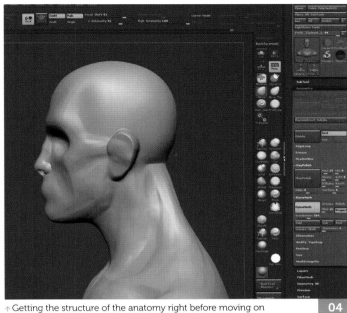

↑ Getting the structure of the anatomy right before moving on **04**

5. The mouth corners are level with
 the center of the eyes.

6. The bottom of the nose is one 'eye' wide.

7. The bottom of the lower lip is halfway between
 the bottom of the nose and the chin.

Proportion is a difficult subject to summarize,
but if you can retain these basic guidelines, you
should be able to create a well-proportioned face.

03 Working the basic volumes
After placing the ZSpheres, I convert them
into an Adaptive Skin mesh. I always keep my
polygon amount very low on the first steps,
which makes them much easier to handle.

In this step, I only want to define the main shapes,
such as the jaw, the neck, the size of the head,
shoulders, and clavicles. Always keep the first
steps very rough and loose, and don't add any
details until the overall shape looks good.

> "Knowing where to add bony
> landmarks, and where to add
> muscle or fat, is essential"

04 Structure
Once I have the main volumes of my character,
I activate DynaMesh in order to start adding
some structure into this gray, formless mass.

Anatomy is the most important part of a
convincing character, even if it's a cartoon.

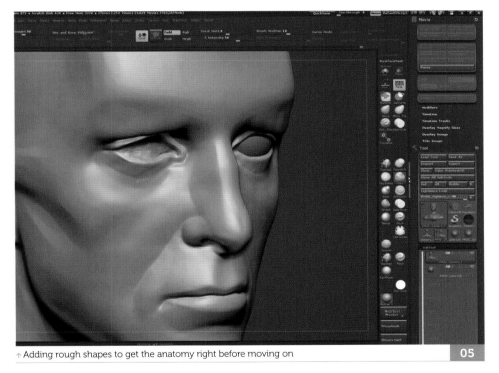

↑ Adding rough shapes to get the anatomy right before moving on **05**

Knowing where to add bony landmarks, and where
to add muscle or fat, is essential. Before adding
details like lips or wrinkles, I start by finding the
right place for the jaw, mouth, eye socket, and all
the main volumes that define the facial features.

After this step, I already have an idea about
what is working and what isn't. I will only
continue adding details if this step looks right.

05 Adding rough shapes
After correctly placing the volumes, I start
adding details. First, I start with the ears, as

they are an important element of the silhouette.
Then I continue with the mouth and the
volumes around it. Finally, I model the eyes.

Lately, I've been trying another approach
when modeling. Before, I used to create
volumes only with ClayTubes and then
smooth them, but now I more often use the
hPolish brush. This gives some sharp edges
that describe forms in a much clearer way.

To finish this stage, I create a sphere to make the
eye globe. I also correct the eye's general shape.

06 Modeling the head protector

The head protector's main bulk is made from a sphere added to my SubTools – as simple as it sounds. After adjusting the size, I carve the sphere to make a space for the face.

At this stage, the head protector still has the sphere's topology, which makes it messy to work with. I therefore use ZRemesher to keep a clean topology. Keeping a clean topology is very important to maintain control over the mesh, so I use it almost every time I modify the mesh in a drastic way.

> "I really can't say it enough – the best thing when modeling, even when you're speed sculpting, is to have a clean mesh with nice topology"

07 Mesh extraction

Now we're ready to create the rest of the pieces for the head protector. First, we'll take a look at some of ZBrush's most useful tools...

For this example we'll use a sphere as the base mesh. To extract a mesh from another object, the first thing to do is draw a mask on your base object. Then, in the SubTool tab, on the Extract parameters, you can choose the thickness of the mesh. Let's pick a value of 0.1 and click Extract to have a preview of our mesh, and then click Accept.

So now we have our new mesh; but the problem is that the topology is messy. To fix this we'll have to go to the Geometry tab and go to ZRemesher. Type 0.5 in the Target Polygon Count parameter, and there you go – you have a nice mesh with clean topology.

08 More mesh extraction

I really can't say it enough – the best thing when modeling, even when you're speed sculpting, is to have a clean mesh with nice topology. This way you can optimize your polygon count, which makes everything easier and faster.

Some of the pieces here are done by drawing masks over the head protector mesh, and some by drawing masks over the head mesh.

After extracting the meshes, I just click ZRemesh, and my mesh is ready to work on. Use a medium resolution subdivision to extract your meshes, otherwise the extraction process can take longer.

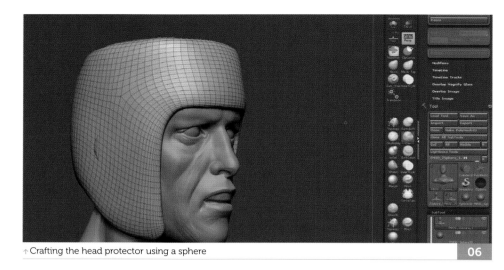
↑ Crafting the head protector using a sphere
06

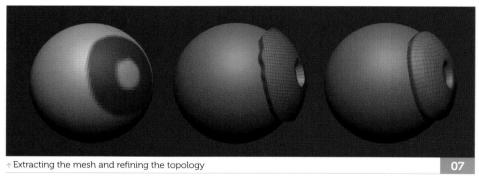
↑ Extracting the mesh and refining the topology
07

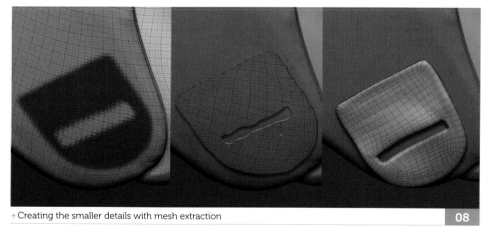
↑ Creating the smaller details with mesh extraction
08

09 Finishing the head protector

I only use standard brushes to do this. First I use the Dam_Standard brush to draw some lines, and then I use the StitchBasic brush for the stitches – nothing very fancy, but it gets the job done.

Most of the time, I don't bother being a bit messy when I do speedsculpts. I concentrate much more on the general look rather than the details. I really like the rough look of speedsculpts, and from time to time, you get some happy mistakes that give life to your characters.

Lastly, I add some folds with the FormSoft brush.

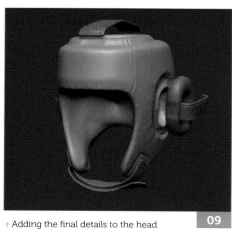
↑ Adding the final details to the head protector using brushes
09

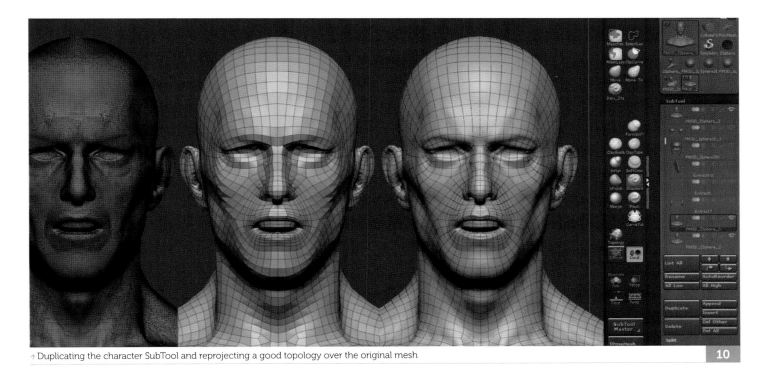

↑ Duplicating the character SubTool and reprojecting a good topology over the original mesh

10

10 Retopology and detailing

Until this step, all the sculpting on the character has been done using DynaMesh – which is great when I have to model fast and when there aren't too many details – but it's better to have a clean mesh with nice loops to add the final touches. To do this, I first duplicate my character SubTool. After that, I draw some guides with the Topology brush on my mesh. These lines will help ZRemesher create loops.

Once I have achieved a mesh with a good topology, I do a projection over my original mesh. This method allows me to recover the details of my original mesh over my new clean mesh.

11 Posing the character

ZBrush offers a really great tool that you can use to pose models with multiple SubTools; it's called the Transpose Master. First, you have to click over the TPoseMesh button. This will take all of your

SubTools at the lowest subdivision level, and it will then convert them all into a single SubTool.

Once you have finished posing your character, click over TPose SubT and you'll recover your pose on your subdivided meshes.

To pose my character, I draw a selection to mask the lower part, then I turn his head from the side viewport and then from the top viewport.

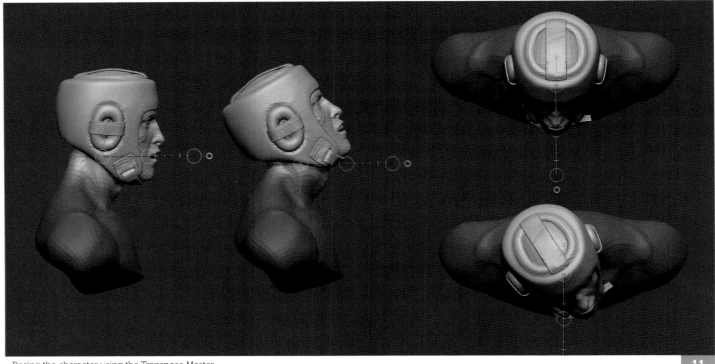

↑ Posing the character using the Transpose Master

11

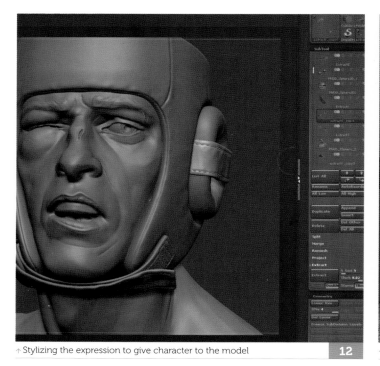

↑ Stylizing the expression to give character to the model **12**

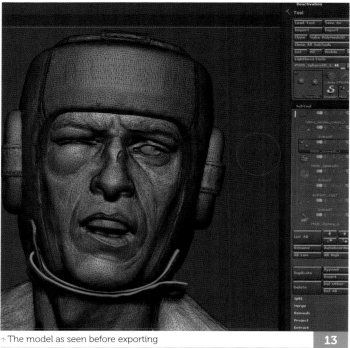

↑ The model as seen before exporting **13**

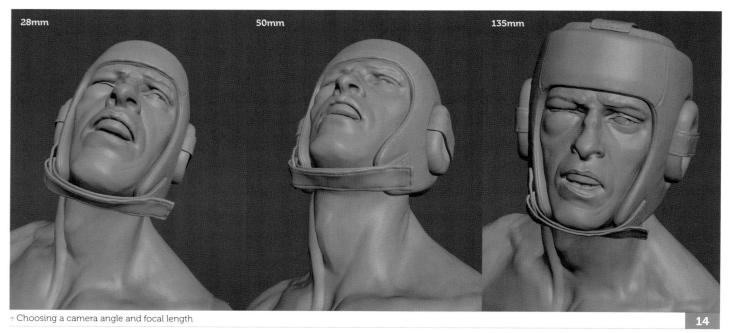

28mm 50mm 135mm

↑ Choosing a camera angle and focal length **14**

"It's a good idea to determine your camera angle before you start lighting, as the lighting will change depending on your point of view"

12 Expression

At this stage, I always start working with the symmetry turned off; this makes characters look much more alive.

I want to make this character look very tired, as if he has just been through a tough fight.

After working the volumes of the cheeks and the transition between the helmet and the face, I therefore decide to add some injuries, as well as a swollen eye.

I add most of the details with the Dam_Standard brush, and stylize the model a bit by creating some flat surfaces with the hPolish brush.

13 Exporting the mesh

I want to render everything as I usually do. I'm very happy with V-Ray and 3ds Max, so I render this project as I always do.

Before exporting your meshes, you need to know that there are two ways to get your models out of ZBrush in order to render them in another 3D software. You can either make UVs with UV Master and then use Displacement Maps, or you can optimize your meshes with Decimation Master and then export them. Since I know that I won't be making textures for this project, I just optimize everything and then click the magical GoZ button.

14 Camera angle and focal length

The camera angle is a deciding factor in the intentions of an image – different camera angles

tell different stories. For me, this is always a critical part of the process when making a portrait. It takes longer for me to decide this than the sculpt itself, and I often go back on decisions or I finish by making more than one image.

It's therefore a good idea to determine your camera angle before you start lighting, as the lighting will change depending on your point of view. Doing this will save a lot of time.

The focal length is also a very important element that you need to consider. This is because different focal lengths, in addition to camera angles and composition in general, can produce different impressions for your final image.

In the three sections of image 14, for example, you'll see the following different effects.

1. The 28mm lens gives a dynamic look, which can be good when there's movement

> "When lighting a character, you always want to start with a key light. I always use small key lights and set up the Directional parameter somewhere in between 0.7 and 0.9"

or action in your image; in this case, however, it is not very appropriate.

2. The 50mm lens looks kind of flat and the character seems to be very distant.

3. The 135mm lens is the standard for portrait photography, and it's what you should use most of the time. The character looks very tired and there's a nice perspective, which is what I was looking for.

15 Lighting the scene

When lighting a character, you always want to start with a key light. I always use small key

lights and set up the Directional parameter somewhere in between 0.7 and 0.9. This will make a very well defined hotspot on your character, which helps direct the attention to the main element – in this case, the face.

Once I'm happy with my key light, I add a light to both sides of the character to make the body contrast with the dark background.

Finally, I add a frontal light just above the camera in order to light up the dark areas, such as the neck.

16 Shading

The shading part is pretty straightforward. I just create a V-Ray Standard material with a very weak Reflection amount and a very glossy finish.

I try to mimic the look of gray clay. I also add a very small amount of Noise to make the surface look more irregular.

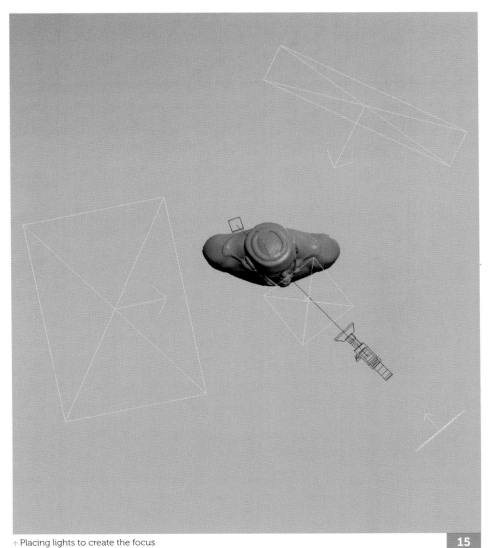

↑ Placing lights to create the focus 15

↑ Using shaders to add dimension to the material 16

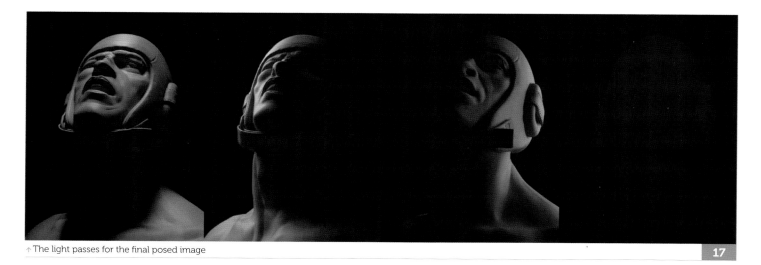

↑ The light passes for the final posed image

"I often use ZDepth to create depth of field (DOF) within Photoshop or After Effects. You can also calculate the DOF directly with V-Ray, but your render time will be multiplied"

17 Render parameters and passes

My render setup is always the same. I render all elements of the scene with GI turned on, and often render my lights in different passes. This is a very handy way to work since this lets you modify your lights one by one, in color and intensity.

Other useful passes are Shadow, Reflection, Specular, and of course, the ZDepth pass. I often use ZDepth to create depth of field (DOF) within Photoshop or After Effects. You can also calculate the DOF directly with V-Ray, but your render time will be multiplied a few times.

18 Final touches with Photoshop

First, I start with my key V-Ray Light Select pass. Then I add all the other light passes in Screen blending mode.

Once all the work with light layers is complete, I use my ZDepth pass to settle the depth of field. For this, I copy and paste this pass into my document's Channels. This will create an Alpha Channel that I can use with the Lens Blur filter. Then, in the Lens Blur menu, I pick my ZDepth pass as the source to calculate the depth in my image. Then I just pick my focal point.

19 Conclusion

Making a good model is never enough. The only way to give value to your work as a modeler is to know and understand how light works and how you can use it to make your models go from a 'good model' to a 'nice-looking image'. This last element is much more important to me.

You should always keep in mind that everything must work together. Lighting, image composition, posing, and modeling – all of this must tell the same story to enable the final image to be coherent.

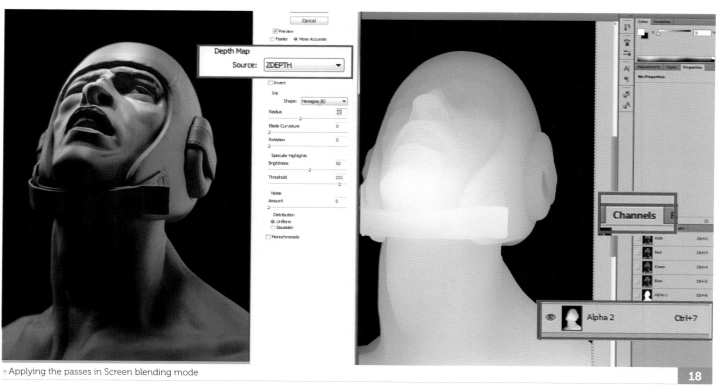

↑ Applying the passes in Screen blending mode

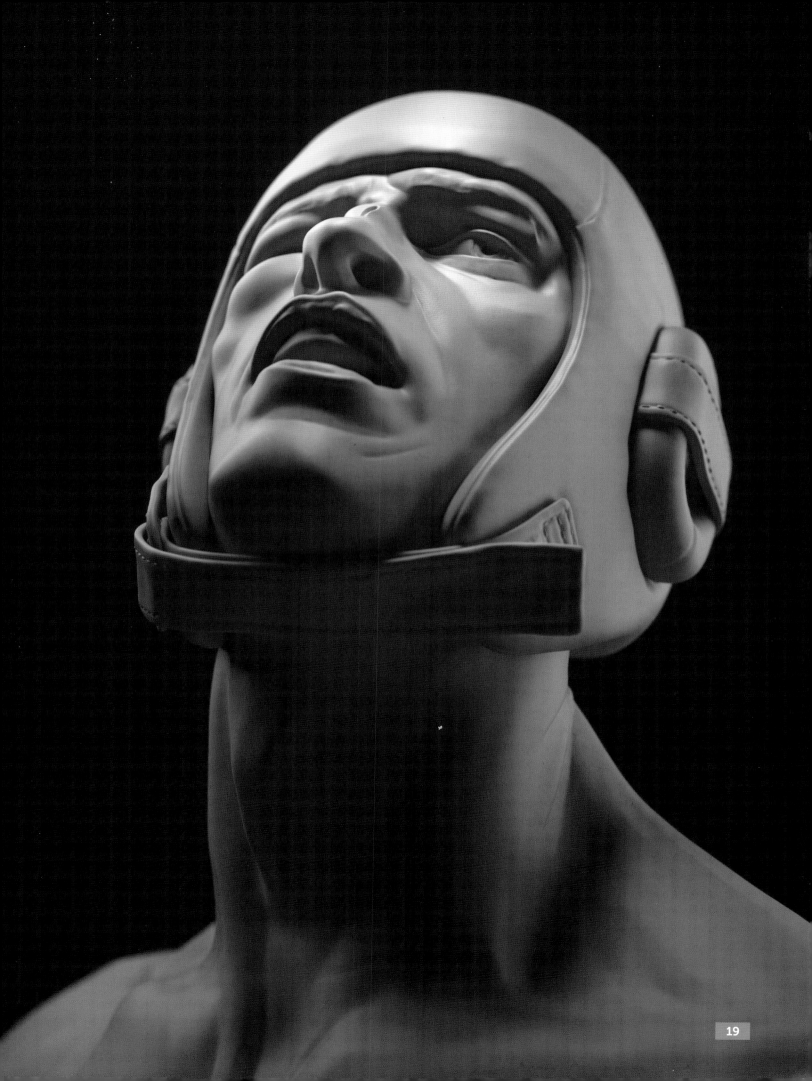

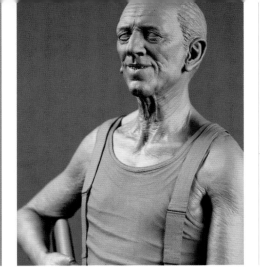

Speed sculpting

Part 04: Model a full-body speedsculpt

By Mathieu Aerni

Lead Character Artist at Blur Studio

As a character artist, sculpting in ZBrush is one of my favorite things. ZBrush gives you all of the tools you'll need to quickly sketch out a sculpture and then take that idea all the way to completion. It allows you to create any kind of project, limited only by your imagination and without having to worry about all the technicalities often related to the work of a digital artist.

Realistic human beings are one of my favorite subjects. I started this project by sketching a head, starting from a sphere and without knowing exactly where I would go next. I ended with an interesting-looking man's head, and the idea of an aged man, who is having a lot of fun scaring an unknown intruder off his backyard, started to take shape.

In this tutorial, I will cover every step of the creation for that sculpture. I will start with the blocking of the head and the torso, explaining the basic ideas of digital sculpting that I always try to keep in mind and apply. I will then explain how I went about creating a production-ready topology and how I created another pass of details on the upper body and head. I will also cover how I created the clothes, how I sculpted the folds, and how I used NoiseMaker to add an extra layer of detail on them. We will then take a brief look at hard-surface modeling, and finally, I'll explain how I posed and rendered the character.

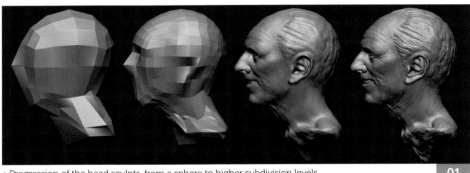

↑ Progression of the head sculpts, from a sphere to higher subdivision levels 01

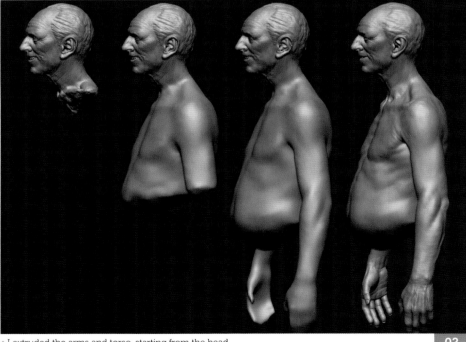

↑ I extruded the arms and torso, starting from the head 02

01 Blocking the head

Sculpting can be broken down into primary, secondary, and tertiary forms. The primary forms are what will make a character believable, so I try to put a lot of emphasis on the basic proportions and volumes. In this case, I did not look at any particular references because I wanted to practice my improvising skills.

I started with a sphere and used the Move brush and the ClayTubes brush to establish the broad shape on low subdivision levels. I always try to get the most out of the lower subdivision levels before moving up. I tried to pay attention to the inflections and structures of the skull, as well as to the fat and muscles that would cover them. The process was mostly done using the Move and Clay brushes. The Clay brush gives you a real-life feeling, just like adding small chunks of clay to build up the surface.

02 Blocking the torso

After I had formed the head and features of the face, I continued on the body, using the Move brush and the ClayTubes brush combined

with DynaMesh. When DynaMesh is pressed, ZBrush provides geometry to the mesh without polygon stretching. This gives me the freedom to continue sculpting without having to worry about the underlining geometry.

I extruded the arm and torso with the ClayTubes and Move brushes. I also used the Dam_Standard brush to cut some of the muscle mass. I proceeded to refine the general volumes and define the secondary forms created by fat, tendons, and folds of flesh, to give me a better sense of the character and to help judge the volumes and proportions.

03 New topology for the upper body

Using all that DynaMesh created a very dense mesh. The new ZBrush ZRemesher provides an entirely rebuilt retopology system. With a single click, it produced a very good new topology based on my original mesh.

I have experimented a lot with the Adaptive Size settings. A low Adaptive Size means polygons are as square as possible and approximately the same size. Higher settings mean polygons can be more or less rectangular in order to best fit the mesh's flow and polygon density, which can be higher where necessary – like on the fingers. I went with a high Adaptive Size. After a touch up in 3ds Max, I had a very good animation-ready topology. I then quickly created some UVs in ZBrush using UV Master.

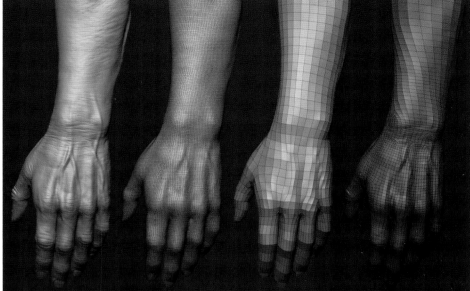

↑ The hand sculpts, the dense DynaMesh topology, and progressions of the ZRemesher topology 03

04 Detailing the head and torso

Now that I had a nice mesh with UVs, I imported it back to ZBrush and projected all the details onto it. I started from the very first subdivision level and slowly moved up, putting as much form and detail into every level as possible.

I moved to subdivision levels 3 or 4 and used the ClayTubes brush in conjunction with the Smooth brush, both with low values. I kept alternating between those two brushes, using the Smooth as a polishing tool to reduce the

hard edges and refine the transition between forms. It was a very iterative process, but it gave natural-looking sculpts with a nice fleshy feeling. I also used the Standard brush with LazyMouse to cut finer details such as the infra, the lower eyelid, and the nasolabial furrows.

I continued stepping down to lower subdivisions to modify large forms. I then moved up to the highest subdivision level in order to sculpt the tertiary forms: The wrinkles, skin pores, and high frequency details.

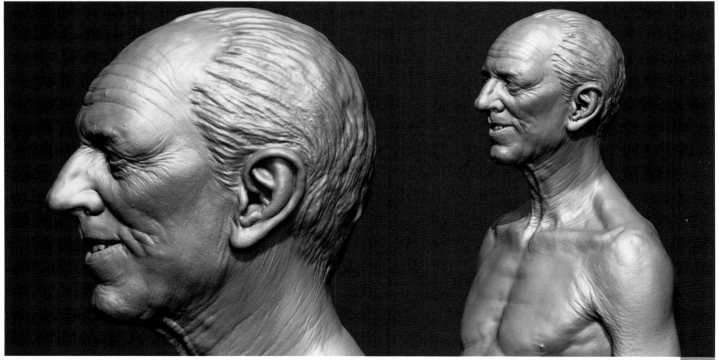

↑ Details of the head and torso 04

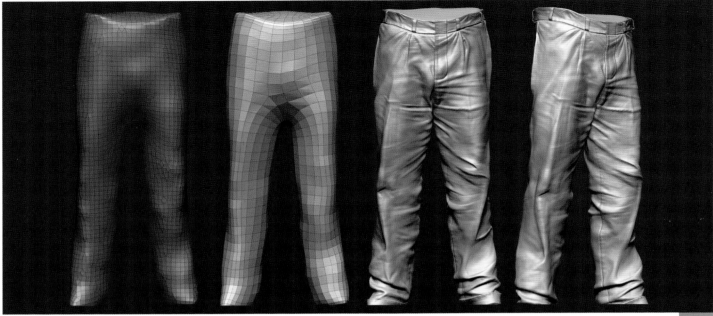

↑ First the DynaMesh topology, then the ZRemesher topology, and finally the sculpted pants

05

"The NoiseMaker tool allows you to create very nice 3D noise with a wide variety of settings and parameters"

05 Creating the cloth

I started the shirt with mesh extraction. I painted a selection on the chest area that roughly resembled the type of sleeveless shirt that I had in mind and then pressed Extract. I then created a production-ready topology using ZRemesher and 3ds Max. I didn't have any existing geometry to extract the pants so I had to block them using the DynaMesh tool.

When I was happy with the basic shape, I started sculpting the folds. When improvising folds, I have a tendency to do mostly long folds that spiral around the legs. I tried to include different types of folds that follow the logic of real-life clothing, like those zigzag, alternating folds that occur on the inside of the bend of a tubular piece of fabric when it buckles; they tend to be more angular the stiffer the fabric is.

There are almost always drop folds falling from the knees, and half-lock folds on the sides, which are produced when a tubular piece of cloth abruptly changes direction.

In addition, pants that have been bent often leave imprints. A lot of those zigzag folds caused by frequent compressions are visible at the back of the knees of well-worn pants.

When working in production, those memory folds work very nicely because they don't fight against the folds created by cloth simulation; they just add a layer of detail on top of them.

06 Adding textures using NoiseMaker

I wanted to take the surface detail of my cloth models further by adding a little fabric texture to the folds. I used the NoiseMaker tool in ZBrush. This allows you to create very nice 3D noise with a wide variety of settings and parameters. You can therefore achieve very nice results, quickly.

The Surface Noise tool can be activated with the press of a button, found under the Surface tab in ZBrush. A library of predefined Noise files can be accessed by pressing the LightBox NoiseMaker button. I chose Noise07, which already had a cool fabric-looking Alpha.

Back to the Surface tab, I pressed Edit to open the Surface Noise preview window and edited the settings. I experimented with different scales and strengths. Once I was happy with those settings, I saved my new Noise file and applied

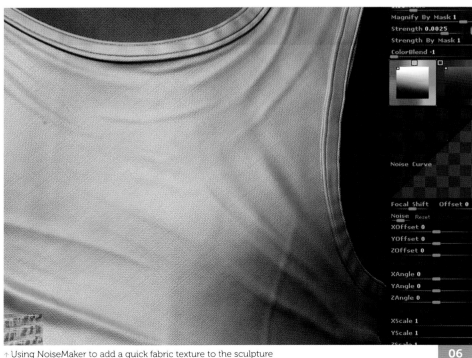

↑ Using NoiseMaker to add a quick fabric texture to the sculpture

06

it to the pants, the shirt, and the suspenders. I applied it to the mesh by exiting the Surface Noise preview window and by clicking the Apply To Mesh button under the Surface tab.

07 Creating the shotgun

ZBrush has several very cool features specially designed for hard-surface or mechanical sculpting. I first created the basic shape of the gun by combining many different primitives. I moved them around with the Move tool to get something as close as possible to the shape of a shotgun.

I also used the Mesh Insert brush, which allows you to pick another mesh and just stick it to the surface of the model. Then I combined everything in one mesh with DynaMesh so I could start to sculpt and add details.

I used the Planar, Trim, and Polish brushes, combined with frequent use of DynaMesh, to define the shape to something that was very close to the general shapes. The Clip brushes turned out to be a great way to cut away areas and slice the borders. I extruded some panels by drawing a mask representing the region I wanted to extrude, and then extruded them with Inflate in the Deformation subpalette.

I proceeded to create a topology that was lower and more efficient than my very dense DynaMesh – again, using ZRemesher. I subdivided this new mesh up to level 4 and then used a lot of standard brushes with LazyMouse in order to define the edges. I used the Polish and Trim brushes as well in order to achieve nice flat areas and polished surfaces.

08 Posing the character

At that point, I had all the separate elements in place so I gave the character a pose to make the sculpture a little more dynamic, using the Transpose Master tool. This creates a low-resolution mesh that combines all the SubTools that you can pose.

I isolated parts of my model and rotated them to the desired pose. For example, to rotate the right arm upward, I masked everything but the arm, moved from Draw mode to Rotate mode, drew a line with the Transpose bone from the shoulder to the elbow, and then dragged the end of the line that was not the shoulder to rotate the arm. Next,

I went back to Draw mode, painted a mask from the elbow to the fingers, and rotated that part up to position the hand so that it could hold the gun.

I repeated this process for each finger and to the wrists. I rotated the shoulder and the spine to give the impression that the weight would be a little bit more on the left side. I also rotated the upper torso, the head, and the arms slightly to the right to give an interesting gesture. All those manipulations damaged some areas of the sculpt and collapsed some of the volumes of the arms, so I re-sculpted those places and added new skin folds and bigger wrinkles where new tension regions were created.

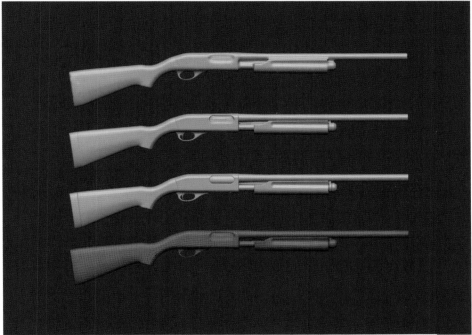
↑ Progression of the shotgun model and the final topology 07

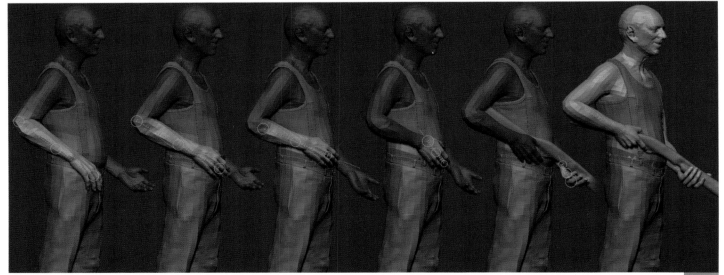
↑ The development in posing the arms 08

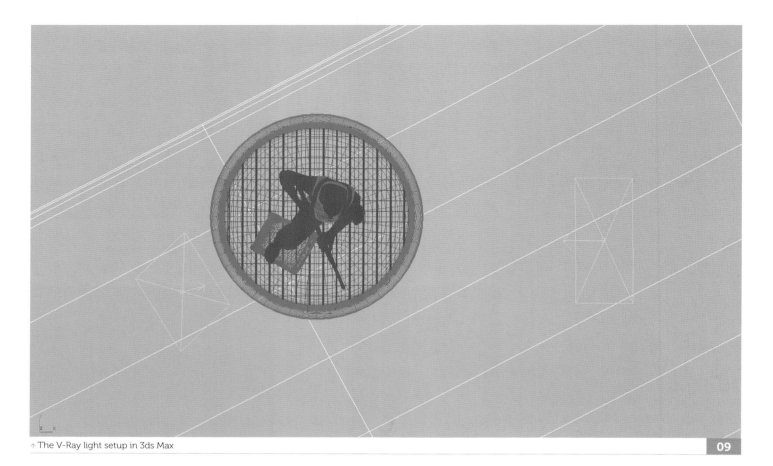

↑ The V-Ray light setup in 3ds Max

09

09 Lighting and rendering the sculpt

ZBrush offers a great solution to render your sculpture. However, I have been using V-Ray for a very long time now and I've become very comfortable with this rendering engine. Therefore, I exported my character out of ZBrush and imported him to 3ds Max for the final steps.

I had very nice topology with good UVs for all the objects, so it was easier to export the lower meshes and to render them with Displacement. I used the VRayDisplacementMod and the type was set to Subdivision. The scene was rendered using one planar V-Ray light as key, and another planar V-Ray light placed behind the character as a rim light.

I first set up the renderer to low values to speed up the render times so as to allow quick experimentation with the light position and also to play with the placement of the camera. I only used VRayPhysicalCamera here, and arranged the depth of field exactly as I wanted. For the final renders, I increased the samples for the image sampler, Light Cache, and Irradiance map. Everything was rendered as one pass straight from 3ds Max.

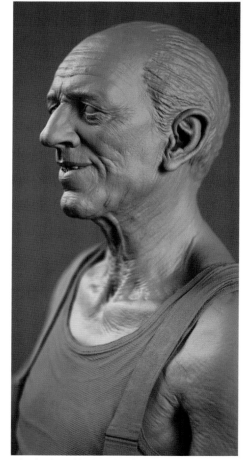

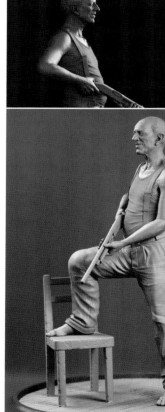

↑ A selection of final renders (see full-page image on right, also)

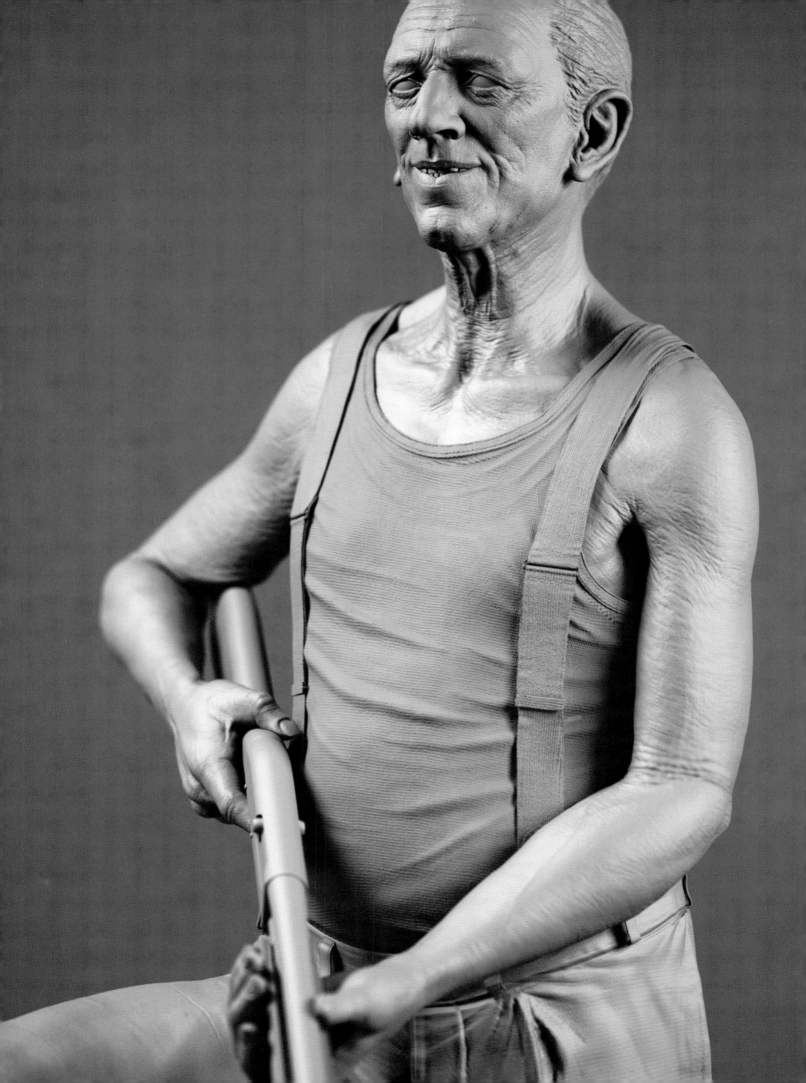

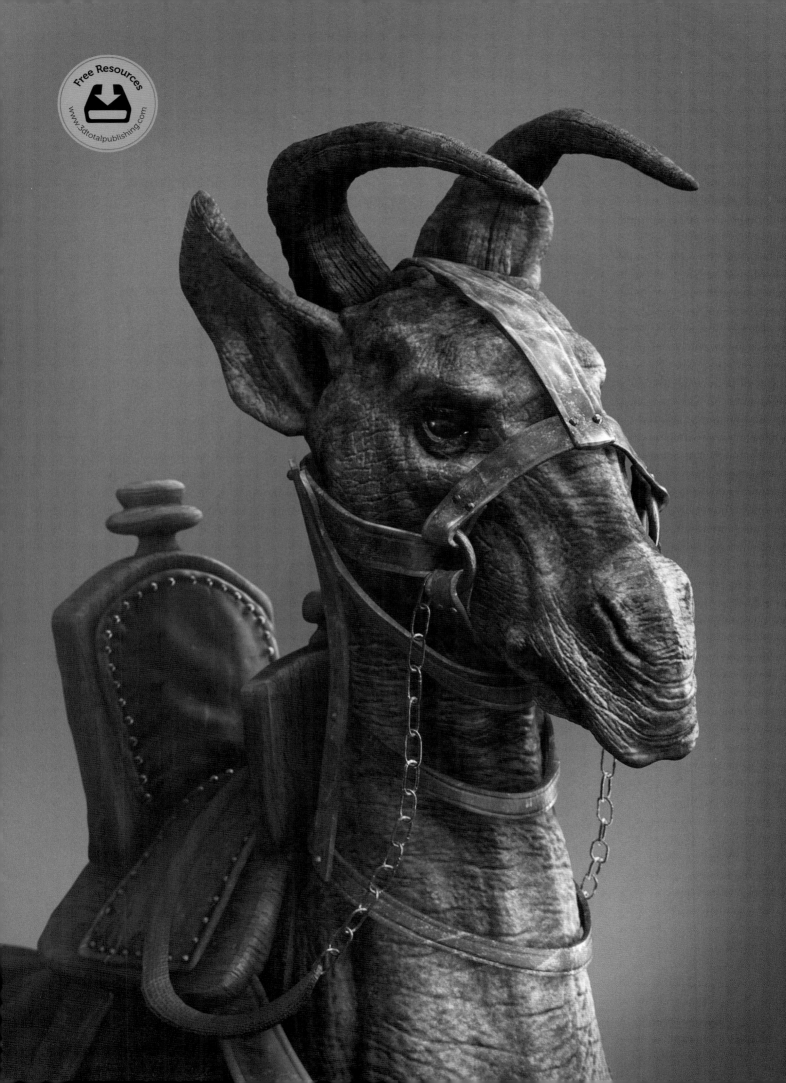

Quadrupeds

Follow the process for crafting credible and impressive quadruped beasts

Creating a solid, realistic quadruped requires a certain understanding of creature anatomy, pose, and balance. In the following set of tutorials focused on composing convincing quadrupeds, talented artists including Daniel Bystedt, Ali Zafati, and Justin 'Goby' Fields break down the entire creation process and reveal a whole host of sculpting techniques, texturing tips, and software suggestions. Aimed at both inspiring and instructing, these tutorials will support the development of your quadruped concepts and motivate you to move your models to the next level.

Quadrupeds

Part 01: Perfect your polygrouping

By Daniel Bystedt

Lead Modeler and Project Manager at Milford Film
& Animation

Free Resources
www.3dtotalpublishing.com

I was really excited about the idea of making a quadruped, as I thought it would be a great opportunity to show people the versatility and creative workflow of ZBrush.

At the beginning of the modeling process I use separate geometry islands for the different pieces of the body. This is a workflow that I think resembles the thought process of roughing out a character in 2D. There is a lot of ground to cover, so let's get started!

01 2D concept

All I know is that I want to create a fantasy quadruped. I don't know which direction to go in, so I sit down and draw some ideas in the form of thumbnails and rough sketches. It's fun to concept and speed-model ideas in ZBrush, but I think the ideas usually transform into a sketch faster from a 2D medium.

After this, I try to analyze the sketches and find a form that I like. I decide that I don't want to go for the typical ZBrush monster, but rather a slender type of desert creature. I imagine that it should be used for traveling by a fantasy race of nomads living in the desert. I want to develop the creature a bit further in 2D before jumping into ZBrush, so I start designing the head.

After doing some design variations of the head, I go for one where the horns follow the curve of the head. Now it's time to refine the creature's body and add some props. I am not sure how many props I want to add, so I do three versions. I sketch one creature without props, which will serve as a reference for modeling the body, and two others with different amounts of props.

02 Base mesh creation

When I sculpt I usually ignore topology for as long as I can. This gives you freedom to try out different

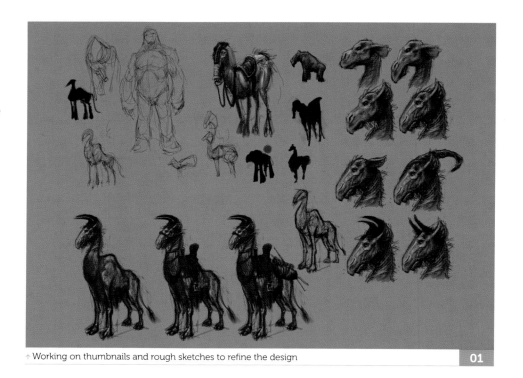

↑ Working on thumbnails and rough sketches to refine the design
01

ideas without worrying about messing up edge loops, which is usually the case when you start pushing and pulling your mesh a lot. The correct animation topology can always be done later. If you work in production, you can easily split up your model as a proxy for the rigging department and hand in a better topology for skinning later on.

There are lots of great ways to create a base mesh in ZBrush; ZSpheres is one, but I want to try something I haven't done that much of for

this tutorial. The workflow I want to try involves creating the different parts of the character as separate geometrical islands and therefore having greater freedom to push, pull, and move around at the start of creating the creature. The plan is to do this with the CurveTube brush and then later convert it to a DynaMesh.

Begin with the DefaultSphere from LightBox to have as a starting point, as displayed in image 02 below.

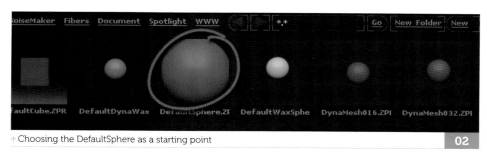

↑ Choosing the DefaultSphere as a starting point
02

03 Loading reference images

Load your reference image into the document (Texture > Image Plane > Load Image). It's good to save the document at this point, so you always have the same position of the image plane. If you were to accidentally drop something on the document or mess it up somehow, you can always load the original back into ZBrush.

04 Lining up the reference image

Go to the lowest subdivision of the DefaultSphere (Tool > Geometry > SDiv or press hotkey D to step down in subdivisions). Then delete the higher subdivisions (Tool > Geometry > Del Lower). Lower the opacity on your model (Texture > Image Plane > Model Opacity) and turn on Perspective and Floor on the right-hand side of the document.

Try lining up the viewport with the sketch. Once you have a decent view you can store the camera position in the timeline. Open the timeline (Movie > Timeline > Show) and set a key frame by left-clicking on the timeline. Existing key frames can be deleted by dragging them from the timeline. You can use the left and right arrow keys to step between key frames.

You can rotate the camera around, but if you still want to keep the image plane with the reference in the background, you might want to use the Zoom and Pan Document buttons on the right-hand side of the document.

05 The Move tool

Continue to move and sculpt the model. The different brushes can be selected by pressing the hotkey B. Please note that all brushes have a letter attached to them. Press this letter on the keyboard to filter out the brushes. You can also learn the hotkey sequence for the brushes that you usually work with – for example Move is B+M+V.

In this phase of the modeling process, I usually use a selection of brushes and tools as described in the subsequent steps, then move the mesh around. By holding the Alt key on the keyboard, the mesh moves in the normal direction sampled by the brush.

06 The Standard brush

It's nice to build up volume using the Standard brush with a low Z Intensity (hotkey U); it's pretty soft. If you want to invert the mesh, you'll find that holding down the Alt key for this tool pushes the mesh inside the model.

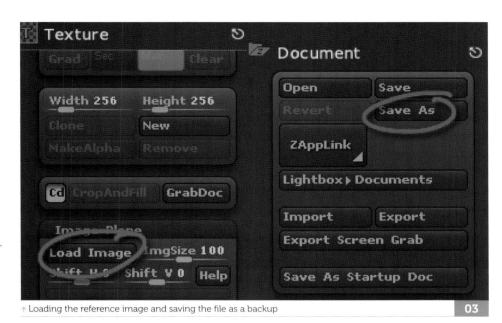

↑ Loading the reference image and saving the file as a backup `03`

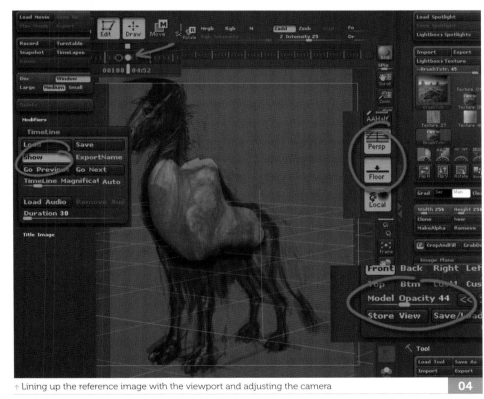

↑ Lining up the reference image with the viewport and adjusting the camera `04`

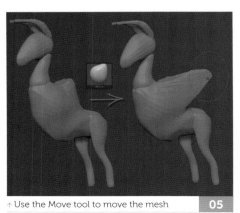

↑ Use the Move tool to move the mesh `05`

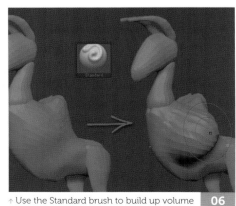

↑ Use the Standard brush to build up volume `06`

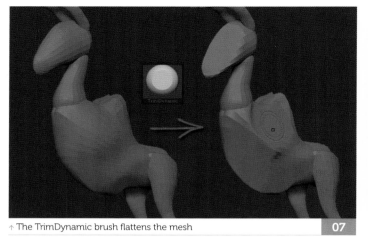

↑ The TrimDynamic brush flattens the mesh | 07

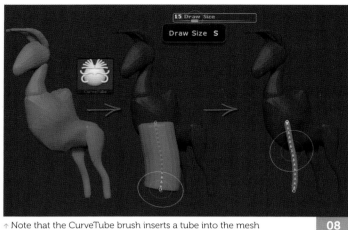

↑ Note that the CurveTube brush inserts a tube into the mesh | 08

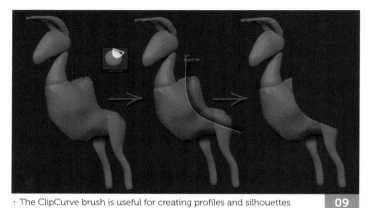

↑ The ClipCurve brush is useful for creating profiles and silhouettes | 09

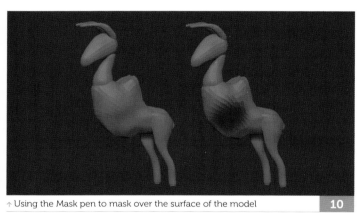

↑ Using the Mask pen to mask over the surface of the model | 10

07 TrimDynamic brush

The TrimDynamic brush flattens the mesh. The brush follows the surface of the existing mesh, but pushes all contours flat against the model, as seen in image 07.

08 The CurveTube brush

The CurveTube brush inserts a tube into the mesh. The bigger the brush you have, the fewer spans the created curve has. The size radius of the tube can be set by adjusting the size of the brush when it's outside of the created curve (red circle) and then clicking on the curve (blue circle).

The curve can be adjusted by dragging the points of the curve. Only one curve can exist on the model. When you create a new one the old one is deleted, but the created mesh is still there. You can also delete the last created curve by left-clicking on the mesh when the brush circle is red. It is only possible to use this brush when the model has one subdivision.

09 The ClipCurve brush

The ClipCurve brush pushes the faces along the curve. This is a good tool for cutting into the mesh and establishing a profile.

10 Mask pen

By holding down Ctrl you can mask the surface of a model. You are unable to affect the masked area with another brush. The mask can be inverted by Ctrl+clicking the document outside the model.

11 Transpose line tool

Enter this tool in three different modes: W for Move; E for Scale; R for Rotate. First you draw a line and then you choose a point on the line to use. You can also use masking with the Transpose line functions by holding Alt and dragging the point. This is a tool that takes a while to get used to.

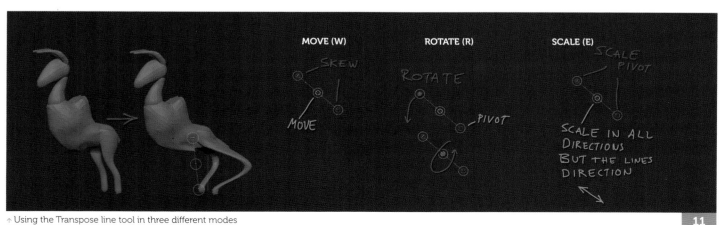

↑ Using the Transpose line tool in three different modes | 11

In addition, you can mask the model by topology with the Transpose line tool. Hold Ctrl and drag it on the model to access this feature. Hold Ctrl and click on the model to mask all but the polygroup that you clicked on.

12 Symmetry

Use the CurveTube brush to build up a base mesh in steps. You can use Mirror And Weld (Tool > Geometry > Mirror And Weld) to create a perfectly symmetrical base mesh.

Once you have a symmetrical mesh you can use Tool > Deformation > Smart ReSym to make the model symmetrical in terms of shape.

Using the different brushes and tools, continue to refine the model. If you wish, you can turn on Polyframe with the shortcut Shift+F.

13 DynaMesh

Since there is an uneven distribution of polygons that are unsuitable for sculpting, we will convert the geometry to DynaMesh. By activating the Tool > Geometry > DynaMesh > Groups button, we will keep the different geometric islands separate from each other.

14 Masking

Don't forget to use masking and Transpose when moving or scaling different parts of the body. Also remember to mask all polygroups with Transpose and Ctrl+click on the polygroup.

15 Clipping brushes

Use clipping brushes to model big forms. To avoid unwanted clipping when using the Clip brush that's facing inside the model, you must mask off one side. Then apply the clipping on the other side with Tool > Deformation > Smart ReSym (don't forget to mask the side that should not be affected by re-symmetry). You can also use Mirror And Weld if your mesh only has one subdivision.

Don't be afraid to use the TrimDynamic or Clip brushes. I don't think it's a bad idea to have hard edges to define the big shapes of the model at this point.

Work on layers when trying out an idea that you are not sure of. Then you can easily turn it off, store a morph target at Tool > Morph Target > StoreMT, turn the layer back on, and paint away the areas that you want to delete the sculpting on by using the Morph Target brush.

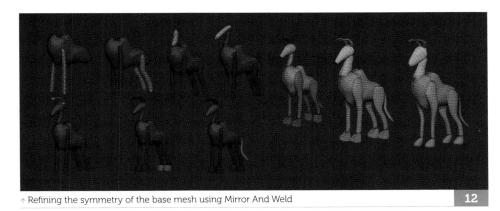

↑ Refining the symmetry of the base mesh using Mirror And Weld **12**

↑ Converting the geometry to DynaMesh and allocating groups **13**

↑ Moving and scaling the body using a mask **14**

↑ Using the Clip brush to work on the modeling **15**

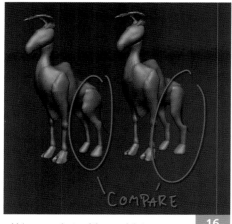

↑ Using snapshots of the models to compare changes **16**

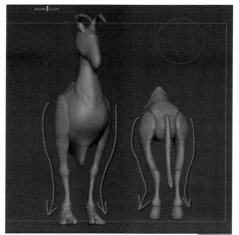

↑ Working on the legs of the model **17**

↑ Using the zbro_Gray_01 MatCap to avoid specularity **18**

16 Comparing sculpts

To try out different sculpt versions, you can turn off a layer and set a snapshot of the document (Shift+S), then turn on the layer and move the model to the side. Now you can compare the two versions by looking at them simultaneously. I find this very helpful in order to decide on different directions for the design.

17 Quadruped legs

Try to get some rhythm/curvature in the legs of the creature, as legs that are too straight look unnatural and stiff.

18 Material

Use a silhouette to make it easier to analyze the big forms. Choose a MatCap material to avoid specularity on your silhouette. Then make sure you have black and white in the color swatch. Switch between the two colors to quickly check your silhouette (hotkey V). If your model has Polypainting on it, you can deactivate this temporarily using the Tool > SubTool > Brush icon.

19 Mid-forms

It's time to combine the geometry islands with DynaMesh. Duplicate the original SubTool and merge the polygroups of the separate geometry islands (except the horns). Hold Ctrl+Shift and click the horns, then invert visibility by holding Ctrl+Shift and dragging on the document outside the model. After that you can choose Tool > Polygroups > GroupVisible and show all geometry by holding Ctrl+Shift and clicking on the document outside the model.

20 Converting to DynaMesh

Now you can convert the model to DynaMesh with a resolution of 128. After converting to

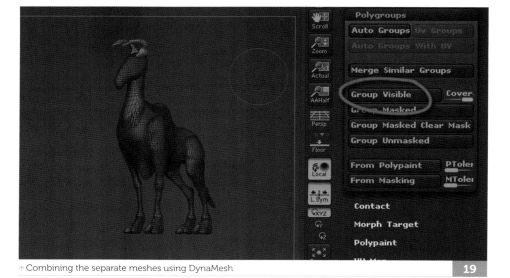

↑ Combining the separate meshes using DynaMesh **19**

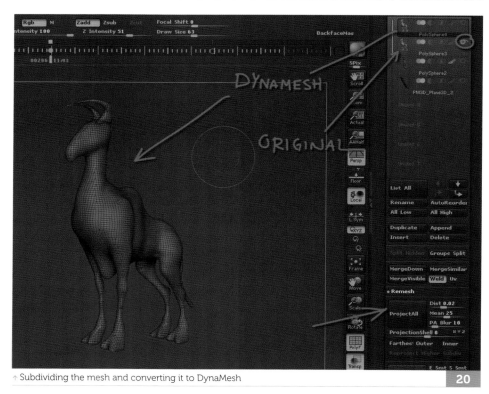

↑ Subdividing the mesh and converting it to DynaMesh **20**

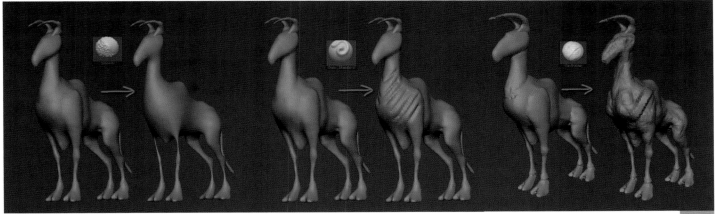

↑ The Smooth brush, the Dam_Standard brush, and the ClayBuildup brush `21`

DynaMesh, the geometry loses its shape. It's therefore time to project it to the original version in order to get the old shape of the model onto the new geometry. Divide the model three times to get more subdivisions so you will achieve a more defined sculpt when projecting. Go to Tool > SubTool and choose Project All.

To attain good results, you can project one subdivision at a time. Start with subdivision 1 and project it; then step up to subdivision 2 and project it; and so on. Make sure only the original body and the new DynaMeshed version are visible in the SubTool menu. You can turn Visibility on and off with the eye icon in the SubTool menu. After the projection, you can delete the old model with Tool > SubTool > Delete.

21 Mid-level details

Now it's time to refine the model and add more mid-level details. When doing this I usually use several brushes:

• Standard brush: see step 06.

• Smooth brush: This smooths out the details and evens out the surface. It's good to work with this brush on different subdivision levels. You get a more powerful smooth on the lower subdivisions and a lower smooth on the higher divisions. More polygons means less smoothing. Press Shift to access this brush.

• Dam_Standard brush: This cuts into the mesh nicely. It is set to 'sub' by default, which means it removes volume from the surface. It has a really small Alpha, so it always gives a stroke with a smaller radius than the current size of your brush. It can be a nice workflow to alternate between Dam_Standard and Smooth.

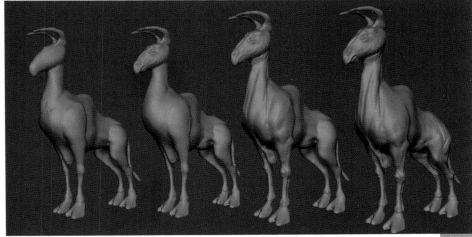

↑ Using the tools from the previous step to refine the model `22`

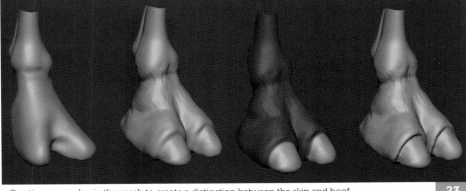

↑ Creating an overlap in the mesh to create a distinction between the skin and hoof `23`

• ClayBuildup brush: This builds up volume and looks very natural. It resembles the Standard brush, but generates a more even and flat surface. Unlike the Clay brush, it keeps adding volume all the time during your stroke; the Clay brush only builds to a certain point.

22 More detail

Continue to refine the model with the different tools and brushes. Cut with Dam_Standard and smooth out the mesh. Use

ClayBuildup or TrimDynamic on areas that seem a bit lumpy and smooth them out.

23 Detailing the foot

When sculpting the foot, there is overlapping geometry on the transition between the skin and the hoof, which creates a defined edge. To create this overlap, mask out the hoof. Then invert the mask by Ctrl+clicking the document outside the geometry. Use the Move brush to move the hoof in and create the overlapping. Don't worry

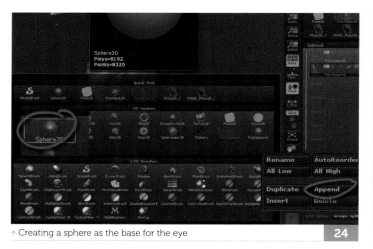

↑ Creating a sphere as the base for the eye
`24`

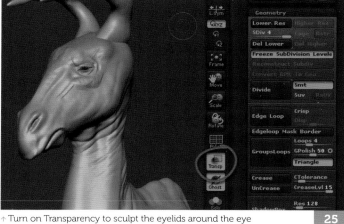

↑ Turn on Transparency to sculpt the eyelids around the eye
`25`

about sculpting the feet on the hind legs. We will copy the front feet to the back later on.

24 Detailing the eye

It's now time to add an eye. Append the Sphere3D (Tool > SubTool > Append) and move it over to the model's right side. You can scale it down with the Transpose Line tool (E). After that you can mirror it over with Tool > Geometry > Mirror And Weld.

25 Detailing the eyelids

In order to sculpt around the eye, you will need to temporarily turn the Transparency on. This will make all SubTools except the active one transparent, so you can sculpt eyelids without having the eye blocking the surface of the face behind it.

26 Detailing the ears

The face is lacking a bit of personality, so let's add big, floppy ears! I won't follow the concept sketch, but will make the ear stand out from the head a bit more. At the moment I will keep it as a separate SubTool, so that I can sculpt it without worrying about messing with the body.

To create the ear, duplicate the body, bake all the layers (Tool > Layers > Bake All), go down to subdivision 1, and delete the higher subdivisions. Then select CurveQuadFill and create a nice profile for the ear.

After that you can isolate visibility on the ear by holding Shift+Ctrl and clicking it, and then delete the hidden polys with Tool > Geometry > Del Hidden.

27 Refining the horns

When refining the horns, it's good to mask the polygroup of the horns with the Transpose line

tool and Ctrl+click the horns. Start by sculpting the grooves of the horns with the Dam_Standard and Standard brushes. Then add the bulge that goes along the horn with the Standard brush. Please note that the Standard brush does not destroy any detail that already exists, unlike the Clay brushes.

Continue to refine the face. I've changed my mind about the ears and made a decision to make them look more like they do in the concept. The first 3D ears we did make the creature look like a common sheep or goat.

28 Copying the mesh

To copy the feet to the hind legs, use SliceCurve to cut out the feet. This adds an edge loop at the cut and puts the feet in a separate polygroup. Isolate visibility on all but the back feet (go into Move mode (W) and

Ctrl+click the feet). Mask out the front feet so everything but the back feet is masked.

Now invert the mask by Ctrl+clicking the document outside the geometry. Hide any unmasked polys with Tool > Visibility > HidePt. Now choose Tool > Geometry > Del Hidden to delete the back feet. Duplicate the model and repeat the steps in order to delete all but the front foot. Choose Tool > Geometry > Close Holes to avoid a mesh with holes in it. Finally, place the foot at the base of the hind legs.

29 Merging the mesh

Merge the ears, body, and feet with Tool > SubTool > MergeDown. Mirror the merged SubTools so that the missing foot is on the negative side of the X axis (Tool > Deformation > Mirror). To make a symmetrical mesh, go

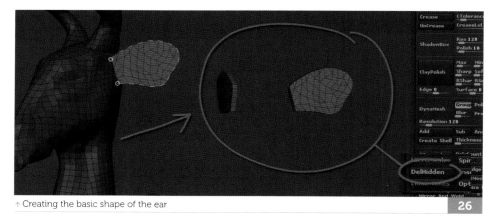

↑ Creating the basic shape of the ear
`26`

↑ Changing the shape of the ears to improve the look of the creature
`27`

to SubTool > Geometry > Mirror And Weld. In order to mirror and weld, we deleted all but the highest subdivision on the model.

I prefer to work on multiple subdivisions, so we need to duplicate the model again. Then convert it to a rather low-poly DynaMesh with Group on and a resolution of 200 in order to get geometry separation between the head and ears. Then divide it and project it to the original SubTool.

Make sure that you have the horns as a separate polygroup and the rest of the model as another

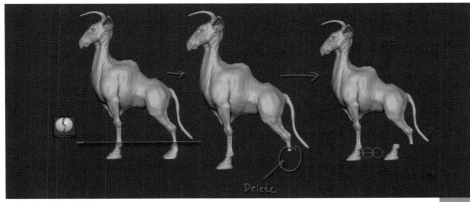

↑ Copying and moving the feet to the hind legs

28

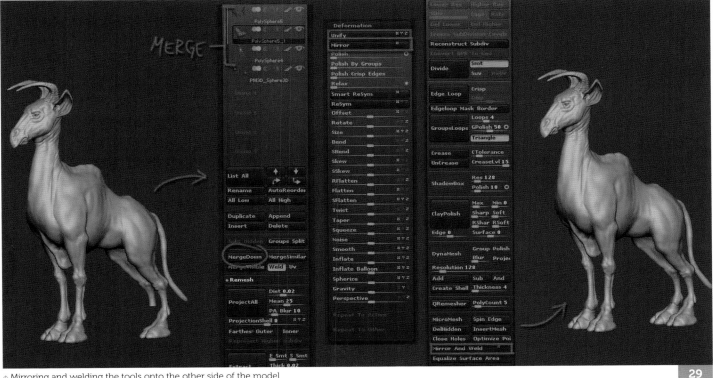

↑ Mirroring and welding the tools onto the other side of the model

29

↑ Highlighting the areas on the model that will require wrinkles, skin twisting, or bending

30

polygroup in order to get a better separation and definition between the horns and skin.

30 Small forms

Now it's time to add wrinkles and other types of small details to refine the model. Don't forget to always work with layers when you sculpt. Try something out and if you don't like it, you can delete the layer.

When creating wrinkles you should think about where they would naturally appear. At the joints and the neck there is usually a lot of twisting and bending of the skin. In image 30 I have painted a rough guide in red where the areas that wrinkles usually appear are. It's also good to check references to find areas where wrinkles occur.

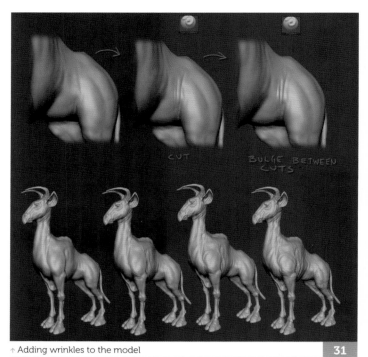

↑ Adding wrinkles to the model **31**

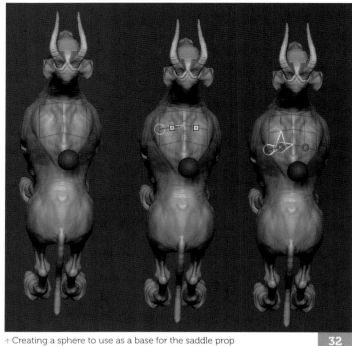

↑ Creating a sphere to use as a base for the saddle prop **32**

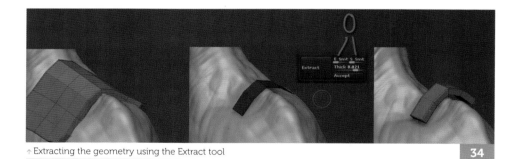

↑ Converting the adaptive skin to a polymesh **33**

31 Small forms

The process that I like to use for sculpting
wrinkles is to use the Dam_Standard brush
in order to cut into the area first, and then
use the Standard brush for bulging out the
areas in between the cuts. In image 31 above,
you can see how the creature develops as I
make progress with sculpting the wrinkles.

32 Adding props

Now we are going to add the props to the
creature. Append a ZSphere with Tools >
SubTool > Append and place it where it's
not going to be in the way. Then go down to
Tool > Topology > Edit Topology in order to
create a new mesh with specific topology.

Next, go into Draw mode by using hotkey
Q and create the topology for the saddle.
You can select points with W. You can
also remove points by holding Alt and
clicking when you are in Draw mode.

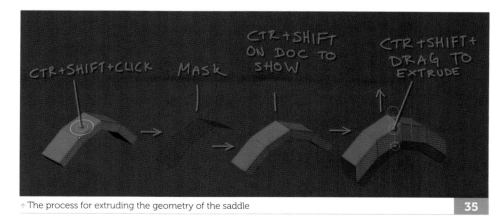

↑ Extracting the geometry using the Extract tool **34**

↑ The process for extruding the geometry of the saddle **35**

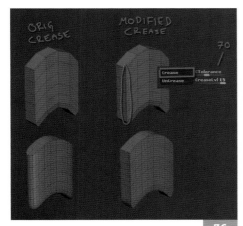

↑ Using snapshots of the models in order to compare changes

36

"A nice way to deform is to use the Transpose tool. If you Alt+drag one of the transpose points, you will deform it with auto masking"

33 Topology of the saddle

To see the created geometry you can press A. You can add thickness to the created mesh in Tool > Topology > Skin Thickness. I also turn on the transparency and polyframe.

Convert the Adaptive Skin to a polymesh with Tool > Adaptive Skin > Make Adaptive Skin. Append the created object and delete the created topology of the ZSphere with Tool > Topology > Delete Topo. You can go back to the ZSphere and repeat the process to create new objects.

34 Extracting geometry

In order to create the support for the back on the saddle, you must hide all polygons except the ones that you wish to extract. You can use the Select Rectangle or Select Lasso tool for this (Ctrl+Shift). Mask off those polygons and make sure the E smt and S smt values are at zero under Tool > Geometry. Then press Tool > Geometry > Extract.

35 Extruding geometry

The back support is not high enough, so we are going to extrude the polygons a bit. Ctrl+Shift+click the polygroup facing up to hide all the other polygroups. Mask the visible polygons by Ctrl+clicking the document outside the model. Ctrl+Shift+click the document outside the model to show all polygroups.

Activate the Transpose tool by pressing W, then drag a Transpose line in the Y axis. Now

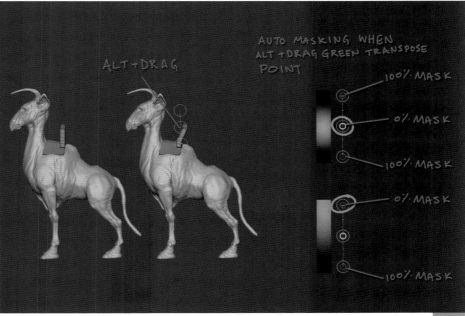

↑ Deforming the mesh using the Transpose tool

37

↑ Adding strap detail to the saddle

38

hold Ctrl+Shift and drag the white, middle circle on the Transpose tool in order to extrude. Repeat the extrude process a couple of times until you reach the desired height.

36 Creasing geometry

If the model was divided, you would see that the creasing is not the way we want it. Fortunately, ZBrush can crease edges depending on curvature. Go to Tool > Geometry and set CTolerance to 70. Then press Tool > Geometry > Crease to crease the edges. You can remove creases by Shift+clicking Tool > Geometry > UnCrease. If only a portion of the polygons are visible then the border edges will be creased when you press Crease.

37 Deforming geometry

When using the Standard and Move brushes to deform the back support, it is easy to mess up the hard-surface look. A nice way

to deform is to use the Transpose tool. If you Alt+drag one of the transpose points, you will deform it with auto masking.

Before you subdivide, you want to make sure that you have a symmetrical topology, so use Tool > Geometry > Mirror And Weld to do so.

38 Finishing the saddle base

Continue to create the saddle using the processes from earlier steps: ZSphere retopology, extracting, and extruding. When adding the metal ring for the bridle, use Tool > SubTool > Append and choose ring3D from the 3D meshes pop-up menu.

In image 38 you can see that I have also used Polypainting on the body of the creature in order to try out the design of the leather straps before I model them. It's nice not to have to think about design when doing topology.

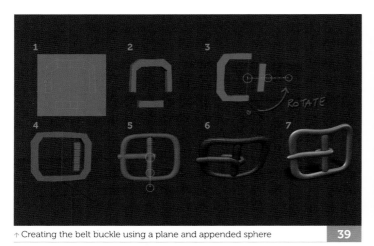

↑ Creating the belt buckle using a plane and appended sphere **39**

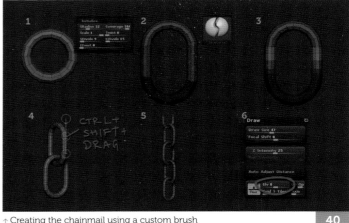

↑ Creating the chainmail using a custom brush **40**

39 Creating the belt buckle

Let's create the belt buckle for the saddle strap. Choose Plane3D from the 3D meshes menu, append a ZSphere, and move it out of the way. Activate Tool > Topology > Edit Topology and draw out the topology (image 39, 1). Set Tool > Topology > Skin Thickness to 0.1 and preview Adaptive Skin with hotkey A (Tool > Adaptive Skin > Preview). Also set Tool > Adaptive Skin > Density to 1. Then choose Tool > Make PolyMesh3D to create a polymesh (2).

Go into Rotate mode (R) and use the Transpose tool to rotate the geometry, so it's going along the X axis (3). Duplicate the model and use Tool > Geometry > Mirror And Weld (4). Go back to the SubTool with the pin and delete all the geometry apart from the pin. Duplicate the pin and rotate it 90 degrees (5).

Merge all SubTools into one and remove the creases by Shift+clicking on Tool > Geometry > UnCrease. Use Tool > Polygroups > Auto Groups to make a polygroup of each geometry island. Now it will be easier to mask (Ctrl+W) and move the different parts around. Position the different parts and divide the geometry (6). If you want to get rid of some unwanted kinks in the geometry, you can fix them by using Tool > Deformation > Polish (7).

40 Making chains

In order to make the chain for the bridle, we are going to create a brush. Go to the Tool menu and select Ring3D. Change the setting so it's a lower poly (image 40, 1). Convert it to a mesh with Tool > Make Polymesh3D. Use the SliceCurve brush and make an edge loop in the middle. Mask off the top and drag it up with the Transpose tool (2). Then add some more edge loops (3). Clear the mask and make a copy by Ctrl+Shift+dragging

the white middle dot on the transpose line (4). Clear the mask and drag out a new copy of the two rings. Repeat this last stroke with hotkey 1 to duplicate a lot of rings quickly (5). Then set your floor grid by setting Draw > Elv to zero (6).

41 Adjusting the chains

Rotate and scale down the chains so they cover four floor grids (same size as a polyPlane3D if you need a reference) as seen in image 41 (1).

Select the InsertHead brush and choose Brush > Clone to copy it. Go to Brush > Modifiers and select the chain mesh that you've created as an insert mesh. Also go to the Stroke menu and activate Curve Mode and Bend (2).

Now you can try out the created brush. Remember that the radius of your brush determines the size of the chains. As long as the curve exists, you can change the brush size when it is outside the curve (red point at end of chain in part 3 of image 41) and click the curve to resize the chains. Don't forget to save your brush once you are done (4).

42 Making studs

We also need to create a brush for the studs. Select Plane3D in the Tool menu and convert it to a mesh with Tool > Make PolyMesh3D. Mask out four polygons (image 42, 1) and use Tool > Geometry > Extract to create a new mesh (2). Use Tool > Deformation > Polish to make it rounder and delete the backside of the mesh (3). Make sure the stud is facing the Z axis, a positive direction. Go to Brush > Modifiers and select the stud mesh as an insert mesh. Save the brush.

43 Creating a blanket

To create the blanket that is wrapped up and tied to the creature's back, start by appending a PolyMesh3D, so you can select it and insert a tube with the CurveTube brush. Also set Brush > Modifiers > Brush Modifier to 5 to get a lower density tube. Draw out a tube (image 43, 1).

Use the Select Lasso tool and click on an edge to hide the edge loop. Then invert visibility by Ctrl+Shift+dragging on the document outside the geometry (2). Delete the hidden geometry with

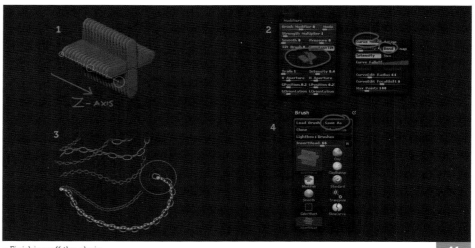

↑ Finishing off the chain **41**

Tool > Geometry > Del Hidden. Rotate the camera to the side and use the ClipCurve brush to flatten the geometry (3). Mask the geometry and extract it with Tool > SubTool E smt and S smt at zero, so the extracted mesh won't be deformed (4).

Mask off one side and start extruding with the Transpose tool (W). As described in step 35, you extrude by Ctrl+Shift+dragging the white middle dot on the transpose line. You can repeat the last stroke with hotkey 1 to extrude faster (5). Deform the blanket with the Transpose tool, Move, and Standard brushes. Also use the Move Topological brush, which has an auto mask by topological distance (6).

44 Finalizing the props
Continue to add props and refine the shapes using the techniques that you learned in previous steps. The prop development is illustrated in image 44.

Lay out UVs and add surface noise. Combine the straps on the lower parts of the body to decrease the number of SubTools and allow easier management of the UVs. Make sure that all the SubTools that will be combined have the same number of subdivisions in order to save the lower subdivisions. If you have three subdivisions on one strap and four subdivisions on another strap when merging, the lower subdivisions will be deleted. Use Tool > SubTool > MergeDown to merge the SubTools.

45 UVs
Once the straps have been merged, we can do UVs. If your project is for production, I would advise you to do your UVs in another application in order to get more control over placement and such. However, ZBrush does a very fast job of laying out UVs itself, so we will use UV Master on this occasion.

In this example, we will do the UVs for the leather straps on the head, which can be seen in image 45, 1. Go to ZPlugin > UV Master and activate Polygroups. This means that each polygroup will be a separate UV island. Choose Unwrap to do an automatic UV layout. You can also attract the UV seams based on Polypainting. Enable this feature by selecting Enable Control Painting. If you want to edit your UV, you have to choose Work On Clone (2).

ZBrush then creates a copy of your current SubTool that only has the lowest subdivision

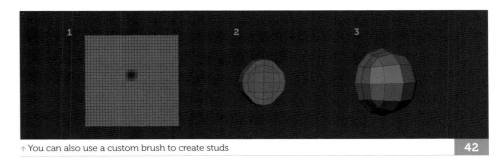
↑ You can also use a custom brush to create studs
42

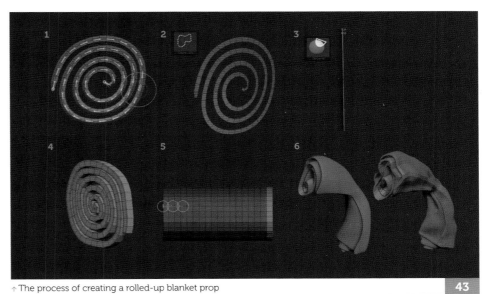
↑ The process of creating a rolled-up blanket prop
43

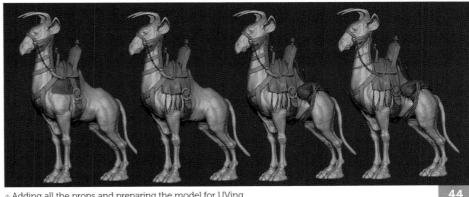
↑ Adding all the props and preparing the model for UVing
44

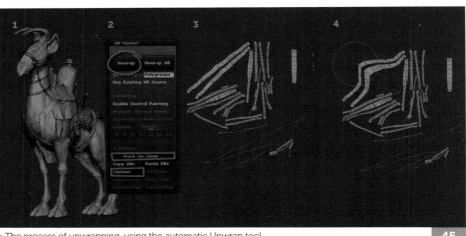
↑ The process of unwrapping, using the automatic Unwrap tool
45

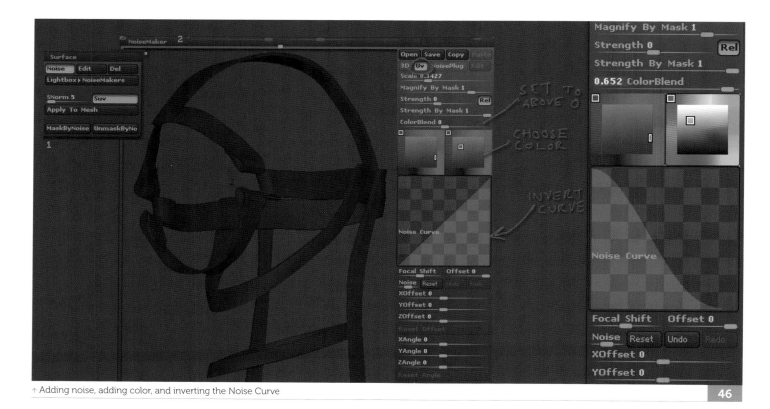

↑ Adding noise, adding color, and inverting the Noise Curve

46

left. If you press Flatten you will see the UV layout represented by a 3D polymesh (3). Edit the polymesh how you want to (4) and press UnFlatten to see the model again. Copy the UVs, then go back to the original SubTool and paste them with ZPlugin > UV Master > Paste UVs. The UVs on your temporary clone will now be transferred to the original SubTool.

46 Texturing the straps

Let's try out a quick texture on the straps. To colorize objects in ZBrush you can Polypaint them, use a texture, or use surface noise. It is actually possible to combine Polypaint and surface noise, which is what we will do. This technique will save time and polycount since we don't need to divide our model to get crisp details in the color.

Go to Tool > Surface/Noise (image 46, 1). Then choose which texture you want to use in the lower left corner (Alpha On/Off). I know that I want to colorize the bright parts of my texture, so I need to invert the curve (2). You should also set the UV button to On, so that the texture will be mapped by UV and not 3D space. Set the color blend to a bit higher and choose a color in the right color slot.

In image 46 you can see all of my settings. Remember that you can save out this noise setting and use it again later, which can save a huge amount of time.

It can also be a nice time-saver to merge objects that share the same type of noise. Don't forget that you can also carry out Polypainting without affecting the noise. Activate Polypainting by selecting a brush, turning off Zadd, and making sure that Rgb is on.

Continue to lay out UVs and create noise settings for the props.

47 Polypainting

Let's go over the workflow of Polypainting and texturing in general. To Polypaint an object, make sure that Zadd and Zsub are off, and Rgb is on in the menu just above the document. First, I look at the flat, basic color of the object, using gradient to vary values and hue. Adding gradients is a great way to avoid a flat-looking texture. See the comparison of part 1 in image 47, which has a

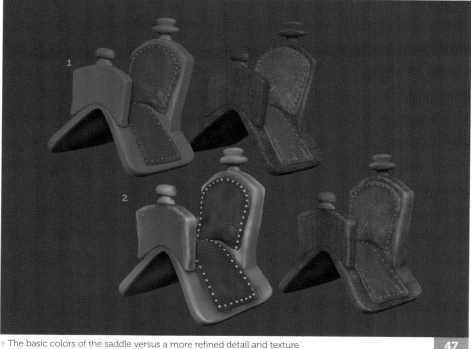

↑ The basic colors of the saddle versus a more refined detail and texture

47

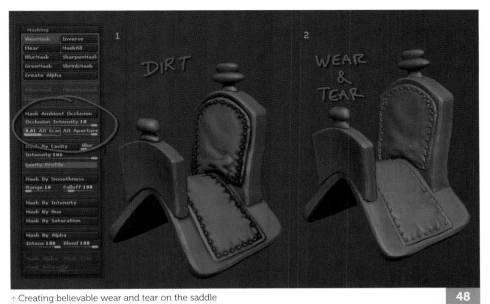

↑ Creating believable wear and tear on the saddle **48**

flat color, and part 2, which has some gradients, wear, and tear in the Polypainting. Both of the versions to the right of 1 and 2 also have fine details (surface noise) added to the texture.

48 Dirt, wear, and tear

Dirt is collected in the cracks and crevices of objects. In ZBrush, you can use Occlusion to mask off the dirt, invert the mask, and then paint. Make sure that the Occlusion Intensity is set to 10. Ambient Occlusion Scan Distance sets the distance for the ray trace when checking for occlusion (image 48, 1).

Wear and tear happens to surfaces that are regularly colliding with other objects, which often happens to corners of objects. I have painted these areas green to give an example (2).

49 Fine details

This is the part of the texturing process that starts to show those small, crisp details. In this tutorial, the texture that we set in surface noise represents that kind of detail. Surface noise can only use one texture, though.

I like to paint in dirt and grime, not only in the crevices of the objects, but on the smooth surfaces, too. This needs to be a bit more subtle than the dirt in the crevices. I usually create a new layer in Tool > Layers and Polypaint that kind of feature on the layer in order to dial it up or down later on.

When painting on layers you can use Alt+draw to erase Polypainting on the recording layer. Spotlight is a great tool, but does not have a smooth falloff between 100% opacity and 0% opacity when projecting textures. We will therefore use a stencil instead.

Import a suitable texture in the Texture menu. Then press MakeAlpha (image 49, 1). In my case, I want to paint in the dark areas of the texture and need to invert it (2). I also want to increase the contrast in the texture so that my Polypainting has better definition. After I'm satisfied, I press Alpha > Transfer/Make St to make a stencil.

Now the stencil pops up in the document viewport. If you press the spacebar you can move it, rotate it, scale it, and so on (3). To hide the stencil while painting, you can press Ctrl+H. If you want to turn off the stencil completely, you can press Alt+H. You can also check the stencil menu for more controls. Finally, repeat these steps for the rest of the props.

↑ Showing how the saddle progresses as it is Polypainted **49**

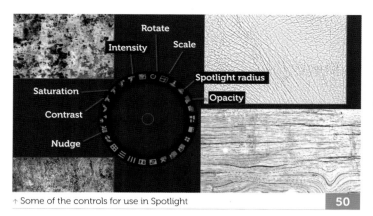

↑ Some of the controls for use in Spotlight `50`

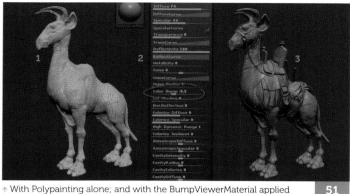

↑ With Polypainting alone; and with the BumpViewerMaterial applied `51`

50 Creature skin

Now it's time to Polypaint the creature's skin. We
will also sculpt the highly frequent details in the
skin. Spotlight is a great way to paint and project
textures onto your model. You have to make sure
that you have a high polycount on your mesh
to get a good resolution on your Polypaint. My
polycount is just above 7 million polys on the body.

Remember that you are painting in screen
resolution, so you want both your model
and the texture to be as big as possible
when you are Polypainting, to ensure that
you won't lose texture resolution.

To load a texture into Spotlight, go to Texture > Add
To Spotlight. If you have loaded multiple textures
into Spotlight, you will only affect the texture
with a red frame on it. Click a texture to make
it the active texture. To turn Spotlight on or off,
press Shift+Z or use Texture > Turn On Spotlight.

When the control wheel is shown, you
can manipulate the textures. To go into
Polypaint mode with Spotlight and press
Z. The Spotlight wheel should disappear,
but the texture should still be visible.

I describe some of the controls in the
Spotlight wheel that I use the most
in the following bulleted list.

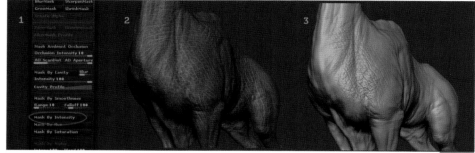

↑ Masking by intensity and sculpting wrinkles using a Standard brush `52`

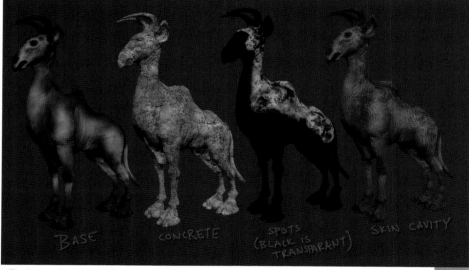

↑ The layers of texture used to create the creature's skin `53`

- Nudge is a way of distorting the shape of the
 texture. You activate Nudge and drag with the
 brush on the texture to distort it. You can use
 Shift to smooth the distortion. You can also drag
 the Nudge icon to restore the original shape of
 the texture. You can use D and Shift+D as well
 to step up and down in texture subdivision.

- ZBrush 4R3 didn't handle blending modes when
 it comes to Polypaint layers, so I found it helpful

to paint textures with high contrast and lower the
layer opacity to show the underlying Polypaint.

- When it comes to saturation, I tend to
 desaturate textures that I'm going to use
 for mask, bump, or displacement. Drag
 the saturation icon on the Spotlight wheel
 and rotate the wheel counter clockwise to
 desaturate, and clockwise to saturate.

- When painting textures that are going to be a
 base for masking, I turn up the intensity, so that
 the areas that should be unmasked are white.

- When painting wrinkles, it's important to get
 the right flow and direction of the wrinkles, so
 rotate and use Scale to scale the active texture.

- When the Spotlight radius is on, you can't see
 the texture while Polypainting and pressing
 down the mouse/stylus. It's good to use this if
 the Spotlight texture overlay is distracting.

- Opacity increases or decreases the opacity
 of all Spotlight textures. This does not
 affect the Polypainting, but makes the
 mesh easier to see through the textures.

51 Painting texture

Now we will paint the skin wrinkle texture, which we will put on a new layer. This will be used as a base for masking out the wrinkles for sculpting later on. Some people sculpt skin with Alphas, but I find that using Alphas makes the skin look repetitive and inorganic. Alphas are great for repetitive details and hard-surface details. They can also be used for organic stuff, but I only use them when dealing with non-repetitive and non-overlapping things.

Bring in a skin texture and use the Spotlight controls, so that it's basically white with some darker areas where the wrinkles are. Switch to BumpViewerMaterial in the Material menu and set the Color bump in the material settings to about –0.5. This material displays color intensity as bumps in the material. Please note that the bump effect is in screen space, so it will look exaggerated when you zoom out with the camera.

Part 1 of image 51 shows the model with the wrinkle Polypainting and the SkinShade4 material; part 2 shows the BumpViewerMaterial settings; part 3 shows the Polypainting with the BumpViewerMaterial.

52 Sculpting wrinkles

When you are done with the wrinkle Polypaint, you can switch back to the SkinShade4 material and mask by color intensity in Tool > Masking > Mask By Intensity, as shown in part 1 of image 52.

Now invert the mask and create a new layer (2). Turn off the layer with the wrinkle Polypaint and set the new layer to Rec again. Now you can use the Standard brush with a low Z Intensity and a big brush size to sculpt the wrinkles (3). Don't forget that you can hide the mask with Ctrl+H.

53 Layers of skin texture

Now we can Polypaint the color of the creature. All Polypainting features should be made on separate layers, so that we can dial them up and down later on. Start by painting in the general hues and values (labeled 'base' in image 53). After that, paint a highly frequent concrete texture ('concrete'). To break up the painting a bit, you can paint in some spots on the creature's back ('spots').

Here, the spots have a big black area for the sake of the presentation. This area is really transparent or unpainted. You can also use the mask from the wrinkle Polypaint and paint

↑ Adjusting the Layers sliders to create the right balance of layers 54

black on a new layer in order to put some dirt in the wrinkles; I have exaggerated this in order to illustrate my point ('skin cavity').

54 Layer settings

When you are done with the Polypainting, you can start dialing back the Layer intensity sliders to get the right look. Please note that the layer that is on top is in the bottom of the layers stack in Tool > Layers. You can see the final result and the Layer Opacity settings in image 54.

55 Posing the creature

Go to ZPlugin > Transpose Master > TPoseMesh (image 55, 1). ZBrush will then create a version of the character where all the lowest subdivisions of all SubTools are merged together (2). Use the masking technique with the Transpose tool, described in step 11. Go to Move mode (W) and Ctrl+left mouse button+drag the

legs to mask off the legs. Use the Transpose tool to rotate the legs into a pose (3). If, for some reason, you need to do new polygroups, then export an object of the pose first. If you don't have the right polygroups, it can mess up the model when transferring the pose to the original model.

When you are happy with your pose, it's time to transfer it back. If you did polygroup changes, then store a morph target of the model at Tool > Morph Target > Store MT, then import the object with the original polygroups.

Now press the TPose>SubT button under ZPlugin > Transpose Master, and the pose should be transferred. If you get some kind of an error, export the pose as an object in Tool > Export, then choose the original model and press the TPose>SubT button (under ZPlugin > Transpose

↑ Using the Transpose Master to pose the creature 55

Master). When ZBrush asks for a file on your hard drive, choose the object with the posed mesh.

56 Materials settings I

Materials are applied to objects by Polypainting with the material channel turned on. You can select which material to paint in the Material slot in the left tray (1). When painting material you need to turn off all layers (2). Instead of painting with the brush, you can flood the entire mesh with the selected material at Color > FillObject (3).

57 Materials settings II

The settings for the materials are quite extensive to go through in detail in this tutorial. I will give you some notes on a couple of the materials, though. Please note that the only way to change the name of the material (that I know of) is to save it. Don't forget to Ctrl+hover over a material setting to show the pop-up help text.

Skin is used for the main parts of the creature's body. I don't want a subsurface scattering (SSS) effect to the material, so I set Wax Modifier > Strength to 14 and Radius to 10. ZBrush only has SSS for back scattering, so if you want front scattering you have to use the Wax Modifier in the shader (image 57, 1).

I've used SkinTranslucentWet for the inside of the ears, the snout, and the eyelids. I want it to have a stronger SSS look than the rest of the skin, so I raise the Wax Modifier strength to 19. I also feel that it should have a bit more of an oily feel to it, so I increase the Specular value and make a sharper specular curve (edited just below the Specular value in the shader) (2).

For the leather material, I wanted the dirty, darker parts of the mesh to have less specularity. I therefore selected the doubleShade1 material, clicked Material > CopyMat, chose another material, and clicked Material > CopyMat to duplicate the original material.

The first shader doesn't have any special values besides Diffuse and Specular. The second shader is a copy of the first without any Specular. In the Mixer section of the shader you should set Black to On. This tells the shader to add shading from a black value. The default of Black is off, which makes the shader brighter than I want it to be.

In the color swatch (marked by a green arrow in image 57), you can set a color. All polygons

↑ Some of the basic materials settings used **56**

↑ Some of the skin, color, and shader settings used **57**

with a color value that are below the one in the color swatch will have the second shader applied to them. Intensity is basically the same as opacity and Intensity Exponent is basically the falloff of the shader (3).

For the metal material, two things are important: Metalicity, which makes the specular inherit the color of the Polypaint or texture; AnisotropicSpecular, which spreads the specular as if it was brushed metal (4).

For the cloth, I've decided to use two shaders. The first is just a normal shader with a Diffuse setting. The second shader has a lower Diffuse value, which adds to the lighting on the first.

The second shader's mixer setting is changed, so that the lighting is only applied to the polygons facing away from camera, to achieve a sort of fuzzy look. This is done with Fresnel and F Exp. Make sure that you set Black to Off, so that the second shader adds to the first shader's shading and doesn't simply replace it (5).

58 Conclusion

I hope that you have enjoyed this tutorial. I have tried to show a lot of different solutions to creating the creature and the props. I hope that you have found all the tips and tricks helpful and that you will be able to use them to speed up your workflow. As you can see, image 58 shows the final result.

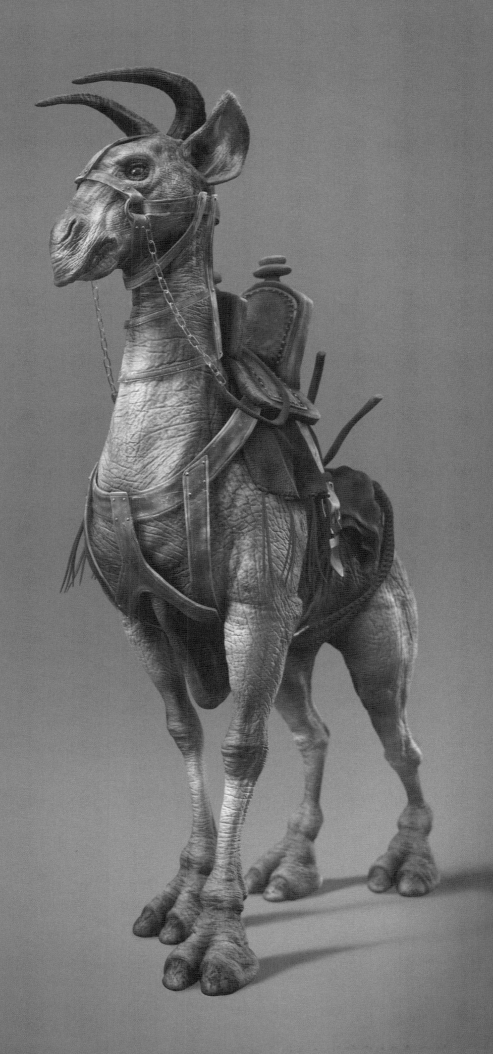

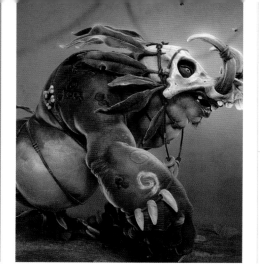

Quadrupeds

Part 02: Master authentic creature detail

By Borislav Kechashki

3D Character Artist at Ubisoft

After establishing the basic shapes and building up realistic anatomy, adding the final detail is a key element of presenting a realistic beast.

This tutorial aims to offer tips and techniques on working detail into the mesh using a variety of ZBrush brushes and tools, such as masking and Alphas, in order to create the best possible finish on this quirky quadruped.

01 Creature concepts

I started with some fast sketches of what I had in mind. I already had a few ideas about some of the features I wanted on the creature, so I included these in the sketches. These were things like the skull mask, beads, rope, leaves, and the overall voodoo feeling. At this stage, I try not to work on one sketch for too long, but rather explore and try different proportions, creating many fast and loose sketches and silhouettes.

When I come to a point where I'm clear about what I want, I start working directly in 3D, where it's easier for me to understand and visualize the creature's forms and proportions.

"The coolest thing I find about ZBrush's DynaMesh is that it is super-fast for creating concepts and for exploring your ideas directly in 3D"

02 Moving to 3D

I moved to ZBrush, where I used ZSpheres to build the body of the creature and then continued to DynaMesh it.

The coolest thing I find about ZBrush's DynaMesh is that it is super-fast for creating concepts and for exploring your ideas directly in 3D. At this stage, I tried not to stick to my original concept too closely, but instead developed it further. I worked on a

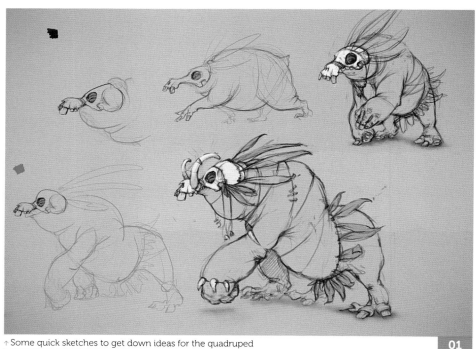

↑ Some quick sketches to get down ideas for the quadruped

01

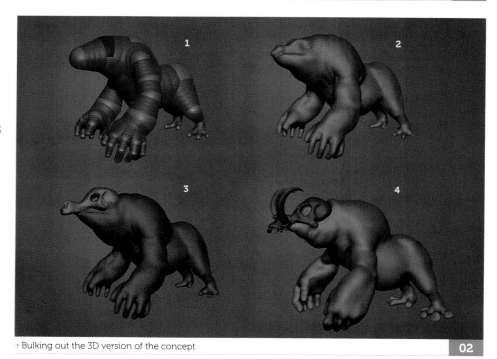

↑ Bulking out the 3D version of the concept

02

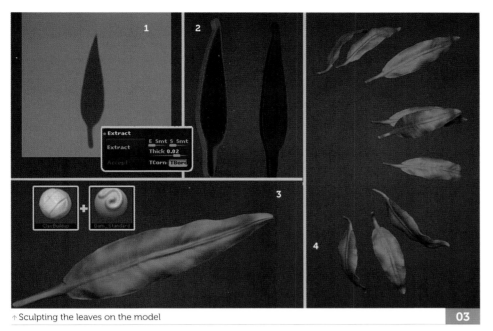

↑ Sculpting the leaves on the model **03**

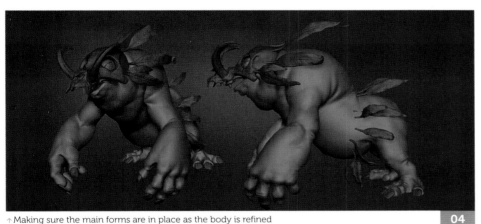

↑ Making sure the main forms are in place as the body is refined **04**

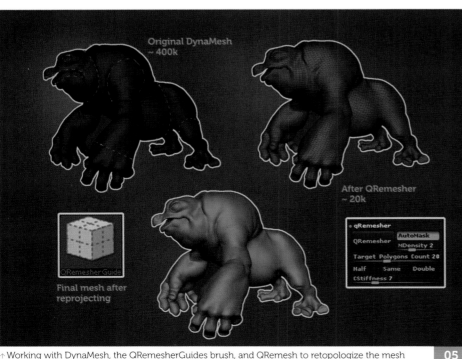

↑ Working with DynaMesh, the QRemesherGuides brush, and QRemesh to retopologize the mesh **05**

"I tried not to spend too much time on one part of the model, but to move across it and develop it evenly"

big scale, mainly with the Move and ClayBuildup brushes set to a larger brush size. I tried not to spend too much time on one part of the model, but to move across it and develop it evenly.

03 Making the leaves

Also using DynaMesh, I created really fast and simple meshes for the leaves, skull, and the tusks – these elements play an important role in the creature's silhouette so it's best to keep them in mind while working on the body.

I used quite a simple technique for making the leaves. I created a plane where I masked an area to look like a leaf and then, using Extract set to a low thickness, I created a mesh from the mask. I then DynaMeshed and copied (Ctrl+drag while in Transpose mode) across the areas where leaves will appear.

04 Refining the main forms

I created the skull from a sphere with a DynaMesh. I also used the CurveTube brush for the tusks; then I used DynaMesh to detail them further.

With all the main forms in place, I continued working on the body. At this point, I still refrained from adding in smaller elements, such as the beads and ropes, as all the small meshes would make posing the model quite difficult. Plus, these kinds of elements all have a different polygon density, so it is best to add them when the model is in its final pose.

05 Retopology

While moving to smaller details and up on the Resolution slider of the DynaMesh, it starts to get harder to make bigger, more global, changes, and it will be extremely hard to pose the model when the time comes.

I therefore duplicated the mesh of the body and drew some lines that would guide the new topology, using the QRemesherGuides brush. After typing in the desired final polycount, I QRemeshed it, which created a less dense mesh with topology more suitable for posing and UV mapping if needed. The last thing left to do was to subdivide it several times and to re-project back the details from the previously duplicated mesh.

06 Posing the model

For this step in the project, with all the major forms and objects in place, I started posing the model with ZBrush's Transpose Master, which involved masking and moving parts of the mesh using the Transpose tools. It also required some adjustments using the Move brush and the Move Topological brush.

One thing that makes posing a lot easier is to have the close polygon density on all the SubTools of the model, otherwise the masks get sharper where there are more polygons, and softer where there are less.

07 Details and asymmetry

While working on the pose, I tried to keep in mind the final view, so that all the important details would be visible as much as possible.

When I was finished with the posing, I started breaking up the symmetry, adding all the little elements and also detailing the existing ones. Here I created all the final leaves using the Topology brush, and all the teeth and bones using the plane masking method.

"Working on the fingers, especially those on the creature's arms, was quite difficult because they are so close together. I needed to make a separate polygroup for each of the fingers. To do this, I started by Ctrl+clicking on a finger in order to separate it from the others, which then made it a lot easier to work on"

08 More detail

For the ropes, I decided to use the CurveTube brush again; by holding the Shift key when moving away from the surface, the ropes then snapped to the mesh while also enclosing it to form a rope-like structure. Then I adjusted the thickness of the tube by changing my brush size and clicking on the curve.

Working on the fingers, especially those on the creature's arms, was quite difficult because they are so close together. I needed to make a separate polygroup for each of the fingers. To do this, I started by Ctrl+clicking on a finger in order to separate it from the others, which then made it a lot easier to work on.

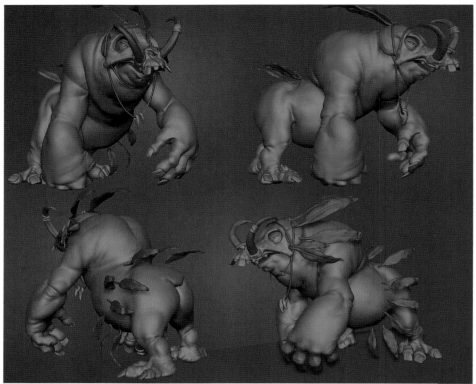

↑ Using the Transpose Master to pose the model **06**

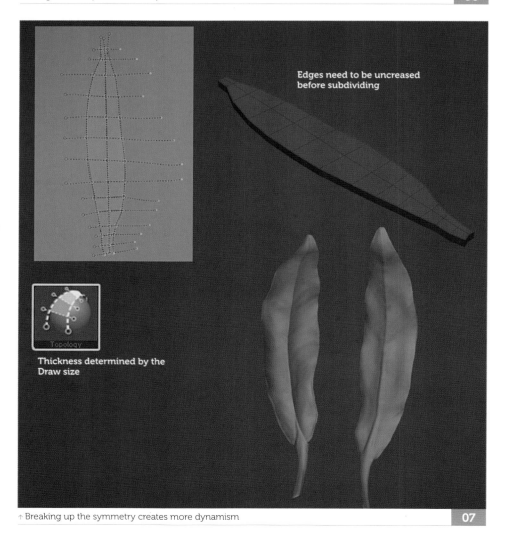

Edges need to be uncreased before subdividing

Thickness determined by the Draw size

↑ Breaking up the symmetry creates more dynamism **07**

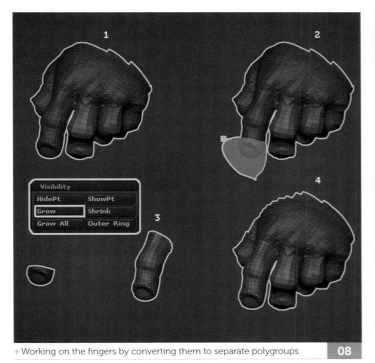

↑ Working on the fingers by converting them to separate polygroups **08**

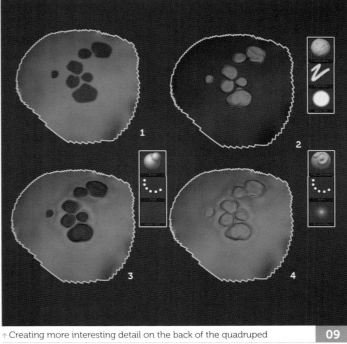

↑ Creating more interesting detail on the back of the quadruped **09**

↑ Making the beads using the Extract and EdgeLoop tools **10**

"In order to create the beaded decorations on the ropes, I decided to mask thin parts of the rope where I wanted the beads to be and then, using the Extract and EdgeLoop tools combined with GroupsLoops, I created each individual bead one by one"

I isolated the fingertip first, because it was easier to select, then I hit Grow in the Visibility tab until the entire finger was visible. I then used GroupVisible to gather the entire visible part of the mesh together into one group. I repeated this for the other fingers (see stages 1–4 in image 08).

09 Detailing the back
A large area on his shoulders and back appeared to look too bare and boring to me, so to make this space more interesting, I masked some spots into clusters using the MaskLasso tool and then made harder details on his back. You can see the levels of development for this process in Stages 1–4 in image 09.

10 Bead detail
In order to create the beaded decorations on the ropes, I decided to mask thin parts of the rope where I wanted the beads to be and then, using the Extract and EdgeLoop tools combined with GroupsLoops, I created each individual bead one by one.

"My approach to the texturing is the same as my approach to modeling: Moving from the largest to the smallest detail. I first started by rendering the whole model with a white MatCap material"

11 Fine details and texturing

For the finest details, I mostly used the Dam_Standard brush in combination with the ClayBuildup and Pinch brushes, with the Brush Modifier around 40 and Alpha 37–38 from the default ZBrush Alphas. At this point, I was trying not to spend too much time on one area and overdo it, but to keep moving across the model and detail it evenly.

My approach to the texturing is the same as my approach to modeling: Moving from the largest to the smallest detail. I first started by rendering the whole model with a white MatCap material and then moved to Photoshop so I could quickly test different color schemes.

When I was satisfied, I moved back to ZBrush, filled every SubTool with its base color according to the sketch, and from there I started adding color variations and more detail.

At the beginning of the texturing I mostly used a brush with the DragRect stroke and some spray Alphas, such as 07 or 08, to create base color variations. I then moved to the smaller detail with a Spray stroke – again with these two Alphas, and the Freehand stroke for the finest details. At the end, I dragged in some Alphas I'd made from photos to enrich the texture. Mask By Cavity and Mask PeaksAndValleys are also really powerful tools here. I tried to put some cold and warm areas in the texture and also some gradients in order to make it look more interesting.

12 Render passes

I started the rendering by saving a custom view in the ZAppLink first, so I could be sure that all my passes were from exactly the same view. Then I began rendering the passes, starting with two BPR renders of the textured model. I filled these with the SketchShaded2 material, with a slightly lowered cavity detection – one with Vibrant Shadows and AO turned on, and one with it turned off. I did this because it seemed to have too strong an effect in some areas, so I wanted to mask them out where needed.

↑ Moving to Photoshop to test different color schemes

11

Then I switched to a basic material, turned off all of the Polypaint information, and picked out black in Color. With this setup, I started rendering all the extra lighting for the scene by playing with light, color, intensity, placement, and the specularity and specular curve of the material.

13 Finishing up

I also made masks by filling all of the SubTools with flat color and changing the Inactive SubTool Dimming in the preferences to Minimum.

The compositing of the final render was done in Photoshop. I used my masks to select and color correct each of the elements of the image, with a Color Balance adjustment layer, to make them look more consistent.

Then I added all of the extra light passes above, switched to Linear Dodge blend mode, and lowered the opacity where needed. The final touch was painting some subtle effects and adding a bit of a lens blur using the ZDepth pass from BPR.

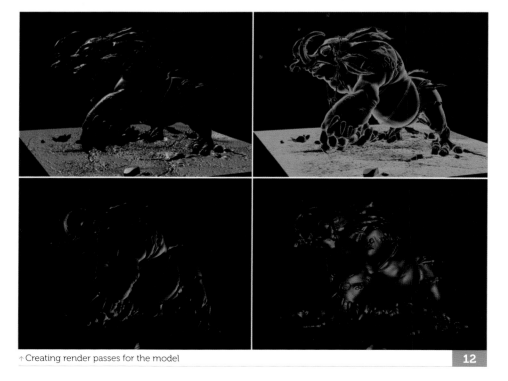

↑ Creating render passes for the model

12

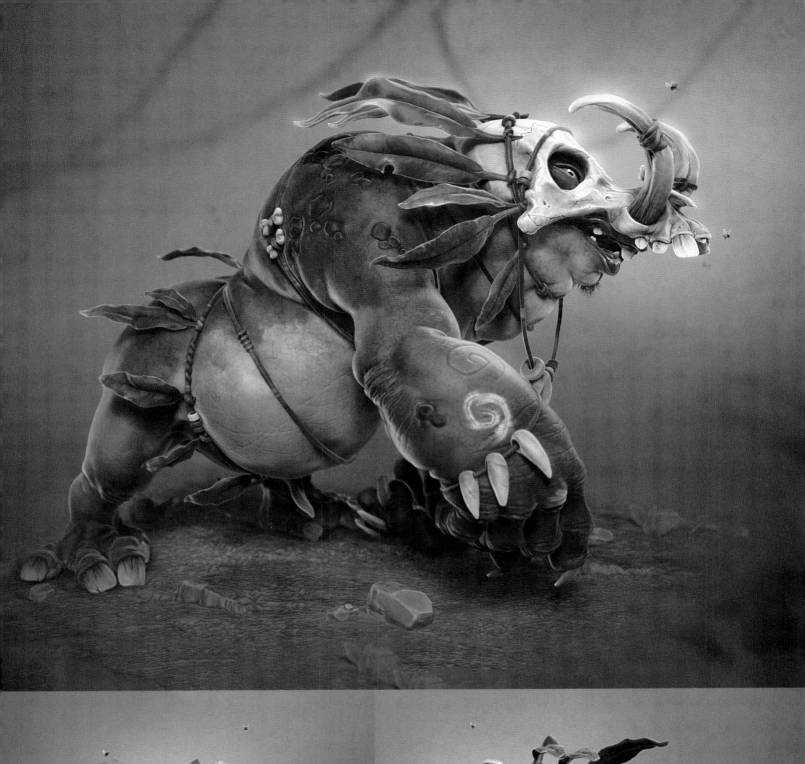
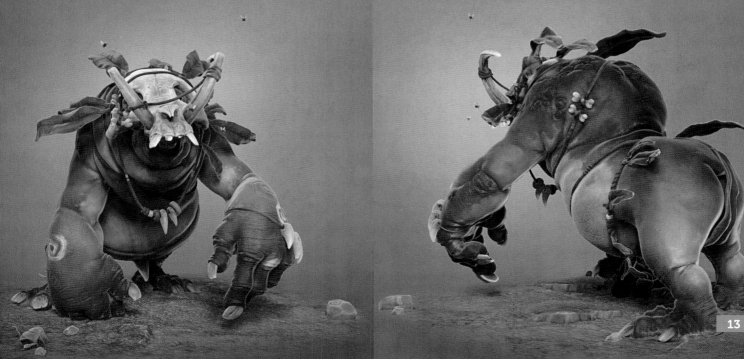

Chapter 02
Quadrupeds
Part 03: Realize realistic creature anatomy

By Ali Zafati
Freelance 3D Character Artist

Though seen as one of the fundamental art skills artists should master in order to create convincing organisms, organic anatomy is often overlooked in favor of 'flashier' coloring, texturing, or special effects.

This tutorial aims to work through some of the more intricate elements of creating creature anatomy in ZBrush – specifically, working through getting the basic structural form, to building up the subdivisions and working on the more subtle muscle contours and general creature features.

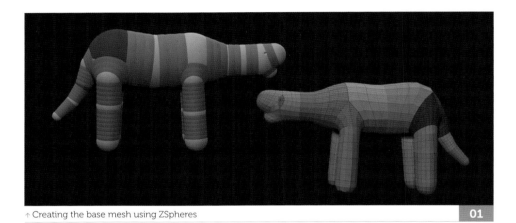
↑ Creating the base mesh using ZSpheres

01

01 The base mesh
In this tutorial, I will try to present the different stages of the realization of the creature. The method that I use is quite simple and does not require extensive knowledge of ZBrush. I think that carving organic forms is essentially based on solid artistic knowledge. With rigor, everything is possible; and then you play.

To begin with, I create my base mesh – in this case using ZSpheres. You could also use ZSketch or DynaMesh. As you can see in image 01, I create a fairly basic form, which is enough for now, given that the target creature will not contain very complex forms.

02 Subdivision
On the Adaptive Screen bar, I click on Make Adaptive Screen and convert the base mesh into SubTools. I toggle the subdivision at level 2 and I delete the first subdivision, as this will serve me better for adding detail. I can then start sketching the shape and proportions of my future creature. This is one of the most important phases because it is the phase which gives the general form. You can do this just using the Move Topological and Transpose tools (Move Scale Rotate) by hiding the desired areas.

03 Searching for the form
Using a higher subdivision, I continue to search for my form. I search for the proportions and silhouette by turning the model in all directions, using the tools used in step 02, the Inflate tool to inflate parts, and occasionally some Smooth. I add the horns that I created separately with a ZSphere. Then I work on the draft of the mouth and eyes.

04 Polygrouping
It is more convenient to separate the object into several components. This is so you can

select them more easily, work on each element independently, and be more comfortable when it comes to working on the details. This can also be useful if you want to hide areas to give the creature a pose. In our case, this will be the jaw.

05 The back legs
At this stage, the work on the muscle and the face has already started. The most important thing I do here is deform the back legs by adding joints because I don't like their previous form. In this sense, I am back on the low-poly model.

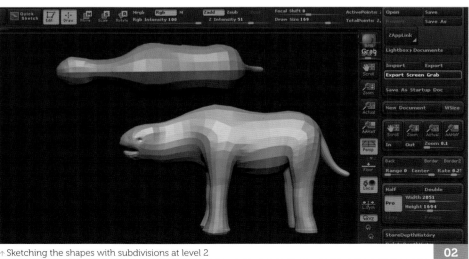
↑ Sketching the shapes with subdivisions at level 2

02

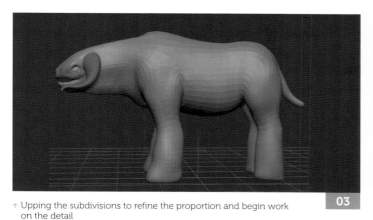

↑ Upping the subdivisions to refine the proportion and begin work on the detail 03

↑ Dividing the mesh to make it a more manageable model 04

↑ Refining the back legs on the low-poly model 05

I have hidden the area at the level of the joints and used the Rotate tool to add shape. Being back on the lower subdivision can be very helpful in such cases. This can be also used to delete unwanted parts with the Smooth tool.

06 Muscles

On the muscles, I turn to a higher level of subdivision, such as subdivision 4, and I draw using the ClayBuildup brush a little, using the pressure of the tablet. Then I fade with the assistance of the Smooth tool. I generally use this with an intensity between 25 and 45 – it just depends on my needs.

You will achieve an interesting result by doing just this. I would advise that you use images for reference as well.

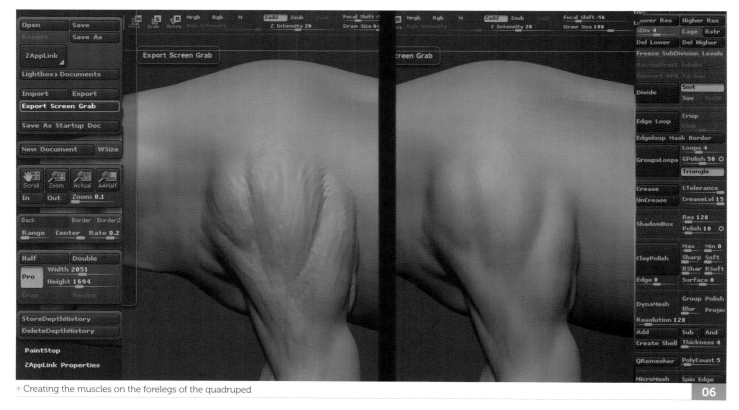

↑ Creating the muscles on the forelegs of the quadruped 06

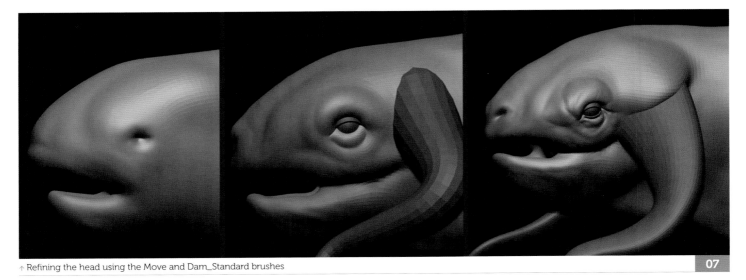

↑ Refining the head using the Move and Dam_Standard brushes

07

"It is important to have a library of predefined elements to save time, although you should always change them, as I've done here"

07 The head

While working on the body, from time to time I retouch the head. You can see the phases of evolution in image 07. I use the Move brush for the general shape and the Dam_Standard brush to draw hollow parts. I often use this brush for subtraction; the first time with a low intensity and with a large enough size. Afterwards, I return to standard brushes, Inflate, ClayBuildup, and also the Pinch brush now and then.

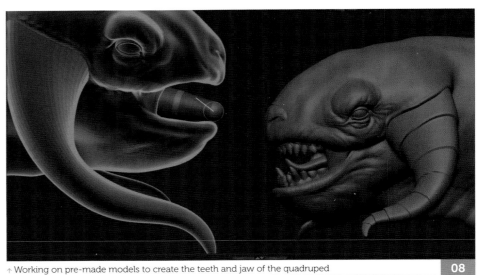

↑ Working on pre-made models to create the teeth and jaw of the quadruped

08

For the eyes, I use a sphere. I draw on the eyelids with a mask and click on Extract in the SubTools bar, after setting the desired thickness.

08 The mouth and teeth

It's time to shape the mouth and add teeth for the creature. I use ZSpheres and a teeth base mesh, which I already had and that I use for all my templates. It is important to have a library of predefined elements to save time, although you should always change them, as I've done here.

09 The nails

I create large nails separately using ZSpheres. I shape the base a little with the Topological Move brush, followed by the ClipCurve brush. I add a few cracks with the Dam_Standard brush and the Noise tool by setting the scale and intensity.

I create splines separately with the CurveTube tool. In the parameters, I choose LazyMouse

↑ Creating the nails using ZSpheres

09

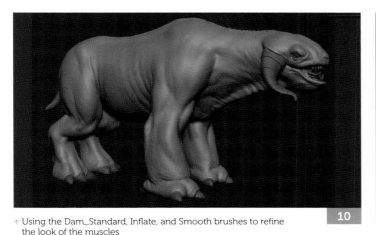

↑ Using the Dam_Standard, Inflate, and Smooth brushes to refine the look of the muscles

10

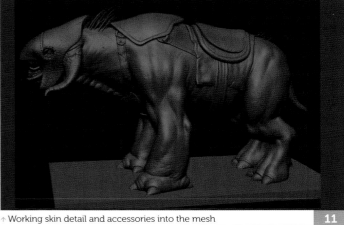

↑ Working skin detail and accessories into the mesh

11

(LazyRadius 35) and activate the scale in Curve mode. Once the first spine is created, I then mask and rejoin the other splines by pressing Ctrl on the keyboard and by moving the duplicates one by one with the Transpose Move tool.

10 Inflating the muscles

The creature's silhouette and muscles are taking shape at this point. In subtraction mode, I use the Dam_Standard brush, varying the scale and intensity, with a LazyMouse setting between 7 and 13.

For inflating the muscles at this stage, there is nothing better than the Inflate and Smooth brush tools.

11 Skin detail

The sculpture is now finished, so I turn to start working on the details of the skin. I begin with a light uniform pass using the Standard brush in Spray mode, with the 07 Alpha that is available by default in ZBrush. I repeat a pass with other Alphas at low intensity. In addition to the Spray mode, using the Drag mode with Alpha 56 can give you interesting results.

Aside from this, I create my own Alphas in Photoshop based on animal images. I desaturate them, slightly increase the levels of black and white, and give them a progressive contour. At this point, you can add a few veins, warts, injuries, and so on.

I choose to create a few accessories by decreasing the subdivision and drawing the shape of the base with masks with a good thickness. I rework them with the same brushes that I worked with on the creature. For the metallic elements, I add a bit of noise.

12 Polypainting

Next, I move on to Polypainting and texturing the model. For metallic elements, I use the Spotlight with a metal texture that I downloaded from the internet. I also turn the MatCap gray. As you can see in image 12, I have opted for a flesh tone as the base color that I apply on the model. I am in Standard brush mode, with an Rgb intensity of 100, and I set my choice of color to Color Fill Object.

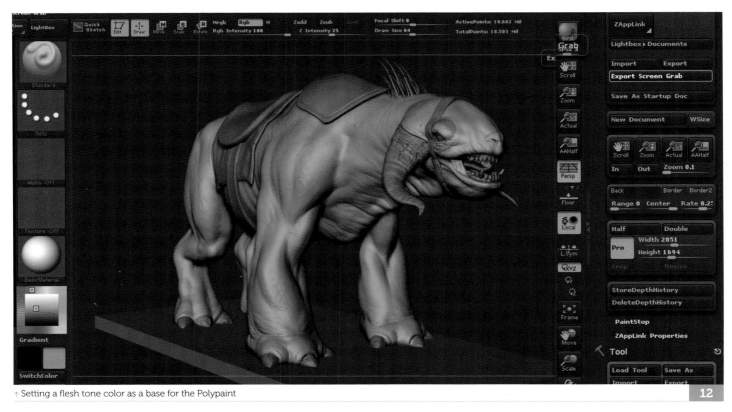

↑ Setting a flesh tone color as a base for the Polypaint

12

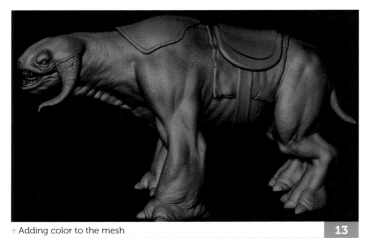

↑ Adding color to the mesh
13

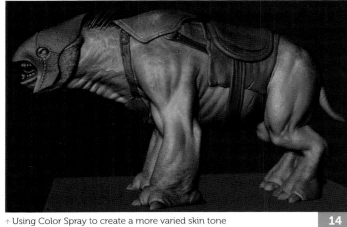

↑ Using Color Spray to create a more varied skin tone
14

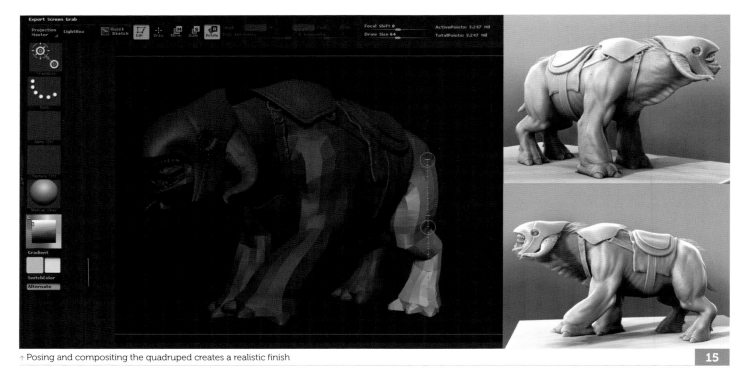

↑ Posing and compositing the quadruped creates a realistic finish
15

13 Adding color

I choose a slightly darker color and with DragRect, I apply the color with a medium intensity as if I'm creating my own shadows to better highlight the volumes.

I choose a color complementary to the base color – a slightly bluish tint that I use to dirty the model with. It will be almost invisible at the end of the process, but the use of the complementary color will still enrich the painting. After doing this, I create a cavity mask (Mask By Cavity) and then paint on it with a dark color to bring out the details.

I apply a slight reddish tint on areas such as the joints and cavities, in order to define them. I also apply a light green on a few veins.

14 Finishing the color

I now use ColorSpray, and Alphas 07 and 08, with a flesh tone color more clearly. I apply it on the creature while trying to create light gradients. Using a slightly darker color for some parts can give a rather interesting result. You can also add some small veins using DragRect and Alpha 22.

I continue with the same process of using Color Spray and my two Alphas until I reach the desired result. Then, using DragRect, I define the area I want to paint, then apply Alpha 62 and a little blur (Alpha > Modify > Blur RF).

You can see the textured surface of the creature in image 14. I used the same principle for all other areas: I added a base color, then added spots and dirty textures, and finally defined

joints and cavities, cleaning things up here and there. This is with the exception of the metallic part, which I have already covered.

15 Finishing touches

I give the creature a pose by going to ZPlugin and using the Transpose Master. I uncheck the splines and the base of my SubTool to avoid any problems, and I resume working manually with the splines at the end. I then create a textureless render to assess the final results and to use later in post-production.

I advise you to take your time when it comes to the compositing stage in Photoshop. Test different modes, with different levels of opacity. Be sure to properly adjust your levels of black and white, color correction, saturation, and so on.

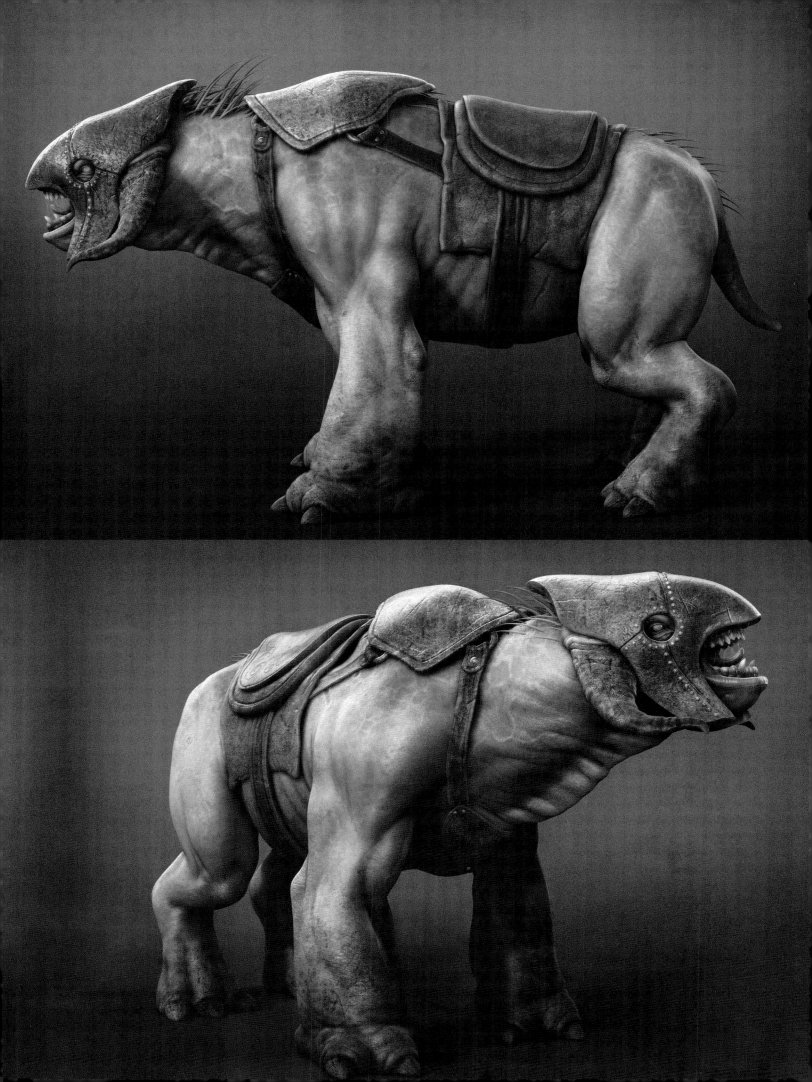

Chapter 02
Quadrupeds
Part 04: Craft a credible aquatic creature

By Mariano Steiner
3D Character Artist and Digital Sculptor

Working with aquatic quadruped concepts can be a bit of a challenge as it can be difficult getting a solid form and credible texturing on an amphibian creature.

This tutorial works through the process of refining the more fluid forms of your model, adding the anatomy, functionality, and personality, and finally finishing your model off with credible aquatic-themed detail.

01 Concept
The concepting process is always extremely tricky for me. Most of the time, I start my 3D model based on an idea or an image of the creature I want to create, which I build in my mind because my drawing skills are terrible. This time, though, I decided to try sketching, as I wasn't sure what kind of creature I was going for. I spent two days drawing many different kinds of quadrupeds, trying different animal species, insects, birds, mammals, and pretty much anything that came to my mind.

Then, suddenly, the idea of a quadruped salamander hit me. It's a cute and disgusting creature at the same time, and would make a pretty cool quadruped creature.

I usually spend a lot of time researching about what I want to produce, gathering as many references as I can in order to make my 3D work easier. I would advise you to do the same.

02 Base mesh
As with most of my personal and professional work, I start my character/creature with ZSpheres. These give me a nice and clean base mesh, with good edge loops and topology, which makes life a lot easier when modeling, unwrapping, painting, and posing the model. I avoid using DynaMesh on the model, in order to keep my edge flow clean.

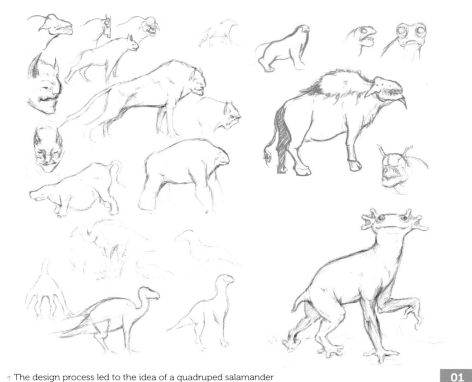

↑ The design process led to the idea of a quadruped salamander **01**

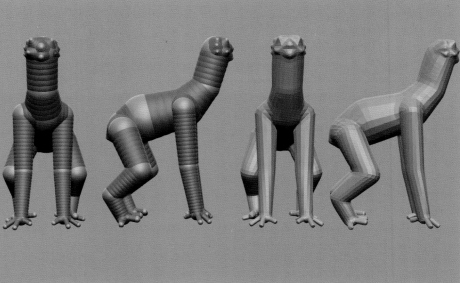

↑ Bulking out the creature using ZSpheres **02**

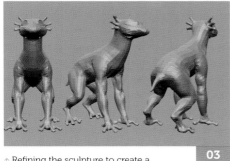

↑ Refining the sculpture to create a realistic creature

03

At this stage, I try to keep my polygon distribution in mind much more than the appearance of the structure. You can see in image 02 that the head of my creature looks terrible right now, but that will provide me with all the loops and poly density I need on the face.

I divide my mesh into polygroups. Doing this makes the sculpting process flow better, as you can hide and unhide parts very quickly. It also makes the unwrapping more organized.

03 Sculpture

Now that I have my base mesh, it's time for fun! With the base on its first subdivision level, I refine the structure. This is the most important stage for me. A well-structured model is everything. It doesn't matter if you have a super-detailed model with pores and wrinkles if you don't have a good and realistic structure – even on a cartoony, 3D fantasy character. The structure tells you if the model is believable or not, if it could really exist – or if it's just some digital clay thing standing there.

04 Refining the model

Still on my first subdivision level, I start to point where the muscles and visible bone joints are. I work each subdivision level as much as I can, not hurrying in order to get a really dense mesh to work with.

I always think on a three-level pyramid: The base level is the structure; the mid level is the anatomy, functionality, and personality; the third level is the details.

With all that in mind, the sculpting process is pretty straightforward. I use the Move brush a lot to block in the main shape and the basic anatomy on the lower subdivisions. Then I use the Standard, Dam_Standard, ClayBuildup, and Inflate brushes to define the bones, muscles, and fat areas on the higher subdivisions.

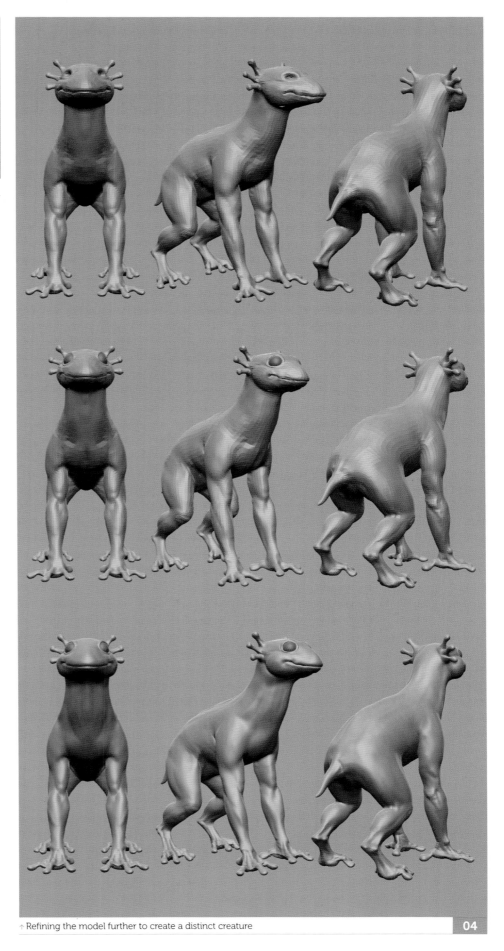

↑ Refining the model further to create a distinct creature

04

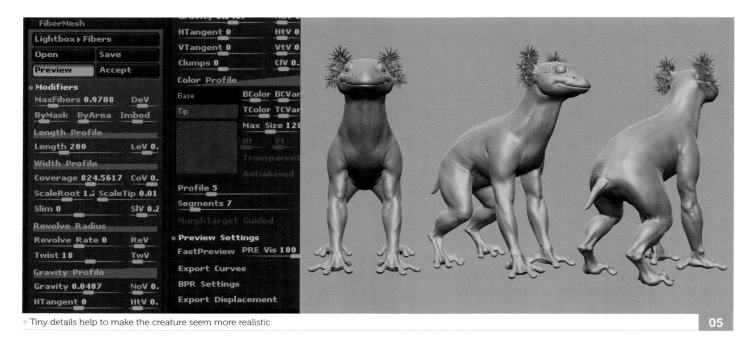

↑ Tiny details help to make the creature seem more realistic

05

05 Detailing

Now that I have my model structure and the anatomy refined, it's time to add some details. Dam_Standard and Inflate brushes are my main tools here; I draw the wrinkles with Dam_Standard and give volume to each one with the Inflate brush.

I base this stage on several amphibious creatures, including the salamander. With the Mask pen, I mask the structures of the head; using FiberMesh, I create the gills, which are part of the respiratory system of a real salamander.

06 Texturing

To start the texturing of my model, I use the UV Master to open the UVs of the mesh. This gives you an incredible range of possibilities, such as baking the textures, painting them in Photoshop, and rendering the model in different

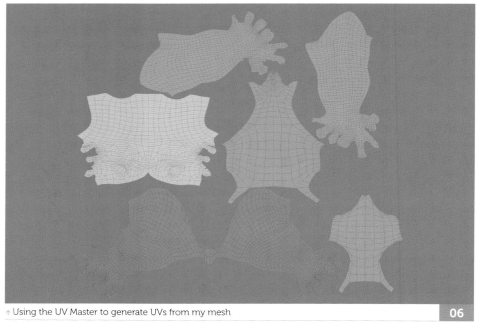

↑ Using the UV Master to generate UVs from my mesh

06

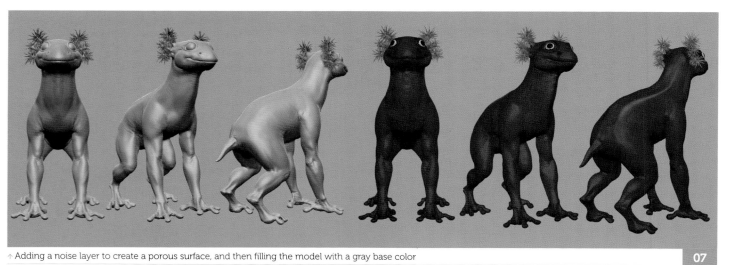

↑ Adding a noise layer to create a porous surface, and then filling the model with a gray base color

07

↑ Adding more color to the model using the masking system 08

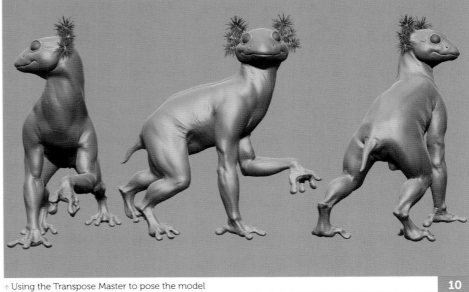

↑ Adding spots to the creature using the Mask By Alpha feature 09

↑ Using the Transpose Master to pose the model 10

"You always have to keep in mind where the bloodstream is more visible, where the creature's skin is thicker"

software; or, in my case, enabling the Mask By Alpha feature. That helps me a lot when painting textures in ZBrush. I can load a texture, edit the tiling, and mask my model based on that texture. Doing this means I can paint realistic textures and details, which would be impossible or much more time-consuming to do otherwise.

07 More texture
As a start, I add a simple noise layer to get a nice porous surface. I fill the whole model with a dark gray color as a base color layer. Then with the Clay brush, Spray stroke, and a variety of Alphas, I create a tonal variation.

This step depends a lot on the reference you are following; you always have to keep in mind where the bloodstream is more visible, where the creature's skin is thicker, where the bones are, how close they are to the skin, dirt, and so on.

08 More color
When all that is done, I refine the texture using ZBrush's masking systems. Firstly, I mask the cavities and paint it with another color. Then in Mask PeaksAndValleys mode, I fill it with another color.

09 Texture detail
To get the texture done, I only need some spots, which are very common in most of the amphibious species. I therefore get an ink-spotted texture and use the Mask By Alpha feature. Initially they look too big, so I tile the image about five times and mask again. It gives me a pretty good result and all I need to do is fill the unmasked areas with a black tint. Of course, you may have some tiling issues visible, but it's only a matter of brushing those out.

10 Posing
The pose is also very important. It delivers a lot of the creature's personality, the way it moves, and the action line of the moment. I've used Transpose Master to pose everything together.

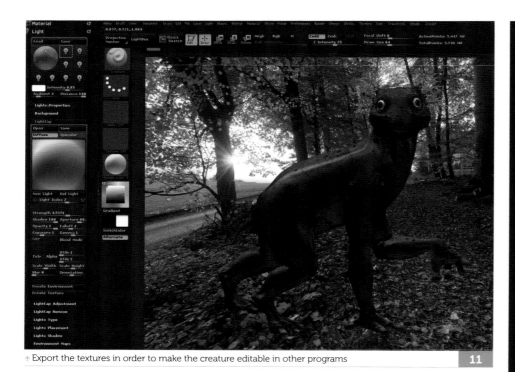

↑ Export the textures in order to make the creature editable in other programs 11

"I recommend that you place a lot of cameras in order to show as many views as you can. I usually use more lights as well, as I have done in this case"

Scene and lighting

This is a really important step in presenting the character and giving an atmosphere or spirit to the image. With different camera views we can create a certain dynamic. Adding lights gives mood to the model.

You should first place the model in the scene, and then, if necessary, re-size it according to the program's measurements (which are important because of the shaders).

I recommend that you place a lot of cameras in order to show as many views as you can. I usually use more lights as well, as I have done in this case. I place the following in my scene: A V-Ray Dome Light (with an HDRI texture because of the reflection); a V-Ray Rect Light; a traditional three-point lighting system with a back light, key light, and fill light. I then use a V-Ray IPR render to set the lights in real time.

Rendering

The rendering process is pretty simple. I load a forest HDR image into the background and generate the LightCaps with reflection. Then I just boost the back light a bit.

Shader materials

For the materials, I tweak the basic shader a bit for the body of the creature, and for the eyes I use the basic Rgb levels shader.

Now for the final composition, I decide to take the following different renders to combine in Photoshop:

1. Base render, with colors, light information, and shaders.

2. Render to boost the back light and reflections.

3. Sharpen specular.

4. Another 'wet' shader to improve reflections.

5. Different specular position.

6. BPR shadows.

7. BPR ZDepth.

8. BPR Mass.

You can see the corresponding render passes 1–8 in image 13.

Final composition

Image 14 shows all of the render passes and shaders composited together to create the final scene.

↑ Generating LightCaps with reflection from forest scene 12

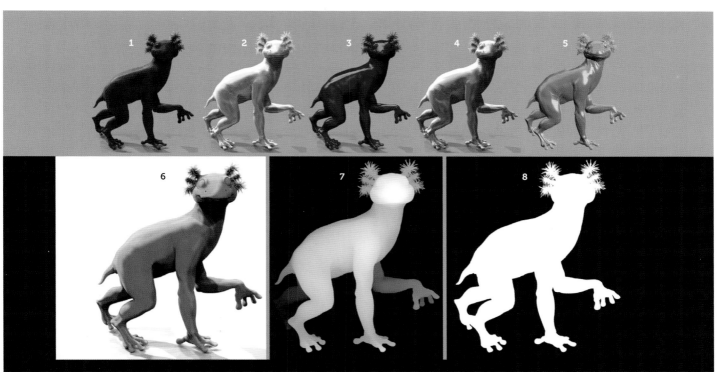

↑ Adding shaders to the creature using the settings described in step 13

13

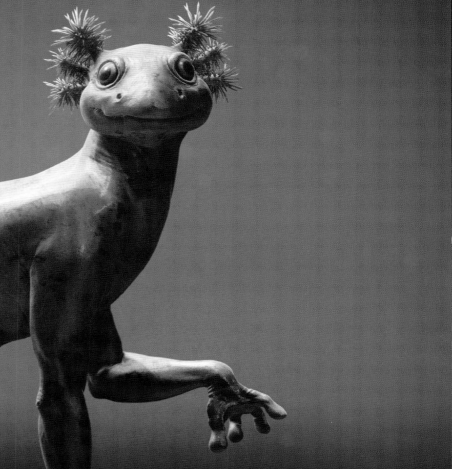

14

Quadrupeds

Part 05: Build a brutish beast

By Justin 'Goby' Fields

Concept Artist, Illustrator, Graphic Designer, and Owner of IronKlad Studios

This tutorial aims to give a complete overview of the creation of this menacing quadruped. Starting with basic shapes, and pulling out the forms inspired by references and original designs, it then works up through the subdivisions and detail levels to create a complex mesh. It rounds off with some tips on compositing your texture and lighting passes into a final scene.

01 Using DynaMesh as a starting point
After I have gathered my references and figured out what my main goals are for the concept, I begin my quadruped using DynaMesh. Sometimes in production, it can be faster to start from a pre-made base mesh from a previous sculpt or template, just to speed things up. This time, however, I will start from scratch to see what kinds of shapes I can make, and what the overall look will be.

After I get my proportions right, I use DynaMesh or break it up into separate SubTools and then DynaMesh.

"Nature is the greatest tool in an artist's arsenal, so spend some time looking at photos and examine what catches your eye"

02 Reference is key
I have a collection of images on another monitor that I continually look at in order to keep my designs in check. Nature is the greatest tool in an artist's arsenal, so spend some time looking at photos and examine what catches your eye. For this image, I look at mammals and reptiles a lot.

03 Block in the forms
I then use DynaMesh to start blocking in forms. Try not to jump in to detailing right away, and

↑ DynaMesh is a brilliant design tool

01

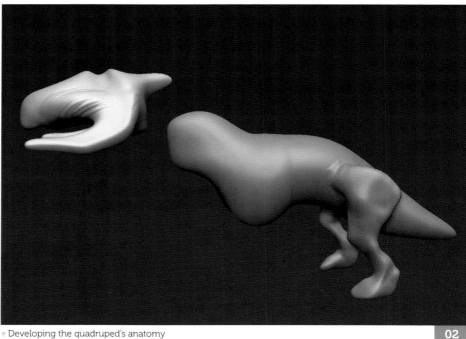

↑ Developing the quadruped's anatomy

02

simply find those forms (I have a tendency to doodle on the face for way too long). Staying at a lower subdivision will help you to make major design changes fast, without the concept becoming too loose. You should also try to keep major elements as separate SubTools so you can really subdivide and achieve some great details.

04 Dynamic shapes and form

After going up in subdivisions and looking at my reference, I use ClayBuildup to build up forms and shapes, and really start to plot out my concept. After that, I begin to smooth and cut into the form. For most of my organic sculpting, I use variations of the Dam_Standard brush using various Alphas, as well the Standard

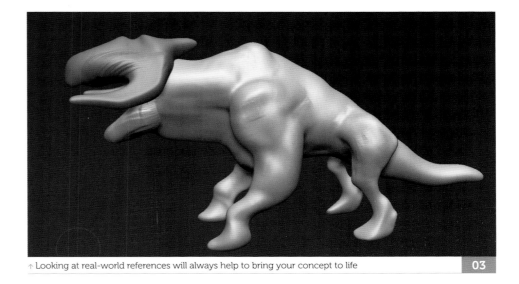

↑ Looking at real-world references will always help to bring your concept to life | 03

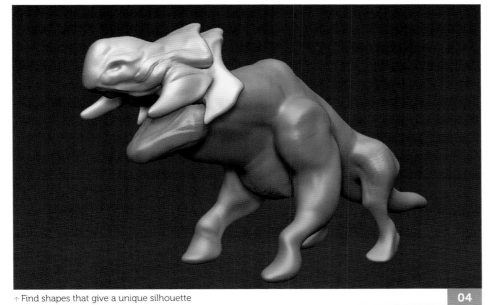

↑ Find shapes that give a unique silhouette | 04

"Now that I have a lot more digital clay to push around, I can really dive into some serious detail"

or the Clay brush on a very low pressure in order to blend in and out of my shapes.

05 Detail

Now that I have a lot more digital clay to push around, I can really dive into some serious detail. Using some more of the same techniques from the previous step, I continue to refine the detail and define the interesting shapes in order to start laying the groundwork for wrinkles and creases, and edges and apexes. Doing this will make my work much easier for the final detail pass later on in the process.

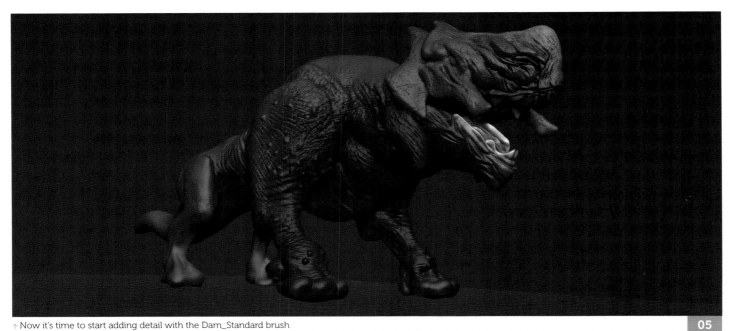

↑ Now it's time to start adding detail with the Dam_Standard brush | 05

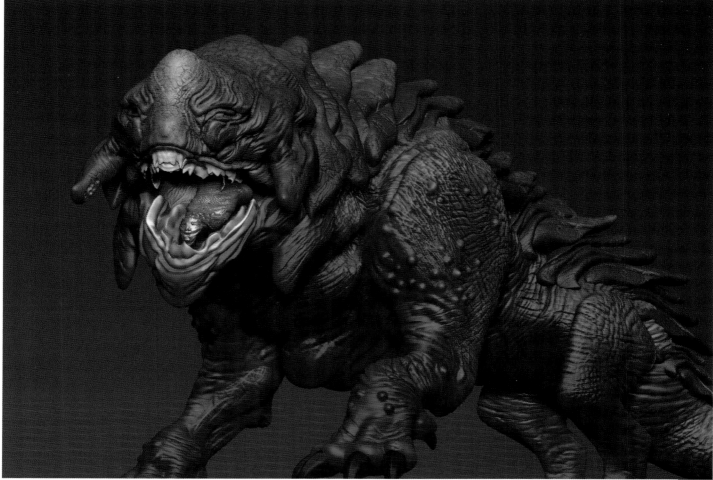

↑ Using multiple SubTools in order to maintain functionality and options for posing later 06

"I usually add eyes early on and test different shapes and sizes to see what looks best. After those are in place, I make sure that the underlying shapes support the eye sockets to give it a bit more character"

06 Time for the head

After adding the head, I use DynaMesh and the Snake brush to pull out some interesting shapes. Following the same steps I used on the body, I quickly lay out my shapes and detail them.

I usually add eyes early on and test different shapes and sizes to see what looks best. After those are in place, I make sure that the underlying shapes support the eye sockets to give it a bit more character.

07 Surface texturing and fine detail

Try to keep your design grounded with areas of rest and subtle textures. Experimenting with Alphas and different brushes, as well as

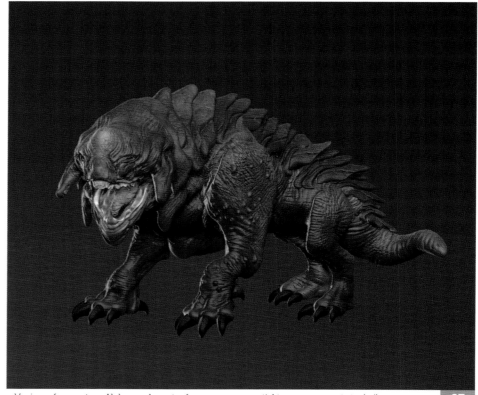

↑ Having a few custom Alphas and great references are essential to your concept stockpile 07

pressure, is a great way to really learn what tools ZBrush has to offer. In addition, you should try to use LightCaps to see how light affects the surface of your creature, as this may change some of your design decisions.

08 Time to Polypaint

Color can drastically change how your design is perceived. I like to choose a flat color and airbrush various colors in to slowly build up my colors. Masking out the cavities and adding some dirt will always make your design 'pop'.

09 Finding the right pose

Since a stagnant T-pose is a very good way *not* to get your design chosen over the work of other artists, we are going to introduce a bit of a change for the current pose.

I find it's usually a good move to turn the head slightly and shrug the shoulders in order to mimic a little bit of action. Using the TPose plug-in here is a godsend.

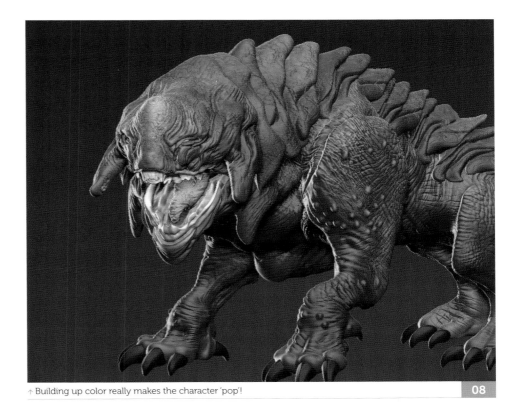

↑ Building up color really makes the character 'pop'! 08

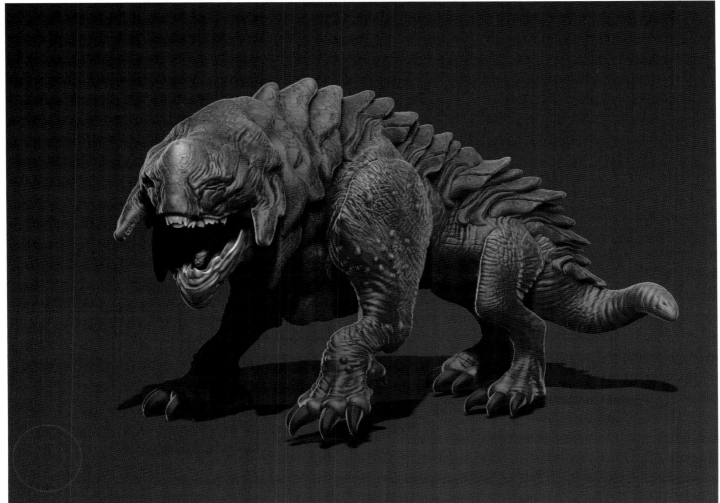

↑ You don't always have to go big on the pose, subtle can speak volumes 09

"It's always better to have that detail in there and not need it, than to need it and not have it"

10 Choose your angle

Now get ready to start the composition. Find your favorite angle and lock in that camera view in the ZAppLink properties. Some of your details will be lost in the view that you choose, however, if your Art Director wants a different pose, all you have to do is re-pose and re-comp, instead of having to go back and re-sculpt detail that isn't there. It's always better to have that detail in there and not need it, than to need it and not have it.

11 Time to render

After setting up your lighting and BPR settings, begin rendering out your passes for post-processing. I get my basic passes out of the way so I can experiment with some other options for use in post-production using Photoshop. After this, I get various light passes for fill and rim lights.

12 Compositing your images

When you have got all your render passes, bring them into Photoshop and lay them on top of each

↑ Take your time and choose an angle that shows off the design work you have done **10**

other. Putting my flat model pass first, I begin experimenting with blending layer options.

This can really vary with every piece, so it's time to use that artistic eye of yours and see what you think works best!

13 Painting on top of your image

Start painting in some detail work, use photo overlays of texture, and drop in a background. Do some final touch-ups and effects, but take the time to blend everything properly. The time you spend at this level really ties the piece together.

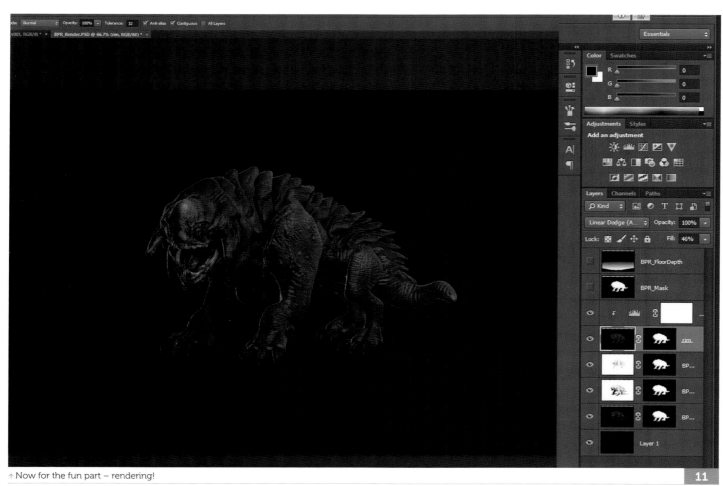

↑ Now for the fun part – rendering! **11**

↑ Drag-and-drop all your render passes into Photoshop

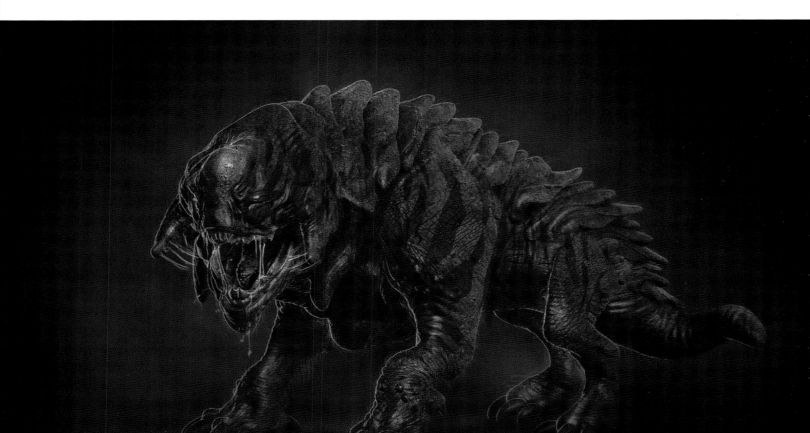

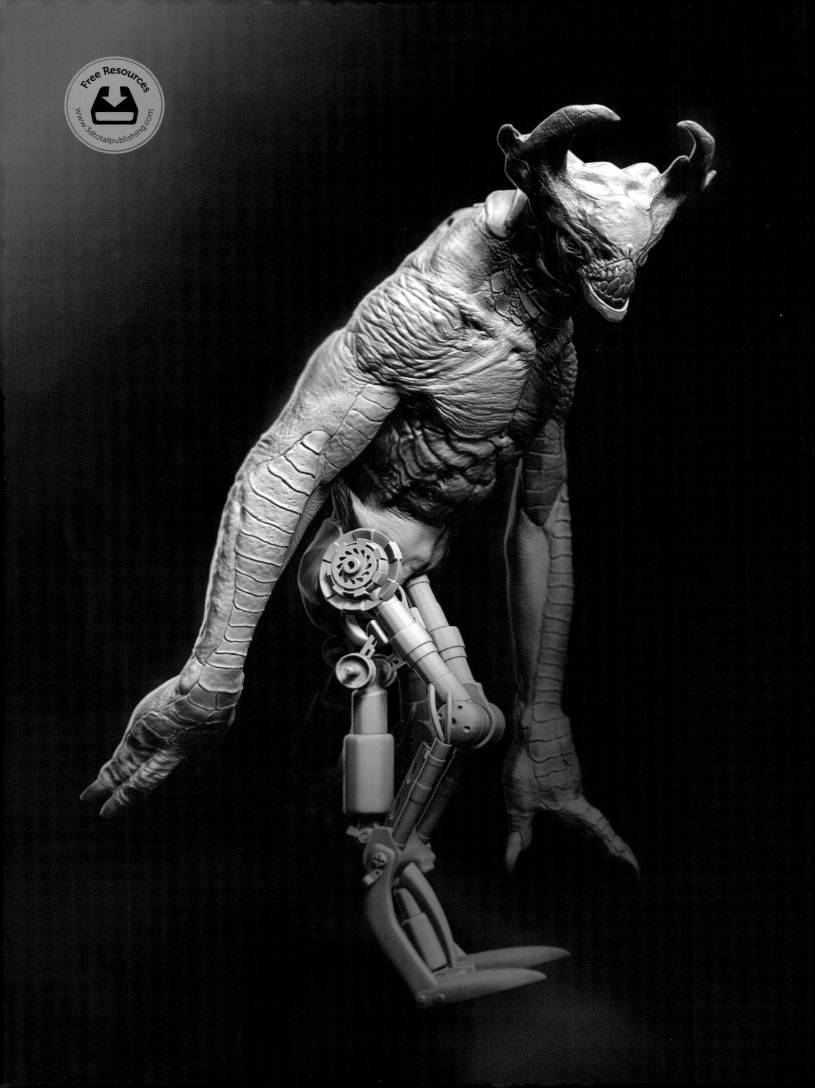

Creatures

Learn how to craft fantastical creatures
with believable details

This chapter looks at a more general set of classic fantasy creatures with a bit
of a design twist! The following tutorials, from seasoned creature creators
such as Bryan Wynia and Glauco Longhi, offer clear and comprehensive
step-by-step guides that give a concise overview of the creature creation
workflow. Each tutorial deals with the development of a different style
of creature in a fantasy setting, covering natural plant-like projects,
spider-inspired sculpts, mechanical mammal models, and more! Read
on to discover how to breathe life into your own creature concepts...

Creatures

Part 01: Explore creature creation with Alphas

By Bryan Wynia

Senior Character Artist at Sony Santa Monica

From gathering useful references and initial concepting, through to the intricacies of tweaking the topology and texturing, creature creation can be a difficult process to master. In this tutorial I will offer all the guidance you'll need to develop your own creature concepts into fully-fledged fantasy beasts.

01 Gathering references

Before I start sketching or sculpting, the first thing I do is gather references. I knew I wanted to design a creature that lived in a swamp, marsh, or wetland-like environment – but other than that I was open to any design path.

So to start, I go through my reference images and gather photos of reptiles, amphibians, fish, elephants, and even bears. I take these pictures on various trips to the zoo and aquarium with my family. Going to the zoo to photograph and observe all the animals is a great way not only to inspire but to inform you about creature designs. You will learn things no art book or monster movie can show you. Having these natural elements in your designs will not only help you create an original and fresh idea but enable you to produce something that is familiar and believable.

I will use these images (such as the ones presented in image 01) as examples and inspiration for anatomy, proportions, textures, and color.

02 Studies

To prepare for this project, I want to create a few studies based on various dinosaurs. I primarily focus on theropods. These studies really help me with learning new forms and anatomy that I might not have normally used. Using these studies and the references I gather will aid me in creating a unique and fresh design, while making sure it is something that can function and feels grounded in the world.

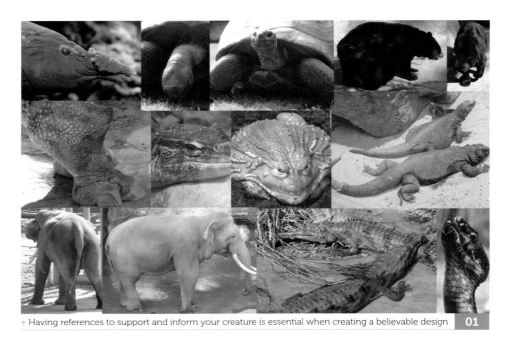

↑ Having references to support and inform your creature is essential when creating a believable design **01**

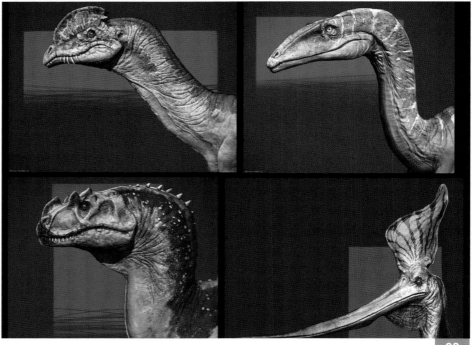

↑ Taking the time to create studies is going to help you build a new mental library of shapes, proportions, textures, and color **02**

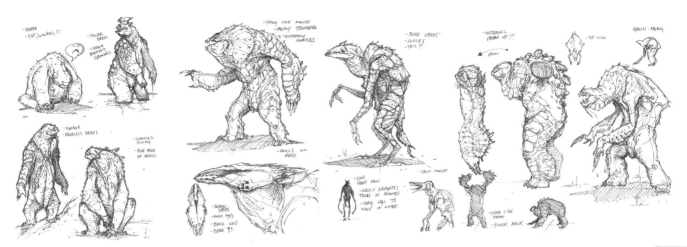

↑ Nothing beats the speed of pen and paper. Your sketches allow you to overcome early problems **03**

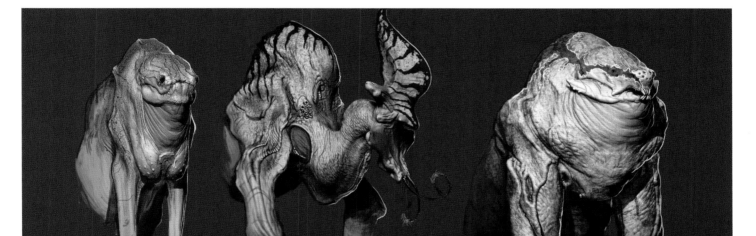

↑ Speed sculpting is an effective way to explore new design paths for our creature **04**

03 Sketchbook

At this point I have a few ideas floating around my head. I use a small pocket-sized Moleskine sketchbook to start sketching some loose ideas. I like to use these small sketchbooks because I can always carry one with me, and if I have an idea at my desk, a coffee shop, dinner with the family, or any other random place, I can quickly get that idea down on paper.

In production, these loose sketches are usually never seen by the Art Directors. These sketches are to help me and to problem solve. This is one of the most difficult yet rewarding steps in the design process. Try to explore as many ideas as possible and don't be afraid to make mistakes.

04 Speedsculpts

It's time to start sketching some ideas out in 3D, or create speedsculpts. I'm not focusing on detail at this point. My goal is to explore as much of the creature as possible and find new ideas. You can take these rough sculpts into Photoshop as well, to explore them even more.

I use Photoshop to explore some patterns and texture variations with these speedsculpts. Even if you don't use any of these designs, it is very important to explore all your design paths.

05 Primary shapes

Using a simple sphere and the DynaMesh feature, I begin to block out the basic shapes of our character. These basic shapes are also known as the primary shapes. I like to have these large elements as separate objects to allow me to adjust them quickly and independently. I think DynaMesh is great – you can simply create and not worry about many technical limitations.

You can also build a library of these different shapes over time and use them to create new designs and creatures. Over time you will come to feel like your very own mad scientist!

↑ DynaMesh is an extremely effective tool for concept sculpting **05**

"Having a very low mesh from the start will allow you to make large changes quickly and keep you from focusing on details"

06 Topology

I like to keep my creative process as simple as possible. One thing I do like to have, though, is an object that will not fight me while sculpting. I use DynaMesh to combine all the separate objects that make up the body.

I then use ZRemesher to create a mesh that is very low and has evenly distributed polygons. Having a very low mesh from the start will allow you to make large changes quickly and keep you from focusing on details.

07 Developing the face

At this point I'm still searching for the overall tone and feeling of the creature. I spend some time on the face to help find a direction for the reptile. Referring to my references and sketches, I begin to push the head and develop more secondary shapes.

If something is not working, I don't hesitate to change it. No matter how long you work on something, don't be afraid to alter it. If it does not work for your creature, it needs to change.

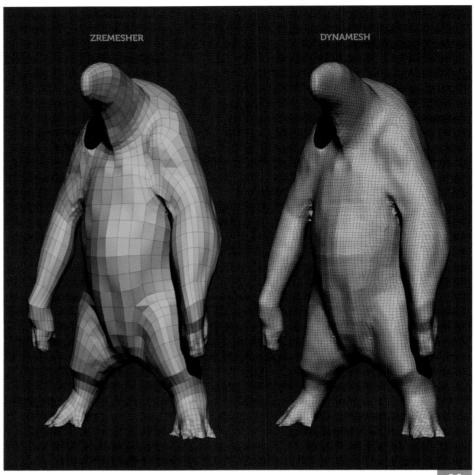

↑ Creating a simple mesh that is optimized for sculpting will save you time later. You can focus on designing your character and on sculpting and painting

06

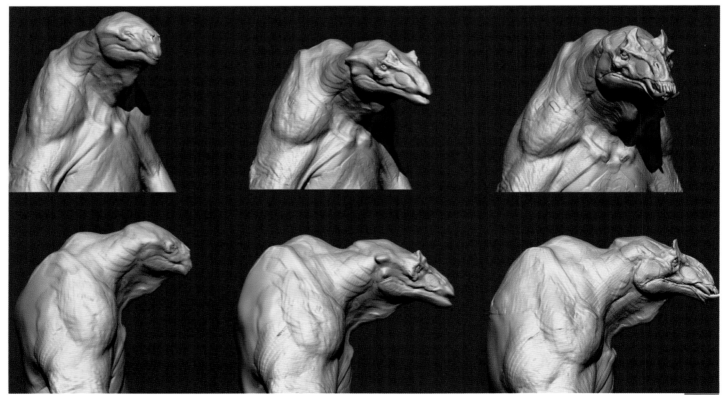

↑ Taking time to develop the head can help with the overall direction and design of the creature

07

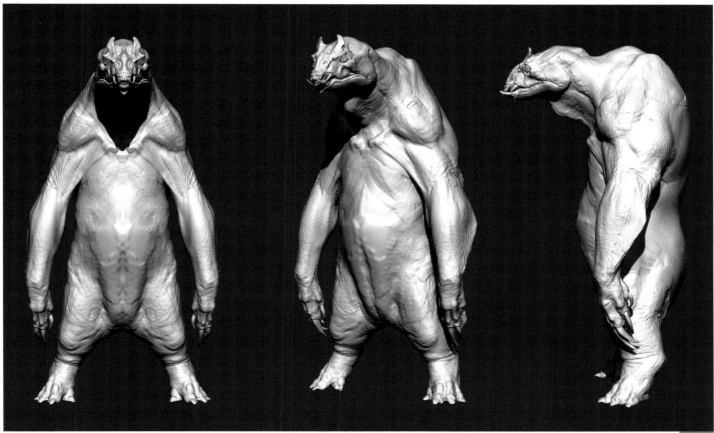

↑ Developing the secondary forms and anatomy of the creature is one of the strongest ways to communicate a believable design. Form follows function! 08

08 Secondary forms

Now that I have a bit more direction, I jump back to the body in order to develop the secondary shapes. My goal is to create unique yet believable anatomy for this creature. I create bony landmarks such as the clavicles, elbows, wrists, and knees. Having these landmarks alongside the large muscular and fatty areas will give a strong sense of foundation for our creature.

Personally, I like using the ClayTubes brush at this point as it helps me to create a natural skin-like texture. This will be very helpful later down the pipeline.

09 Blocking out colors

Even though I'm not finished with the sculpting yet, I like to block out the paintwork of my creature. Working this way allows me to visualize the final design very quickly.

I try to use simple gradients and values to emphasize the focal points on my character. You can also use color along with texture to describe materials. Just like when you start blocking out the sculpt, keep it simple. We will be able to focus on details at a later point.

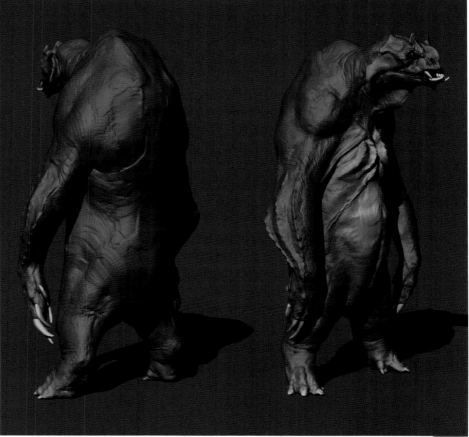

↑ Use Polypaint to quickly block out the initial colors of the creature 09

10 Sculpting with Alphas

I want to achieve a heavy, leathery quality for this creature's skin. A reference image of a rhinoceros is a great example. Using Alpha 58 set to spray, you can get a great leathery skin texture. You can also using the Mask By Cavity feature and use the Inflate brush to create large folds.

Don't be afraid to experiment here. Try to create layers of detail as well. There is nothing worse than a well-sculpted creature that is covered in zits. Having variation in your sculpt will make it feel much more natural.

11 Final painting pass

After I complete my sculpt I move back to painting the creature. You will see much more variation and layers to the color. Building the colors up in subtle layers is a great way to give a skin-like feeling to your painting.

I refer to some other reptiles and amphibians online and also add a pattern to the creature. The intention is to create a graphically interesting design, yet also something that could possibly function as camouflage for him as he hunts his prey.

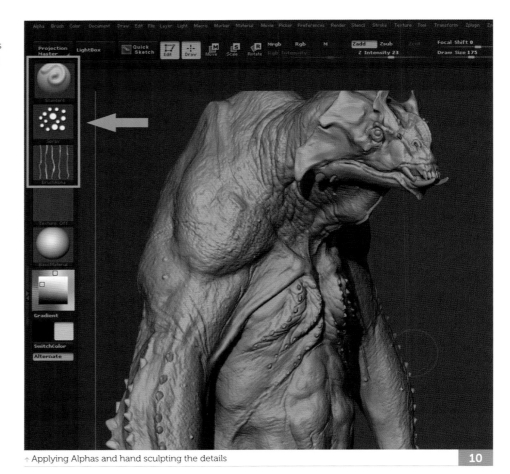

↑ Applying Alphas and hand sculpting the details

10

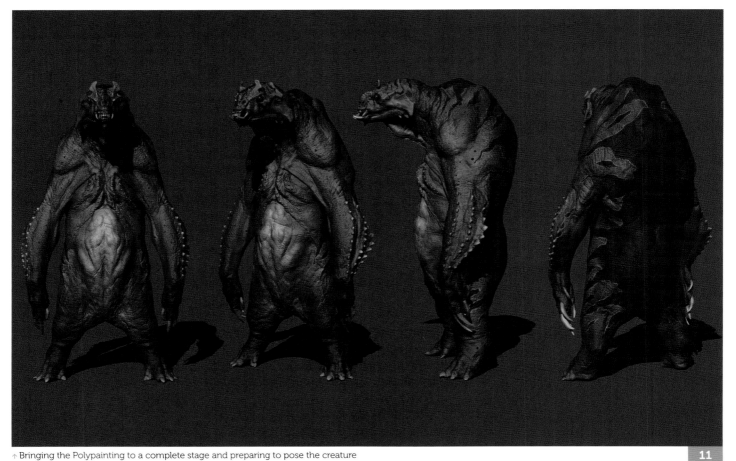

↑ Bringing the Polypainting to a complete stage and preparing to pose the creature

11

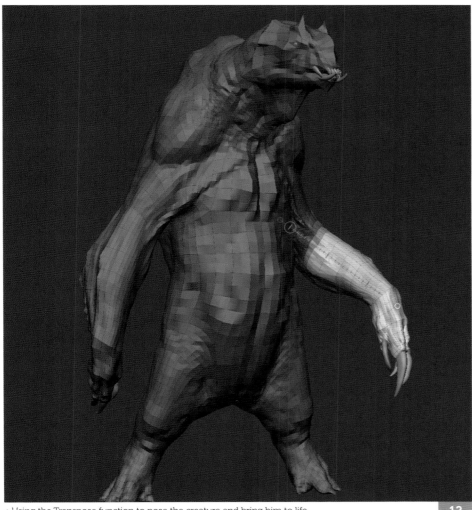

↑ Using the Transpose function to pose the creature and bring him to life **12**

"I prefer to work at a low subdivision level and use the Transpose function to pose my design. I also make sure I view the creature from multiple angles to ensure his silhouette is clear"

12 Posing your creature

Even the simple pose demonstrated here in image 12 is critical, as having some sense of gesture or movement will really bring your creature to life. This will also help describe his function or perhaps how the creature hunts or eats.

I prefer to work at a low subdivision level and use the Transpose function to pose my design. I also make sure I view the creature from multiple angles to ensure his silhouette is clear.

13 Rendering in ZBrush

Rendering in ZBrush is very quick and pretty straightforward. I adjust the position of my light and turn on the Shadows and Ambient Occlusion features. Under the Render Properties tab you will find a good deal of options.

I also suggest using the WaxPreview to give an even stronger sense of skin and sub-surface scattering. In addition, you can save a ZProject of your file to save all your lighting and rendering adjustments.

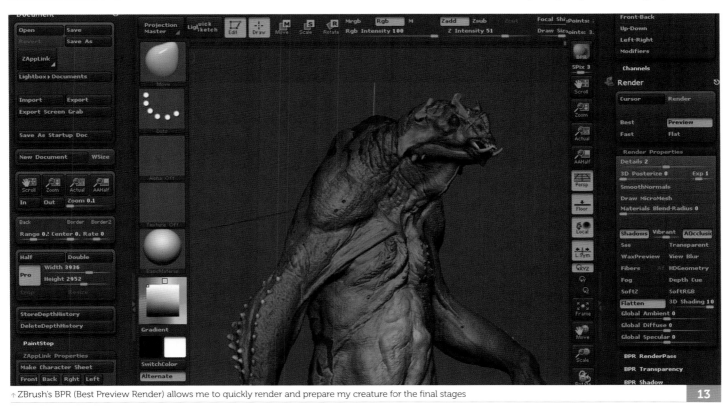

↑ ZBrush's BPR (Best Preview Render) allows me to quickly render and prepare my creature for the final stages **13**

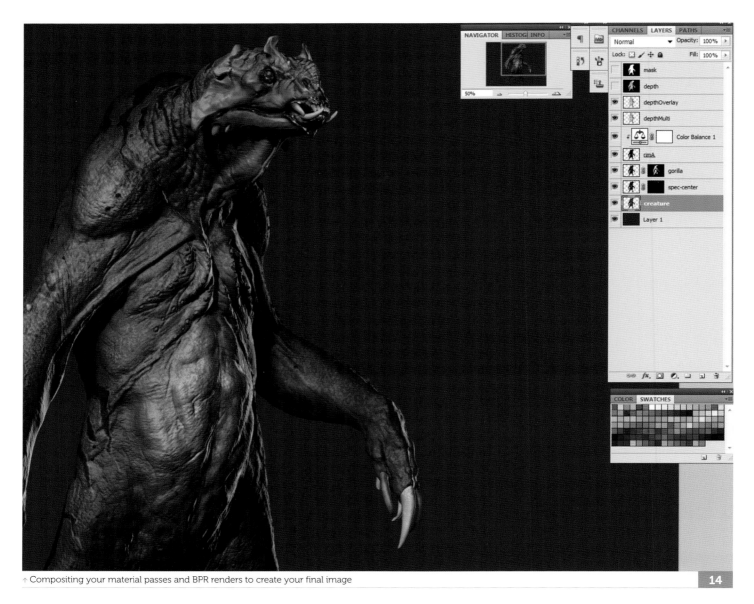

↑ Compositing your material passes and BPR renders to create your final image

14

14 Compositing in Photoshop

Using the material and render passes I created in ZBrush, I open Photoshop and begin to create my final image. The main aspects I check in my layers are: The creature, lighting information, specular information, and depth.

I will also use some photos to create variation and breakup. I found some great images of plaster walls at **freetextures.3dtotal.com**.

I like to hand paint a bit on the image as well. I feel it gives it a bit more life and movement and makes it seem similar to a sketch. Using all these techniques can create a very realistic, yet painterly, image.

15 Presenting your design

I like to save multiple versions of my final design. Once I'm happy with it, I flatten the image and use some simple filters to tie it all together. Adding some film grain or noise along with the Lens Correction tools will help to create a very finished image.

I also like to blur parts of the image as well and use Brightness and Contrast to help direct the viewer's eye to major focal points. Most importantly... don't forget to sign your work!

☑ **Top Tip**

Creating a color palette

You can use a hidden area of your character, or even a plane, as a palette for your colors.

I use the bottom of the creature's foot as a place I can sample color from. This is very helpful when building the opaque layers of colors on your creature.

↑ Use a hidden area on your character to test color schemes

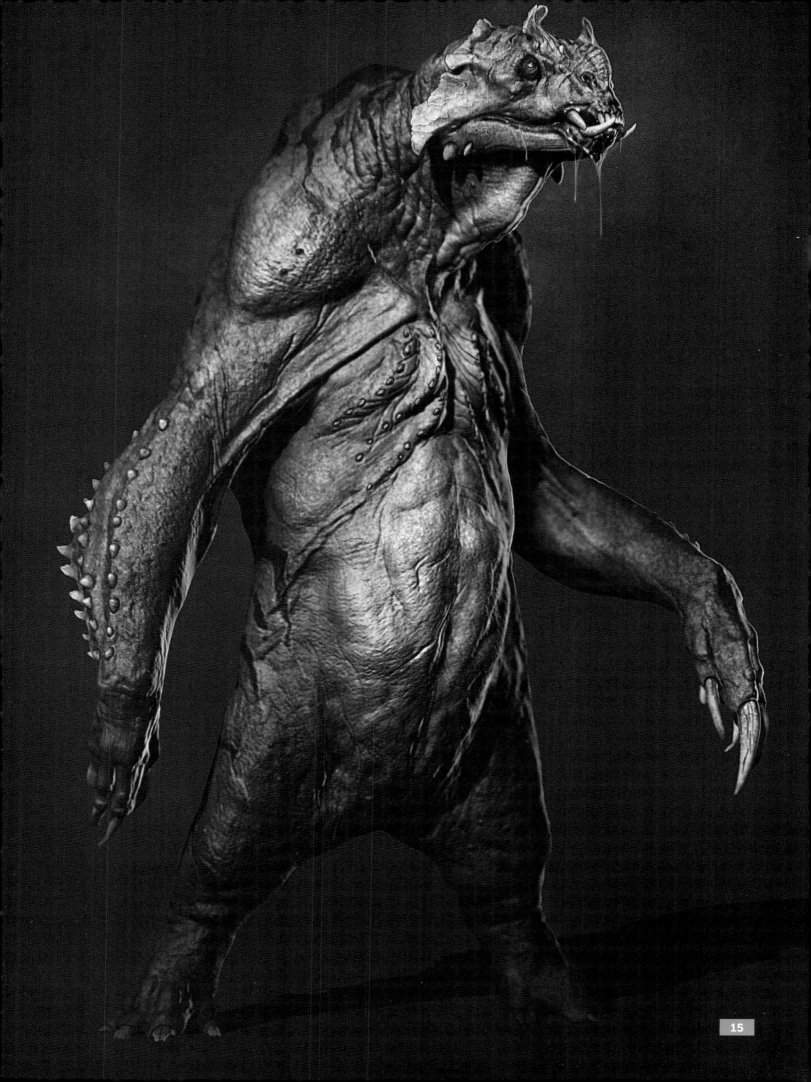

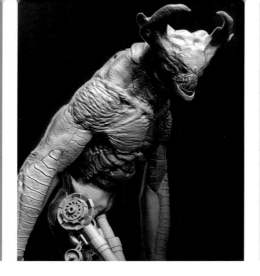

Chapter 03
Creatures
Part 02: Craft your own cyborg creature

By Glauco Longhi

Freelance Character Artist, Sculptor, and Creature Designer

This tutorial will follow my creative process in making a ZBrush creature, from the very beginning to the final image. My brief involves creating a creature, but I don't want to make something too generic or similar to a normal animal/creature. So let's see what happens.

01 The silhouette
Before opening ZBrush, I research a huge number of references online.

After this, I open ZBrush and select the DynaMesh064.zpr sphere option. Using the SnakeHook brush, I start pushing the sphere around and Ctrl+clicking to update the DynaMesh, so that it maintains a clean mesh. My goal here is to experiment and find an interesting silhouette.

To finish this step, I select the arms, legs, torso, and head, and create a polygroup for each group, so I can easily select them as I go. I like to keep things as simple as I can, since that's the way I've been sculpting in traditional clay for the past six years.

02 Playing with shapes
Now it's time to start adding more volume – though at the same time, it's important to keep it simple and flowing with the rest of the piece. Thinking about the whole piece while sculpting is key to helping with this – so if you work a little on the head, zoom out and check how that part is relating with the rest of the model. Maintain the flow, silhouette, and interesting curves. I use the ClayTubes and the Move brushes here.

"The eyes are facing forward since I'm doing a predatory creature. Usually in nature, predators have front-facing eyes while prey have lateral eyes so they can use peripheral vision to escape easily"

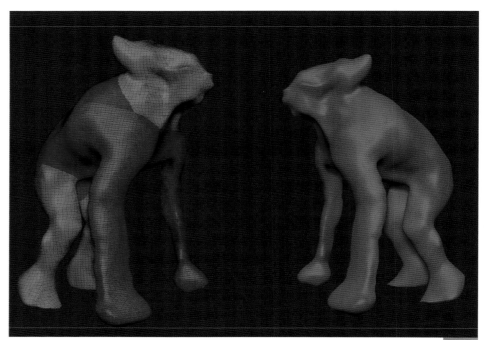

↑ The polygroups and overall silhouette for the initial design

01

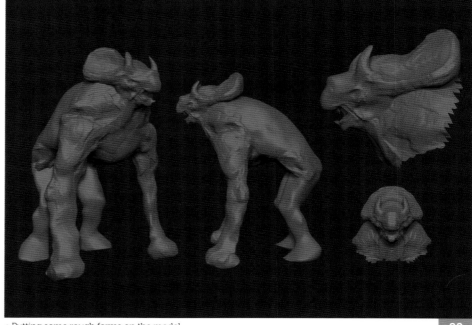

↑ Putting some rough forms on the model

02

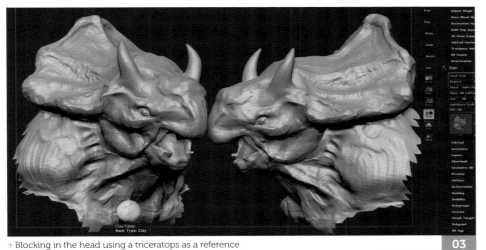
↑ Blocking in the head using a triceratops as a reference

03

03 Head sketch

I then try to figure out the head design using a triceratops and other references. I first block out the general shapes and feel out the design.

The eyes are facing forward since I'm doing a predatory creature. Usually in nature, predators have front-facing eyes while prey have lateral eyes so they can use peripheral vision to escape easily.

04 Hard-surface blocking

For cinematic or game work, I always start with a very rough ZBrush sketch, then retopologize in another package such as 3ds Max and finish the modeling there. For a conceptual work, however, I feel comfortable polishing the forms in ZBrush. So this is how I start the blocking phase.

Using the ClayTubes brush, I start putting in the overall shape. With the TrimDynamic brush, I can start adding some hard surfaces. Then I use the hPolish brush to finish the forms and give that final clean look.

Since I'm only sketching and I haven't subdivided the mesh too much, I can't achieve this look yet; but the goal here is to design first, and then polish everything in order to finish the sculpture afterwards.

↑ Working on the raw form, blocking, using TrimDynamic, and finally the hPolish brush

04

05 More hard-surface objects

I then add some sketchy lines using the Dam_Standard brush, trying to make these forms more interesting. I also add some objects using the MultiMesh Inserts that come with ZBrush. To use these, simply select the brush you want, then press M and choose the object. Drag and drop the object wherever you want.

Again, I have a rough image of the final look I want, so experimenting is key here.

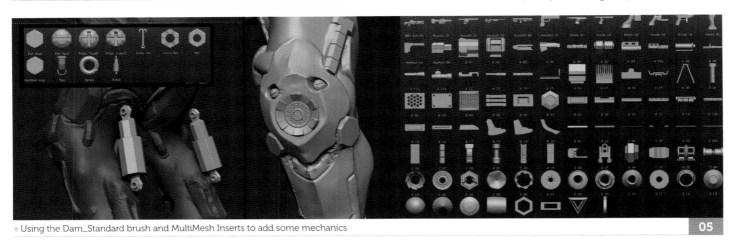
↑ Using the Dam_Standard brush and MultiMesh Inserts to add some mechanics

05

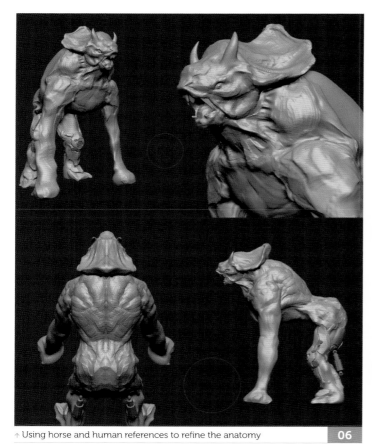
↑ Using horse and human references to refine the anatomy **06**

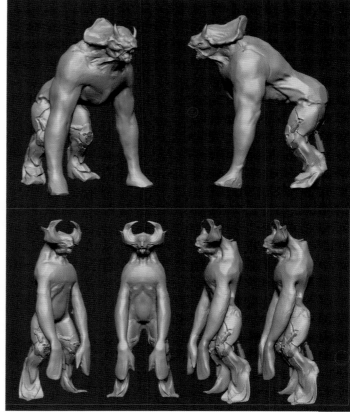
↑ Before and after shots of experimenting with the pose of the creature **07**

06 Anatomy

I always base my designs on human or animal anatomy – I like to refer to nature as much as possible. I start adding human/horse shapes to the model, trying to figure out what I want in the final piece. I check the silhouette, the negative spaces, and the overall shape as I go.

Here in image 06, you'll see I work a little bit more on the head. I never spend too much time in one spot – for example the back with refined muscles and veins – and finish. Keep it as simple as you can, and work on everything at the same pace, switching from legs, to head, to back, and so on.

07 Changing plans

This is what I like about designing – the experimenting phase. I always think you should experiment as much as you can. You can also take screenshots and paint variations in Photoshop.

I had this idea to transform the creature into something a little bit different and decided to try it. The mechanical legs make more sense now, since he can use them to jump higher and run faster.

Using the Move tool, SnakeHook, Clay, Transpose, and TrimDynamic, I re-shape the entire character.

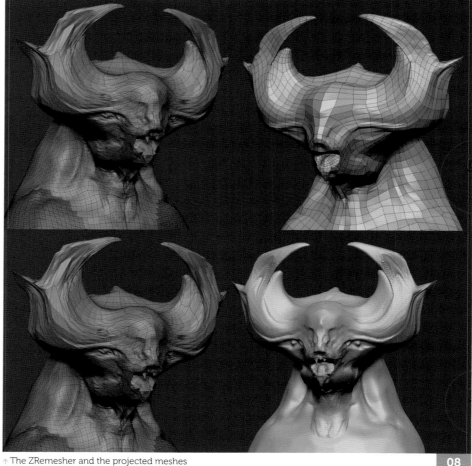
↑ The ZRemesher and the projected meshes **08**

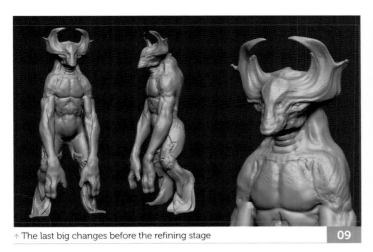

↑ The last big changes before the refining stage **09**

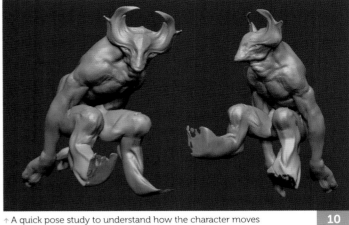

↑ A quick pose study to understand how the character moves **10**

08 ZRemesher

The mesh is now a mess. Yes, I used the SnakeHook and changed all the proportions, but now it's time to re-adjust everything. I like to use the ZRemesher feature here.

First of all, I freeze the subdivisions, click on ZRemesher, and then click again on Freeze to unfreeze it. ZBrush will calculate all the subdivisions and re-project all the details.

If you have trouble doing that, you can use the old fashioned way – just duplicate your model, ZRemesher it, then project all the details onto the duplicated model. Note that you will lose the polygroups in the process, though.

09 Anatomy tweaks

Now I start adding more anatomy and change the overall shape of the head. I'm pretty happy with it now, so I won't be changing too much from now on.

That's what I like about designing my own characters – I'm free to change whatever I want, whenever I feel comfortable to. Of course, depending on the project, budget, deadline, or even the script, I often can't do that; but let's enjoy it this time!

10 Understanding the character

In order to better understand the character I'm creating, it is a good idea to think about the environment he would live in, what the character is, how he was created, how he would move, and so on.

This is one of several quick pose studies I make before moving forward. Using the Transpose tool, I quickly pose the character in a dynamic jump pose.

11 The mechanical legs

I approach the mechanical and hard-surface parts of the model in different ways. I really want to give it an old-school, solid mechanical look, as if it was hand-built; as it is a Jurassic creature, I don't think high-tech mechanics would fit in that well, contextually.

Using only standard InsertMultiMesh (IMM) brushes, I build the legs using some classic machine references and try to think about how they would bend and work. I try to not get crazy here about the functionality but I only include parts that would make sense. Now it looks good, but I'll probably add more details later.

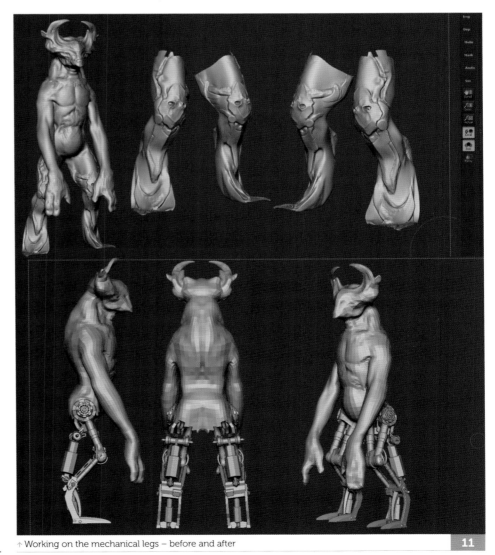

↑ Working on the mechanical legs – before and after **11**

> "It's really awesome to see how ZBrush is becoming more like working with traditional clay"

12 Extracting objects

After adding a lot of IMM objects, I like to separate the parts in SubTools so my file is much cleaner and easier to work on.

I group all the IMM objects, the legs, and the rest of the character, use Hidden Group Split, and then delete the lower leg. I now have one SubTool for the upper part and another for all the mechs.

13 Closing the gap

You can easily close gaps in the mesh using the Close Holes option under Geometry > Modify Topology > Close Holes. If you have a different situation or it's not going well, you have another option. Here, I use DynaMesh, then re-ZRemesh, and finally use the Unfreeze option.

DynaMesh allows you to create or close holes, and create things like membranes, so keep it in mind while sculpting and designing. It's really awesome to see how ZBrush is becoming more like working with traditional clay.

14 Head and body details

Okay. So now we have this creature pretty much defined, it's time to start adding secondary forms and finer details.

First, I scale down the head a little bit. I then begin carving some wrinkles and scales, using the Dam_Standard brush. I use animal references here, along with some of my own imagination, in order to create some interesting hybrids. Additionally, I add some teeth to make him even more interesting.

15 Teeth and scales

I want to separate the teeth, so I push down the old teeth mesh and put two spheres in as SubTools. Now I have a clean mesh to sculpt the teeth. Depending on the project, I model the teeth one by one, so it can render easily.

I carve the scales using the Dam_Standard and ClayTubes brushes. I put some volume on the lower edges and carve down the upper ones so it gives a nice sense of volume to each one. You can mask it and push/pull away too, but as a traditional sculptor, I think I have more control when really sculpting these pieces one by one.

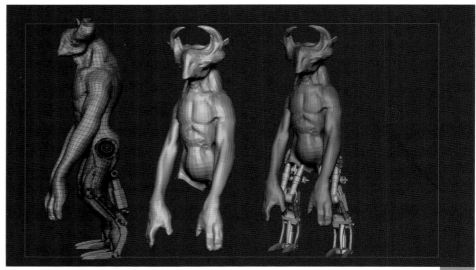

↑ Showing the polygroups and the SubTools `12`

↑ Closing the holes in the mesh using DynaMesh and ZRemesher `13`

Then I use hPolish in order to refine the shape and the Standard brush on the edge in order to make it pop even more. I clean it using Smooth and it should now look like a cool scale. It requires patience to do that, but it is very much worth it in the end.

16 Alphas and more detailing

For the fine details we can use Alphas. In a traditional medium, we have something called stamps – latex or silicone copies of cool textures – to stamp on models. Most of the time, though, we apply textures freehand. So, the majority of

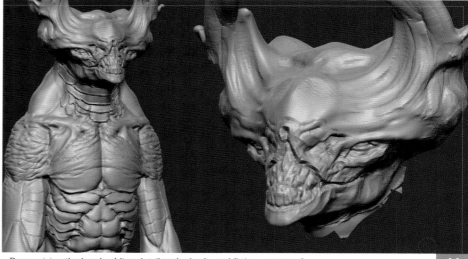

↑ Down-sizing the head, adding detail to the body, and fitting some teeth `14`

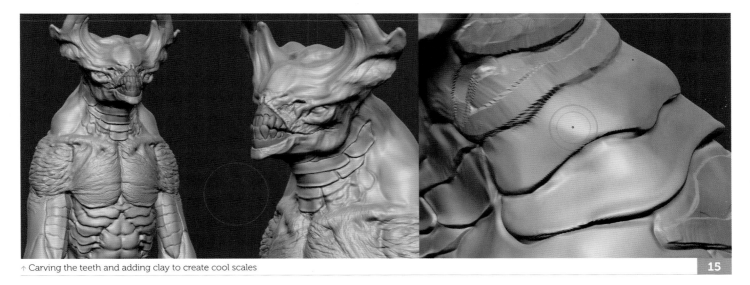

↑ Carving the teeth and adding clay to create cool scales **15**

my work here is done freehand, or I use small Alphas to simulate some wire tools. Recently I've started using some Alphas to do realistic heads and they help a lot, but again, I still sculpt a lot of folds, wrinkles, and pores by hand.

I use Alpha 58 to simulate the leather skin, and make circular motions with the brush (going with the skin direction) to achieve the right effect.

Usually, wrinkles are created by bending the skin and compressing it millions of times, so the pattern always follows a direction perpendicular to the muscle that compresses it. The forehead has horizontal lines because the muscles are positioned on a vertical line, pulling up and raising the eyebrows. This is a simplified explanation though; wrinkles can also be created by fat, age, collagen loss, and many other causes.

I continue adding details, trying to give it volume and remove the flat look achieved after the sculpting stage.

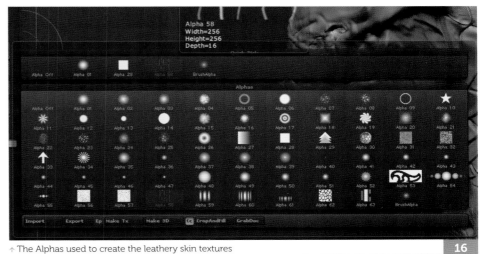

↑ The Alphas used to create the leathery skin textures **16**

17 Final head

I want to create a look of deep sea coral and rotten rocks, so using a mix of Alphas plus hand detailing and the Flatten brush, I try to create this mixed look.

I refine the teeth using Dam_Standard, Pinch, hPolish, and some standard brushes. I try to avoid the ultra clean look and keep some irregular shapes to help sell the hard-look material.

I adjust the body proportions and lower a little bit into the mechanical parts, so it's ready for posing and the final render.

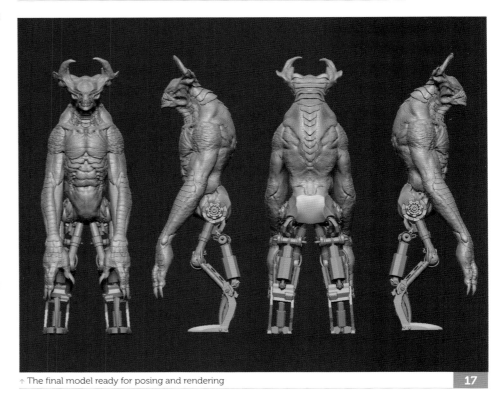

↑ The final model ready for posing and rendering **17**

18 Posing

It's time to pose our character. I've done many studies of poses for this character and the purpose here is to show the emotion or personality it would have, or at least show how he would walk.

Using Transpose, I quickly mask by holding Ctrl and dragging onto the surface. Then I adjust my pivot points and rotate each of the anatomical components, for example the arms.

There's a feature called Replay Last, so if you rotate the head, you can select the eyes and use the Replay Last to give the same rotation to the eyes and keep them in place. There's also a plug-in called Transpose Master, but it never really works that well for me.

Remember to lower all subdivisions so the mesh will be more stable and easy to pose. Try to use the floor (Shift+P) as a guide for the pose. I find myself removing the perspective (P) and using the orthogonal left view a lot while doing this kind of pose.

19 Render and composition

First, I resize the document. I set something around 6000 × 3000 and click on Resize. Now we can move forward to the rendering stage.

I set two lights – a key light and a rim light to cut it out from the dark background. Exporting these layers separately gives me a lot of room to play with in Photoshop, so I export the key light with shadows, and everything else without them. The key light shadows will be my guide to putting the other layers over.

20 Coloring steps

I'll now quickly explain my texture-painting process to reveal a few of my usual tricks.

I start by adding a base color – a light brown – and painting the back darker to mimic other animals we see in nature. Then using the spray, I start painting some color variations in a technique that traditional painters call 'mottling'. It simply involves making small figure-of-eight shapes, breaking up the surface and adding more realism and detail.

After that, I use a small dot Alpha to paint more details and variations. Always use nature references to achieve more realistic results. Image 20 shows the final head painted.

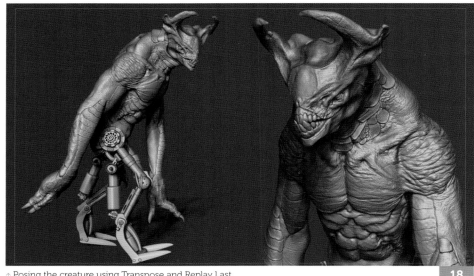

↑ Posing the creature using Transpose and Replay Last

18

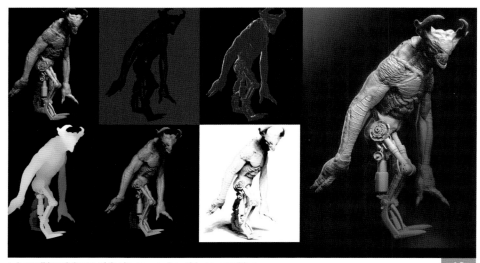

↑ A small breakdown of the layers used on this composition

19

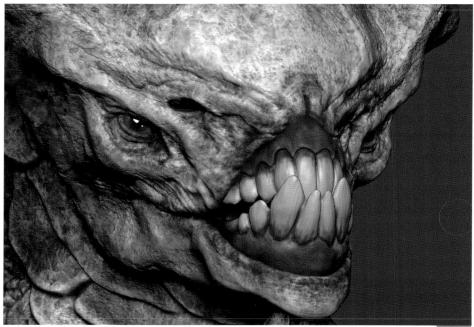

↑ The final head painted using references of natural animals

20

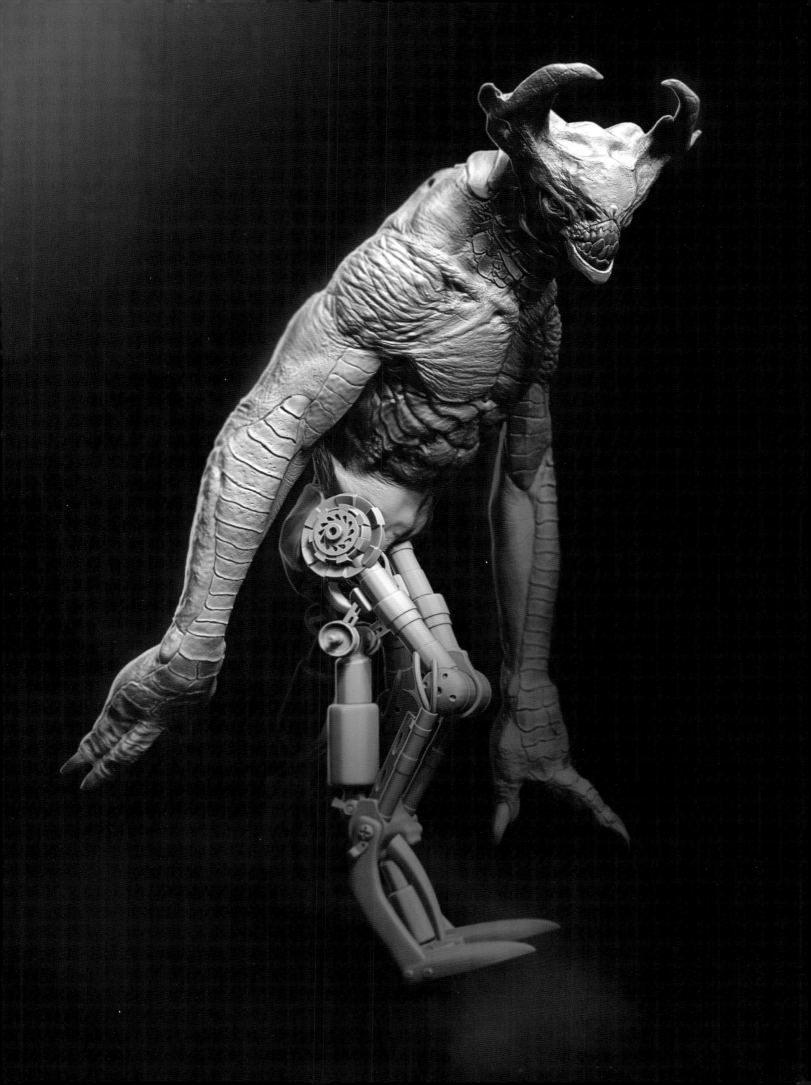

Chapter 03
Creatures
Part 03: Master working with base silhouettes

By Pavel Terekhov

3D Generalist

Free Resources
www.3dtotalpublishing.com

This tutorial is mostly dedicated to the character creation process, and more specifically to my own strategies for modeling. First, I will explain a little about developing an idea and about the important role of reference images and how to create sketches inspired by them.

After that, I will describe how to build a base silhouette with ZSpheres and create a rough 3D sketch.

We will learn a little about forming a shape and about the importance of keeping a balance in your image. I will also describe my method of retopology and the various techniques I find useful. We will work over the head, the body, arms, and legs of the character step by step, adding detail and specific features consistently.

Next, using just a couple of tools, we will quickly create an environment that suits the character. We will then proceed to texture and color the creature and the environment with the help of Spotlight and other tools.

We will finish up by posing the creature to create its personality, setting the proper lighting, applying any final rendering, and adding some post-production actions.

01 Finding the idea

At the beginning of this project I was encouraged to develop my own concept, so it was my personal mission to generate an idea. In a situation like this I usually ask myself some questions in order to define and describe a character. This helps me to build up a visualization of my future creature.

For this image, I schematically represent key points to consider when creating a character. The more questions asked and answers received, the

↑ I set out a mind map to explain how I lay out my ideas and thought processes when creating a character

01

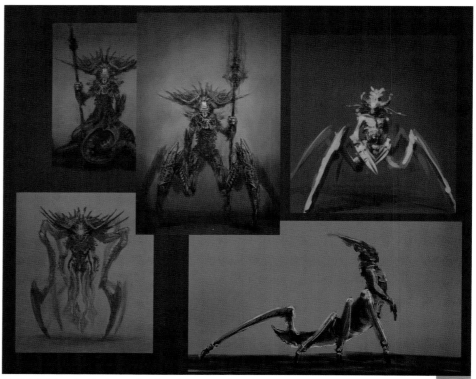

↑ Initial sketches developing my first thoughts on my character

02

more detailed your ideas will become. The first question I ask myself is: What is the nature of the creature? It may be a human-like species or a wild beast, or a fantasy being like a mage, dwarf, genie, or golem. I decide that my character will likely be a monster with some demonic features.

The next point is to describe its archetype. After the role and specific character features are thought up, you continue on with the creation of visualization. I primarily see my character as a sort of brutal, harsh monster – emotionless and severe upon his enemies.

98

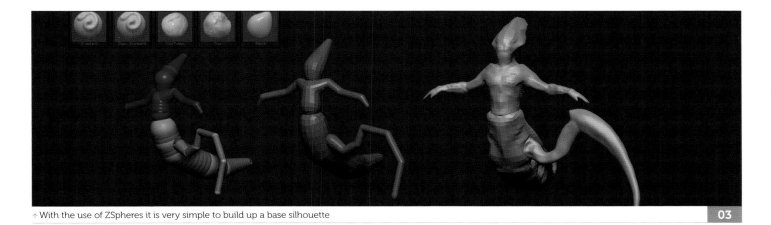

↑ With the use of ZSpheres it is very simple to build up a base silhouette

03

After the archetype follows the habitat. It mostly predetermines the appearance. Here, I single out three main ingredients – climate, environment, and habitual element (though you can go even further!). These matters require deep analysis, but once established you get lots of details that determine the appearance.

I spend a while thinking about it and decide that such a tough guy must live in inhospitable conditions – somewhere in the wet subterranean ruins of a lost ancient city. And the plot forms when I start drawing!

02 Sketching ideas

Now that I am full of ideas, I am ready for sketching. First though, I need to prepare the project by gathering some reference images. I go through tons of references and choose those ones that suit my ideas and themes the most. By doing this, my details and problems are slowly worked out.

It's not enough just to know how the details will appear, though – it's also necessary to understand how they work, and what they are for in each particular area.

Form analysis is also a very important element; so to understand better, I read articles on the subject. I always think that it's okay to overdo the research sometimes, rather than be under-prepared!

With these ideas in mind, I draft out several sketches with different designs. In image 02, you can follow the evolution of my ideas. I start with four legs and finish with eight of them – and eventually end up with an extra two arms in the upper portion of the body.

Finally, I had a breakthrough idea – my creature is a guard! He is the guard who stands at the gate between our world and the land of nightmares. His environment has left an imprint on his appearance, and so he has features of both sides of the gate – a human-like upper body and insect-like lower body with the limbs of a crayfish. Why insects and crayfish? Because many people are afraid of them. At the same time these species are effectively armored with a protective exoskeleton.

03 3D sketching with ZSpheres

I start to build up a base mesh using ZSpheres. These allow me to create a base ZSketch very quickly. I then build up the separate lower insect-

shaped body with eight legs ending in claws, and the upper human-like body with two arms.

I use the Standard brush to add mass quickly and then sculpt with the Clay and ClayTubes brushes. At this point, I work only on large details, not paying attention to pores and wrinkles. There is no need to add detail as the shape changes every few minutes. The main goal here is to build the mass and form a silhouette.

04 Volume and mass

The shape now needs to be detailed. At this stage, the modeling process simply involves dragging polygons to and fro in order to create the individual features such as the shield, limbs, and head shape.

An important thing to consider, especially in complex characters, is balance. Legs and arms can over-elaborate the model, and I've got eight lower limbs to take into account. It is essential to have harmony in an image and, I would say, the limbs must be in the right place. It's not an easy task – at least for the first time. It's very useful to switch to orthogonal view from time to time to prove to yourself that the result looks good.

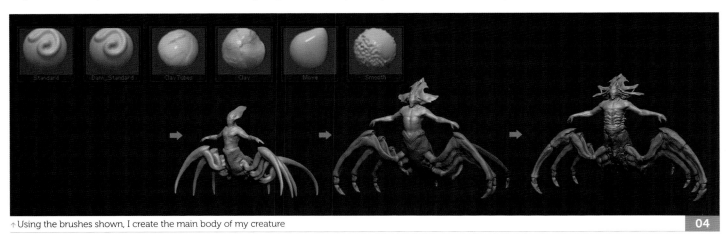

↑ Using the brushes shown, I create the main body of my creature

04

05 Finishing the concept

We've now reached the end of the base-mesh-forming stage, though I'll continue improving the mesh by looking at some of the finer details.

I work with the Standard brush, the Clay and ClayTubes brushes, as well as Move, Dam_ Standard, and Smooth brushes. This enables me to get the result I would usually call a 3D sketch.

You can see in image 05 that I add several small details and give the human-like body some hands. I also emphasize the plates and shields and specify the lower limbs, as well as add some claws to create a more aggressive look.

06 Photoshop

The character is now ready to be moved into Photoshop for over-painting. I usually prepare several screenshots in ZBrush and start drawing over images. Using the Liquify filter, I move legs and arms, resize them, and estimate the result. This approach can save much time!

Then I need to choose the variant I like the most. I usually engage my relatives and friends in discussion and receive their verdicts. By asking for an opinion and taking advice, it helps get a fresh look at the work. I've found that an onlooker will notice mistakes much more quickly!

Now that I've got a concept that suits me (and my relatives), I just need to fit the model to it!

07 Retopology

Retopology is one of the most boring elements of 3D design I've ever encountered. But if you must, you must! There are a couple of methods for retopology in ZBrush. They are both really great, but I much prefer the old approved manner of retopologizing in Maya, simply because it's handy and habitual for me. I used to do it with a NEX plug-in, but now it's included in Maya by default.

My model created in ZBrush is a single mesh, though while retopologizing I divide it into isolated parts: A head, body, arms, and legs – even each shield. As a result I have lots of details that form a more natural appearance.

08 Hand detailing

As opposed to the previous step, we can now begin the most interesting step – the final detailing. I imagined quite a complex head, so I decide to start the detail there. That way, I have

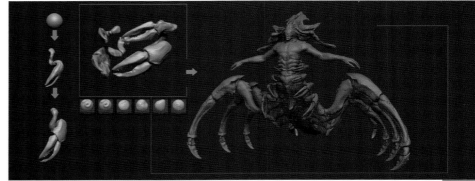

↑ Adding details should serve a purpose – they should make the model both unique and colorful **05**

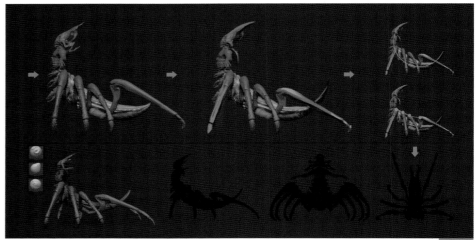

↑ Demonstrating how the model changes after the over-paint tests **06**

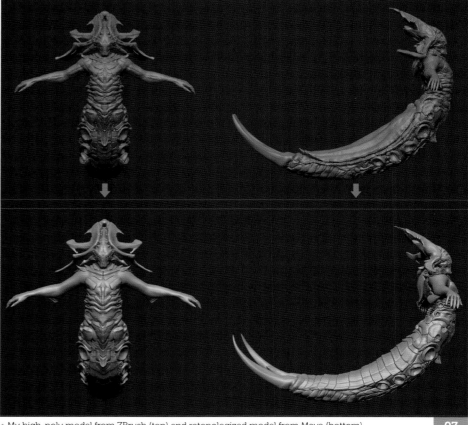

↑ My high-poly model from ZBrush (top) and retopologized model from Maya (bottom) **07**

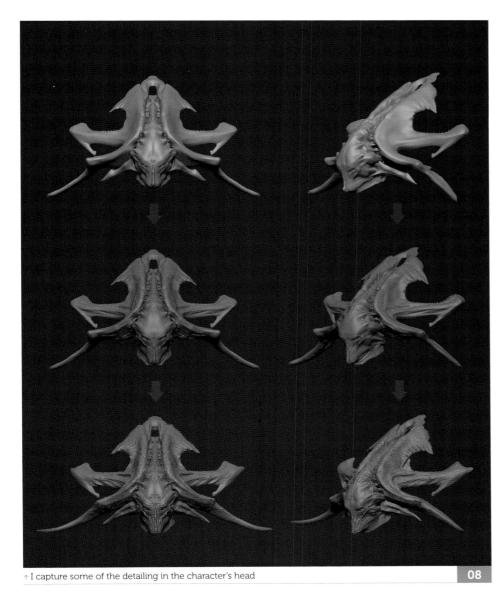

↑ I capture some of the detailing in the character's head

08

an opportunity to return and work over some of the details after I finish the body and limbs.

I use the same brushes as before – the ClayTubes, Dam_Standard, and Smooth brushes. My idea is to cover the head with a thick skin and to sculpt the bone outgrowths that make up the external protective covers. In my opinion, too many tiny details will make a mess of this creature, but if you want to add some you can apply the Dam_Standard brush or use the trick I describe in the top tip later on.

09 Body detailing

After retopology, all the shields are saved as separate meshes, which means there are too many to load into ZBrush individually.

To counter this, and in order to detail each element without affecting nearby parts, I first load the lower body (the right side of it) to work on and then copy and mirror it to get the left part.

I then enable the Unwrap function to get UVs for all the character's geometries (ZPlugin menu > UV Master). I also enable the Auto Groups with UV function (Tool > Polygroups). The whole model then becomes divided into polygroups. Using Ctrl+Shift+left mouse button I am able to choose each shield and work over it.

There is also another way: By accessing the Brush menu > Auto Masking, and changing the Mask By Polygroups setting to within the range 0–100.

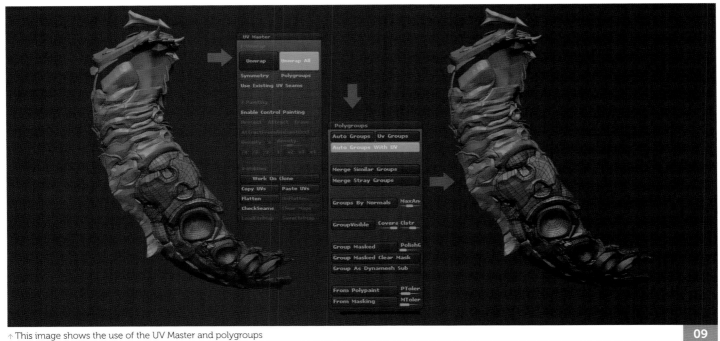

↑ This image shows the use of the UV Master and polygroups

09

With regard to the limbs, I have four pairs of legs. Three pairs are very similar, and the last pair is a little different. When the retopology of one pair is finished, I move one side back into ZBrush and detail it according to the process described in the previous step.

After it is detailed, I copy it as many times as required in order to achieve the correct leg count. I then start to change the sizes and angles; I also add features to make each individual leg more varied. I am then able to acquire pairs of legs simply by copying and mirroring the ones I already have.

"I start over-painting the image, keeping in mind crayfish and crabs as references. This is just one more way to save time and to check different color schemes. It is also very helpful to get other people's opinions at this point"

II Building up an environment
To create the ground I use a sphere. I deform it with the Move and Clay brushes and then apply the SnakeHook brush to create sharp rocks. I use the Tool > Surface > NoiseMaker function to mimic a stone pattern, and apply the Tool > Geometry > ClayPolish function to make the surface look natural.

I then texture the ground in faded colors and use Tool > Geometry > ClayPolish once more to create the edges.

At the end, to make the picture more attractive and interesting, I form a stone tunnel using the Tool > Deformation function. You can follow the process step by step, as well as find the settings, in image 11 on the right here.

I2 Over-painting for texturing
I usually find that the best coloring solution consists of over-painting in Photoshop. I put a grayscaled screenshot in the program and start to color experiment using the Overlay filter on a new layer.

I start over-painting the image, keeping in mind crayfish and crabs as references. This is just one more way to save time and to check different color schemes. It is also very helpful to get other people's opinions at this point.

↑ The process I follow when detailing the limbs `10`

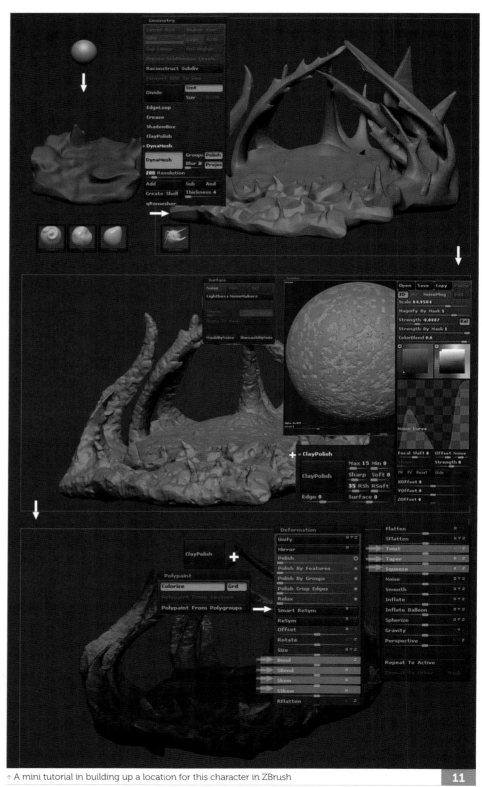
↑ A mini tutorial in building up a location for this character in ZBrush `11`

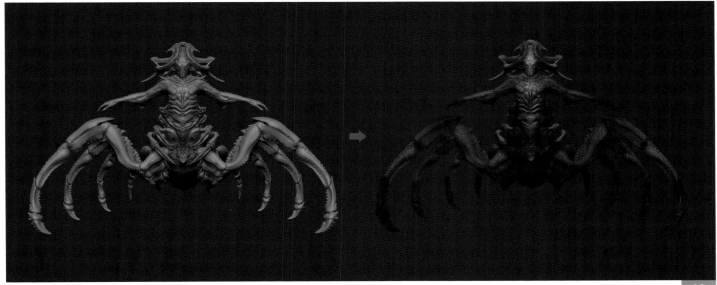

↑ The results of a quick over-painting to capture the color schemes of this concept

12

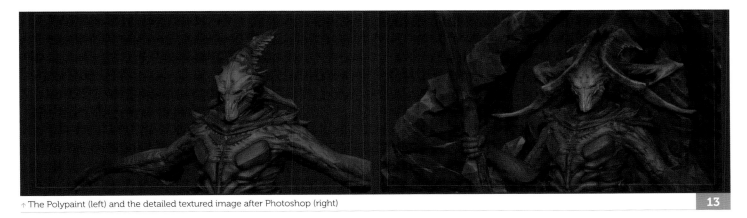

↑ The Polypaint (left) and the detailed textured image after Photoshop (right)

13

"Back in ZBrush, I like to start texturing using Spotlight from the Texture menu. It is one of my favorite tools in ZBrush as it allows you to project downloaded images onto the model and adjust the texture"

13 Texturing

I occasionally choose textures in the skin shader too, or take some from open sources on the internet, but for the most part I paint them myself.

Back in ZBrush, I like to start texturing using Spotlight from the Texture menu. It is one of my favorite tools in ZBrush as it allows you to project downloaded images onto the model and adjust the texture.

After using Spotlight, I then begin coloring with Polypaint. To do it properly, I enable the Rgb button and disable Zsub or Zadd (depending on which is enabled) so that

✅ **Top Tip**

Creating a chitinous/external protective protein-based surface

I have a trick I use when I want to recreate a chitinous surface on my creature.

First, take an object that doesn't have a dense wire frame. I use the Dam_Standard brush (but you can use another) and draw some strokes on the surface. Then I go to the Tool menu, select Geometry, and enable the ClayPolish function.

While polishing the surface, ZBrush creates the mask. I go to the Tool menu, select Masking, and enable the Inverse button. Now I have inverted the mask and all the strokes become unmasked. I apply the Inflate brush and get the result you can see in the image to the right here. Using the Smooth brush, I then flatten the surface until the image is good.

↑ The process of creating a chitinous/external protective protein-based surface

the surface does not become deformed.
I also use different Alpha textures and Tool
> Masking > Mask By Cavity On, to darken
the texture in deep levels. When most of
the work is done, I bake the Polypaint
and continue the job in Photoshop.

14 Setting the pose

Posing a character is not that easy, but it is
still very important. You'll find that even if
a character is highly detailed and expertly
finished, it is simply inappropriate to leave it
in a standard, default T-pose. Even a lesser-
detailed but better-posed character might get a
better reception than a lifeless representation.

Before using ZBrush to pose my character,
I run some simple posing tests in Maya
using a model with a low subdivision level. I
change the position of the front legs, move
the arms around, and pose the creature's
limbs until I am satisfied with the result.

After that, I return to the model in ZBrush and
change the position of the two front pairs of
legs and arms. I also turn the head a little so
it contrasts with the position of the body.

You can see from the poses shown in image 14
that the character has instantly taken on more of
a persona, and has become much more lively and
realistic compared to his non-posed counterpart.
I think the character looks pretty good now,
so I'm ready to move onto the next stage.

"I set the lighting for the scene
and try out a few different light
schemes; as a result I develop
and use the scheme you can
see in image 15. All of the
individual components that I
use to comprise my scene are
shown in this image"

15 Lighting, the final render, and post-production

I originally aimed to create a severe and
dramatic mood for my final scene. The main
idea was that the creature is appearing from
the darkness of a stone tunnel, probably some
kind of labyrinth, looking for a stray visitor.

I set the lighting for the scene and try out a few
different light schemes; as a result I develop
and use the scheme you can see in image 15.

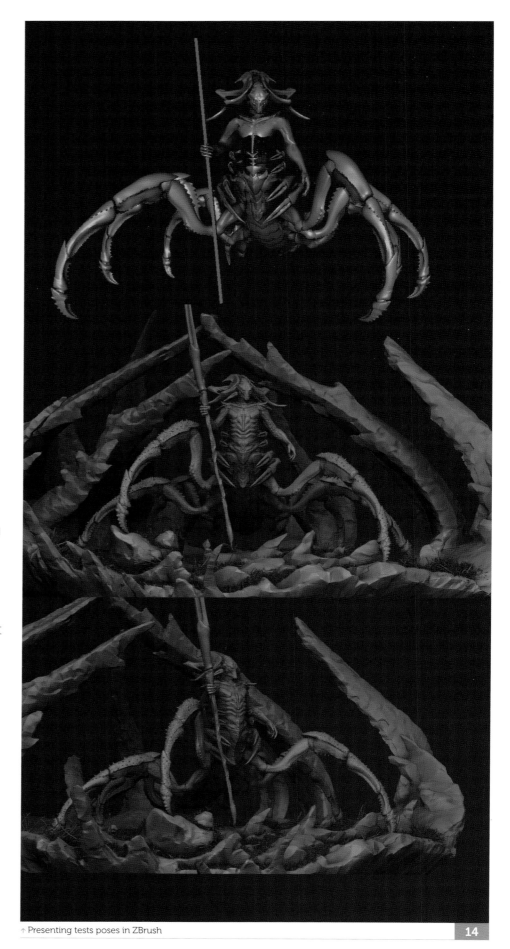

↑ Presenting tests poses in ZBrush

14

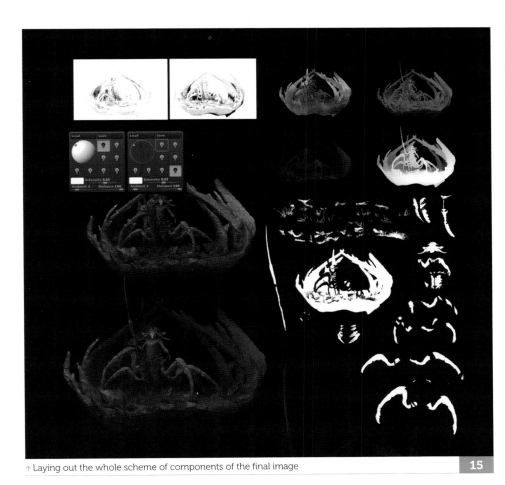

↑ Laying out the whole scheme of components of the final image

15

"I then move my image into Photoshop in order to add a little post-production to the scene. I change the background and tweak and drag levels and adjustments until I feel the scene captures the mood, atmosphere, and story I'm trying to demonstrate with my image"

All of the individual components that I use to comprise my scene are shown in this image.

Now I just need to compile all the render passes, set the render and wait – the most relaxing stage is when you can feel that your work is almost done!

I then move my image into Photoshop in order to add a little post-production to the scene. I change the background and tweak and drag levels and adjustments until I feel the scene captures the mood, atmosphere, and story I'm trying to demonstrate with my image. I then overlay an Occlusion layer to refine the details and add the depth of field to the image in order to create the final scene below.

Chapter 03
Creatures
Part 04: Experiment with hybrid organisms

By Tanoo Choorat
Freelance Character Artist

With this project, I don't initially start with a 2D sketch. I first look at a lot of designs and references, which give me an idea of the main shapes I might want to use. I then combine all of my references and inspirations in my head to create my final design. I think that consulting and referring to many references over the course of a project improves your design skill.

In this project, I imagine a creature that is part insect and part plant, with a mix of my favorite weird shapes from many different genres to create the body.

After the initial design process, and for the next step of my project, I will use a ZBrush base mesh and DynaMesh. I think each of these have their own merits, and here I will use both to create my design.

When the sculpt is complete, I will go to Maya to render the model. I know that ZBrush's render tools are awesome, but I also love the atmosphere created by the lighting and rendering in a dedicated render engine.

Finally, I will use Photoshop to adjust the color and texture, and add all of those finishing touches that can make the image come alive.

01 The base mesh
With a design planned out in my head, it's now time to go into ZBrush. My design has two arms and two legs like a human and I therefore use a base mesh for the human form and separate the arm to allow me to comfortably adjust the proportions.

I love DynaMesh, but I think that the base mesh is easier to find and adjust the proportions on a model, because it has a lower subdivision — which I really like about ZBrush.

I begin adjusting the base mesh to establish the shapes and volumes I have in mind.

02 Create the form
Next, I continue working with the model's proportion and shape – I stay with the base mesh, but work in the highest resolution. I think that it is particularly important to focus on the proportion early on in the process because your work will be more interesting to viewers if you get it right.

Knowledge about basic design is very useful. With my designs, I always try to make new and weird shapes because it's more fun to create fresh and unique concepts.

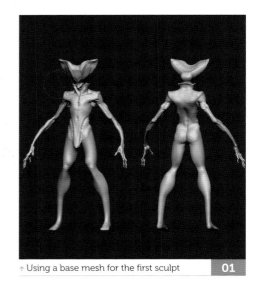

↑ Using a base mesh for the first sculpt 01

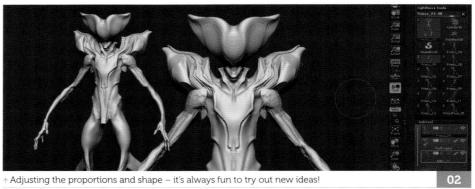

↑ Adjusting the proportions and shape – it's always fun to try out new ideas! 02

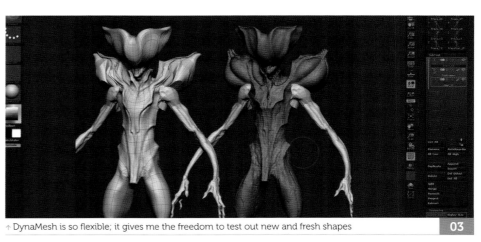

↑ DynaMesh is so flexible; it gives me the freedom to test out new and fresh shapes 03

For this step in ZBrush, I use the Move and SnakeHook brushes to create the main form. After that, I use Standard (this is such an amazing brush, you can make so many things with it!), Clay, and Dam_Standard to create the details.

I find this step really fun, because I can test out new ideas and experiment with a lot of new shapes and ideas.

03 It's DynaMesh time

For this next step in my project, I start using DynaMesh; I keep the face around 50,000 polygons because I think lower subdivisions make it easier to adjust the main form. I also work in middle-level detail so I can keep an eye on the overall look and shape of my model. I use the Standard, Clay, and Dam_Standard brushes to create form and detail.

DynaMesh just rocks! I think it's really easy to use, and you can have fun with your sculpt without worrying about topology.

In this step, I think the proportion should be still and balanced to allow you to organize the shapes and work on the details.

04 Detail on the head

It's time to add detail! The first area I choose is the head. This is because I think the head plays a really important part in making your character unique, and I like to create unusual head shapes to give my character an immediate impact.

For this character, I want to make its head resemble a petal or leaf, and add a collar to it in order to make it look terrifying.

For the detail in the sculpt, I use a Standard brush with Z Intensity 35 to create the line on the head. I then use the Standard brush with the default settings (Z Intensity 25) and the Clay brush to create dirt and wrinkles on the skin.

If you're confused as to why my model doesn't have an eye, it's because I love the flow of the form; I think that without eyes, a nose, ears, or other features, I'm free to create shapes without rules – which I feel is important for creating a unique concept.

05 Detail of the body and leg I

For the body, I want to add a flowing line of muscle and a bodysuit inspired by the online game *Warframe* – I was inspired by the flowing

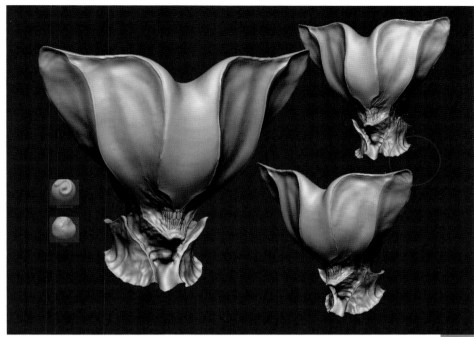

↑ Standard and Clay brushes are used to make the skin **04**

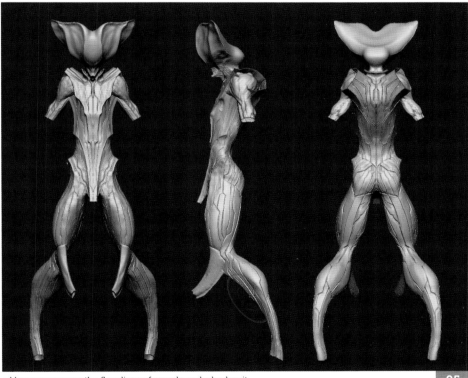

↑ Here you can see the flow lines of muscle and a bodysuit **05**

lines I saw in a trailer for it. I think it's a good idea to adapt and use everything around you in your work as inspiration (but never simply copy).

On my sculpt, I then start using the Dam_Standard brush to push the surface in order to create a guideline and cavity in the body. I decide that the rim is too soft, so I change to the Slash3 brush instead, which sharpens

the rim and creates a much nicer effect. I spend a lot of time redrawing the line over and over again, because I prefer to work with the flow and continuation of flowing lines.

I also think that the scale of the cavity is important because it gives the image a voluminous 3D appearance; if the lines were all the same size, the image would be boring.

06 Detail of the body and leg II

When I have the guideline and cavity refined, I push the rim out again to create a better dimension and make it more like a bodysuit. At this stage I use the Standard brush again, because this brush is so versatile. I set the Z Intensity to 35 for a thick rim and use hPolish to polish the surface in this area in order to make it flatter. Finally, I use the Pinch brush to pull the line into a sharper shape.

Here, I think the anatomy and base for a simple design is very important, because the line on this character is a major part of its composition. If the line is not continuous or flows badly, then this model just won't work.

For the legs, I follow the same principle as the body, though it is perhaps a little harder as the shape of the leg is more complex (longer and rounder). It may take time to find a good flow and curve.

07 Detail on the arms

So far, I think the arm looks a little boring, especially as I'm using the same themes and ideas in the rest of the body, so as a result I'll create the arm in another way…

I choose to use a human arm to start and simply sculpt it into a more 'creepy' form, while still in keeping with the creature concept. I make the arm particularly long to match up with the horizontal line on the body.

For the sculpt, I find adding wrinkles and skin details the most fun. I use the Standard and Dam_ Standard brushes to create the folds, wrinkles, and skin details, because I don't think the skin texture will work if you only either push or pull the surface.

I use the Clay brush to continue the surface area and finally use the Standard brush with Z Intensity at around 45 to create a variety of veins.

08 Tweaking the proportions

When I'm happy with the body and arm parts, I go back to check the overall shape and proportion. At the moment, I think it looks weird because of the position of the shoulder and chest, but I think I know a way to make it better…

First, I use Move and SnakeHook to find a better shape. I test a lot of shapes at this stage. This is one of the most fun parts because I can learn and make a new shape if I'm still not happy

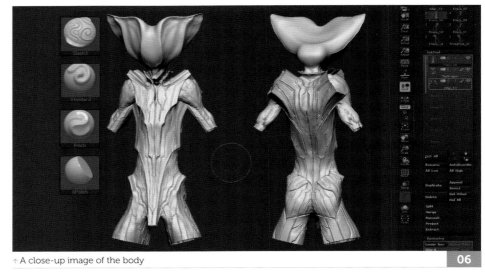

↑ A close-up image of the body

06

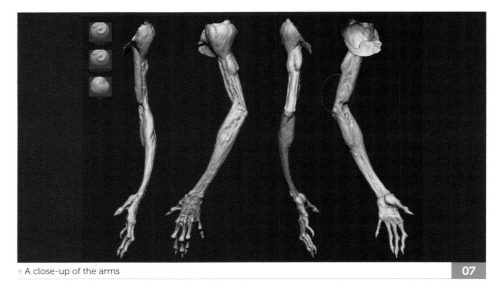

↑ A close-up of the arms

07

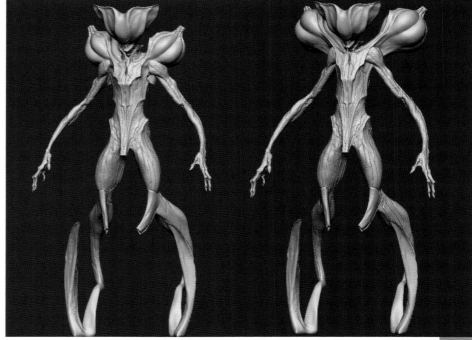

↑ A comparison before and after tweaking the proportions

08

with it; I just continue experimenting until it looks okay. As for my model, I then stretch the arm out. I think the longer arm matches with the line and curve in the body parts and the slimmer look is a lot better than the older one.

I think, in general, that the version after my adjustments is better because it now strikes a more interesting balance.

09 Connecting the arm

As I am now happy with the proportions, it is time for me to connect the arm to the body. This is where I encounter a problem: The shoulder/torso is flat (like a bodysuit) but the arm is rounder and more organic. It's my job to make the two connect now.

At this point in the process I think I can make it work, but I might have another trick up my sleeve to improve it: I use SnakeHook to find a new and more interesting shape in the shoulders. I drag the top of the body down to the elbow and add a few little touches.

I spend some time choosing which version I prefer, before deciding that I prefer the older version as the upper arm part looks much clearer and more natural.

10 Combine and polish

I'm okay with the final image at this point, so it's time to group the items. DynaMesh is so flexible and it's able to combine separate extracts or Booleans; it gives me the freedom to create every shape.

In this project, I merge the SubTool body and arm together. Don't forget to duplicate and store those SubTools though, because we need to use them to project detail on a new SubTool later.

I get a new SubTool that combines the arm with the body, but the seam is not continuous. For that reason, I will turn it into DynaMesh. Once this is done, we have one SubTool and the seam is connected – but it has lost its detail.

This is where those pre-stored detailed SubTools work. I project the detail from the older (with detail) SubTool onto a new (lost detail) SubTool.

Afterwards, I sculpt in the seam and nearby areas in order to merge the arm realistically with the other body parts.

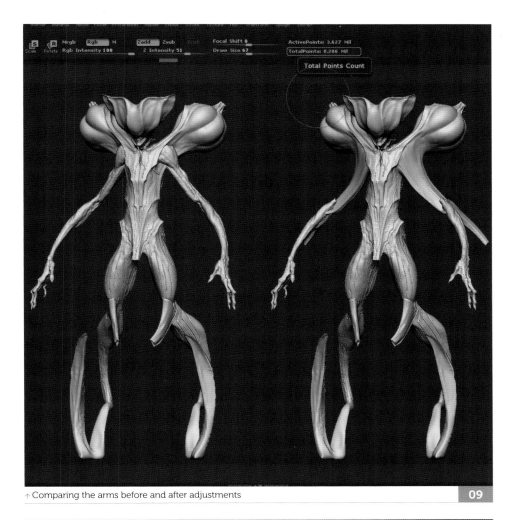

↑ Comparing the arms before and after adjustments

09

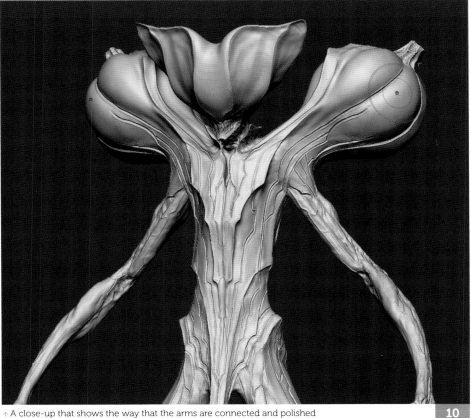

↑ A close-up that shows the way that the arms are connected and polished

10

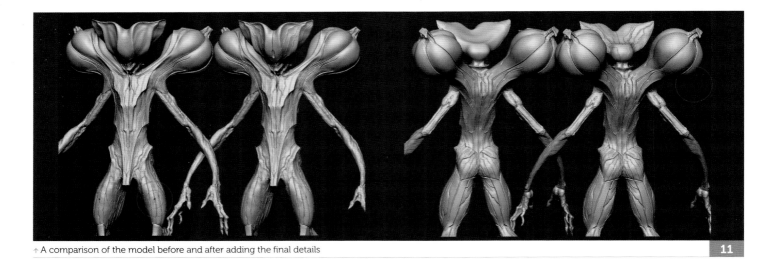

↑ A comparison of the model before and after adding the final details

11

11 Final detail

When I reach the final model with all of the detail and I notice something imperfect, such as disrupted flow lines (especially the seam at the arm and shoulder area), I think the image loses something.

Judging this image so far, I think that the head is particularly flat when compared with the other areas, so I think I should spend some time on this step.

It's really important that you're happy with the smaller areas of details, because though they may seem okay at the time, they may look out of place when you compare them to other areas.

Next in our project, I will drop detail into other areas to make them more consistent. After this, I will check all of the details over before I create the pose in the next step.

12 Pose and polish

In our final step in ZBrush we will give the character an action pose. I think that a character can look really boring if you finish your image in a T-pose. Designing an action pose helps your work have movement, so it's not so still and boring.

This character is actually quite terrifying, so an extreme pose is not my first choice. I choose to pose only a little of the character to highlight the head and chest; I think these two areas can

gain a greater response than the others. Adding asymmetry to the arms and legs completes the look. When this is finished, I begin polishing the areas that I posed, as the character has lost a lot of the shape and detail in transition.

After that, I use the Decimation Master to Decimate the model and then go to Maya and prepare the image for rendering.

In this step, I always use a low-resolution version of the model to test the shading and lighting, as it's faster than using a high-resolution model for testing; when you get the final lighting, you can replace the image with a high-resolution version to render. This saves time and is more flexible.

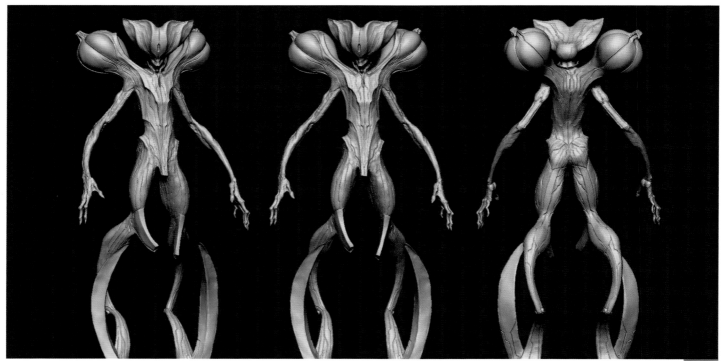

↑ The pose can tell the story of your character; so let him pose!

12

13 Shading and rendering

For rendering, I use mental ray in Maya. I set up the camera first, because it makes a big difference in the default settings. In the render camera, I create a mia_exposure_photographic lens shader to get more natural light in the rendered image. This is the most effective method to render this image, so I try to make this part solid before working with light (see top screenshot of image 13).

The lighting setup I use is three-point lighting. I only use a key light and rim light to make my scene high-contrast and seem more dramatic. I then use an area light with a mental ray physical light. I find that physical light from mental ray gets a better falloff than the default one. After that, I tweak the physical light color (the light intensity, for example) until I get the lighting I want. In Render settings, I enable Final Gather in order to achieve more natural lighting with a bounce light from the stage.

Once I am happy with the lighting, I then set up render layers in order to create a more varied range of materials. I also make some passes for the composite. For the material, my technique involves using only specular and lighting parts for the texture. I will create this in Photoshop because I think it is a little easier to do it in that particular software.

For this piece, I need three materials for the main section of the body: Skin material for the arm, a Subsurface Scattering shader to add realistic skin, and finally matte areas to help the composite process in Photoshop.

↑ Settings for the shading and rendering using mental ray in Maya

"I find that it is very useful and much easier to make a base texture where you can add custom textures from other resources. From a personal point of view, I like to use blood or gore-themed pictures to create a creepy texture that works well on my final images"

14 Compositing

Image 14a shows the rendered parts that make up the composite. I now move my image to Photoshop. I think that if there is a way to make your work better, you should do it, because that's what all artists should aspire to do. So here, I will create the final coloring, texturing, and adjustments of the surfaces. For the coloring, I use a matte part to select and adjust the color in another area (this makes my job so much easier).

For the texture, I use a 3D texture in Maya in order to add some noise to the surface of the model. I find that it is very useful and much

easier to make a base texture where you can add custom textures from other resources. From a personal point of view, I like to use blood or gore-themed pictures to create a creepy texture that works well on my final images.

I will adjust the color to make the image more balanced and add some background noise and dirt. As a final touch, I will then adjust the overall

color. For this piece, I initially choose three color tones: Green, yellow, and blue (see image 14b). I choose green to be the overriding color tone to emphasize that this concept is based on a plant. The image to the right here is my final render.

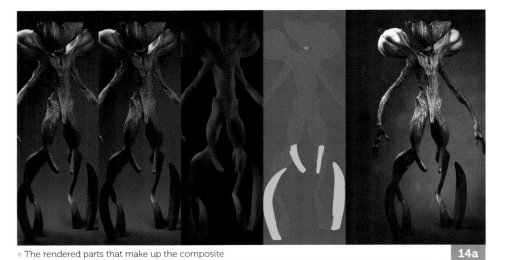

↑ The rendered parts that make up the composite

14a

↑ The three color variations

14b

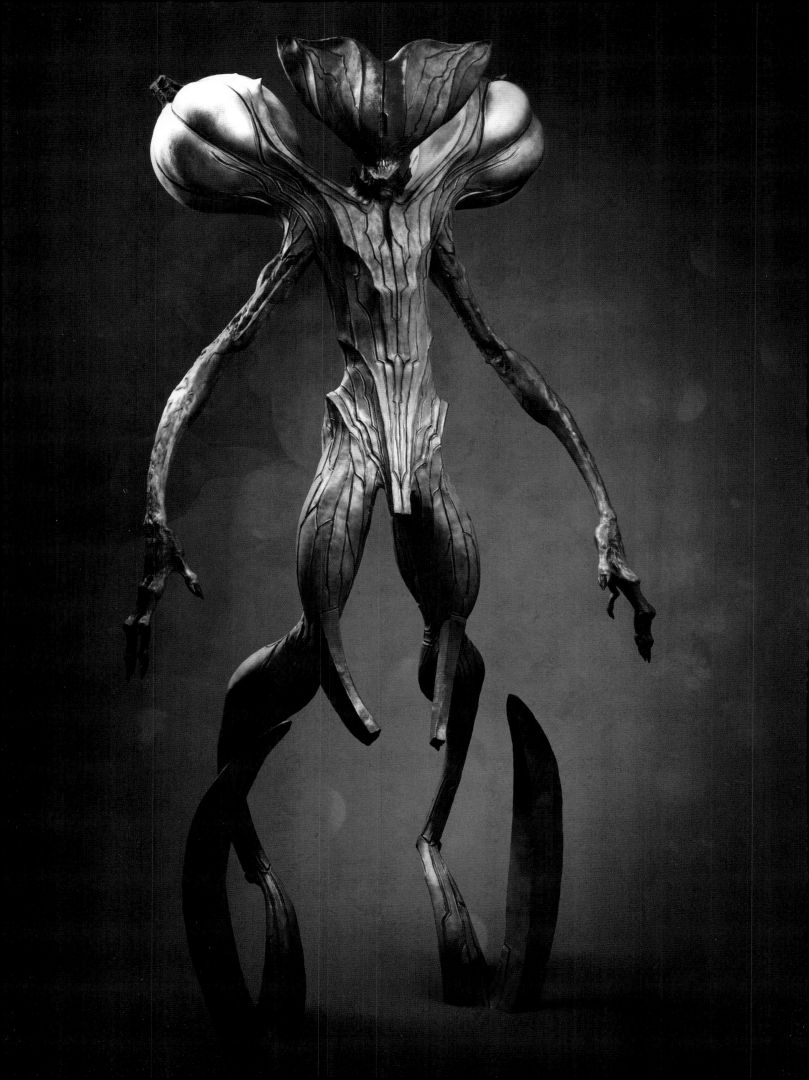

Creatures

Part 05: Discover the ZBrush and Maya workflow

By Zsolt Vida

Character Modeler at DIGIC Pictures

In this tutorial, I will work through my usual creature creation workflow – just one of the possible methods of creating a character. I use ZBrush for the basics of the model: For making the concept, texturing, and also for making the UV of the model. Then I continue with Maya, where I compose the final image and render it with V-Ray. Finally, I work through the post-production in Photoshop, where I correct the colors and piece the several layers together.

01 Setting up the concept in ZBrush

The first step (just after having the idea) is to shape the character, so that we can work out all of the dimensions. By doing this we're able to see whether the appearance of the character is working or not.

For me, the simplest way to set up the concept is by shaping it with DynaMesh (Tools > Geometry > DynaMesh). This program is a dynamic and fast-working one, and what's more, if there's something wrong with the model, we can change it easily.

I start with a sphere and shape it into the form of the model by masking and using the Move tool and Move brush. As I give new details to the character, I recalculate the mesh according to the value of the resolution still in DynaMesh. The bigger the number is, the more polygons we'll get.

02 Retopology with ZRemesher

Now it's time to optimize the mesh. DynaMesh is suitable for reaching those higher resolutions; however, after a few million points the model may become untreatable (the lack of memory can cause the program to crash). In this case, I use ZRemesher (Tools > Geometry > ZRemesher), which is an auto-retopology tool in ZBrush.

First I duplicate the model. This step is important, and if you forget about it you may lose the concept.

↑ Using DynaMesh is a simple way to set up the concept and change things 01

On the duplicate, I draw the directions with the ZRemesher Guide brush – the topology will follow these lines. Now I can just click on ZRemesher.

03 Projecting the details over the new mesh

Now that the low-poly mesh is ready, details have to be projected from the high-poly version. ZBrush offers you a simple solution for this. First, ensure both of the high- and low-resolution meshes are on show in the SubTool menu. The eyeballs should be undercover. After checking this, mark the low-res mesh, then go to Tool > Geometry and click on Divide. The next step is to go to the SubTool menu, click on Project > Project All. Repeat these two steps until all of the details are in low resolution.

↑ The new mesh requires less effort from the computer, which makes the subsequent steps easier 02

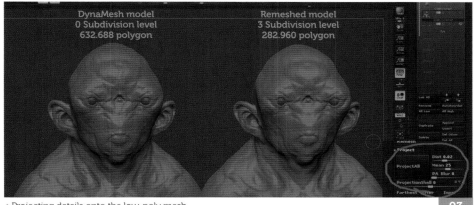

↑ Projecting details onto the low-poly mesh

03

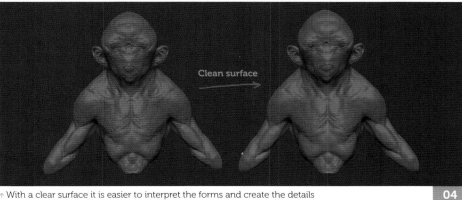

↑ With a clear surface it is easier to interpret the forms and create the details

04

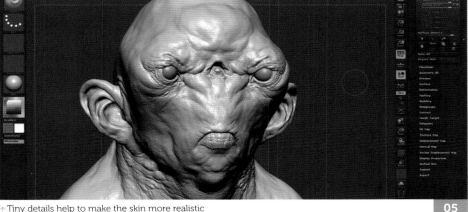

↑ Tiny details help to make the skin more realistic

05

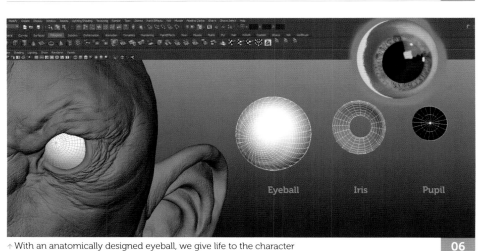

↑ With an anatomically designed eyeball, we give life to the character

06

04 Refine the main forms

After projecting the details over the new mesh, I observe that the surface is still obscure – this is because the concept was just a basic sculpt. As a result of this, I need to clean the surface, re-interpret the forms, and also emphasize the important ones.

For this, try to work with the lowest resolution. Any of the brushes will do; remember that pushing the Shift button means the program switches to the Smooth brush.

The basic Z Intensity is 100 but if it feels too much we can switch to a lower one by holding down the Shift button. Move along the surface and remove the grooves and the prints of the brush, keeping the forms whole. If it's necessary, I use the Dam_Standard brush to emphasize the basic form.

05 Detailing of the character's skin

I can now continue adding details to the skin. First, I make the model's subdivision value higher, so the tiny details show up. Then I create some layers for the different types of detailing: One for the wrinkles; one for the pores; another one for the bumps; and one more to determine the surface's direction.

I use various brushes made from the Standard brush. You can choose the Standard from Brush Types and Spray from Stroke, depending on what you need it for. We can choose from Alphas, too. I don't use them for the wrinkles and directions though, because I prefer to draw those myself with the Dam_Standard brush, as if I were using traditional sculpting techniques.

06 Creating the eyeball

I then start to create an eyeball using spheres. The eyeball is a tender spot that we need to take care with, as we usually say that the eyes are the window to the soul – so don't cut corners here.

First, export the head from ZBrush in OBJ format, and import it into the Maya scene – this way the eye can be manipulated until it's in the correct position. I make the eyeball in Maya by poly-modeling from primitives. Starting with a simple sphere, I make the eyeball itself; then from a Torus I create the iris. The pupil is made using the top of a sphere. All three components are then given a UV.

When I'm done, I export the whole eye and start to paint the textures.

"Polypaint is a great method when applying these textures"

07 Texturing with Polypaint

The next step is to create the texture of the skin and its material features. We need to decide the color textures that determine the color of the skin, the subsurface scattering (SSS) texture which refers to the color of the layer under the skin, and the specular and reflection textures which are responsible for the sparkling and reflection of the skin. The specular map is a black and white map; the brighter color results in more sparkling, the darker in less sparkling.

Polypaint is a great method when applying these textures. Starting with a white substance, I choose a basic color for the model, then in

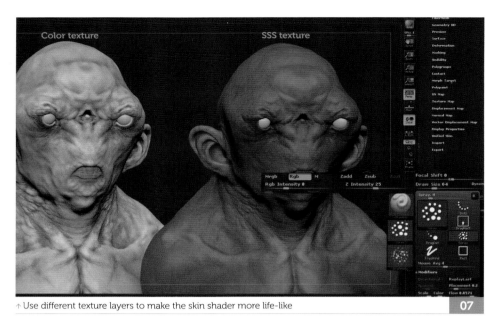

↑ Use different texture layers to make the skin shader more life-like

07

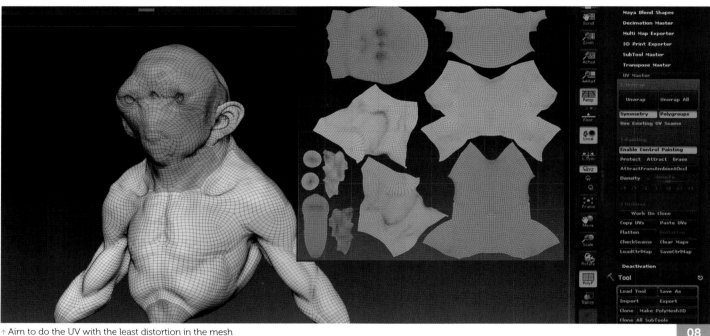

↑ Aim to do the UV with the least distortion in the mesh

08

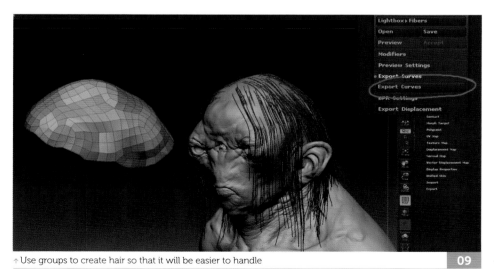

↑ Use groups to create hair so that it will be easier to handle

09

the Color menu use FillObject. I also make a specific brush with low Z Intensity for painting.

08 Creating UV

To be able to use the textures in other programs, I have to create a UV for the model, which will store information about the colors. Switch into the lowest subdivison, then click on Work On Clone in the ZPlugin > UV Master.

Divide the clone into groups, according to where you want the UV seams. I permit Control Painting then paint the whole model in red – this will protect polygons from distortion. Use blue by clicking on Attract to draw out where

↑ Export the textures in order to make the creature editable in other programs

10

you want to cut the UV groups – for example along the arms. Check the Symmetry and the Polygroups opportunities, and then click Unwrap. On the Clone options, use Copy UV, then go to the original model and click on Paste UV.

09 Create hair and fur
Hair and fur give extra details to the model and also provide more character. First, create a scalp on the model's head where you want the hair to be. I would suggest that this scalp is divided into groups in order to make the hair creation easier. For creating the thickness, length, and density of the hair, I like to use ZBrush's FiberMesh because of its simplicity.

I mask the scalp and choose a scheme from LightBox (Tool > FiberMesh > LightBox > Fibers). I set the proper position of the hair with different Groom brushes.

I use only a few hairs at this point, because these are only guides – the final hair will be made with Shave and a Haircut in Maya. The fur is created with the same method, but instead of the scalp I mask the character's mesh, then export the guides in Curve format.

> "A pixel resolution of 4096 × 4096 is usually enough for a texture map, but feel free to set a bigger or smaller size, if you think it's necessary"

10 Creating/exporting the maps
After I've done all the texture maps (like Color, SSS, Specular, Reflection, and so on), I have to export them in a 2D format, so that other programs can use the image.

First, set the size of the Texture Map (Tool > UV Map). A pixel resolution of 4096 × 4096 is usually enough for a Texture Map, but feel free to set a bigger or smaller size, if you think it's necessary.

Always generate a Texture Map for textures that are painted with Polypaint as well. The Displacement Map and Normal Map can be counted in a separate menu.

When these are complete, clone them and then flip them vertically. Choose the Map option in the Texture menu, then click on the Flip V button. Finally, export and save, and then save the model itself.

✅ Top Tip
Always use layers
Let's take a closer look at the face. It has millions of tiny details such as wrinkles, pores, and surface directions. Use different layers to make these individually – this will save us from a lot of stressful moments later on. As a simple example: If you want to modify or delete wrinkles, you won't lose the pores around it if they are on a separate layer. In addition, you can also change the intensity to make it work with other details, so take care to put everything in the proper layer.

It's also a good idea to work in Recording mode. This method is useful during Polypainting as well, but here we can create and blend shapes, and pose the model, too.

↑ The correct use of layers makes it easier to modify or delete areas or details

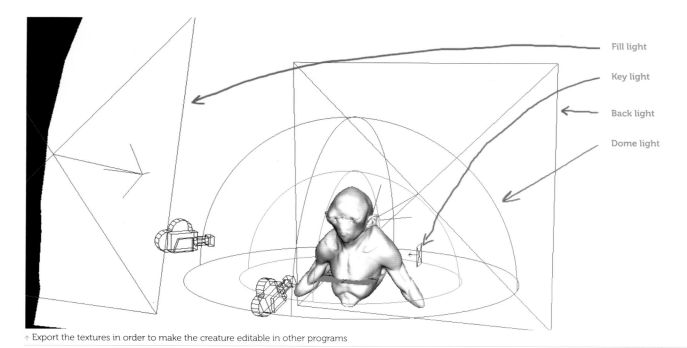

Fill light

Key light

Back light

Dome light

↑ Export the textures in order to make the creature editable in other programs `11`

11 Scene and lighting

Making sure that the scene and lighting work harmoniously is a really important step in presenting the character and giving an atmosphere or spirit to the image. With different camera views we can create a certain dynamic, and adding lights gives mood, tone and a little personality to the model.

First place the model in the scene, and then, if necessary, resize it according to the program's measurements (which is important because of the resolution of the shaders).

Place lots of cameras in the scene to show as many views of your model as you can. I usually use more lights as well, as I have done here (see image 11).

I place the following in my scene: A V-Ray Dome Light (with an HDRI texture because of the reflection), a V-Ray Rect Light, and a traditional three-point lighting system with a back light, key light, and fill light. I then use the V-Ray IPR render to set the lights in real time.

12 Shaders

I now have a character with nice lighting, but it's still just a piece of clay. Since I want it to be a flesh-and-blood character, I have to work on the skin with the Texture Maps I created earlier.

I do this in Maya, where I go to Menu > Window > Rendering Editors > Hypershade. You'll find a lot of materials here, and so the only task

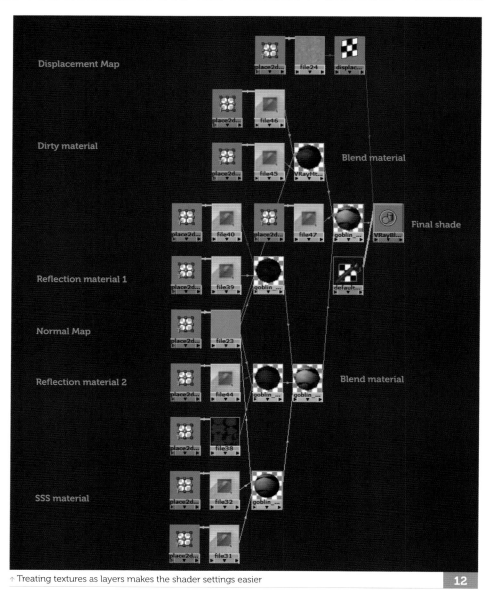

Displacement Map

Dirty material

Blend material

Reflection material 1

Normal Map

Reflection material 2

Blend material

SSS material

Final shade

↑ Treating textures as layers makes the shader settings easier `12`

for us is to choose the one we need. This time it will be VRayFastSSS2 and V-Ray Mtl.

Load the texture maps to the chosen material slots, then decide on their attributions – for instance, skin, dust, reflection, and sparkling. I also use some V-Ray Blend Mtl to melt the different featured materials together. It's a really useful tool, and a simple way to control and mix the materials' features and textures.

13 Creating hair and fur

I'm now going to add more characteristics to the model, such as detailed hair and fur on the surface of the skin. For this, I use Shave and a Haircut. This program needs some practice when you first start, but once you learn to handle it you can create pretty awesome hair shaders, styles, ringlets, flyaway hair, and so on, that really add believability to your model.

First import your FiberMesh guides from ZBrush. Now mark out those polygons that replace the scalp and create one or more hair systems (Shave > Create New Hair). In the Attributes Editor we

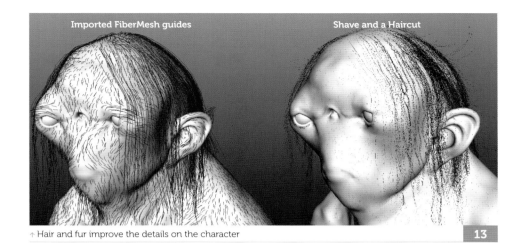
↑ Hair and fur improve the details on the character 13

are able to change some of the settings, such as Hair Count, Scale, Thickness, Shader, Density/ Cut map, and more. Feel free to try everything!

14 Render settings

A few words about render settings. I use V-Ray to create my picture because it can be used easily and quickly, and produces a nice result. I create render layers during the final composition in order to separate the layers

like Specular, Reflection, Diffuse, GI, AO, and so on – this keeps the quality of the picture under my control (to find these settings, head over to Render Settings > Render elements).

I choose to use Global Illumination for lighting the more life-like models and scenes, so that the model will get the light not only from the light sources, but also from reflections on any surrounding objects.

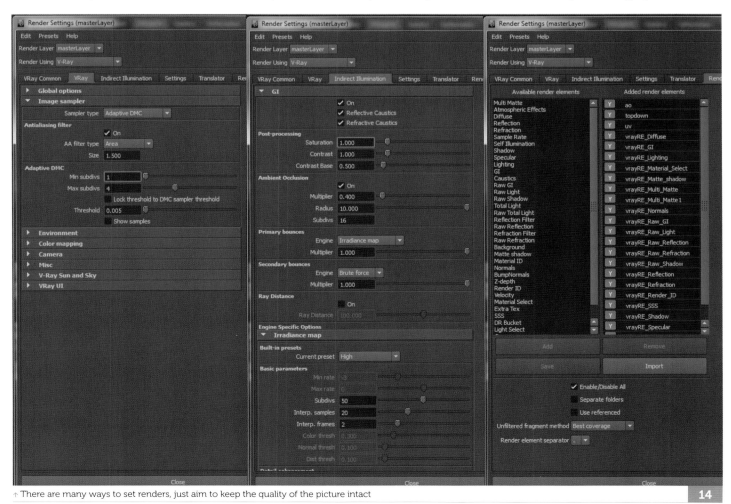
↑ There are many ways to set renders, just aim to keep the quality of the picture intact 14

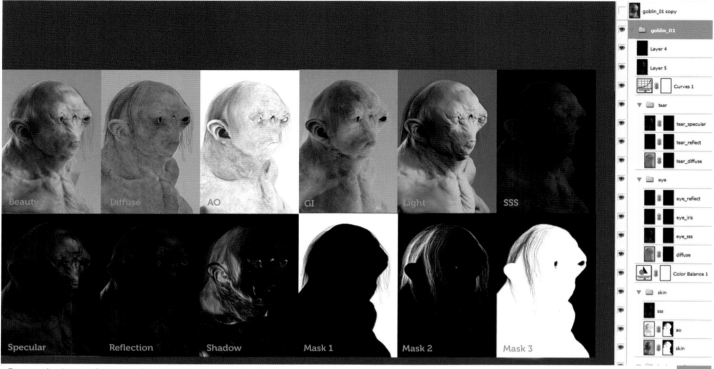

↑ Post-production results in grandiose changes compared to the original render

15

> "With different masks we can separate parts of the character into sections, such as the hair, fur, eyes, or skin, and modify them from layer to layer"

With a higher subdivision value, the detail in the image will be clearer, but it will increase the render time as well.

15 Finishing touches in Photoshop
It's now time to set up the post-production in Photoshop (you may use other compositor programs if you like). I prefer this software because we can modify and compose the layers separately in order to fine-tune each individual element of our model to our specific needs. These settings can be, for example, color correction, depth and sharpness, intensity of lights, background, foreground, and so on.

With different masks we can separate parts of the character into sections, such as the hair, fur, eyes, or skin, and modify them from layer to layer. We can then build up the model's skin in a logical order, and give the eyes, fur and hair any extra little details.

The only thing remaining is to save the image out and add it to our portfolio! The images to the right show some camera angle shots of the final model.

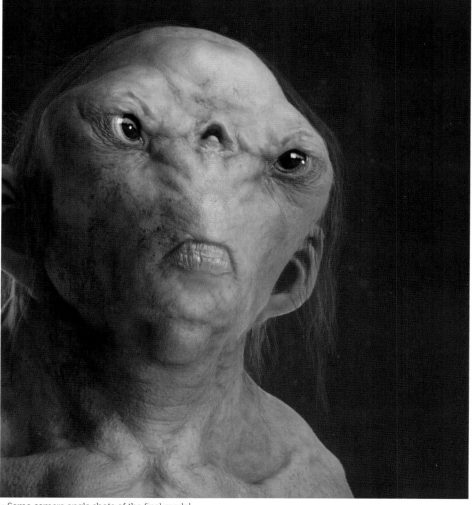

↑ Some camera angle shots of the final model

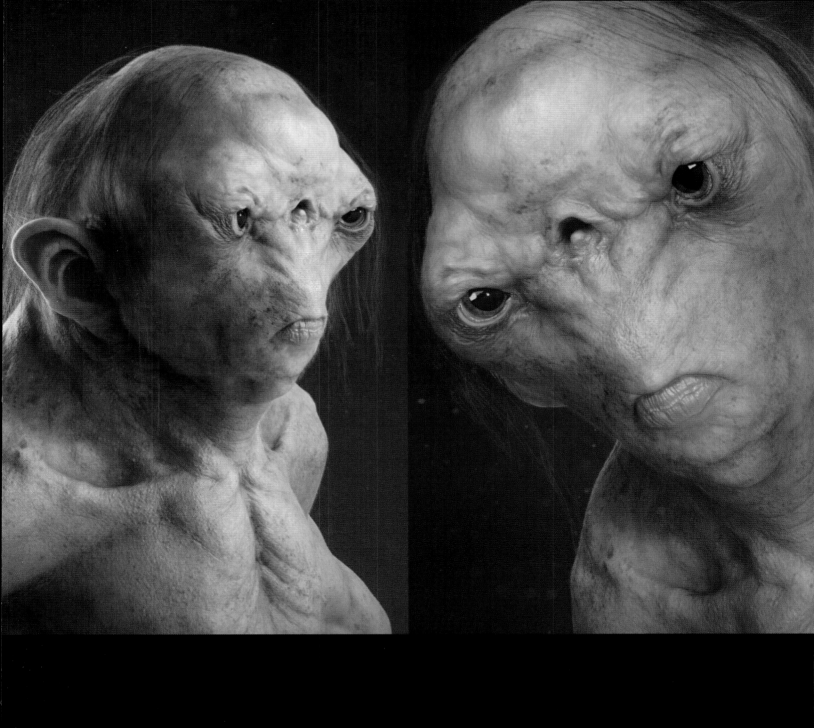

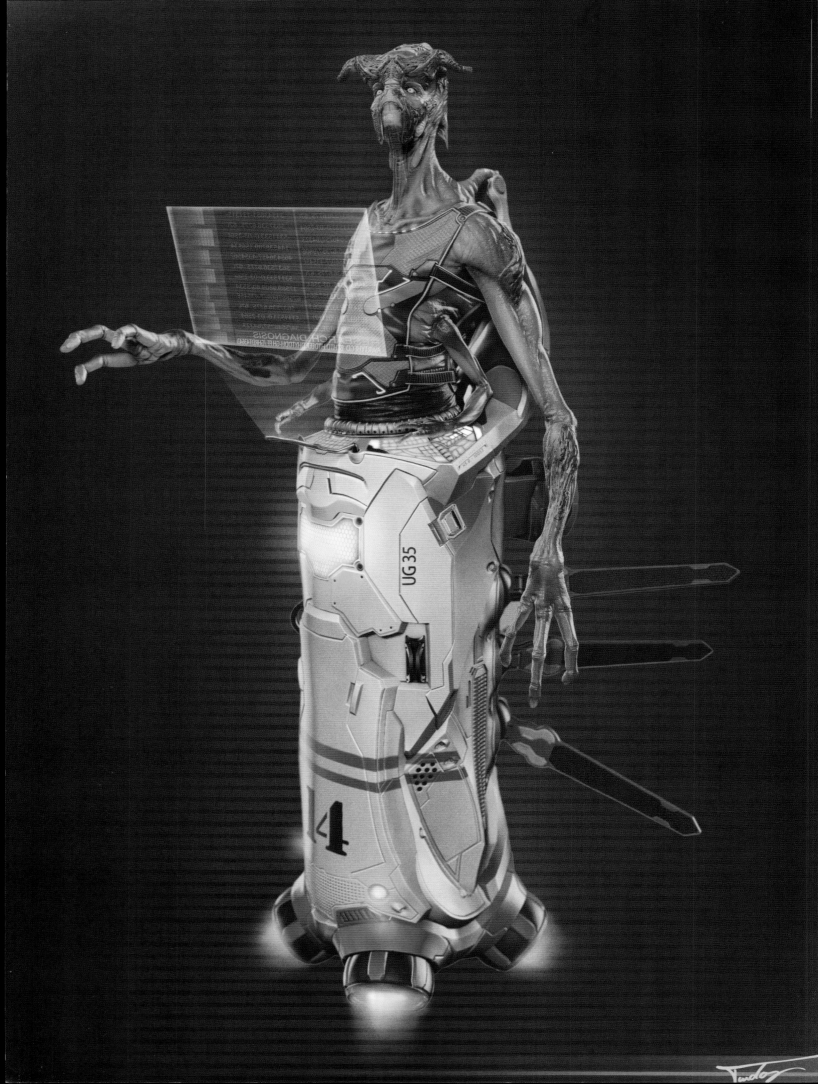

Aliens

Discover top tips for creating your own ZBrush aliens

No ZBrush creature guide would be complete without a series on creating one of the most popular character elements of a sci-fi scene – the alien. The next set of tutorials will take you through the creation of four different alien species from the minds of top digital artists such as Caio César, Maarten Verhoeven, and Tudor Fat. Each tutorial takes an in-depth look at how to create an original alien design, from concept to final piece, and reveals a mass of techniques to try and ideas to inspire your own otherworldly creations.

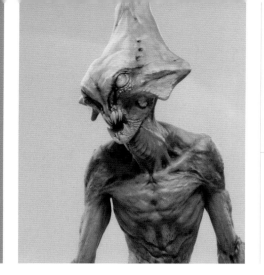

Chapter 04

Aliens

Part 01: Setting up your sci-fi scene

By Caio César

Freelance Character Artist

I will go through my workflow and creation process for creating an alien figure in ZBrush.

The first thing I do before creating a character is look for references to inspire me. This is a mental process: The more you look at pictures, things in nature, movies, and the work of others, the greater your mental reference will be. From there you should begin to gather ideas on how to start modeling your project.

When making a character, it's particularly important to collect anatomy references, both human and animal, so that you can make sure you've got the proportions correct, even when designing an alien like this one.

01 Modeling the form

I start with any polygon shape that has symmetry. In this case I start with a cylinder. Thanks to my reference image sourcing, I have some idea of what I want the final image to be in general (mainly in terms of his proportion and main forms).

I start with the head using DynaMesh. I really like the ZBrush DynaMesh tool. It gives you a lot of mobility and flexibility with the mesh by keeping the amount of polygons balanced so you can move and stretch without losing definition. I use the Move brush to adjust the main shape. I use the Clay, Standard, and Smooth brushes to build and adjust everything else along the way. When I am satisfied with a stage, I re-DynaMesh and carry on working. I also add two new SubTools to the model: One for the eyes and one for the upper teeth.

At this point, I also define his chest. After that I insert the arms and legs with the CurveTube brush. I'm not sure about putting horns in his arms; I think it might be best to remove them because they might not work when

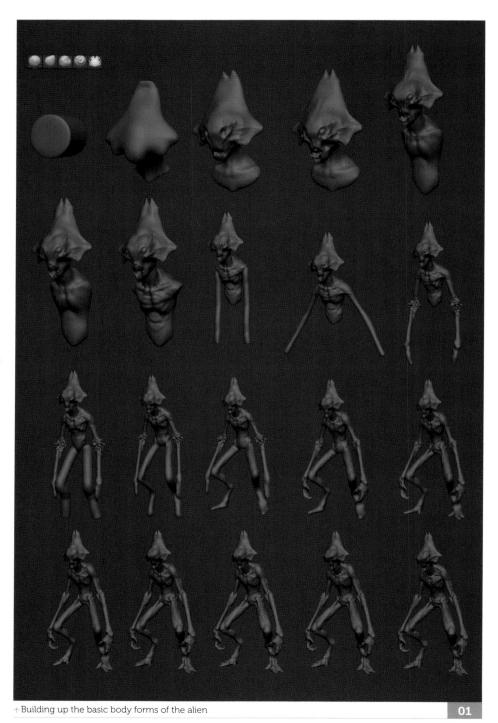

↑ Building up the basic body forms of the alien

↑ Checking the silhouette looks good before continuing with the design
02

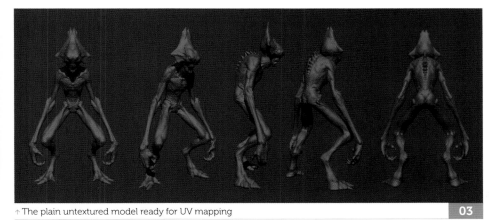
↑ The plain untextured model ready for UV mapping
03

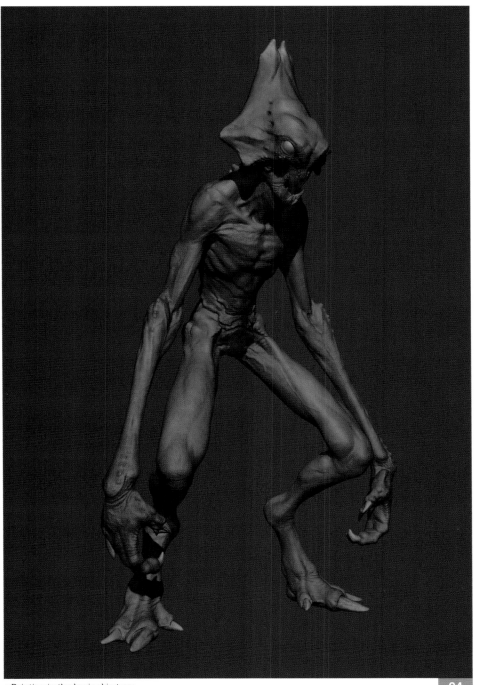
↑ Painting in the basic skin tone
04

the arms bend. It is important to consider a creature's functionality. It may not actually exist in reality, but it must look like it could.

All along the way I continue improving the anatomy by using the Clay brush and the Standard brush.

"It is important that you are aware of this before detailing the model. The silhouette must always be interesting"

02 Silhouettes

Also throughout this process, I use the Flat Color material so I can see how the silhouette is working. It is important that you are aware of this before detailing the model. The silhouette must always be interesting.

After I have finished modeling, I take a last look at the silhouette to check the overall proportions and sizing.

03 Detail

So now I can add finer details such as veins, pores, and scales. As the model will not be animated, I don't see the need to retopologize the mesh; so I just use the mesh DynaMesh generated. My final plain, untextured model can be seen in image 03 above.

04 Adding color

After finalizing the model, I search for some references of fish and lizards to help me paint the model. I thought he might live in an arid environment, so he would always be exposed to the sun and his skin would be darker.

I paint a basic skin tone in ZBrush so that I can roughly define what I want as my final texture.

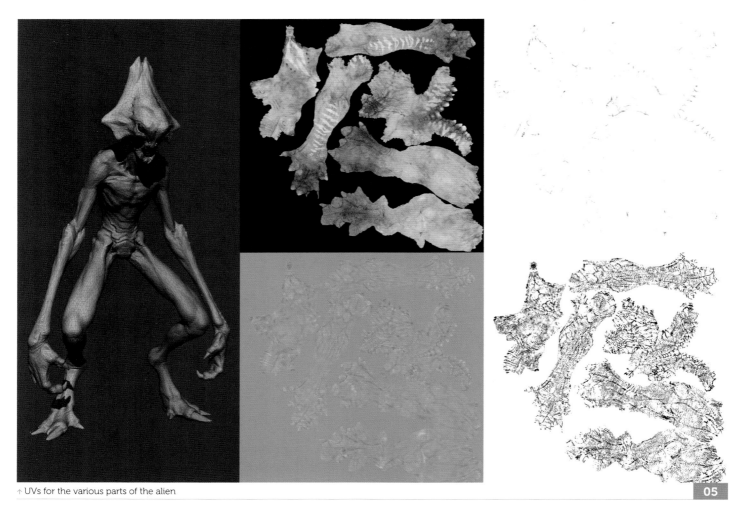

↑ UVs for the various parts of the alien

05

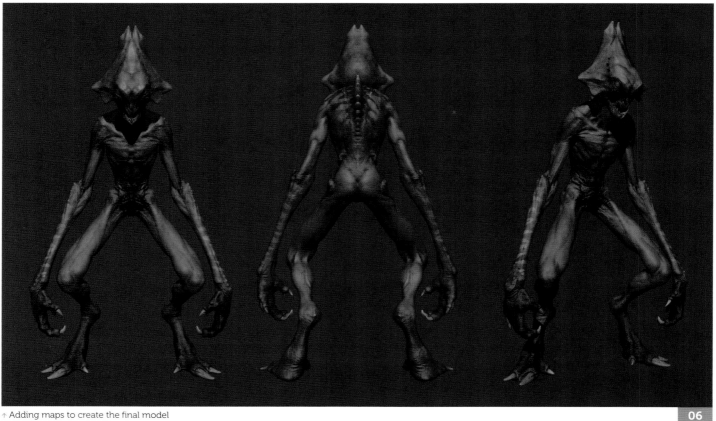

↑ Adding maps to create the final model

06

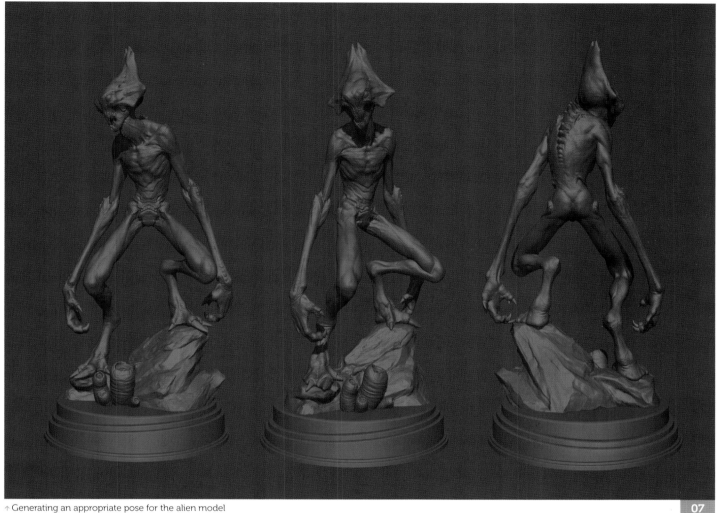

↑ Generating an appropriate pose for the alien model

05 Preparing for UVing

Once I am done with the main color, I divide the model by polygroups so the UV Master plug-in can lay out the UVs through them automatically.

Image 05 shows the various polygroups on the mesh that the UV Master plug-in uses to generate a series of UV maps.

I then work on the 2D maps taken from the model to create the textures I have in mind for my alien creature. In the four squares on the right-hand side of image 05, you can see that the mesh of the arms, legs, and torso of the model have been laid out flat. I use these flat canvases to paint on a series of dirt and skin textures to add realism to the alien.

06 Generating maps

From here I generate Displacement, Ambient Occlusion, and Cavity maps, which will allow me to composite them later, and be able to add more volume and dimension to the texture itself as a result.

"The base comprises a mesh sculpted to look like a natural stone or rock, and I have added several alien plant-like forms around the stone and the base to mimic the natural spread of an alien landscape"

I combine these maps in Photoshop and carry out some color correction in order to make sure that the texture and hues match the overall ideal I have for my alien. In addition, I overlay a metal texture to add some more detail to the painting of the texture.

07 Posing the model

I'm inspired by the poses of some collectible figurines, so I try to make my model mimic these dynamic setups by adding a base and tweaking the general pose of the model.

The base comprises a mesh sculpted to look like a natural stone or rock, and I

have added several alien plant-like forms around the stone and the base to mimic the natural spread of an alien landscape.

These props, when deliberately placed around the base, will also help balance out the composition of the model itself.

To pose the model, I use the Transpose Master plug-in for ZBrush. I pose the model by putting smooth masks through the joints so I can move and position each of the limbs and main body parts smoothly.

There's always a requirement to make some corrections after moving and posing the model. Adding wrinkles in the areas of heaviest contact will help support the illusion that this is a real figure.

At this stage, I also check how the silhouette is working in order to make sure the proportions are correct.

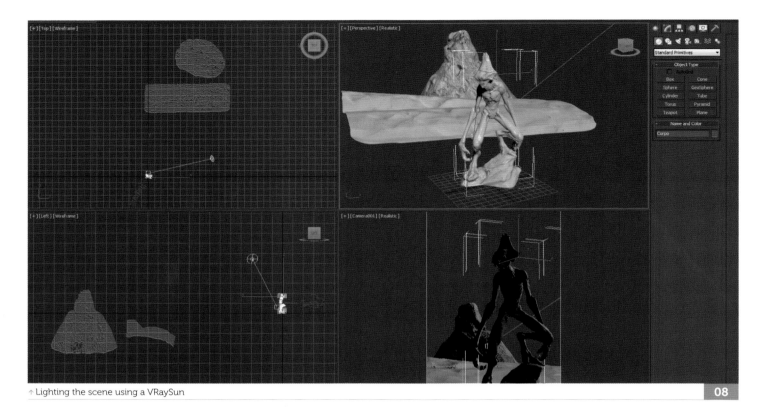

↑ Lighting the scene using a VRaySun

08

"Here I create some specular, falloff, and light passes from my 3D file"

08 Lighting the model

I model some elements of the scenario: The stone where the alien is, the mountain, and the sand layer. All the background modeling is meant to work for the camera only, so I don't bother to do more than I should.

Then I create a decimated version of each object in order to manipulate them in 3ds Max. I use VRaySun to light the whole scene. I also add some lights around the alien to make him more distinguishable from the background.

09 More render passes

I then do some separate render passes to help me with the compositing. I start collecting all the render passes into Photoshop and combining Photoshop blending modes and other effects into the image to create the final atmosphere I have in mind for this scene.

For example, here I create some specular, falloff, and light passes from my 3D file. For these I then usually use Screen or Overlay blend modes in Photoshop. For the Shadow and Ambient Occlusion I use the Multiply blend mode. A selection of these passes I create can be seen in image 09.

I then compile all of these render passes together into one file to create the final scene for the alien.

10 The final image

To finish, I do some color correction and contrast adjustments over the top of the composited layers, and use a map to create the Lens Blur effect.

For the background image, I use an image of a rocky environment, and also apply some smoke particles and dust to create a more 3D, realistic background scene for my alien.

Finally, this image shows my model with a basic render and lighting setup.

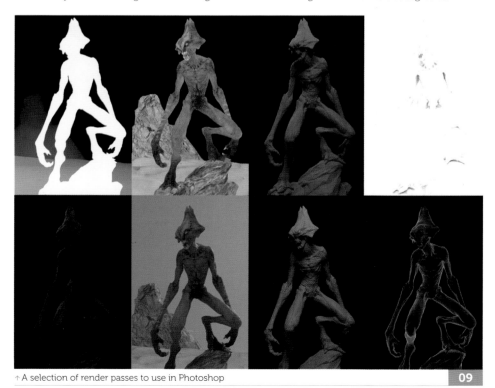

↑ A selection of render passes to use in Photoshop

09

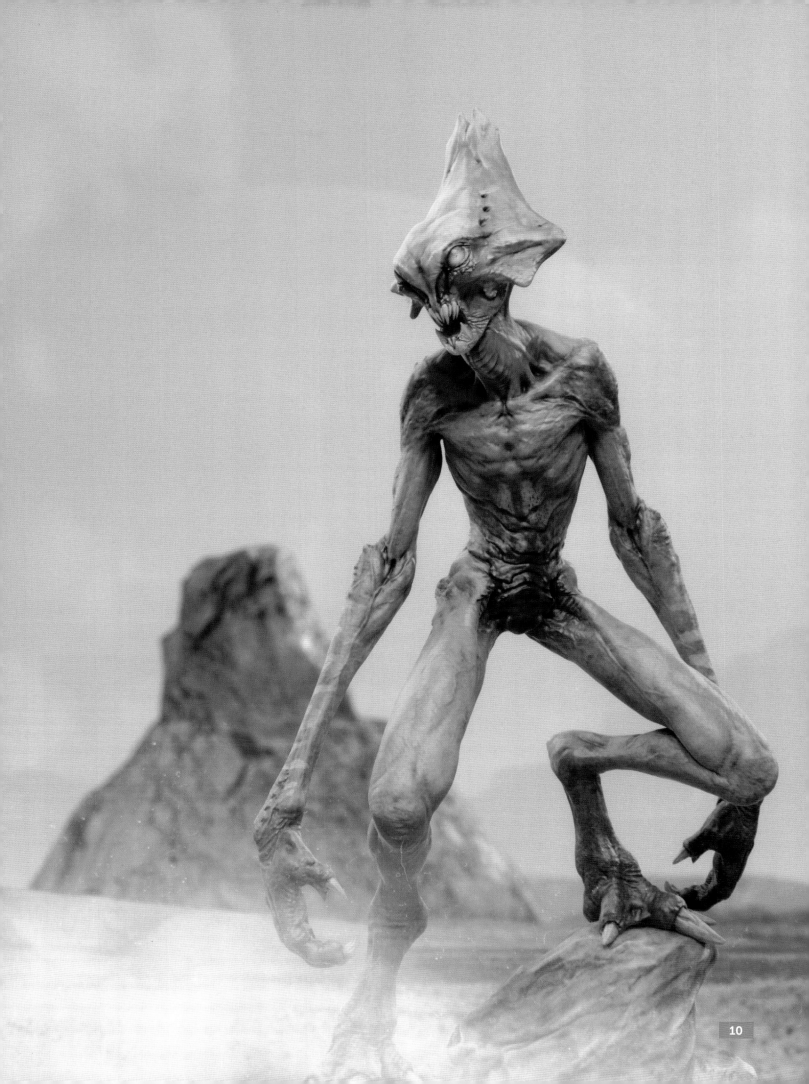

Chapter 04

Aliens

Part 02: Professionally present a portfolio piece

By Kurt Papstein

Freelance Concept Artist at Bad Robot

The process of creating interesting creatures and character concepts is getting easier and easier it seems, and the tools available to us are helping by allowing us to focus primarily on design, and freeing us up to portray what is in our head more quickly to our audience.

My goal with this tutorial is to complete a high-poly creature concept that can be delivered as a working asset in the production pipeline. The more ideas you are able to communicate with a concept, the clearer the message is. This is why I will be using tools such as ZBrush and Photoshop to create my ideas.

Rather than focusing on the idea itself, I want to run you through the process of finishing your ideas, and presenting them professionally. By keeping the process modular, we will be able to produce a handful

of images from the same assets, providing a more complete look into the character's design, using a high-poly model, textures, lighting, and rendering with materials. We will then finish with compositing in Photoshop.

I'm writing this tutorial assuming you have some basic knowledge of ZBrush (navigation, UI, how it operates, and so on), as well as Photoshop. I will keep a few things brief, as there is plenty of free information that goes into more depth about many of these features at www.pixologic.com. I want to make sure you are shown the overall process, which allows me to share the more artistic thoughts and techniques with you. So let's get started!

01 Armatures
To start our character, we need to begin with an armature, which is the frame around

which a sculpture is built. There are so many ways to begin this and we have tons of tools at our disposal. The important thing to remember is that with features like DynaMesh we can change *anything* in our design.

To create this armature, I'm using ZSpheres to create a simple structure that represents the character. By selecting the ZSphere in the Tool palette and using the starting sphere as the pelvis, I begin to draw out limbs and a spine with Symmetry turned on. Using ZSpheres helps us control the big picture and keep our shapes clean.

02 Gesture and maintaining volumes
With the basics figured out, we've reached the point where we can further refine our design. You can see there is a big difference from where we started. To move from ZSphere to DynaMesh, I select Make Unified Skin under

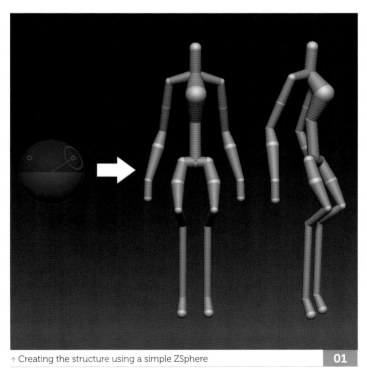

↑ Creating the structure using a simple ZSphere **01**

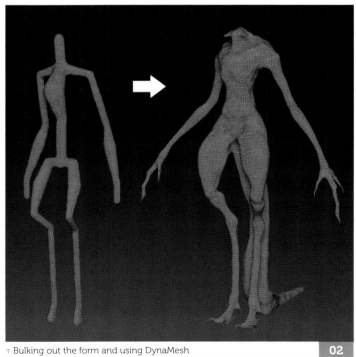

↑ Bulking out the form and using DynaMesh **02**

the Unified Skin submenu of the Tool menu. The Resolution slider will determine how much form is captured. This makes a duplicate version of my ZSphere rig as true geometry.

With that tool selected in our drop-down, we can open the Geometry menu and turn on DynaMesh. I want to avoid DynaMesh destroying my shapes, so in order to maintain thin volumes I need to up the resolution only when necessary.

03 Structure, form, and contrast

Once your design is complete, it's time to leave DynaMesh for good. Any additional details will be added with subdivisions. Think of the design as major, medium, and minor: Major being the silhouette, medium being the muscles, and minor being the small details.

Use ClayBuildup to add volume to the muscles, Dam_Standard for the cuts and recesses, and Inflate to bring it all together.

Avoid making gooey, melting, alien blobs with the use of contrast. When you have a soft form, it is contrasted by a hard form on the opposing side

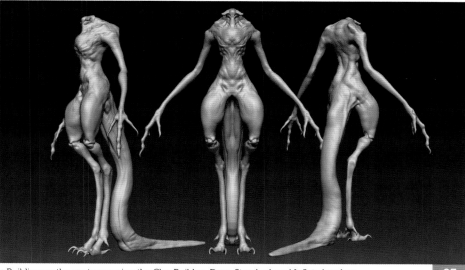

↑ Building up the anatomy using the Clay Buildup, Dam_Standard, and Inflate brushes `03`

of the anatomy. Introducing some anatomical contrast will help your sculpt be much stronger.

04 Details and realism

You should note that detailing is a stage in the process that people can easily overdo. First, we need to decide on at least three types of details we want.

I want this character to have an exaggerated skin feel, so I will use at least two types of skin wrinkle Alphas: One for the surfaces and one for the transitions in between the muscles. The third detail will be veins, done using the Standard brush by hand. Using Masks and their blurring and inverting options will provide interesting locations to place my wrinkles in between the medium shapes.

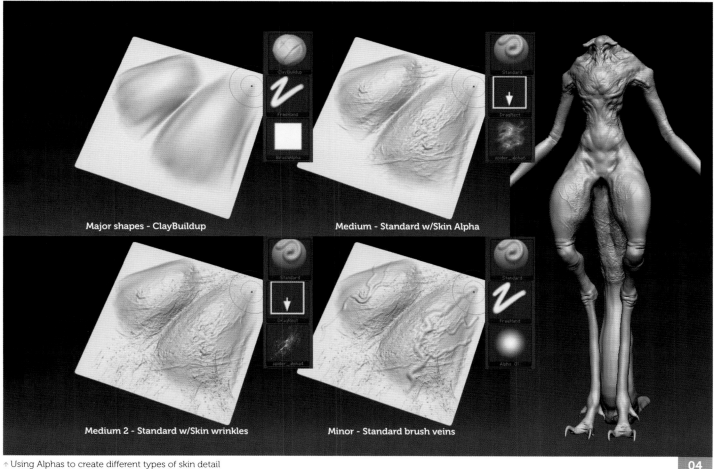

Major shapes - ClayBuildup

Medium - Standard w/Skin Alpha

Medium 2 - Standard w/Skin wrinkles

Minor - Standard brush veins

↑ Using Alphas to create different types of skin detail `04`

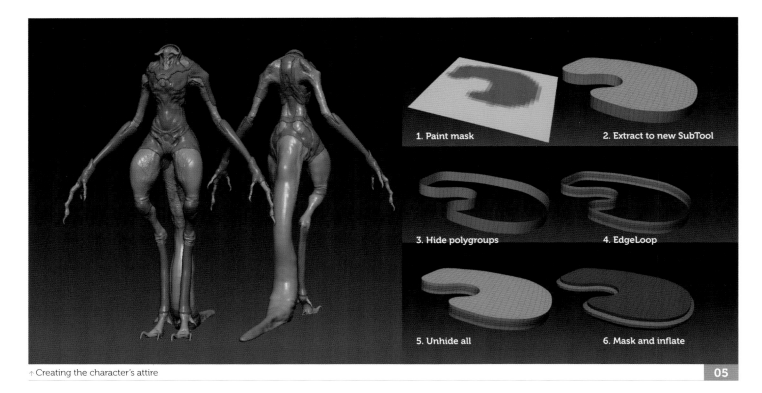

↑ Creating the character's attire

05

"With a good base of clothing on the character, we can now build over these shapes with hard-surface armor structures to create the outer mech suit for our alien"

05 Dressing the character

As our character's anatomy is now complete, we can start building up new meshes over the sculpted form, and work from the inside out to layer up our character's attire.

Through painting masks on the surface of our character's body, we can then use the Extract function in the SubTool menu. You can easily tune the settings to how you prefer them before then clicking Accept and committing to the shapes.

Extract will give you polygroups as well, which will allow you to create additional edge loops to extrude from (using the Move Transpose line, right-click and drag the outer handle to inflate). In this way, you can add nice ribbing to the clothing with an extra detail.

06 Mechanical design

With a good base of clothing on the character, we can now build over these shapes with hard-surface armor structures to create the outer mech suit for our alien.

To start this step, I'm going to append a new primitive PolySphere into my SubTool list. From here, we can use DynaMesh, in conjunction with ClayPolish, to create some nice mechanical, sci-fi-style shapes. I then apply detail to these forms using the Dam_Standard brush

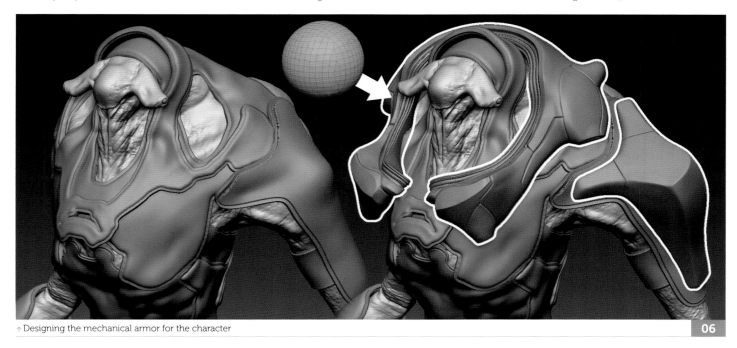

↑ Designing the mechanical armor for the character

06

"Remember to keep the shapes of your mesh simple and clean, and use the Dam_Standard and Hard Polish brushes to sculpt the form"

to cut nice seams and details into the mesh, as well as the CurveSlice tool when working in DynaMesh with Groups turned on.

Additional internal details to the collar are created with the Extract and EdgeLoop technique we used to create the clothing in the previous step. Remember to keep the shapes of your mesh simple and clean, and use the Dam_Standard and Hard Polish brushes to sculpt the form.

07 Mechanical parts

Let's now move on to the medium shapes of the clothing design. I want to create a collection of parts that will be used for the character's suit/armor and mechanical pieces. Working with cylinders, DynaMesh, and radial symmetry, I sculpt out some interesting tech ports. Other more mechanical pieces are created using ZBrush's ShadowBox.

Once you are done with one piece, you can move on to the next one by duplicating it in your SubTool menu and start working on the next design. This will allow you to keep creating new ideas and refining them with DynaMesh, and ShadowBox for the complex shapes.

08 Assembling the pieces

Now we need to turn these sculpted mechanical objects into a brush. First make sure they are oriented properly with the floor grid as a guide for the surface you will be drawing them on.

Make sure your camera is oriented to look down on your objects, and click Create InsertMultiMesh in the Brush menu.

You can now place the mechanical parts on your character and split them into their own SubTool. The final step here is to use the CurveTube brushes to create the various hoses connecting the plugs and ports over the surface of the character's metal armor.

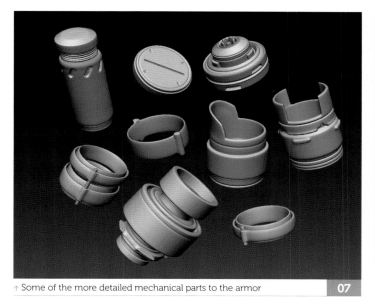

↑ Some of the more detailed mechanical parts to the armor 07

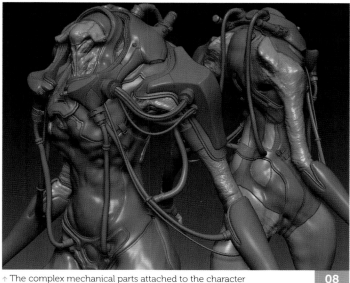

↑ The complex mechanical parts attached to the character 08

✅ Top Tip

Glass in ZBrush

Using the Chrome BlueTint material inside ZBrush, fill a simple DynaMeshed PolySphere sculpted into a dome shape for our alien's helmet. This is the starting point for our glass.

All we need to do now is turn on the Transparency options in the SubTool's Display Properties, under the BPR settings. We also need to activate the Transparency option for ZBrush in the Render settings.

We can then tune how the transparency looks based on surface normals or color in the BPR Transparency submenu.

It's just a matter of knowing where the 'on' buttons are; you can turn any material and SubTool transparent.

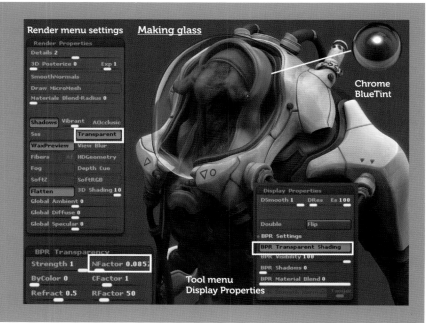

↑ Adding transparent glassy surfaces to the alien character

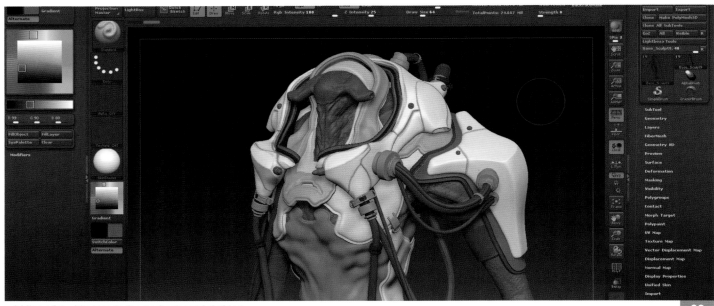

↑ Adding a flat white tone to the mechanics and clothing **09**

09 Flat colors

Now that the modeling stage is complete, we can begin our texturing and Polypaint. I like to start slow and just fill each SubTool with a different color, selecting my color with the Color menu and clicking FillObject while Rgb is activated for my brush. Using the Standard brush with only Rgb activated, and the SkinShade4 material, I can begin painting in my basic tones.

For this stage, I'm not thinking about texture or detail, just flat tones; what are the basic color schemes of this character? I'm also using this time to make sure that I don't make my design confusing with too many colors, and that I control the values.

10 Skin variations

It's time to really make our character dirty and grimy to give it some realism. Again working from the bottom layers out, we are going to add subdermal skin noise to the surface of our character, then later paint over it with the top skin tones.

Colors such as green, blue, and red will be great choices to pepper in some variation. We don't want to completely cover the original color pattern.

With all that down, we can paint in our dermal layer of color by eyedropper-selecting (holding the C key) and painting in the original color. Don't be worried if your colors stray from the original tones; we want some variety and messiness.

11 Masking and texture

To enhance our textures and help our forms from the sculpt pop out more, we are going to use the masking tools to control where we paint our color tones. Just as before, I will be using Mask By Cavity, Surface, and PeaksAndValleys to generate interesting patterns. Blurring the mask, inverting it, and growing it will allow me to control where I

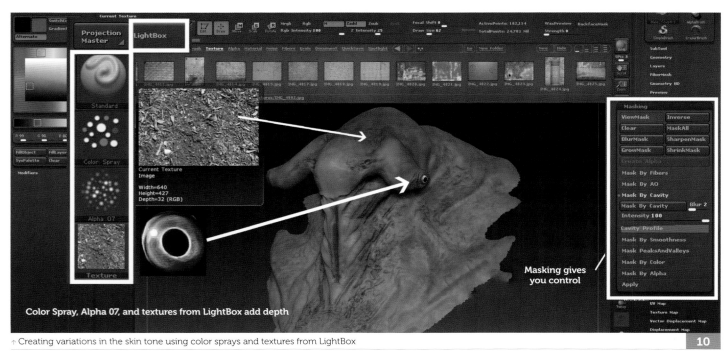

Color Spray, Alpha 07, and textures from LightBox add depth

Masking gives you control

↑ Creating variations in the skin tone using color sprays and textures from LightBox **10**

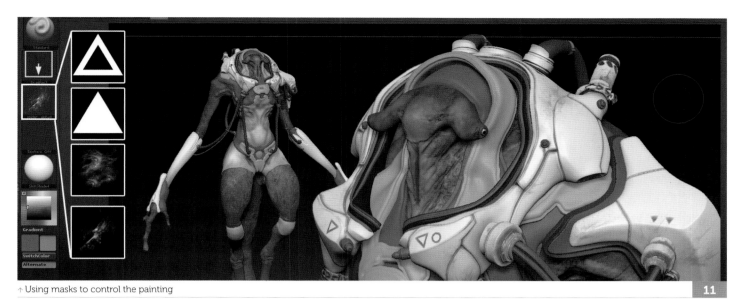

↑ Using masks to control the painting

11

↑ Creating an appropriate lighting setup

12

↑ Making a series of custom materials for the wet/dry areas

13

lightly paint in darks and lights on my character. Using custom Alpha shapes, I can also place decals and scratches on the hard-surface areas.

12 Lighting with LightCaps

Now it's time to make it look killer. Open the Lights menu and open the LightCaps submenu. Turn off the one Standard light by clicking its icon at the very top of the Lights menu. Your model should look almost black.

Open the Background submenu and click the image thumbnail; here you can load an image to act as both a background and a light source. Click Create LightCaps. You will now see your model lit and your preview LightCaps window filled with lights. You can select each light with the Light slider and adjust each of them to your liking. You can also turn off the background from being displayed.

13 Custom materials

Until now we've been working with the skin shade material to Polypaint and light our character because it is such an easy and simple material to use, and allows for a lot of customization.

To start customizing the materials, we need to fill all our objects with this material by selecting M for our brush settings, turning off Rgb, and then using Color > Fill to fill the SubTools. To create additional materials, copy the desired material and paste it over an unused material. I've made two, adjusted their specularity for dry and wet, and filled the desired SubTool with it. You can also paint the material in specific locations with your brush. Be sure to save your materials out!

"I'm going to finish my renders by turning on Ambient Occlusion in my BPR settings submenu, and double the resolution of my document in the Document menu"

14 Rendering in ZBrush

There is so much power in ZBrush when it comes to rendering; you can get a huge range of different looks.

Let's begin this step by starting with the shadows. Open the BPR Shadow menu, and try tuning the Angle and Blur sliders as you test your renders. The Angle will duplicate your lights a certain number of degrees left and right, and create a softer look, while Blur will create a very soft and ambient feel.

Next, we've got the BPR Filters. My favorite is Orton; it allows me to pump up my lights while keeping the shadows dark. I'm going to finish my renders by turning on Ambient Occlusion in my BPR settings submenu, and double the resolution of my document in the Document menu.

15 Compositing and finish

This is our last step. Here I want to make changes to our renders that can be used quickly on any additional renders I make. By exporting the document out of ZBrush, and further adjusting the look in Photoshop by building up correction layers like Curve Adjustment and Hue Saturation, I can easily tune the color of any given value in the image and replicate it on other renders.

Make a merge copy of your character and use Filter > Render > Render Lights, to replicate a top-down spotlight effect or area light, pushing the lights and realism a little more.

If this is too intense, remember you are working with layers; you can simply turn the opacity down. I'll finish the render with an Unsharp Mask (Filter > Sharpen > Unsharp Mask).

↑ Tweaking the render settings to get the right look

14

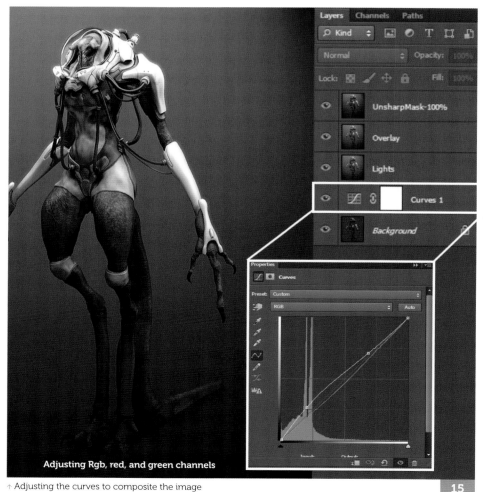

↑ Adjusting the curves to composite the image

15

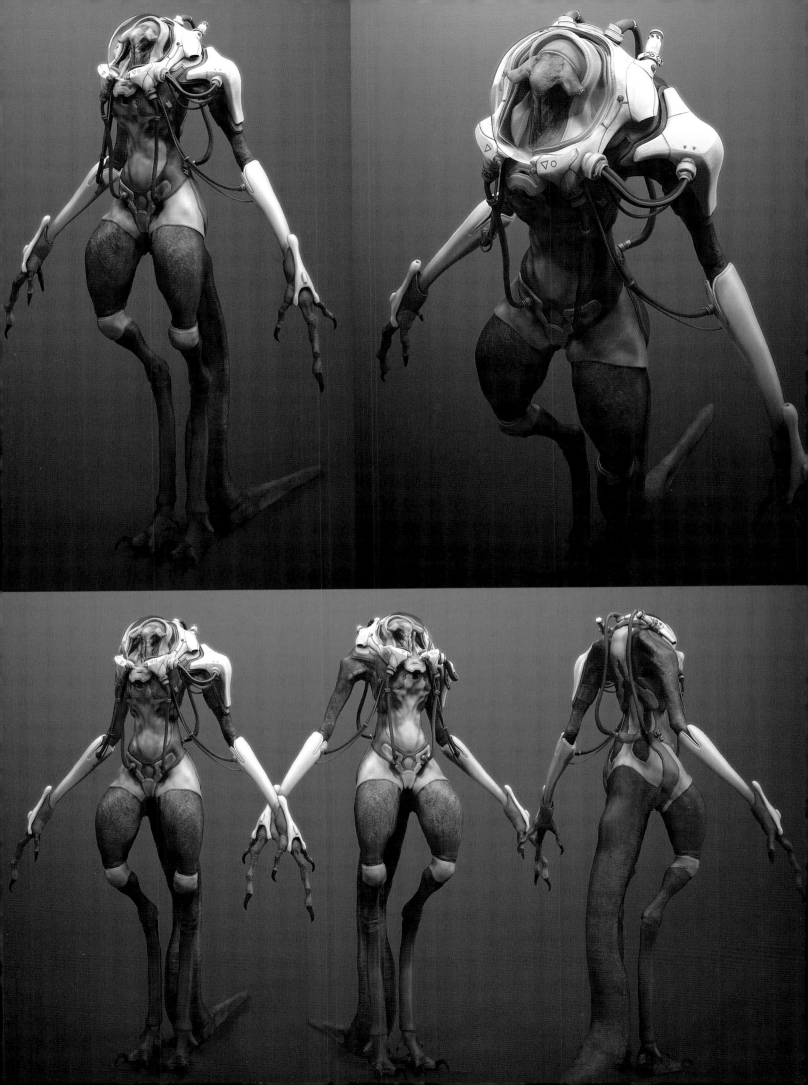

Chapter 04

Aliens

Part 03: Sculpt a four-legged space alien

By Maarten Verhoeven

Freelance CG Sculptor and Designer

I was given complete freedom of design for this project, and had the opportunity to explore any form of alien concept I so desired. So, where to start? My initial thoughts are to try a flower-head-mandible design with four appendages. Nothing too weird, I like to ground my designs in reality…

01 Getting started

I like to create all of my sculptures and designs on the go – I don't make any sketches in 2D first. I love to have the feeling that my design process isn't set at the beginning of a project, and that it can evolve as I go over shapes and forms. You will notice that I keep adjusting parts of my image until the very end. This could be a bit confusing to see in an organic workflow, because I try different things as I go along, but it will give you an insight into how I design creatures in ZBrush.

I should also say that I have a huge library of images and art that I have collected over the years to inspire me. These sorts of things are perfect to use as a reference when you're stuck!

There are two ways to create easy base meshes in ZBrush: Using a ZSphere and using DynaMesh. In this case I've used a ZSphere, as it's easy and fast. All you need to do is draw a ZSphere on your canvas, start editing it (making sure to turn on Symmetry), and start creating.

I know that I want to go in the four-legged direction with my alien, so this is what I've imagined and it should be enough to start with. The shapes will not contain any complex forms, but this isn't important at this stage. Now I can create the Adaptive Skin on my ZSphere rig.

02 Polygroups

You can check the pre-skin by toggling the A shortcut on your keyboard. This will give you a preview of the mesh you will be creating. At this stage you can always refine your ZRig. I've played around with it for a few minutes and am now happy with the result. I go to the Adaptive Skin tab and press Make Adaptive Skin. This will append it into my SubTool.

You'll notice that this creature's base mesh consists of many polygroups. This isn't easy to work with, so I create new polygroups by masking off the pieces that I want to be unified. To do this, I go to the Polygroup tab and select Group Mask/Unmask everything, then do the same for all the other parts. The reason for doing this is that, logically, it's always easier to hide the biggest part of my mesh so I can focus on sculpting when I push in the details.

Keep in mind that the topology for this creature is symmetrical and I will use symmetry over the course of the entire project.

03 General form

To create the general forms, I use the Transpose tool to find the correct proportions, and the Move Topological tool to get individual pieces

↑ Using a ZSphere to create the initial four-legged design **01**

of topology in place. While searching and looking at the model, I also use the Clay and Inflate brushes to define the major shapes.

Posing the creature with the Transpose tool is incredibly easy. Simply mask off a part you want to move, invert the mask and move it.

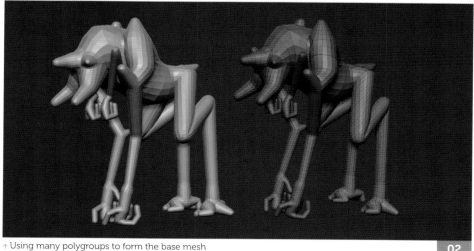

↑ Using many polygroups to form the base mesh **02**

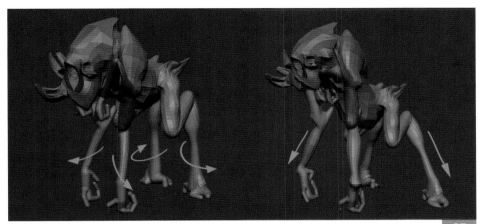

↑ Using the Transpose Master and Move Topological tools to pose the model **03**

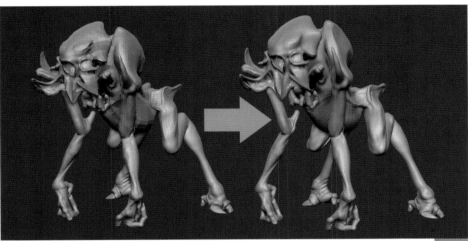

↑ Stepping up the subdivisions to work on the big skin details **04**

When you have a piece that consists of more SubTools, it's easier to use the Transpose Master. This will bring your SubTools back to the lowest subdivision and in one SubTool layer, so you can easily move all the parts in one movement. I use it here on the body and legs.

I adjust the direction of the legs with Transpose and rotate them into a more realistic direction. I keep on looking for the right shapes without stepping up the subdivision level.

I don't like the scale of the head at this point in the process, so I scale it down a bit. The head was actually the thing that changed most in my design. I had more of an alien/flower design idea in my mind, but it took a while until I found the shape. In my eyes, if you don't get your base shapes right in your low-resolution mesh, the final result will not work. For me, it's still a lot like drawing or sculpting with clay.

04 Increasing subdivisions

I step up a subdivision by choosing Divide under the Geometry tab, and then start sculpting. For sculpting at this stage, I use the Standard brush with an Alpha of 38 for punching in the sharper edges, in combination with the Clay brush.

I work specifically on the bigger shapes and masses, and the wrinkles and fat on the body. I also now define more detail on the deformed claws by putting in extra tissue and muscles.

05 Refining the head

While working on the body, I realize I'm still not happy with the shape of the head, so I enlarge it and deform it a bit more by pulling the mandibles open, making the shape of the head heavier and bulkier. I'm also not completely happy with how the shoulders look, so I remove the spikes on the shoulders by pulling them in with the Move Topological brush, and smooth them out.

Next, I start to redefine the scapula with the hPolish brush. I tend to use this brush a lot when I want to roughly re-shape objects in planes or re-design a base mesh.

I also add a base at this stage to help me define the gravity and weight of the creature (checking its natural stance). Later on I'll remove this because I don't need it to create a drop shadow with a BPR, as the floor mode in ZBrush will automatically create this.

↑ Redefining the shape of the head and shoulders **05**

↑ Generally working on all areas of the model with the Inflate brush

06

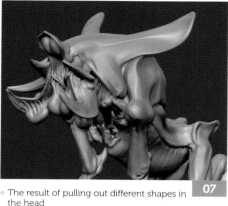

↑ The result of pulling out different shapes in the head

07

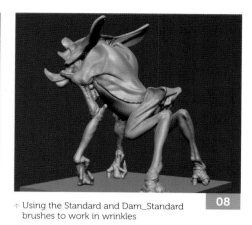

↑ Using the Standard and Dam_Standard brushes to work in wrinkles

08

↑ Twisting the multiple tongue suckers using the Twist slider

09

06 General refining

I keep looking at and tweaking my model from all sides, working on it from back to front and in reverse, with all the standard tools that I use. Turning my Gravity setting to 100 on the Inflate brush helps me to push the wrinkles closes together and allows me to create a heavier muscle weight.

07 Further refining the head

I'm still not happy with the general shape of the dome on the bony head, so I pull out some different shapes to see what would work for me and this creature.

08 Smaller details

Stepping up in polycount is where the fun starts for me. I love to work on details and wrinkles. For larger wrinkles I use the Standard brush with the Alpha 38 and a Strength setting of 30, and for smaller ones I use the Dam_Standard brush, which is an older brush that a lot of people still love to use. It cuts a line/wrinkle in the material, but it also pinches and squeezes the model, which makes it great for detailing.

The tricks I use for detailing skin pores are actually fairly easy. I use a mixture of different things on this model. I use the Displace brush with a

low Intensity (8–15) and some standard Alphas (07, 25, 40, 58) combined with a Spray Stroke.

When I use them, I follow the muscle/skin flow of the creature. I work closely on the surface of the creature to create extra fine details such as veins and little imperfections with the Standard brush.

09 Building the suckers

The mouth is the most important thing for me on this creature; I want to make it scary, horrible, and detailed. To do this, I decide to create multiple tongue suckers from ZSpheres, pose them, make an Adaptive Skin, and detail the suckers. Then I

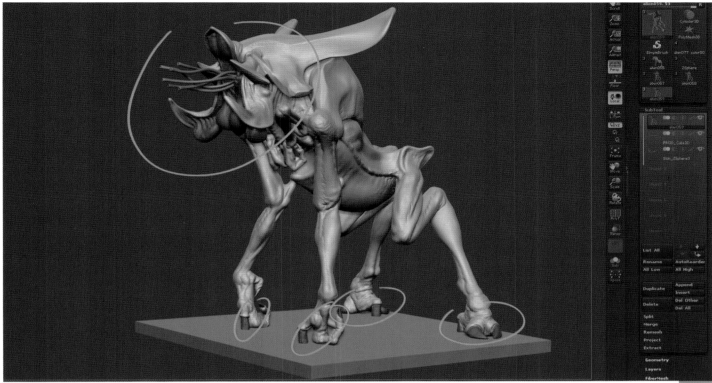

↑ Creating a little more detail using noise from the Surface Editor `10`

↑ Working on the eye-catching detail in the mouth `11`

↑ Adding in a set of sharp, hooked teeth `12`

re-scale them and copy them in a circle. In order to create the overall twist, I use the Twist slider that you can find under the Deformation palette.

10 Adding noise

In a final pass on the body, I mask off the areas I don't want to use, such as the inner mouth and nails, and use a bit of noise with the Surface Editor. I felt that some parts just needed a little more grain on the skin.

11 The mouth

The inner mouth now gets one last treatment. I go in close to the model and use the Inflate brush to create all the little zits, bubbles, and balls on the lip and mouth of the creature. This is fun to do, and I go in close to detail it all. I make sure that I break the symmetry in the details and proportion. I know the mouth will be the 'eye-catcher' on this creature.

12 Teeth

I create some teeth for this creature with DynaMesh and pop them in place (nothing special here!). My idea is that he could catch his prey by luring it in with his phosphorescent skullcap, grabbing it with his suckers, and then using his teeth to keep it locked in his mouth. For this reason, the teeth don't have to be big in scale, but rather look like sharp hooks.

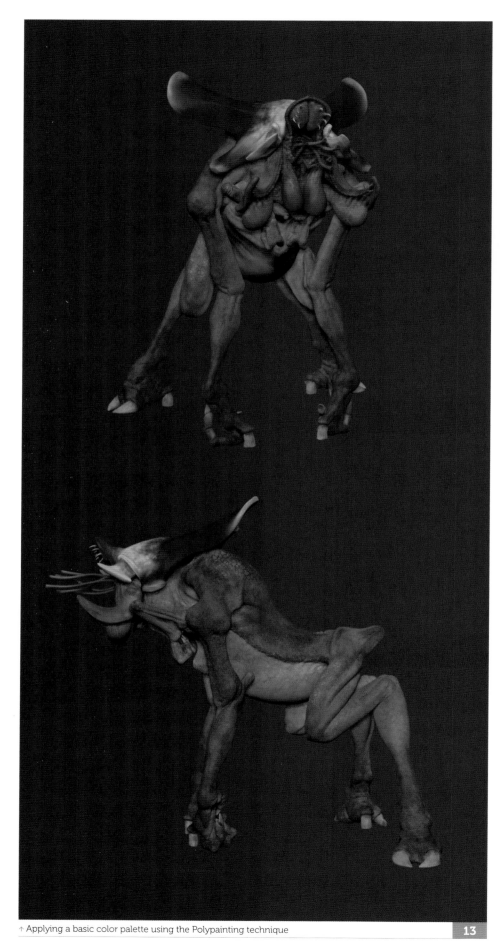

↑ Applying a basic color palette using the Polypainting technique **13**

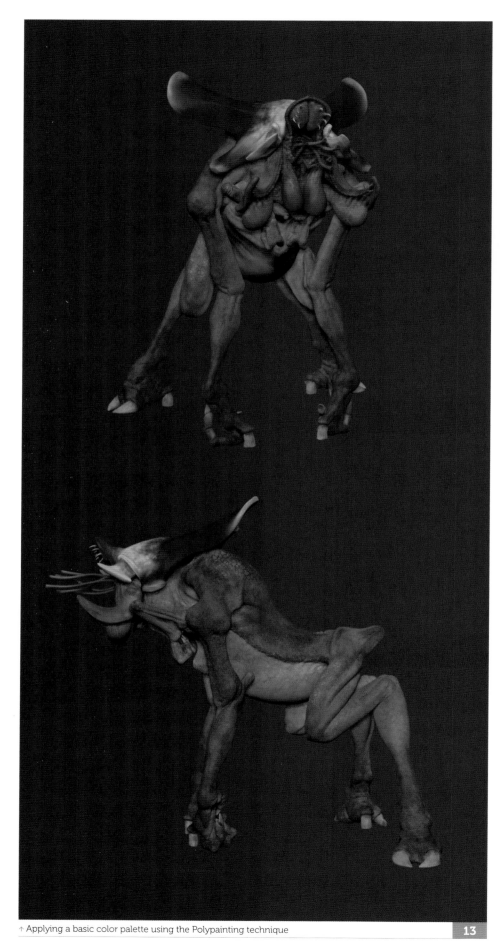

↑ The final Polypainted look **14**

"I fill the whole creature with a base color, and then I start spraying on the colors – like you would paint or airbrush a resin figure. I lay out the base colors and refine as I go further, then start Polypainting my details at the end with finer brushes and cavity masks"

13 Adding color

When I have to color a piece, I usually use Polypaint, but this can be difficult when you have so many options in color usage. To help myself (or to help a Director), I create a color concept that consists of a few renders in ZBrush and then create a paint-over image in Photoshop as a guide; this just allows me to get the look and mood correct for my creatures without spending too much time trying different colors schemes during Polypainting.

14 Polypainting

Using Polypaint in ZBrush is easy! I just start with building up my colors using the Spray brush and the standard Alphas – for example 07, 08, 22, and 25.

First I fill the whole creature with a base color, and then I start spraying on the colors – like you would paint or airbrush a resin figure. I lay out the base colors and refine as I go further, then start Polypainting my details at the end with finer brushes and cavity masks.

Now it is time to crank out some renders!

"In the end, after putting the layers together, I add extra paint work on the background and the creature to give it a bit more of a creepy mood"

15 Render passes

For the final composition in Photoshop, I've provided a small breakdown of the passes that are used for the final image (see image 15). This shows some different Light, Ambient Occlusion, Shadow, and Material passes using the BPR engine in ZBrush.

When I put an image together and realize I'm missing some renders that will help finalize my image, I make some extra material or light setup renders to help me out. It's therefore very important to create a project file of your object/scene. Why? It will remember your exact camera angle and light setup. Otherwise it will be impossible to return to ZBrush again to create extra render passes.

In the end, after putting the layers together, I add extra paint work on the background and the creature to give it a bit more of a creepy mood. I then make a color correction on the entire image to make it all blend nicely together, and I would call it done!

16 The final image

The final image (on the next page) is a concept piece that has evolved during the process. I know this isn't a workflow that will work for everyone, but I like to work without a mold.

It can create some weird and wicked designs if you go with the flow of your imagination during the sculpting process. It also gives you time to learn to know your designs. I can't help it, but I always create a small back-story in my mind for my creations. You do need to have some fun when you're sculpting, after all!

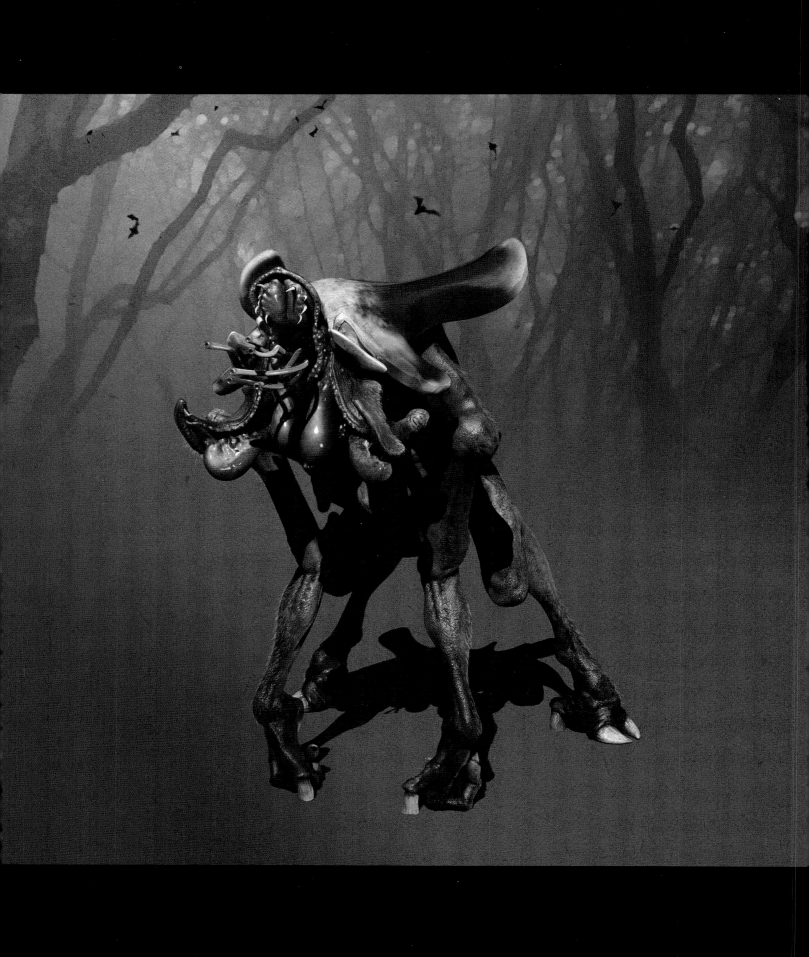

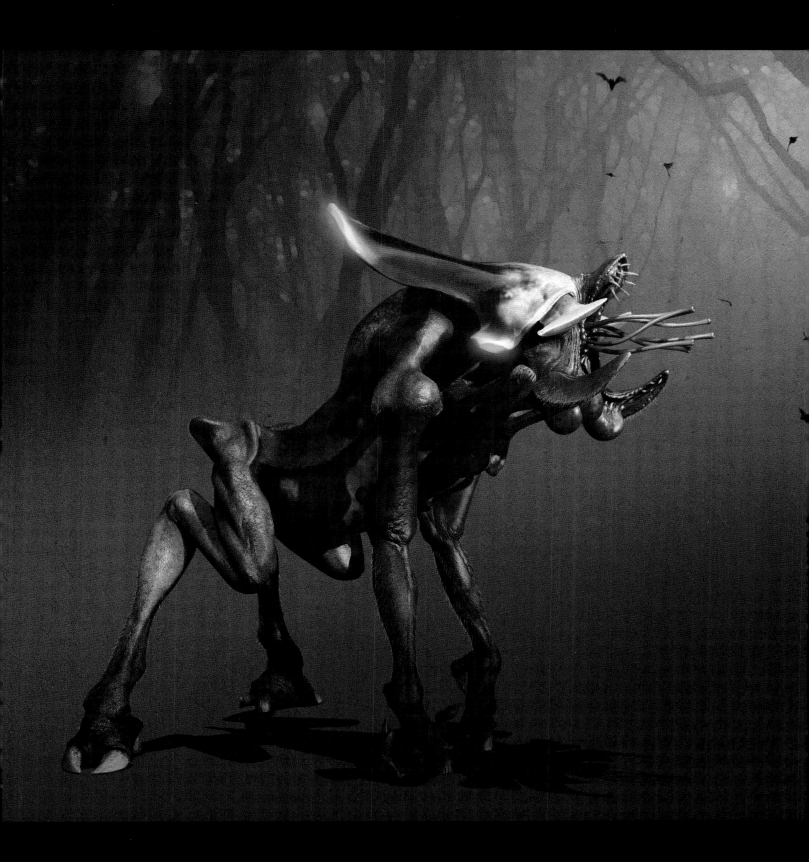

Aliens

Part 04: Create a convincing cyborg alien

By Tudor Fat

Freelance 3D Character Artist

Here I will describe the process I went through in order to make a ZBrush alien character.

The idea for this tutorial was to make an alien character that is technologically advanced and has brilliant abilities to make high-number calculations. His race is not very strong from a physical point of view, so they have to manage in other ways.

I don't necessarily make a sketch before I make the model (although technically that's the 'right' way to do it), because I want to avoid getting stuck or heading in the wrong direction with my creation. Instead, I jump straight into ZBrush and play with the amazing tools it has to offer.

I really enjoy the liberty that ZBrush provides. You can work freely and without hesitation or concerns about the mesh that you work on, which is why for this character, I went directly to ZBrush to have fun with it. I really enjoy the exploration process and I find it to be very rewarding, at least in my case.

01 Starting out

I start out with a simple, primitive PolySphere. Using this sphere means I have the freedom to construct anything and just play with the form as I wish. I choose a basic material, make the base color black, and turn down both Specular and Diffuse to zero so I can see the silhouette better.

I search for a form that I like for my character's head and start pushing and pulling with the Move brush. After I make a few iterations, just with a black color, I return to white so that I can see the shape that I've created. At this point, the mesh doesn't concern me, only the shape and the volume.

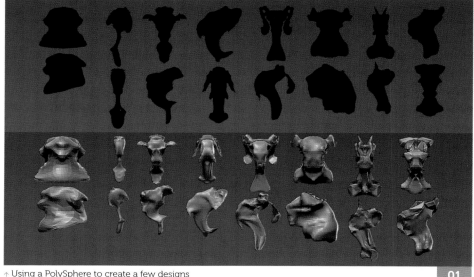

↑ Using a PolySphere to create a few designs

01

↑ DynaMeshing all the designs to refine my choices

02

02 Refine the designs

I look through the designs for something that inspires me – something that has visual potential. I have a vague idea in my head that needs to connect with something. After looking through the iterations I decide that I need to explore a bit more, so I take all the meshes a step further.

The first thing I do is apply DynaMesh (with Resolution set to 48 and Project turned on) to all the meshes. After that I use the Standard, Move, Spiral, Nudge, and Fold brushes so that I can get some more interesting forms and find what I am looking for.

03 My final choice

After I choose the version that I like best (the first model from Step 2), I start to play with the volume and shape of the head. I'm still not satisfied with the model so I modify it a little bit more by making the horns more prominent and adding some more elements to the face.

When I'm satisfied, I continue with the re-topology of the head. This is done very simply with the help of a ZSphere. I select a ZSphere, add the head mesh to the Rigging menu and press Select Mesh. After that I press Edit Topology and start adding faces.

04 The body

Continuing with the body, I start thinking about the functions and how it would look, as well as the mobility and the proportions.

After deciding that my character was going to be an engineer, I want him to be supported by a gadget that would help him move easily from one point to another. But how would he control it – with his mind or with his hands? That's when I decide to give him four arms: He is going to have two big arms to hold things and do the heavy lifting, and two smaller arms that control the keyboards and gadgets that he uses.

So I grab a ZSphere and start to sketch out the body for my character, adding more ZSpheres and trying out different positions for the body and the hands.

I try not to add too many ZSpheres so that the mesh is cleaner and easier to work with. I find that the fewer ZSpheres there are, the better the mesh holds. I also find with fewer ZSpheres that the geometry doesn't require too much tweaking.

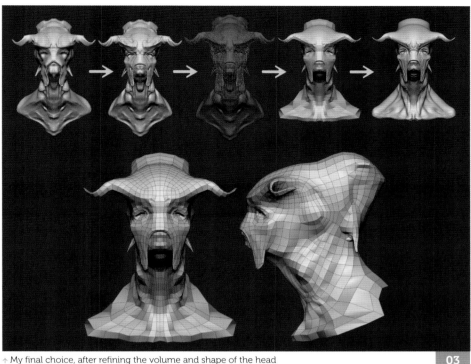
↑ My final choice, after refining the volume and shape of the head 03

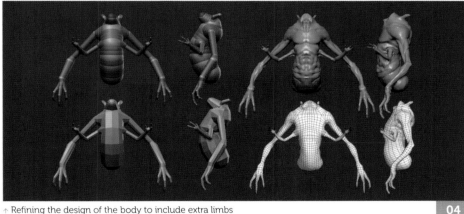
↑ Refining the design of the body to include extra limbs 04

↑ Correcting the topology in 3ds Max 05

05 Topology

After the base mesh is done, I divide it and start to do some modeling, just so I can see the base form and where I need to change the mesh or add more geometry. When I'm satisfied with the body, I move it into 3ds Max so I can correct the topology of the hands and add some loops where needed.

Back in ZBrush, the first thing I do is define my polygroups, so I can work more easily with the mesh. First, I use GroupVisible on the whole model so there are no mistakes afterwards. By clicking and dragging the mouse and holding Ctrl+Shift, I only leave the parts that I want to group. I do this for the whole body.

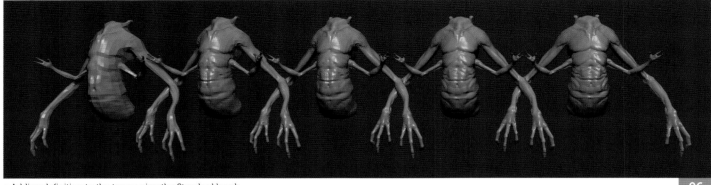

↑ Adding definition to the torso using the Standard brush 06

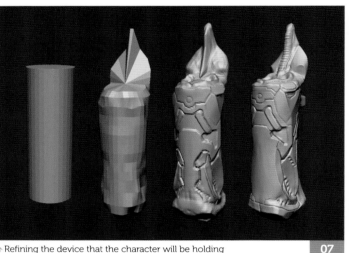

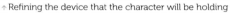
↑ Refining the device that the character will be holding 07

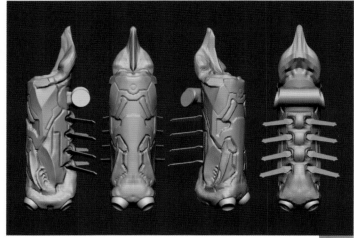
↑ Adding detail and propellers to the transport device 08

"When I've finished retouching the body of the model, I start to add some definition to it by placing the main muscles, correcting some proportions, and defining the volume so it matches the head"

06 Defining the anatomy

For every part that I do, I really like to think about functionality and try to incorporate it into the character. For me, every part and every piece on a character has to serve a role and have a purpose. Sure, it can be visually appealing, but can it move properly? Can the character bend its hand or neck without looking weird?

When I've finished retouching the body of the model, I start to add some definition to it by placing the main muscles, correcting some proportions, and defining the volume so it matches the head. For this part I mainly use the Standard brush to add volume and definition to the surface, and also the Clay brush, which is the best for building up the mesh and adding volume quickly and with precision.

07 Hard surfacing

For the hard-surface part, I begin by adding a Cylinder3D to my SubTool and then start to sculpt the device that the character would use. After this I use DynaMesh (Tool > Geometry > DynaMesh) using 16 for the Resolution and enabling Project mode, so that whenever I use DynaMesh the mesh remains as unchanged as possible.

For the sculpting aspect, I use the Polish, Hard, Move, Standard, and Clay brushes. I'm not trying to define the details at this point, just placing the big volumes and defining the proportions so they fit the character.

08 The transport device I

Now I move onto developing the transport device. To get a better shape to the model, I add some more PolySpheres and, using ClipCurve and Symmetry, I make some rough models of the support wings for the transport device. After I've finished cutting, I use DynaMesh to remesh the models.

For the propellers, I add a PolySphere and using the Move brush with Shift,

press to add a hole so I can see where the exhaust that holds him up would go.

09 The transport device II

For the smaller mechanical details on the transport device, I use ShadowBox to create exactly what I want. It gives more control over the volume and makes it easier afterwards to clean out, use DynaMesh, and detail the parts, rather than just going with the DynaMesh.

There is actually a difference between each of the shapes in the extra accessories on the transport device – some of them are more simple and others more complex. When you make something like this, the distinction between them has to be made so you know which to use in which area on the device. Of course, you can make everything just one way, but this is how I choose to work.

10 Finishing the device

After I'm happy with the form of the device, I start to add the details. For every major part, I duplicate the original mesh and use SliceCurve, Del Hidden (Tool > Geometry > Modify Topology > Del Hidden), and Close Holes

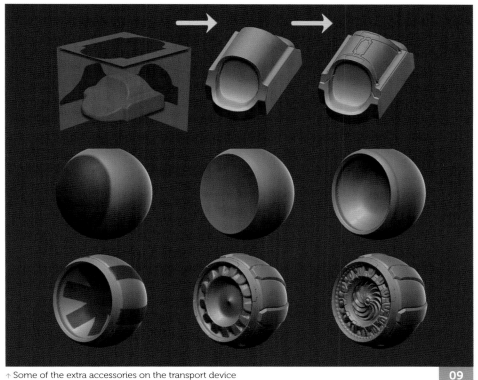

↑ Some of the extra accessories on the transport device

09

↑ Using DynaMesh to get the best geometry

10

↑ Creating the vest and editing the topology

11

(Tool > Geometry > Modify Topology > Close Holes), so only the part that I want remains.

Finally, I use DynaMesh to unify my mesh so that I get that crisp edge when I start polishing. The inside of the meshes that are not visible are not important so I leave them as they are.

"After doing that and re-polishing everything, I start to add some nuts and bolts where they fit best so that the device will be in keeping with the character. I don't want to overload the mesh with too much detail; I want to make sure everything is kept very clean and simple"

For detailing every part of the device I use the Hard Polish brush to get a good edge, the Standard brush to elevate where I feel the need, and the Move brush to correct the form where it's too curved, and place everything so that it fits perfectly. Of course, I also use ClipCurve to obtain a perfectly straight line where it's needed.

To finalize every part of the transport device, I use DynaMesh with Projection on and increase the resolution in order to obtain the best possible geometry for the details that we'll be adding later on.

After doing that and re-polishing everything, I start to add some nuts and bolts where they fit best so that the device will be in keeping with the character. I don't want to overload the mesh with too much detail; I want to make sure everything is kept very clean and simple.

⓫ The vest I

For the vest, I use the body as a base and use the awesome ZSphere, as I did for the head. I construct the topology for both the front and the back of the vest. I use ZSpheres to create the panel and the strips that fasten the vest, using the body with a mid resolution as a support.

Afterwards, I just select Edit Topology in the Topology panel and start to lay out the vest. When I'm done, I adjust the Skin Thickness in the Topology panel and preview it by pressing the A key. When I'm happy with it, I turn it into a PolyMesh with Make Adaptive Skin from the Adaptive Skin panel.

"I find the detailing part to be the most fun, because I just play with the surface of the model without modifying major things"

12 The vest II

After that, I add the mesh to my main ZBrush file and use Crease (Tool > Geometry > Crease) to add some edge loops so it's crisp when I divide the geometry. For this, I separate every part with the Select Lasso tool, while holding Ctrl+Shift. When I'm done with that, I start to work on the strips that hold the vest together. The process is the same as for the vest; the difference is

↑ Refining the details on the vest

12

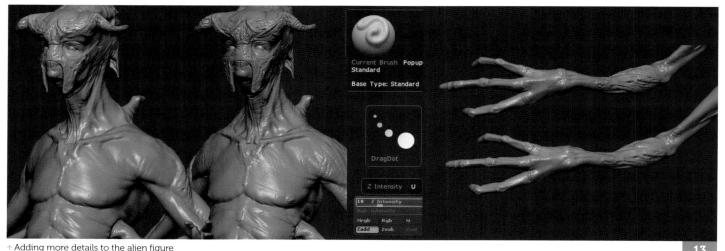

↑ Adding more details to the alien figure

13

↑ Using the Slash3Line2 brush to add details to the transport device

14

that I just make one side, and after finishing up some tweaks (such as matching everything to fit), I use the SubTool Master (ZPlugin > SubTool Master) to mirror everything.

13 Fine detailing

I find the detailing part to be the most fun, because I just play with the surface of the model without modifying major things.

First off, I make a new layer so that everything can be retrieved. Then I store a Morph Target so if I go too far with my brush, I can put everything back in place. For me, these two things are important to do before I start adding Alphas or cuts to the character. By having layers I can later adjust the intensity of the changes I have done. Of course, you can have multiple layers and play with them as well.

So, starting with the head and body, I grab some Alphas from **www.pixologic.com** and start adding them to the mesh. For this, I use the Standard

brush with DragDot and a lower intensity. I try to organize the details for the model from the soft ones, such as skin pores and wrinkles, to the harder ones, such as cracks and bumps – all of them on different layers so I can manage them individually. For this part of the process, Symmetry isn't active so the skin will look more natural.

14 Adding the skin/device details

For adding the skin and the Alphas, I use the Standard brush with DragDot as a stroke and a low intensity of 10. After I'm done with the body, I start to add details to the device and the vest of the character. This part is rather easy because I want to keep it simple, so there's not much to add. For this I use the Slash3Line2 brush with these settings: Intensity = 30; Stroke > LazyMouse > LazyStep = 0.05.

I really like the line that this brush gives, but of course there are many other excellent brushes. Still, I prefer this one and with LazyMouse at 60.

15 Alphas I

For some of the details I use Alphas – some found on **www.pixologic.com** and some made

by me. The process is very simple: You grab a plane, divide it, and then with Symmetry on you start to model in the middle of it. After you are done, go to Alpha > Transfer > GrabDoc and then you should have the new Alpha.

When making an Alpha, if you try to apply it to the mesh and it looks weird or shows the borders, you should then play with the

MidValue that controls the gray point in the Alpha (Alpha > Modify > MidValue). Just play around until it looks the way you want.

16 Alphas II

When the details are complete and I am satisfied, from the Layer panel I bake all the layers to the mesh so that they are permanent. I do this to all the SubTools (Tool > Layers > Bake All).

↑ Playing around with Alphas

15

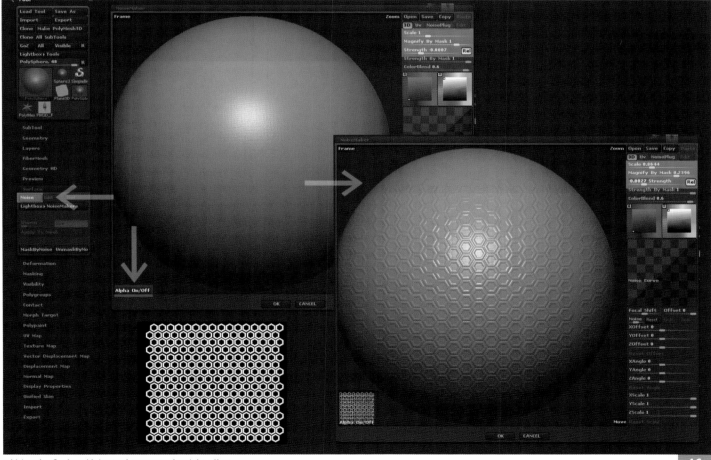

↑ Using the Surface Noise tool to create the right effect

16

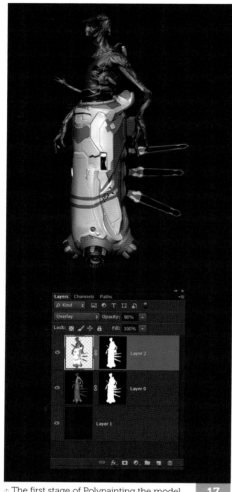

↑ The first stage of Polypainting the model **17**

↑ The basic material on the alien's body **18**

Of course, there are areas where I have to use the Surface Noise tool (Tool > Surface > Noise). I use the Alpha function and play with the values of Strength and Scale until I obtain what I want. I place the masked part that I want to modify with the front facing the canvas and apply the Alpha with Surface Noise.

17 Polypaint

First off, I take a screen grab of the whole model from a three-quarter profile pose, then take it into Photoshop and make a color test. This is very simple; I just bring the image into Photoshop, add a new layer with the blending mode set to Overlay, and start playing around with the colors and the values to see which fits best. When I'm done with that part I come back to ZBrush and start to Polypaint the model.

I like to keep things ordered when I work so my SubTools won't get mixed up. As with the details, I start with the head and body by adding some base color with the Standard brush, and Zsub or Zadd deactivated and Rgb on.

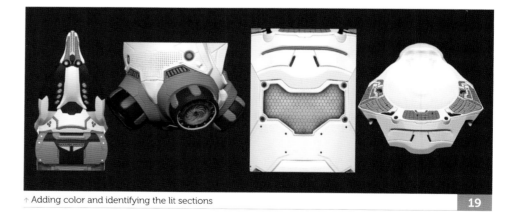

↑ Adding color and identifying the lit sections **19**

18 Materials

The material I use is the Basic material, as I find it very convenient; I just turn the Specular down so I can see the color better. For this character, from the color point of view, I want to have a contrast between the body and the device he uses for moving – the body having warmer colors and a more natural tint.

For all the pores and the cavities on the body I use the Mask tool (Tool > Masking >

Mask By Cavity), with a Blur value of 2. With this, I add a new layer and paint it with a darker color, so they are made visible.

Of course, there are always places in an image that I don't like the look of, and for these I like to use the Hard Polish brush with Zadd and Zsub deactivated and Rgb on. I really like the effect that this brush gives with color and if you press the Alt button, it colors only the outside or the inside of the cavities.

19 Clean colors

I want the device to be clean so the color has to reflect that as well. I want to have just three colors so it has a better contrast – white, orange, and dark blue, which are closer to the body of the character and give a sense of consistency.

On the device there are a few parts that have to glow: the hologram projector, the control buttons, the light source, the propulsion, and the attention lights. For all of these I apply a basic color without any details because the glow will cover a lot in the end, which will be done in the final BPR set.

20 Posing the character

After all the details are done, the next thing to do is to start thinking about how the character is going to look in the final image – what his posture is going to be. The fact that the legs are incorporated in the device leaves only the hands, the upper body, and the head to be arranged.

So I hide every SubTool except the body, the head, and the vest. After this I go to the ZPlugin menu and choose the Transpose Master plug-in. I check the Layer and the ZSphere so I can use the ZSphere to control my rig.

The rig is pretty simple. First I make the rough form and place the key joints, and afterwards I add some support caps to every point for the arms. For the rig, you usually have to check how the geometry holds up and if the ZSpheres are not influencing more geometry than they should.

The vest, for example, needs some extra ribs so it won't stretch too much when I turn the character around. For every point and modification, I check the rig by pressing Bind Mesh (Tool > Rigging > Bind Mesh).

After I'm done with the posing of the character, I go back to ZPlugin and press Transfer TPoseMeshed to SubTool, so the modifications I make are transferred to my mesh on the new layer. Of course, it's not going to be perfect; there are always going to be problems to correct afterwards, but these are very easy and fast to correct in the lowest subdivision level with the Move brush. Now everything is in place and baked out as I wish, I move on to the BPR render.

21 Best Preview Render (BPR)

To start with the BPR render, I first have to establish the resolution that I'm going to use

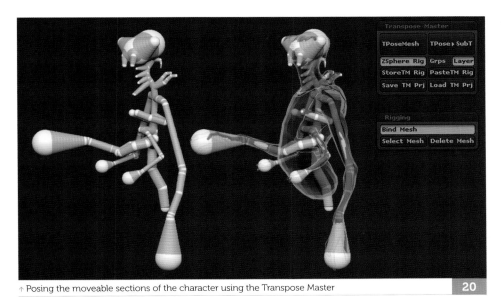
↑ Posing the moveable sections of the character using the Transpose Master
20

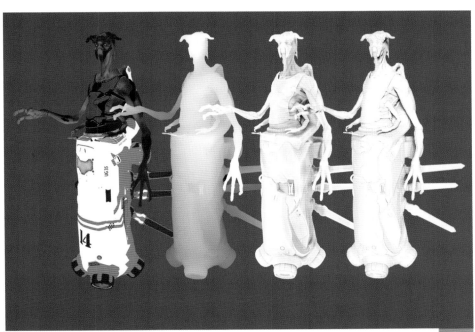
↑ Creating a series of passes for the character
21

for rendering and for the final composition. I try out some layouts and consider that 5000 × 4000 pixels is just right and leaves enough room between the character and the canvas borders. I like to make images larger so after I am done with them, I blend everything together by reducing their size a bit – by about 5% – in Photoshop.

I make some keys in the Timeline (Move > Timeline > Show), just by clicking on it. I do this to ensure that if I drag over the canvas with the mouse by mistake, it's easy to put everything back just by dragging the Timeline slider between the keys.

After I'm done with these, I start to do my render passes for the final composition. This

is a straightforward process. First off I make a simple color pass without any Shadows or Ambient Occlusion. For this, I apply the Flat material to every SubTool I have, make a BPR render with a Sub Pixel AA of 4, and keep this setting for every other pass that I do. Every render that I do is saved as a PSD file to ensure it has the best quality possible.

After that I want to make the Shadows and the Ambient Occlusion passes, and for that I change the Ambient Occlusion resolution to 4096 so it becomes smoother. I leave the shading as flat because the passes will still be saved in the Render > BPR Render Pass. When this is done I save them and the Depth pass, too.

22 Remaining passes

I continue to make the rest of the passes for
the final composition. For the material I use
a Basic material so that I have a base for the
white that I have on the device. The rest of the
passes are made using the same Basic material,
but with Ambient and Diffuse turned down to
zero. I also play around with the specular and
the position of the light to get a better effect.

For some of my passes, I try to separate the device
from the rest of the body and the vest by filling
the body with a solid color and a flat material so I
can make selections easily later on in Photoshop.

"The structure of my
Photoshop file is simple. I
want to keep everything in
groups so things don't get
mixed up"

23 Compositing in Photoshop

After everything is done and the render passes
are finished, I take the images into Photoshop
and start to compose them. The final image
is going to have lots of glows, light, and the
hologram, so I kept this part for last.

The structure of my Photoshop file is simple.
I want to keep everything in groups so things
don't get mixed up. First off, I structure the
compositing of the character into two parts:
The device and the body. This makes my
work a little bit easier, as I can control them
separately and make better adjustments for
each one. The groups are hard surface, body,
AO and add (which contain the added glow
and other effects), and the background.

The Alpha and the depth are added to new
layers in the channels set so I can quickly add
masks to my layers, and Lens Blur at the end.

For every pass and layer I add, I try to get
the best out of them and play with every
aspect of them, such as blending mode,
opacity, color, contrast, hue, and so on.

Regarding the additional graphics, I
make them from scratch. The rest is just
text that I modify with Transform.

On top of everything I make a new layer
with some noise from Filters > Noise > Add
Noise so it unifies the entire image.

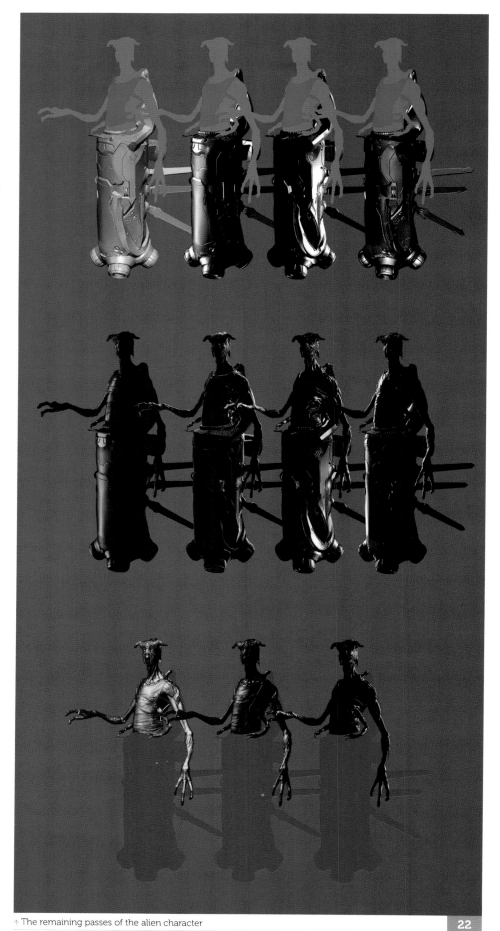

↑ The remaining passes of the alien character

22

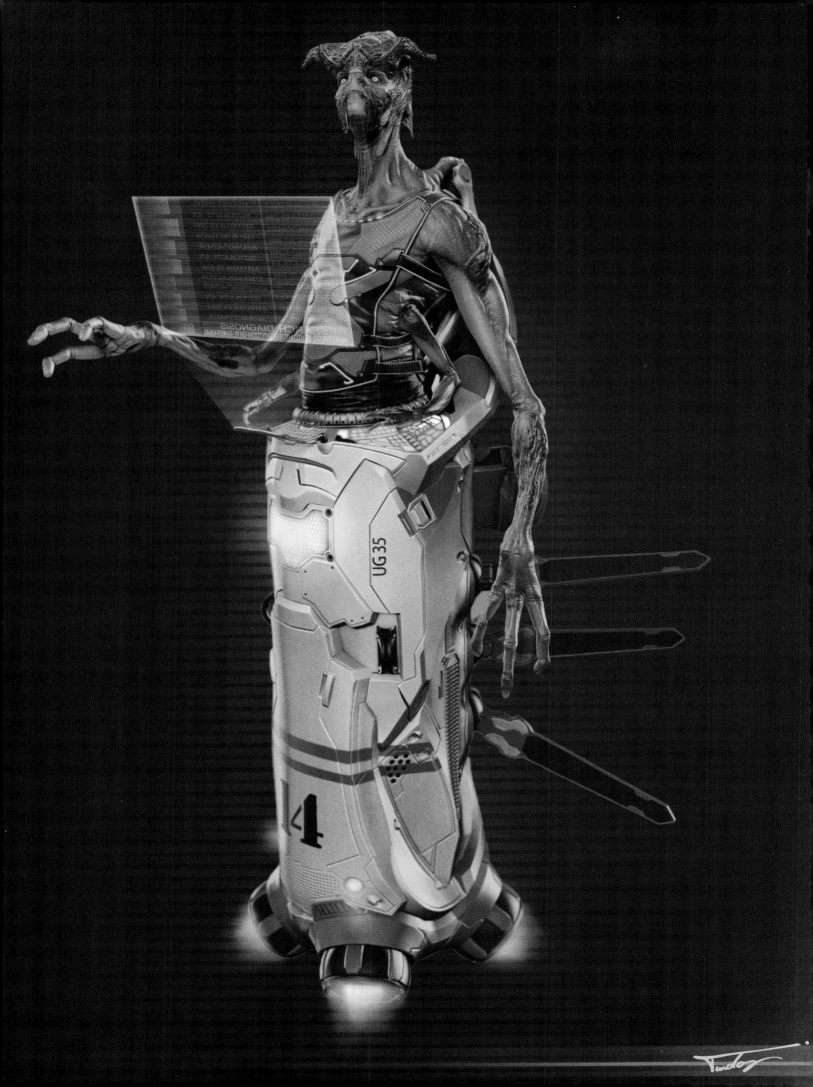

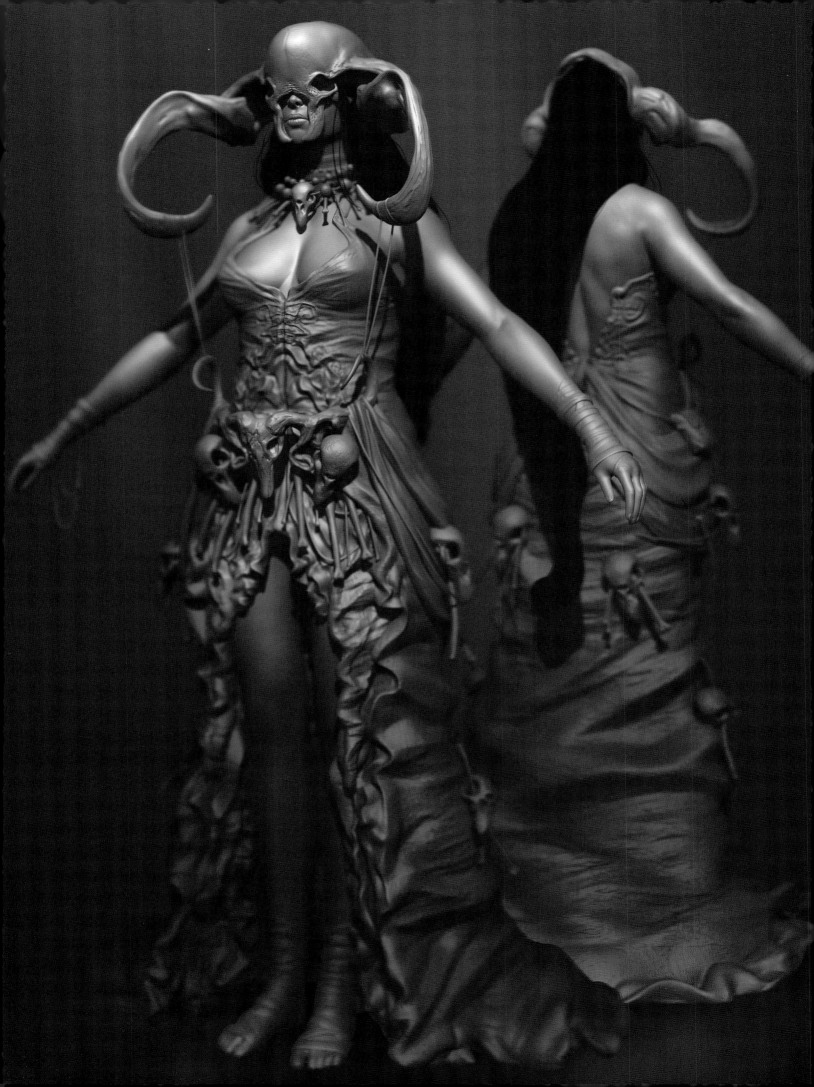

Creating fantasy figures

Discover the complete workflow behind
the creation of a fantasy-based female

After lightly covering the creation of a range of mythical beasts, we
now delve deeper into the dark and feral realms of fantasy. Veteran
character and creature artist, Kurt Papstein, works through a more
in-depth project and shares some of the key features of ZBrush used
in the creation of his dramatic character, *The Harpie Queen*.

Starting with the initial concepting stage, Kurt describes how to refine your
design, pose your character, sculpt detail and texture, and finally add those
last finishing touches, revealing a whole host of helpful hints and advice to aid
you in the creation of your own fantasy-inspired characters along the way.

Chapter 05
Creating fantasy figures
Part 01: Creating the concept

By Kurt Papstein
Freelance Concept Artist at Bad Robot

Inspired by voodoo traditions, fashion design, and the macabre, *The Harpie Queen* is a kind of witch who dwells deep in the southern forests. In this project, I will share how I begin the character, starting with the design process.

All we have at this point is a rough idea of what the final character will be, so for now let's try to find that design. Using software including ZBrush and Photoshop, we will explore the possibilities of this character.

Starting with the character's proportions and structure, I show how I use Mannequins to block out the armature. Posing is also covered, exploring mood and testing the armature for balance. With the anatomy decided upon and refined, I go over shape language, using hair as an example of good visual rhythm. This also translates into the clothing design, managing SubTools to help us work through many different ideas.

Art direction and reference
It's typical on a new project, personal or for a client, to have some kind of direction when starting out. Sometimes it's a vague idea, a feeling, or a few descriptive words. Other times there is more to it, and you will even follow an existing concept.

For this project, the goal is clear but there is a lot of freedom to go in multiple directions. I like to start out by doing some research first, collecting inspirational imagery from around the internet. Websites such as Tumblr, Pinterest, and Google Images are treasure troves for visual artists.

Here I will mainly stick to the explosive world of fashion for its surreal sense of design. Of course, I also pull inspiration from current

↑ Keep your sketches loose and gestural, nothing is refined or detailed. They will still provide some ideas for your sculpt

01

trends in commercial concept art. In Photoshop, I put my collection of references together on a few image sheets so that I can see everything at once. Anything counts as reference: sometimes it will be a bit of photography for color palettes; sometimes a painting for lighting – as long as it gives you an idea and direction.

01 Thumbnails and sketching
Working in two dimensions at the beginning can make it easier to launch your project. Personally, it's rare for me to work this way (as you can tell by my sketches), but it can help to get a lot of bad ideas out early. It may also help you see things quicker and come to a decision sooner if you aren't as comfortable in 3D.

For this project I start my thought process in Sketchbook Pro for its symmetrical drawing ability. You can achieve this in Photoshop as well by duplicating a layer and flipping horizontally.

For this step, it's all about small, simple drawings. Just sketch out some little gestures and thumbnails – they don't need to look good,

just play with the lines and try not to think too much. The reference sheet is optional at this point; don't let those images hold you back.

02 Proportion development
To begin translating our ideas into 3D, we are going to open up ZBrush. In ZBrush you'll find a huge selection of projects, tools, textures, and assets readily available in LightBox. By opening the Mannequin folder under the Project tab in LightBox, we can preview the different Mannequins ready for use.

I choose the 8HeadFemale by Ryan Kingslien for its realistic proportions which also have a heroic feel. Mannequins work identically to ZSpheres, so you can freely move the joints, rotate limbs, and adjust the proportions. I did this a little bit just to exaggerate my character even more.

03 Posing the Mannequins
It's important to play around with the posing of your character at this stage as it helps you to visualize the future possibilities and test to see if the proportions you made are working.

Before you start posing, first open up the Layer menu. Create a new layer for each pose – this way you can work freely in one tool and save it out to your character folder rather than saving a new version for each pose. Remember these are just studies; they don't need to be perfect.

Sometimes combining layers together gives you a different pose that works really well. These happy accidents are very welcome. You can combine layers by simply having them visible at the same time, and adjusting their strength slider as needed.

04 Hand construction

In that very same Mannequin folder, located in the LightBox tab, you will find a very useful hand. I stamp the character's body Mannequin on the document by pressing Shift+S on my keyboard. This helps me to visually line up the hand's proportions as I adjust the digits to be slightly more feminine.

The hand Mannequin comes preloaded with layers in it already with different gestures. In this case, I won't be doing any posing with the hand; it's just there to help build out the mesh. Save this as another tool in your folder to bring back later.

"Sometimes combining layers together gives you a different pose that works really well. These happy accidents are very welcome"

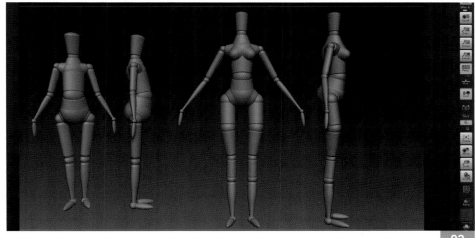

↑ Use ZBrush's Mannequin system to start your character's armature. This saves time and allows you to focus on the design

02

↑ Pose your Mannequin with Layers to create a library of possibilities in one tool. Use these later as a character guide

03

↑ ZBrush has a collection of powerful assets in its LightBox tab. Using the hand Mannequin we can build out our character's hand armature

04

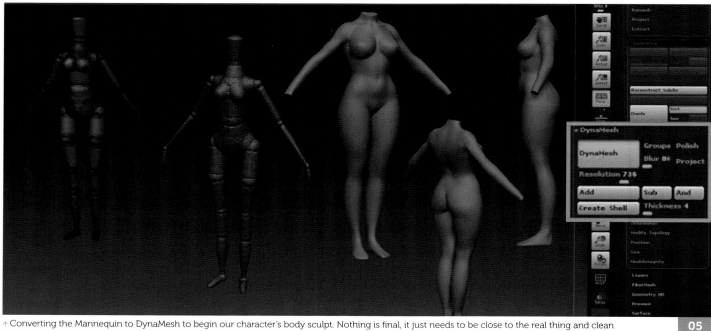

↑ Converting the Mannequin to DynaMesh to begin our character's body sculpt. Nothing is final, it just needs to be close to the real thing and clean **05**

"This is where tons of references, studies, and patience will come in handy. I highly recommend taking life-drawing classes. It can really improve your sculpting and observational skills"

05 Building the core anatomy

Going back to the character's body Mannequin, I begin building out the anatomy with DynaMesh, by converting the Mannequin to DynaMesh. This might require you to increase the resolution of your DynaMesh settings to prevent any loss of form, but once this is done, we are free to sculpt the anatomy.

This is where tons of references, studies, and patience will come in handy. I highly recommend taking life-drawing classes. It can really improve your sculpting and observational skills.

Your sculpt should be without hands or a head at this point, and very rough. We will bring it together in the later steps.

06 Head construction

In some ways, the head is a little easier than the body and in others it can be much more challenging. In either case, avoid ideals. Your brain is going to try to tell you to sculpt in a certain way; it's how your mind interprets the world. Overcoming this barrier is something that takes time and practice.

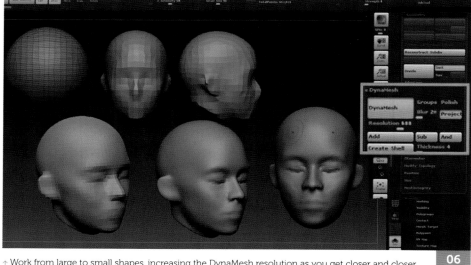

↑ Work from large to small shapes, increasing the DynaMesh resolution as you get closer and closer to the basic shape of your character's head and face **06**

What's nice about working in 3D is we aren't spending hundreds on clay, so we can practice and mess up as many times as we want! Starting with a sphere, and a low DynaMesh resolution, I begin sculpting the large proportions of the head. Working from large to small, I slowly increase the resolution to capture more information to define the head.

Don't feel like you need to make a perfectly finished likeness of someone; just make it a nicely shaped and recognizable human head.

07 Personality and facial sculpting

Spending more time on the face, we are going to uncover just who this character is. Unfortunately,

I am still trying to figure a lot of things out at this stage, so I didn't expect this to be the final version of her face. It's important, however, to spend more time with it so we have less work later on, and to provide a clean sculpt that can easily represent the final piece.

More references are needed for proper alignment of proportions and features. Using sculpting brushes like Inflate, Move, ClayBuildup, Nudge, and Dam_Standard, I slowly but surely refine the clay into a feminine face. Using Groups with DynaMesh, you can use an InsertSphere brush to place eyes without them 'melting' into the head. And with a layer, you can add a little personality with an expression.

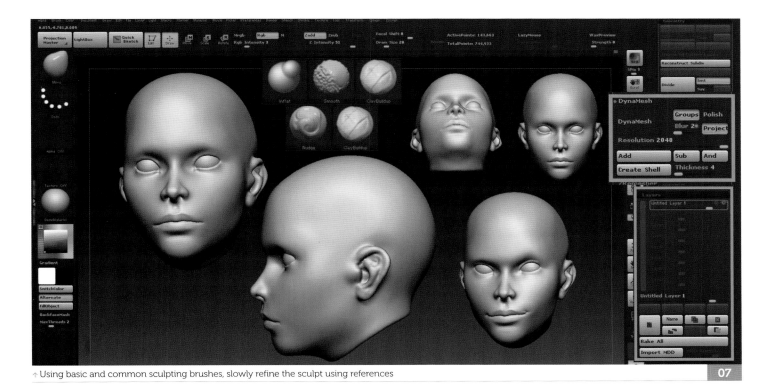

↑ Using basic and common sculpting brushes, slowly refine the sculpt using references

07

08 Melding the anatomy

With all of the tools loaded into ZBrush, it's time to bring it all together. Starting with the body, I append the hands and head into the SubTool menu. At first, each of these things have their own SubTool, but next I merge them together by clicking MergeDown under the SubTool >

Merge menu, starting with the top SubTool selected and merging them downward.

I am still working with Groups turned on to keep the eyes separate, but before I update DynaMesh I want to make sure the hands, head, and body are on the same polygroup.

I assign them the same polygroup, keeping the eyes as their own assignment, and update DynaMesh. This melds everything together in the topology, while keeping the eyes as their own mesh. This just helps us to keep our SubTool list clean in the early stages of the process, before we fill it up with clothing and props.

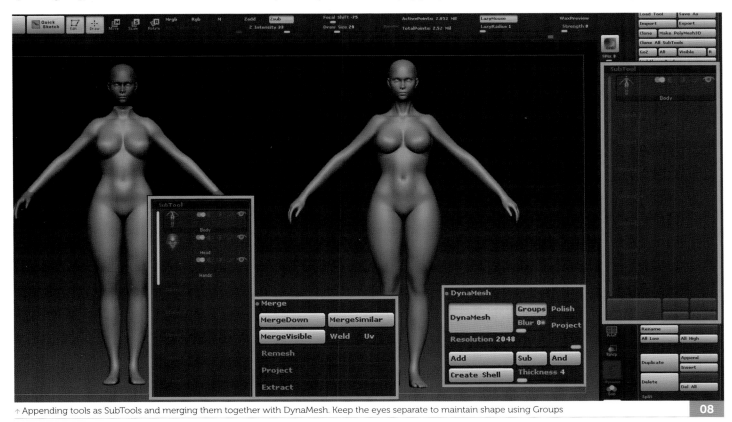

↑ Appending tools as SubTools and merging them together with DynaMesh. Keep the eyes separate to maintain shape using Groups

08

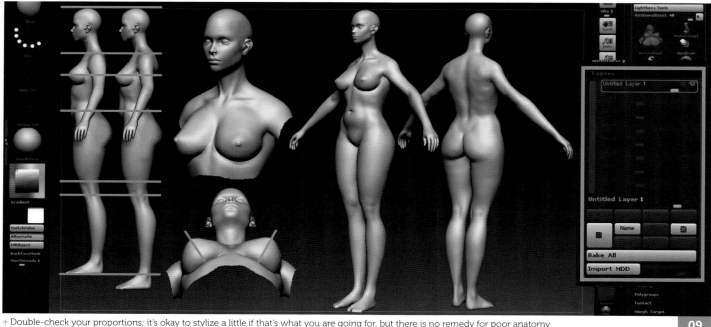

↑ Double-check your proportions; it's okay to stylize a little if that's what you are going for, but there is no remedy for poor anatomy

09

"You should be paying attention to the shadows. Shadows indicate low points across the form, which can sometimes be unwanted dents and irregularities in the sculpt"

09 Completing the anatomy base

With everything together in one SubTool, we are able to make broad adjustments and sculpt across the body. Spend plenty of time looking at references and comparing your work to what you see in the images.

You should be paying attention to the shadows. Shadows indicate low points across the form, which can sometimes be unwanted dents and irregularities in the sculpt. Make sure that the muscles are correct, and don't forget the layer of soft tissues over the muscles. A lot of anatomy references consist of muscle charts or bodybuilders, however most people have a little fat to their build. I make the final proportion adjustments on a new layer, and then when happy, I bake the layer down.

10 Building a concept project

Save your pristine sculpt file, because we are going to start experimenting with design soon! I want to create a new file or tool that is dedicated solely to the design stage. To do that, I make duplicates of the character in the SubTool list – about three of them. There is no golden number; I am just choosing three to get started.

These three duplicates are in the exact same spot in space – overlapping the original, but sitting at a lower resolution in DynaMesh, so I can easily make big changes to the sculpt.

‖ Hair design

Let's dive into the character's hair designs. This will get us warmed up to the idea of exploring shapes in 3D, which can be pretty challenging if

↑ Create duplicate DynaMesh copies of the character's body to act as 'sketching' SubTools to experiment with as we design

10

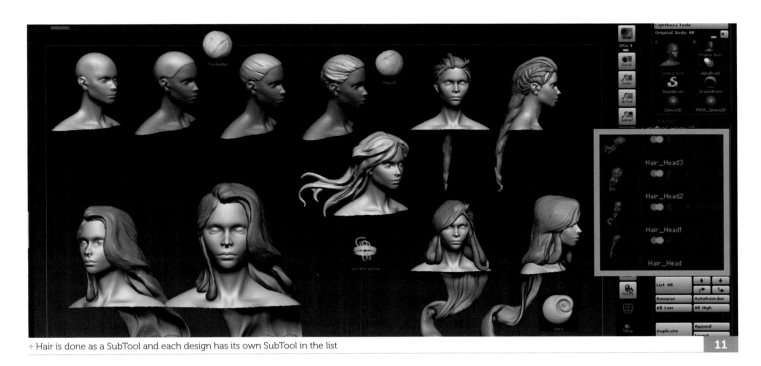

↑ Hair is done as a SubTool and each design has its own SubTool in the list

11

✅ Top Tip
Values and design

There are many important elements in any design. Typically, shape is the most favored, but don't forget that you have other tools such as color, saturation, and material qualities.

I usually take some time during the sculpting process to apply different materials to my character with different specular values and brightness settings. This helps break the shapes up, gives the character strong focal points, and makes graphic

shapes more apparent. It's a good test to perform, as it can help to reveal a lot about the three-dimensional composition of your work.

↑ Applying different basic materials in ZBrush with varied brightness and specularity help you refine the graphic read of your character

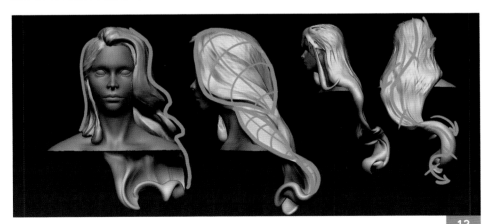

↑ Notice the contrasting elements to the hair. Large shapes are countered with small tight ones, and smooth is balanced with rough

12

you've never done it before. First, I take one of the duplicated bodies and remove everything apart from a little swim cap of geometry on the head.

I use the InsertSphere brush to subtract from the mesh while in DynaMesh. To do this, draw the sphere out while holding Alt. Now you have a giant geometry eraser! Using brushes like ClayBuildup to make some big shapes, I weave to carve lines through the hair. I also use SnakeHook and Move Elastic to pull geometry, and finally Spiral to create twists and swirls. Additional strands of hair are done with the CurveStrapSnap brush with some smoothing afterwards.

12 Shape language

Sticking to the hair, I'm going to talk a bit about shape language. It's important to understand some principles before diving into the clothing design. Contrast is fundamental when it comes to design. It's the strongest way to create interest in your visuals.

Contrast isn't just light and dark, but can be referring to any opposing elements. For instance, detail is the opposite of visual rest, both of which are important elements and if well balanced can create a successful design.

Smooth versus rough, large versus small, straight versus curved. Take the viewer's eye on a rollercoaster of lines, directing them through your character and back again. This is how we achieve 3D compositions.

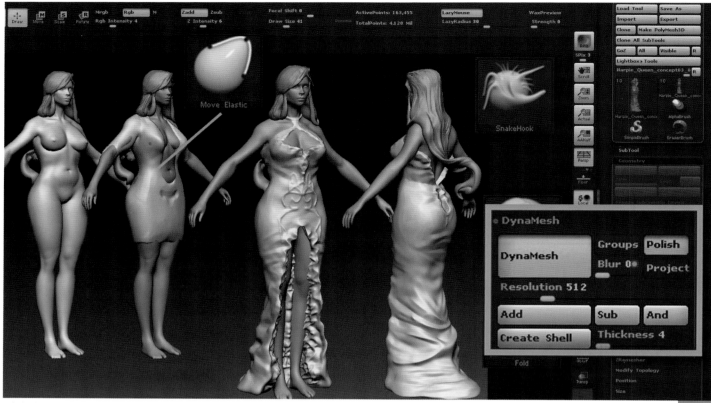

↑ A duplicated body acts as our starting point for clothing. The Fold brush can create some quick fabric shapes at a low Z Intensity

13

"Think of it as a giant blob of clay; we aren't building anything elaborate – it's just overlapping messy geometry separated by SubTools. Think about the detailed and visual rest areas"

13 Clothing design

With a good understanding of shape language, let's move on to blocking out our character's clothing.

Working with a duplicated body again, at a lower DynaMesh resolution, I start subtracting

with the InsertSphere brush again, stretching with Move Elastic, and sculpting with any number of brushes to build the slip of the outfit.

These are the under garments that may or may not be exposed. It's just the first layer of clothing, establishing a flow on the character.

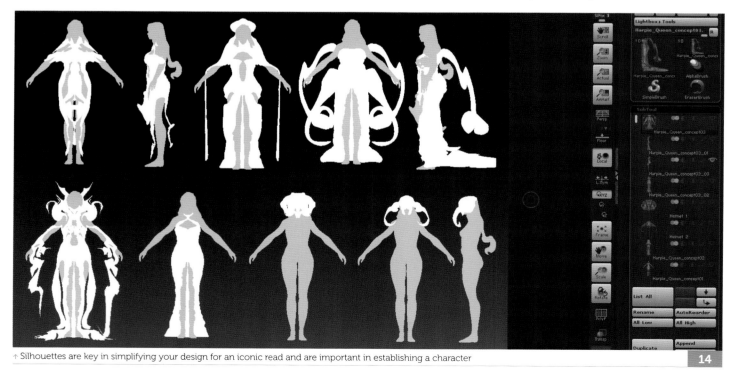

↑ Silhouettes are key in simplifying your design for an iconic read and are important in establishing a character

14

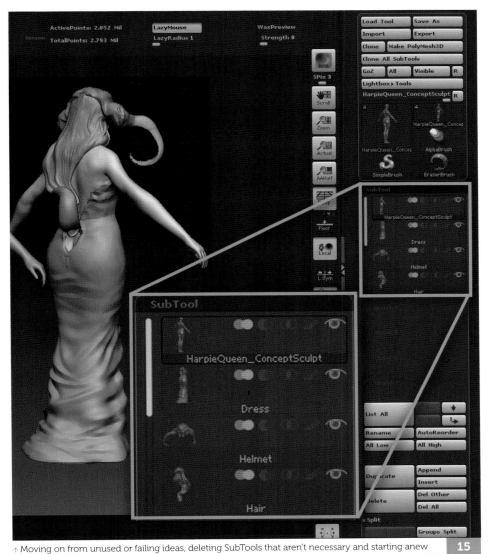

↑ Moving on from unused or failing ideas, deleting SubTools that aren't necessary and starting anew **15**

↑ All additional pieces seen here are created from a sphere in DynaMesh. It's never too late to adjust the design **16**

Think of it as a giant blob of clay; we aren't building anything elaborate – it's just overlapping messy geometry separated by SubTools. Think about the detailed and visual rest areas.

> "Only looking at our character from the front for now, and using SnakeHook, Move Elastic, and Spiral, I explode with ideas. Remember, nothing needs to make sense – refining the answers comes later"

14 SubTool ideations

This is where we start to get creative and really break out of our design shell! I start by duplicating the dress and switch over to a flat shader in the material menu. I only want to focus on silhouettes, so there is no need to worry if the sculpting is messy or doesn't make sense.

Only looking at our character from the front for now, and using SnakeHook, Move Elastic, and Spiral, I explode with ideas. Remember, nothing needs to make sense – refining the answers comes later. Each idea is a separate SubTool. I stamp ideas to the document as I go along so I can see my progress. Notice that helmets are also being explored with spheres at this stage.

15 Consolidating concepts

Hopefully you've found some of your own designs that you like. It can be a good idea to take those silhouettes into Photoshop and cut and paste parts together to find the ultimate idea. For my character, I feel like the basic slip dress is a good start. After combining it with the morbid skull helmet, I think it now has a compelling contrast.

So with that, it is time to clean up the SubTool list. Delete any unused ideas, layers, and meshes, and save the Tool as a new iteration of the character.

16 Clothing additions

ZBrush makes it easy to slap a new idea into an existing character. Here I append a sphere whenever I am struck by a new idea. Converting it to DynaMesh at a high resolution allows me to play around with those same sculpting brushes we've been using, to find important design elements.

To enhance the character's narrative, I add to the dress, creating a long trailing outer layer with lots of folds. I also create an ornamental bird skull hanging from the larger skull helmet.

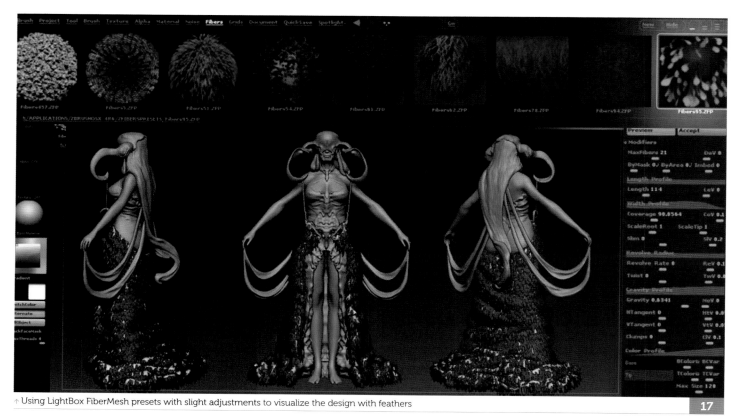

↑ Using LightBox FiberMesh presets with slight adjustments to visualize the design with feathers

17

> "So far we have done a lot of work on a larger scale. It is now time to consider what some of the design elements are going to be on the surface, within those shapes"

17 Feathers

While in the design stage of the process and evaluating our character, I decide that it is worth taking the time to carry out a quick feather test. This is the 'Harpie Queen' after all, so of course it is necessary for her to encompass some iconic bird imagery.

I start off by selecting a SubTool as a base, in this case the outer dress. Under the Tool > FiberMesh menu, I click the LightBox > Fibers button to grab a preset in LightBox. Double-clicking something feather-like as a start, I increase the MaxFibers slider and decrease the length to make them look more like feathers of a raven. Hitting Accept will place them as a SubTool, and trying this concept without Fast preview mode enabled will give us a good visual representation.

Please note that this is just a test: Later on we will make some proper feathers, but this just helps us to figure out where they might go and how they will work.

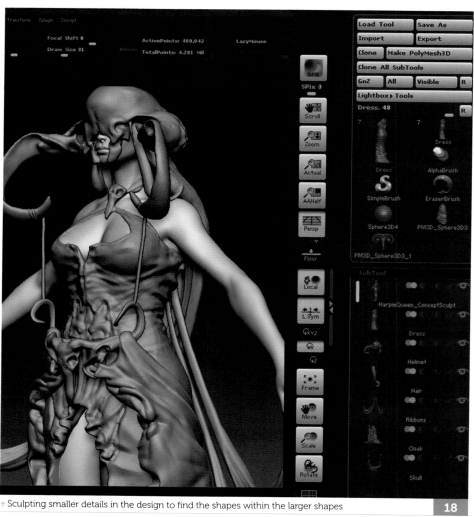

↑ Sculpting smaller details in the design to find the shapes within the larger shapes

18

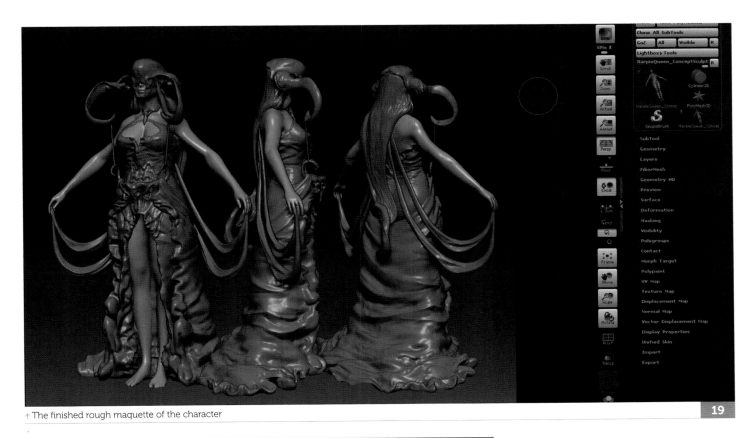

↑ The finished rough maquette of the character

19

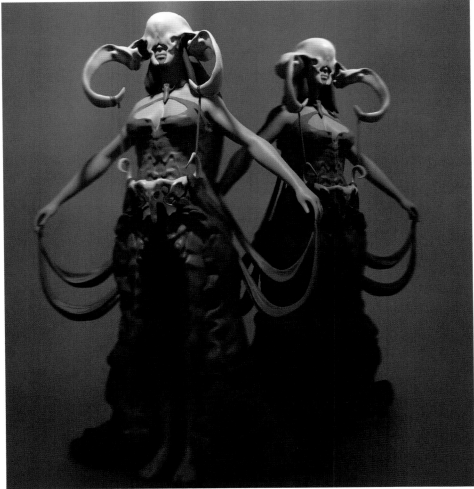

↑ The model so far, ready for the next stage...

18 Refining the concept

So far we have done a lot of work on a larger scale. It is now time to consider what some of the design elements are going to be on the surface, within those shapes. Using a higher DynaMesh resolution on some of the SubTools, and brushes like Dam_Standard, I begin sketching on the surface of the SubTools.

At this point then, I decide to spend some time making some of the elements feel more like cloth, putting more design into the detailed areas while remembering to not get too carried away with the details.

19 Concluding this stage of the project

The design is never truly finished when working on an artwork such as this. She's going to evolve more over time as I continue working on the character. But for now, we have a much more focused direction and have accomplished some of the more technical things.

"She's going to evolve more over time as I continue working on the character. But for now, we have a much more focused direction and have accomplished some of the more technical things"

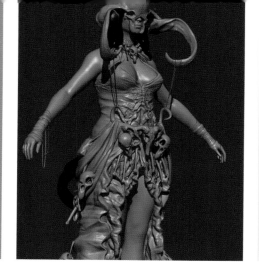

Chapter 05
Creating fantasy figures
Part 02: Refining the design

By Kurt Papstein
Freelance Concept Artist at Bad Robot

Now we are going to refine the design of a ZBrush character with in-depth sculpting techniques, new mesh generation, and clean topology flow. I'm also going to share how I save myself plenty of time by recycling parts of the sculpt, creating detail with the Insert Mesh and Curve brushes.

We will start on the interior shapes and work our way out. Using tools like ZRemesher, we can create a brand new topology for existing pieces by lowering the amount of waste in our file and thus making our lives easier in the long run. Everything we do is with the final goal in mind: a posed and rendered character.

Besides cleaning up existing prototype meshes and making some small detail pieces, we will also dive into the Topology brush for creating clean geometry for large pieces of the sculpt.

By the end of this chapter, the character will be completely sculpted, excluding certain things like the hair or the feathers. The character should be fully realized by the end of this lesson, before we move on to posing!

01 Preparing for retopology
So to get started, we need to look through our SubTool list and make sure our concept sculpt is nice and clean, and that everything is properly named and easily understood. As we progress, we are going to create many more SubTools, and work with multiple 'dummy' tools, which are temporary copies to work on top of inside of ZBrush. Organization is key to your sanity, and makes the process much faster.

Besides proper naming and organization, we also need to make sure DynaMesh is turned off for each SubTool to prevent accidental re-meshing or errors.

↑ Make appropriate names for your SubTools and turn off DynaMesh

01

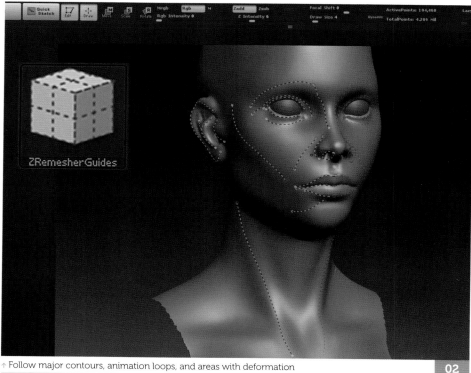

↑ Follow major contours, animation loops, and areas with deformation

02

02 ZRemeshed guides

Starting with the anatomy, we will retopologize the SubTool properly for a cleaner base mesh with lower geometry. This will be good for posing later on, and saves on memory in the long run.

ZRemesher makes this extremely easy, and to improve our results, I'm going to use the ZRemesherGuides brush. Like all Curve brushes, the amount of points in the curve is dictated by the Draw Size of the brush. Keep it simple – let ZRemesher do most of the work. Place curves along key features and joints on the body for clean topology lines.

03 Using ZRemesher

With your curves drawn on the character's body, you can switch over to the ZRemesher submenu under Geometry. I activate the Use Polypaint option to control the amount of topology in specific areas of the mesh.

I want more geometry in the face, hands, feet, and groin area to prevent the mesh from losing its silhouette, and keep the fingers or the legs from melting together. We also want to provide enough geometry to the face to take advantage of the Curves function. Be sure to always work on a duplicate SubTool, just in case.

04 Subdivisions and Projection Master

I normally work on two different SubTools of the body while retopologizing in ZBrush. This way I retain the original DynaMesh sculpt with all of its information, while creating a new base mesh that will be easier to pose. Once ZRemeshing is complete, I add some subdivisions to match the original sculpt of the body. With only these two SubTools visible and the new retopologized version selected in the SubTool list, click Project All. Your details will now be transferred, and you can delete the original DynaMesh sculpt.

05 Sculpting female anatomy

Typically I sculpt one subdivision at a time and work my way through the anatomy down to the subtle details. However, with the female figure, I find it easier to just sculpt at a low Z Intensity for all of my brushes at the highest subdivision level.

Use lots of reference! There isn't a trick to it, or a special brush. I use the same brushes that I use when I sculpt monsters: ClayBuildup, Standard, Inflate, and Dam_Standard. These brushes work differently with minor changes to the intensity.

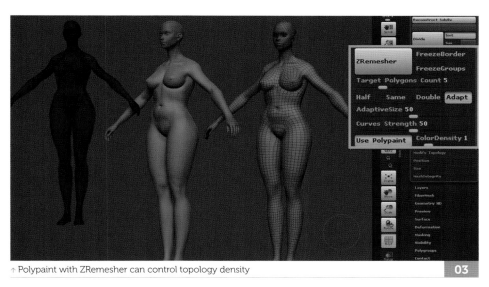
↑ Polypaint with ZRemesher can control topology density 03

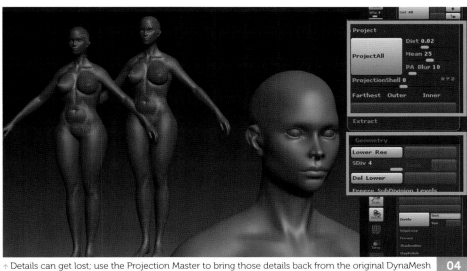
↑ Details can get lost; use the Projection Master to bring those details back from the original DynaMesh 04

↑ When sculpting the female form, work slowly with a low Z Intensity 05

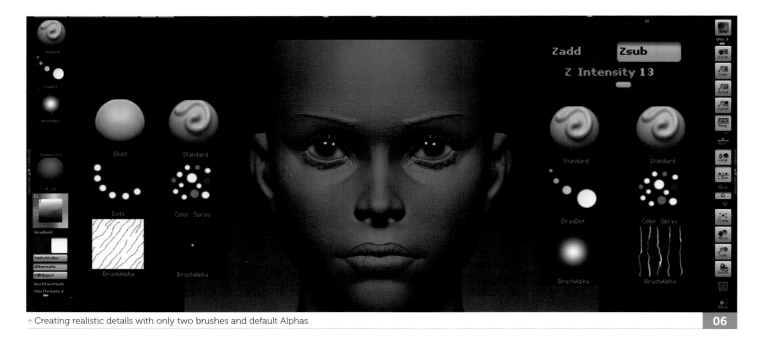

↑ Creating realistic details with only two brushes and default Alphas

06

06 Detailing skin

All of the final touches to the character's face are done mostly with the Standard brush. This is my weapon of choice when it comes to using Alphas. By using a color spray for the stroke, I'm able to very lightly sculpt in wrinkles and pores. These are for the more pronounced areas of the face.

The Skin brush (located in LightBox > Brush > Patterns) fills in the smooth spaces with some noise. Notice the pores on the human face and how they form a pattern. It varies greatly across the surface, and this is where lots of high resolution references come in handy!

07 Bird skulls

Creating additional props for costume decoration is pretty easy. I begin by appending a sphere into my SubTool list, and convert it to DynaMesh. Turning Solo on isolates this SubTool visibly, making it easier to work. The SnakeHook brush can pull shapes out of the geometry; use InsertSphere (drawn while holding Alt) as a volume eraser.

Start at a low resolution in DynaMesh, and work your way to a higher number as you need more information in the sculpt.

08 Retopologizing bone assets

I create a few extra little pieces to be used around the character. Sticking to a 'witch doctor' vibe, I make a few extra bird bones to go with the skull. I start these the same way; appending a sphere in my SubTool list and sculpting with DynaMesh, SnakeHook, and ClayBuildup.

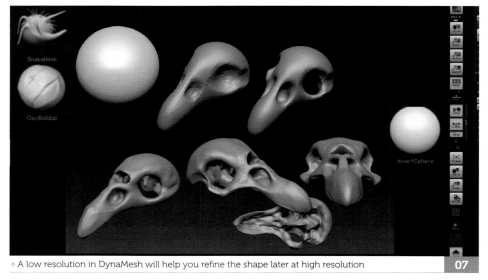

↑ A low resolution in DynaMesh will help you refine the shape later at high resolution

07

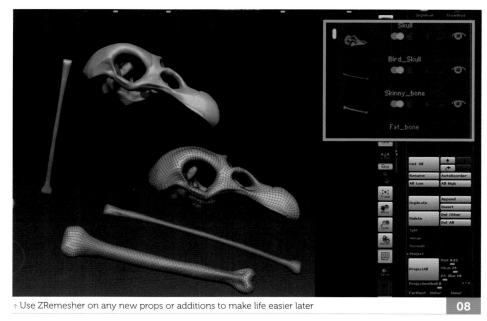

↑ Use ZRemesher on any new props or additions to make life easier later

08

With these roughly completed, it is a good idea to retopologize them so they are a little more efficient and we can get more use out of them later. Using the default settings, I run ZRemesh across all of these new objects.

09 Sculpting bone details

This is an optional step in the process. It's nice to have both a high-poly detailed version, and a low-poly base mesh that can be duplicated many times throughout a project without the use of too many polygons.

I isolate these bone assets into their own ZTool so that I can reuse them easily in future projects. I use the Dam_Standard brush after

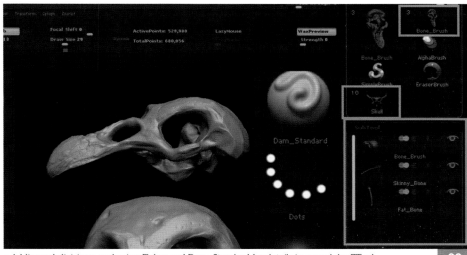

↑ Adding subdivisions, and using Flakes and Dam_Standard for details in a modular ZTool **09**

adding subdivisions to create cracks in the bone. I use Flakes with a soft round Alpha and low Z Intensity to build irregularities. Finally, I use the Standard brush with Color Spray and a small pin Alpha for small holes in the bone.

10 Creating insert brushes

With the bone pieces in their own ZTool, we can turn them into an InsertMultiMesh (IMM) brush. Make sure DynaMesh is deactivated across all of the bone pieces, and that there are no subdivisions. If you wish, you can use the high-resolution versions with all the detail, but it will get dense really quickly when used.

I end up using the ZRemeshed versions for my brush. Make sure the SubTools are named, and oriented properly on the floor grid to show how you would want them placed on a surface. Looking down on them, click Create InsertMultiMesh in the Brush menu.

↑ An IMM brush can be very handy when you need to place the same object over and over **10**

11 Placing jewelry and using curves

Now that we have a small library of assets in our Brush window, it's time to put them to use.

When using Insert Mesh brushes, you can't place them on a SubTool with subdivisions, and since we are trying to preserve detail and shape, it is also not a good idea to have DynaMesh active.

In this case, I am going to create a merged copy of my character by clicking MergeVisible in my SubTool menu. This will create a new tool for me to work on. I work from one item to the next, and split them into organized SubTools that can be appended into our original character when it has been completed.

↑ Using our brushes, begin placing them on a merged copy of our character **11**

12 Straps

Continuing work on the dummy tool, I use the CurveStrapSnap brush to create leather and cloth wraps on the arms and feet (this brush is also good for creating belts). You can draw these curves anywhere and they will snap to any visible surface. To create full loops around an arm, begin drawing on the arm's surface and hold Shift as you draw out into the empty document. It will then create a closed loop, forming a completed strap. I use this design element to create extra layering under the beads around her neck.

13 Topology brush

Another great way to build out geometry and conceptualize new shapes is with the Topology

↑ The CurveStrapSnap brush can be used to create convincing straps

12

brush. By drawing out curves with this brush, and overlapping these curves, you create a vertex. Continue drawing in curves to form triangles and quads. The brush size determines the amount of points in the curve. If you are satisfied with the low-poly shape you are drawing, simply tap the surface of the mesh away from the curves to convert them into geometry. The size of your brush also determines the thickness of the geometry.

↑ The Topology brush can build new shapes over existing geometry

13

14 Clothing with topology brushes

Working across our dummy tool again, you can now refine your design even further using the Topology brush. Try to stick to the silhouette of the shape you want to create. It also makes it easier if you stick to an existing surface, as opposed to flowing the curve out into negative space.

Once you have the silhouette drawn, you can begin connecting the shapes with topology lines, forming quads. It's helpful to step back and look at the preview geometry to get a sense of how the design looks. Keep your SubTools organized so that you can append them into the original character tool.

15 Bags and pouches

DynaMesh gives us a lot of power to shape our sculpt into a variety of things. Starting from a sphere, I activate Polish and Groups in my DynaMesh settings. Polish will keep my shapes clean and more hard-edged. Groups will keep all additional pieces of added geometry or polygroups separate. Taking the ClipCurve brush to the surface of the sphere, I begin carving it into the shape of a bag. With ClayBuildup, I slowly sculpt it into shape with DynaMesh. You should try to create some variations to experiment with how it looks on the character.

↑ Design your silhouettes first before you get caught up in the topology of the shape

14

↑ DynaMesh, the ClipCurve brush, and Polish are the perfect tools for clean sculpting and hard surfacing

15

☑ Top Tip
Beads and jewelry

In a new tool, I decide to create two SubTools – each one is meant to be a different mesh in an InsertMultiMesh brush. Both of the SubTools consist of a sphere and a cylinder, with one of them using an additional sphere in order to add variation.

Hide and delete the ends of the cylinder so that they can be welded together in the Brush Modifier settings using the Weld Points button.

Clicking the Create InsertMultiMesh button will create a new brush for you, and activating the Curve option under the Stroke menu will allow you to draw them as a connected and continuous row of beads – perfect for bracelets and necklaces.

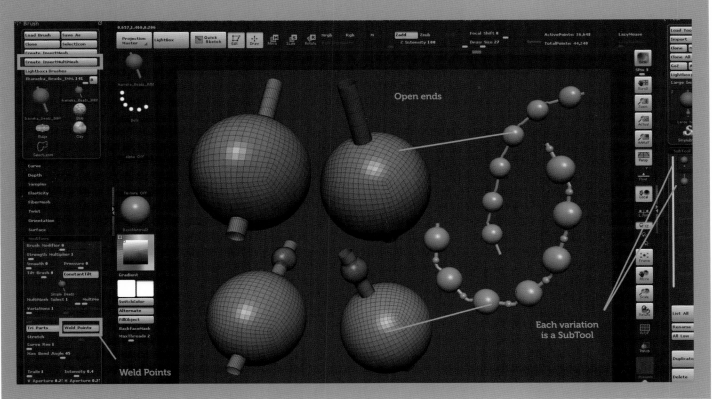

↑ You never know when an IMM brush of beads can come in handy with your character designs

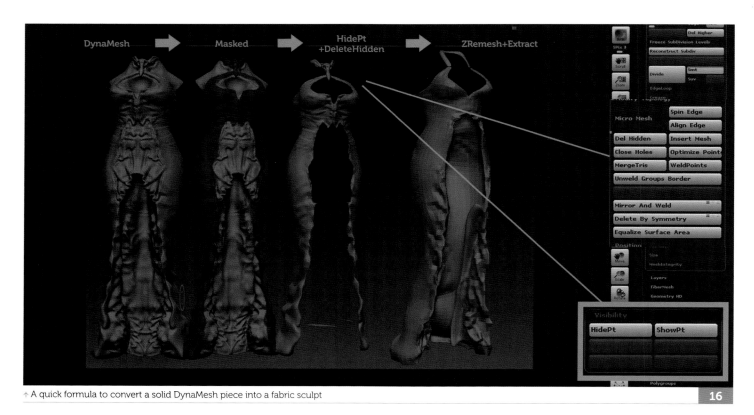

↑ A quick formula to convert a solid DynaMesh piece into a fabric sculpt　　**16**

16 Replacing concept clothing

Going back to our original Character Tool now, I'm going to convert the rough DynaMesh clothing concepts into usable geometry. With DynaMesh turned off, I start by painting a mask across the surfaces I want to keep in place. Click HidePt under Visibility, and then Del Hidden under Modify Topology. You are now left with a shell of the clothing that you can then ZRemesh, and from there, Extract, to create a new SubTool of the clothing with thickness. You will lose your details and some of the form, but that's okay as it was only a quick concept.

> "Exaggerate the peak of the fold with Dam_Standard, and create the effect of gravity on the underside with ClayBuildup"

17 Clothing forms

With all of the clothing ZRemeshed and extracted into clean geometry, we can start the real cloth sculpting. It looks a lot more challenging than it really is, and the process can be done quickly with the Fold, Dam_Standard, and ClayBuildup brushes. Keep your Z Intensity low for your Fold brush to have a gradual effect and plot in the shapes.

Exaggerate the peak of the fold with Dam_Standard, and create the effect of gravity on the underside with ClayBuildup. Remember

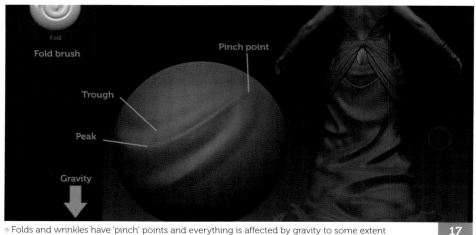

↑ Folds and wrinkles have 'pinch' points and everything is affected by gravity to some extent　　**17**

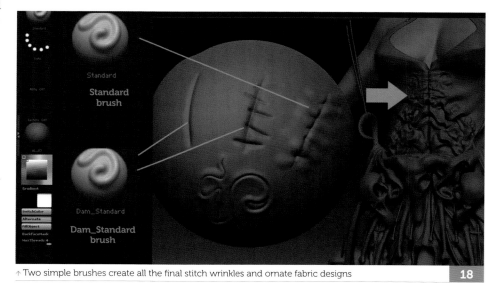

↑ Two simple brushes create all the final stitch wrinkles and ornate fabric designs　　**18**

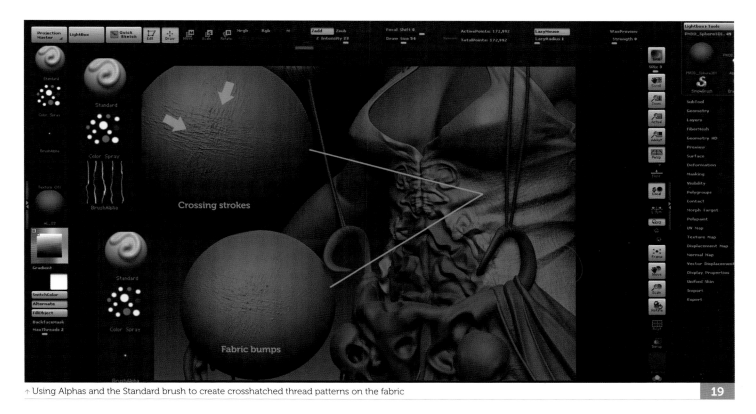

↑ Using Alphas and the Standard brush to create crosshatched thread patterns on the fabric

19

"I use the Dam_Standard brush to 'sketch' my original swirl design on the surface around the edges of the fabric"

where the fold is pinching, and think of the shapes as an accordion folding in on itself.

18 Fabric details
Using the Standard and Dam_Standard brushes, I finish off all the ornate design work and tighter stitch wrinkles. I use the Dam_Standard brush to 'sketch' my original swirl design on the surface around the edges of the fabric.

I also use it to cut into the cloth and plot in my stitch lines. After that I use the Standard brush to inflate some of the areas around the cut sections, creating the illusion of folded-over fabric and more wrinkles.

19 Sculpting fabric texture
Typically, I stick to the Standard brush for all my Alpha work and texturing. It is very predictable and easy to use. For clothing, I'm going to carry out a mixture of both Alpha work and hand sculpting. For this I'm using a ZBrush-installed Alpha that is very common, and set my Stroke to Color Spray. This will create some variation in the Alpha pattern.

I then begin crosshatching my strokes to build up sewn thread patterns over the surface. To finish it, the same brush with Color Spray and a small pinpoint of an Alpha illustrates loose fibers across the surfaces.

✓ Top Tip
Eyes
For visual guidance and to reassure me of her face design, I like to apply the Sebcesoir Eye Shader available for download from Sebcesoir on **www.zbrushcentral.com**. There are many MatCaps available online with similar features – even the preloaded Toy Plastic will work well; anything with a very intense but small Specular reflection.

I also do some rough Polypainting using Rgb on my Standard brush. Fran Hazard's Eyelash brush was used around the eyelid. You could also opt for FiberMesh.

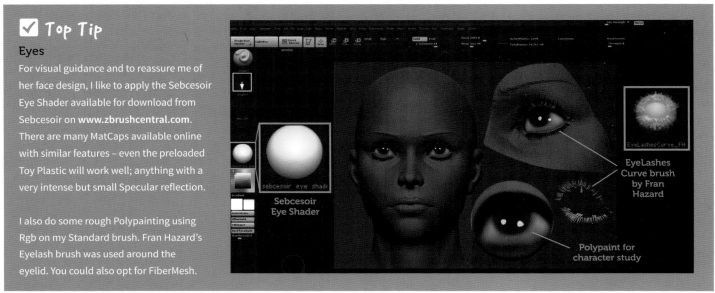

↑ Pre-visualizing the final look to our character's face is important in determining if the structure is working

Chapter 05
Creating fantasy figures
Part 03: Posing the character

By Kurt Papstein
Freelance Concept Artist at Bad Robot

The techniques covered in this tutorial can apply to any sculpt at any number of stages, but I am assuming you have a character with multiple SubTools, and each SubTool has multiple subdivisions. Using a combination of the Transpose Master, layers, and sculpting brushes, I will share with you my simple process of managing a complex character such as this into a dynamic pose.

Before we even begin the process, I want to shed some light on the foundations of a good pose. I will therefore share with you my thoughts on what it takes to make a compelling composition out of your symmetrical sculpture, based on my own experience and lessons shared from other experienced artists.

By the end of this tutorial, you should have an understanding of how to pose your character in ZBrush. Your character will have layers applied to each SubTool with subdivisions, and on each layer there will be the pose information – allowing you to work between a symmetrical stance and a dynamic pose, and keeping your work free and non-destructive.

01 Mannequin posing
Before we even start working with our completed character, let's take a moment and plan out the pose and study some fundamentals. To begin, I use Ryan Kingslien's 8HeadFemale Mannequin located in ZBrush's LightBox Project tab, under Mannequins.

Mannequins are essentially ZSphere rigs, designed to resemble the final form. By using a Draw Size of 1, you will limit the amount of error in your work as you rotate each limb into position. Our character was originally built using the 8HeadFemaleMannequin, so I am going to continue using her as a guide.

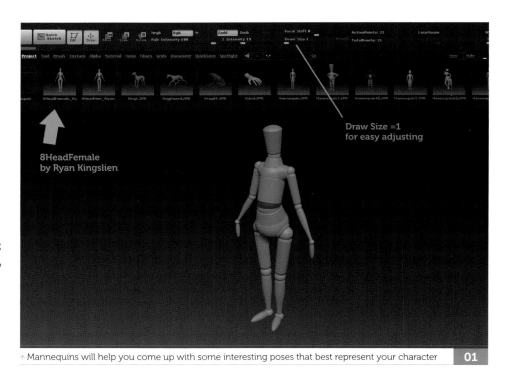

↑ Mannequins will help you come up with some interesting poses that best represent your character **01**

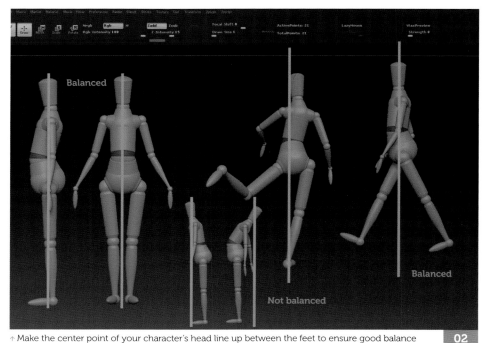

↑ Make the center point of your character's head line up between the feet to ensure good balance **02**

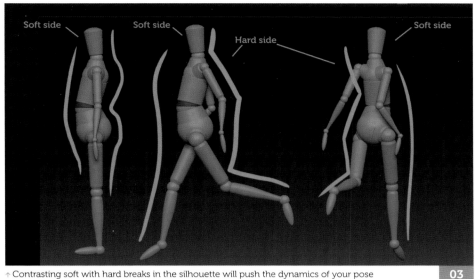

↑ Contrasting soft with hard breaks in the silhouette will push the dynamics of your pose **03**

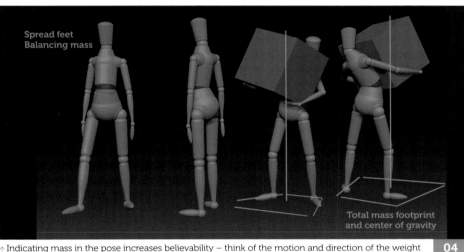

↑ Indicating mass in the pose increases believability – think of the motion and direction of the weight **04**

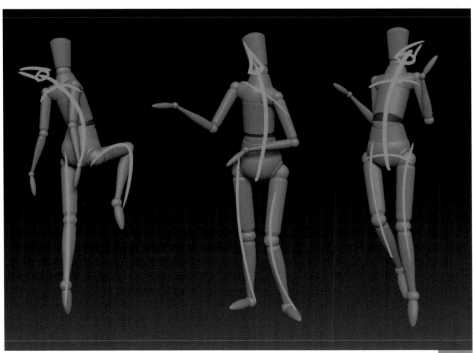

↑ Gesture is the momentum of the character – the spine is a good indicator of the direction **05**

02 Balance

Balance is the key element to a successful pose. It's a simple concept but can easily be overlooked, even by seasoned professionals. Before you dive headfirst into something dynamic, just check your sculpt and look for a few important points to ensure balance.

A typical balanced pose will have the center of the head in alignment between the character's feet. Standing upright in a classic T-pose is where you would see the center of gravity fall in line. If not standing in a symmetrical pose, the head's center will be located over the center of the balance point – possibly slightly over, depending on the counter balance.

03 Composition and contrast

When dealing with three-dimensional characters, you have to consider the composition from all directions. This involves focal points, visual rest, and, of course, direction. Another important element to your composition is visual interest through contrast. In the music world this could also be viewed as tension and release. Here in image 03 you can see one side of my character is compressed – this is the tension – and the opposing side is stretched, softer in the form – this is the release. All together, this can create contrast in the pose and builds visual interest, helping to push the dynamic effect of the final composition.

04 Gravity and weight

In order to keep a pose believable and natural, one must consider natural elements such as gravity, which affects everything. Weight also works hand-in-hand with gravity, and these two important factors will determine how real your character's pose looks. Weight can affect the amount of counter balance needed in posture and by spreading the feet a bit we have implied mass. This will help your character feel grounded and heavy, as opposed to floating, weightless, and digital.

05 Gesture

The gesture of your character is the overall flow and direction of everything. An easier way to think of it is the arch of the spine. Depending on how it is bent or twisted, the limbs will follow to balance and counter balance. In this case, it is to give everything a point to pull from. Think of the head as the point of origin for all movement, and the eyeline as a guide for the character's intended direction. Giving the character an exaggerated gesture will help the pose read clearly.

06 Body language

Body language is a key component to communication. In this instance I'm not looking to tell a giant story, just to show off the character in a compelling way and say a little something about who she is. The posture is a great way to do that. An arched back and open chest is a strong and dominant stance, with confidence, whereas a hunched-over direction indicates passiveness.

Think about what it is you want to say about your character, and do some research poses in ZBrush to convey your ideas. Have a friend look at them and describe the character based off the Mannequin pose to see if you are successful.

07 Counterweight

Once the center of motion is decided through the gesture, and the body language is conveying the feeling you want, you can consider the counterweight and the center of balance to your character.

The center of balance to your character is pretty self-explanatory; simply factor in the mass and the direction of the motion to find it. Typically it will be right down the middle of your character, but say for example the torso is leaning heavily to one side: Counterweight will need to be applied with either the leg or arm of the opposing side.

08 Finding the pose

So now we begin working with our character, but before we close our project with the Mannequin, let's do some sketching. Create a rough version of the final pose you hope to achieve with the Mannequin and save a version of it from each angle. You can do this by taking a screen capture, or exporting the document.

Drawing over your Mannequin in Photoshop or something similar will help you visualize all of the major elements to your character. Remember to factor in all the elements mentioned in steps 02–07, starting with personality and body language to help tell this character's story.

09 Benefits to a base mesh

Having previously taken our concept sculpt and high-poly assets and ZRemeshed each SubTool earlier, we've made the posing process easier. By having a low-poly base mesh for each SubTool we can easily paint masks and manipulate large areas of the character. Having an extremely dense SubTool can slow the process down with the

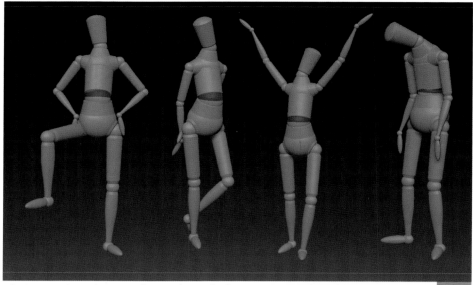

↑ Posture can change how your character is perceived – an open posture is confident and strong **06**

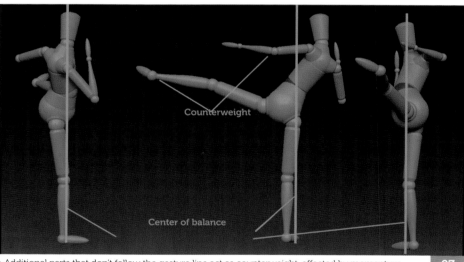

↑ Additional parts that don't follow the gesture line act as counterweight, affected by momentum **07**

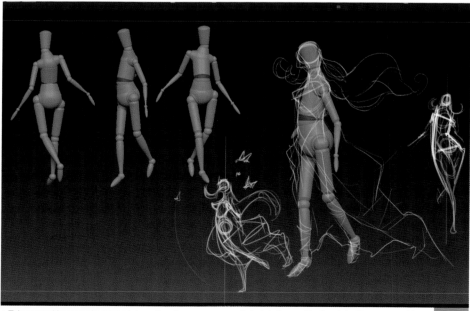

↑ Take your Mannequin poses into a drawing program and sketch the particulars into the composition **08**

↑ Using a low-poly base mesh for your SubTools makes masking and posing easier

`09`

frame rate, and also make moving the surfaces very tedious – like trying to pose melting clay.

10 Transpose Master

Using ZBrush's Transpose Master, we are able to merge all of the separate SubTools down to one tool at their base subdivision

level. The Transpose Master is located in the ZPlugin menu, and is the fastest way to position across multiple objects. Click the TPoseMesh button to create your TPose tool.

You can see why having a ZRemeshed base for each SubTool will make the process faster

and easier – you now have a version of the character that is merged and easy to manage.

Once the process is complete, you will automatically be switched to the TPose version of your character with the original high-poly in your Tool palette on the right.

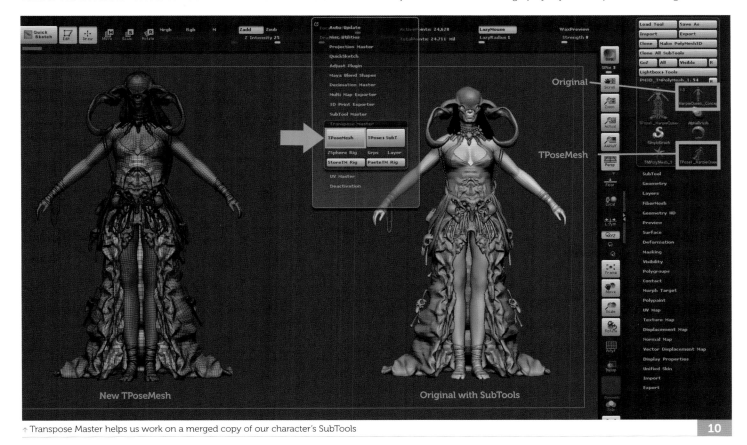

↑ Transpose Master helps us work on a merged copy of our character's SubTools

`10`

↑ Create clean masks by drawing down the topology with the Transpose line and the Ctrl key

11

"Remember the spine is your gestural line, the core to your character's body language"

11 Masking

There are three major ways I go about masking off areas of the character. The most convenient and accurate way is with the Transpose line, holding Ctrl, and dragging it down the topology. ZBrush will create a new mask based on the topology you are drawing on.

You can also Ctrl+Shift+click on polygroups to isolate them visually, and mask them (Ctrl+clicking on the document inverts the mask as well). I also use the MaskLasso brush to select specific regions. You can use all three methods together and find ways that work for you to speed up the process.

12 Torso adjustment

I tend to always start with the biggest parts initially. This is true in the case of design, sculpting, texturing, and even posing. To start my pose, then, I begin with the torso area, working from the hips upwards. I Lasso mask the lower body of the figure and use the rotation Transpose line in order to twist the spine as based on my conceptual pose work.

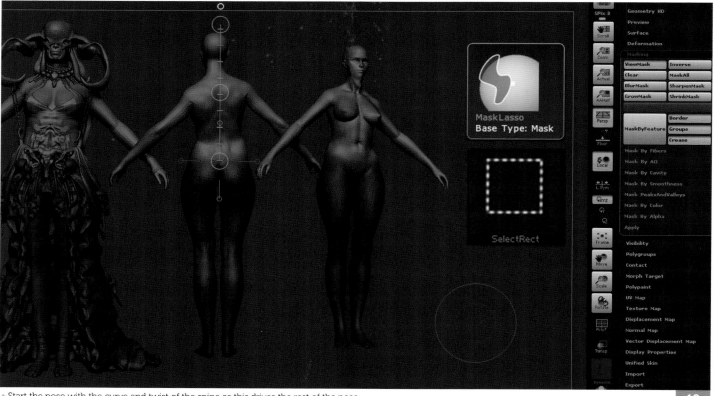

↑ Start the pose with the curve and twist of the spine as this drives the rest of the pose

12

Let the head and arms rotate with the torso; it will look a little rigid and awkward but that will change shortly. Remember the spine is your gestural line, the core to your character's body language. Be careful to represent the character as well as possible.

↑ The shoulder and hips are the foundation to your limbs – adjust them and the rest will follow
13

13 Shoulder and hips

I usually offset the shoulders and hips from each other as it creates a natural stance – a more restful and less robotic posture – and you will have a compressed and relaxed/extended side to the torso. This can also be used to enhance the character's flair or 'sass', making her a lot more confident and putting a lot of swagger in her step.

These alterations will play a huge role in the coming steps with her legs and arms. Remember to also twist the shoulders and hips from the top view as well, so she isn't so static.

> "Whatever you do with the head, whichever direction you chose, just know that it is now deciding your character's forward motion and will affect the limbs"

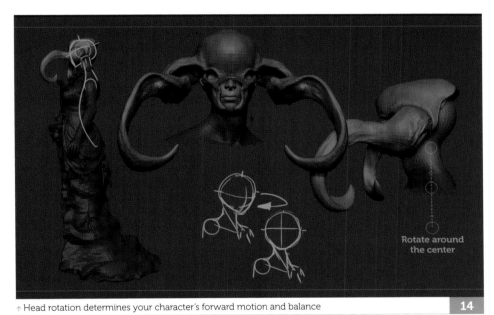

↑ Head rotation determines your character's forward motion and balance
14

Rotate around the center

14 Head rotation

Ideally the head's position should reflect the gesture and motion of the spine, continuing the gesture and completing the nice fluid motion of the body. However, sometimes you can counter that line, lowering the head so the jaw is in the chest as the back arches, creating an open posture – or maybe the chest twists to the left and the head looks to the right. This contrast can be very compelling and tells a bit about the character. Whatever you do with the head, whichever direction you chose, just know that it is now deciding your character's forward motion and will affect the limbs.

15 Lower body

Start the lower body by posing the legs first; the outer layers of clothing will be adjusted after. I like to work with the core on the inside and then adjust the outer layers. With the legs, use reference to determine which leg should lead in a stride. Keep in mind there will be compression in the buttock, unless the leg is extended – in which case the cheek will be at a resting position. Notice the feet are also not in a straight line, but instead they are pointing outward in different directions to ensure balance in the step.

New TPoseMesh

↑ The legs and feet ground the character, providing balance and a sense of weight
15

"When posing the arms with the Transpose line, it is important that you place the anchor point of the line inside the shoulder joint. Not on top, or slightly outside, but right in the center of the rotation point"

16 Counterbalancing the arms
For the arms, she will gesture towards the distance, where I will put one of her pet ravens on her arm. The other arm will be slightly behind her, counterbalancing her mid-stride.

When posing the arms with the Transpose line, it is important that you place the anchor point of the line inside the shoulder joint. Not on top, or slightly outside, but right in the center of the rotation point. This will ensure a clean adjustment, preventing the accidental slight relocation of the joint, which makes it look broken and requires fixing.

17 Gestural motion
Before we finish the pose in the Transpose Master, let's make some very big adjustments to the character in order to enhance the feeling of the pose. What I am describing is a subtle nudge here and there to amplify the gestural line of each element of the 'Harpie Queen'.

Using the Move Topological brush, I very gently move the highlighted parts of the character's body so the curves have more shape to them,

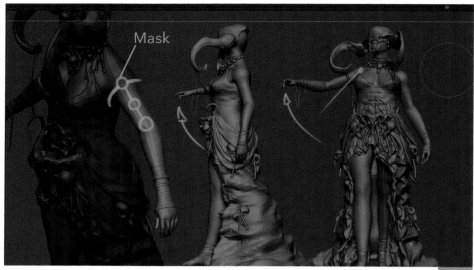

↑ The arms and hands work as a team, counterbalancing the motion of the character **16**

↑ Subtly adjusting the large shapes with the Move brush will enhance the motion of the character **17**

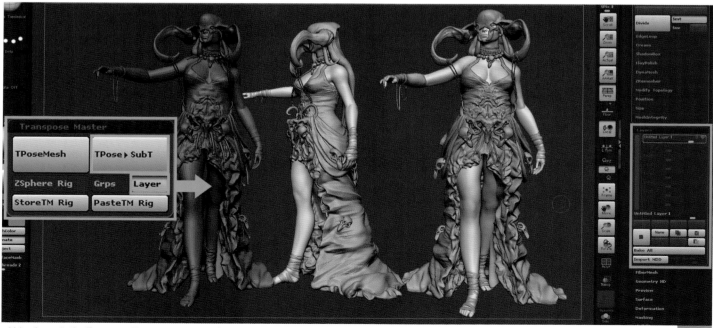

↑ Using Layer in the Transpose Master, you can continue working symmetrically across all SubTools **18**

↑ Chances are you will need to adjust the sculpt after posing

19

giving the pose more life, and natural gesture. Be careful you don't break any of the bones however, and don't make the character look too extreme if the style doesn't call for it.

> "You will see that each SubTool now has a layer applied to it, and in that layer is the pose data. This is extremely convenient because you can turn that layer off if necessary and continue sculpting on the character symmetrically"

18 Transferring the pose with layers

With our posing complete, we can now transfer this information back to our original sculpt. Be sure to save a ZProject however, just in case an error occurs (File > Save As).

Open the ZPlugin menu again and look in the Transpose Master submenu for the TPose > SubT button; before you click, ensure that Layer is also turned on. It will take a few minutes to transfer the data over, but once complete, you will see that each SubTool now has a layer applied to it, and in that layer is the pose data. This is extremely convenient because you can turn that layer off if necessary and continue sculpting on the character symmetrically.

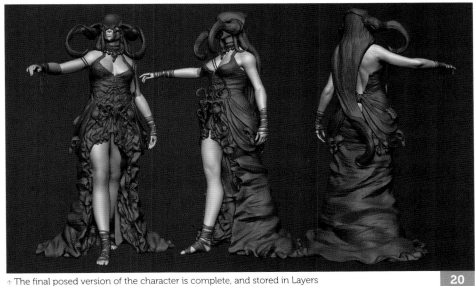

↑ The final posed version of the character is complete, and stored in Layers

20

19 Sculpting into the pose

Sometimes things don't translate quite as well as you would have hoped. No worries though, we can still make adjustments and corrections to our SubTools by activating the Record button to the pose layer. With Record on, you can make any number of changes to the SubTool that will only be apparent in that layer.

For slight adjustments like the foot wrap in image 19, I use the Move brush and the Move Topological brush to make large adjustments. You can also get

into the actual sculptural qualities of certain areas that need more subtlety, that you can only get at a higher resolution. When done, turn Record off.

20 Conclusion

To finish the character, I go through each SubTool at its highest subdivision level and comb through the details. If something is warped, stretched, or just looks wrong I turn Record on and make my adjustments in the layer.

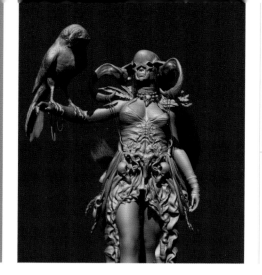

Chapter 05
Creating fantasy figures
Part 04: Sculpting detail

By Kurt Papstein
Freelance Concept Artist at Bad Robot

This tutorial will cover the refinement stage of the design and composition of the character. She's been concepted, sculpted, and posed, all in ZBrush. Now we will be adding important elements such as feathers and hair.

While much of this stage deals with ZBrush's FiberMesh, I will be spending some time talking about sculpting and posing very briefly, to incorporate these new elements into the existing sculpt. These new additions will drastically enhance the current iteration of the sculpt so we will also need to begin planning for our final composition and render. With a clear plan and direction, we can begin creating the new content that will be added, such as feather insert meshes, additional bird parts, and even some objects to be used with FiberMesh. Finally, I will cover how I handle complex subjects such as long, flowing human hair, shaping it into the final desired shape.

As an added bonus, I will discuss how I create her pet ravens! We will recap the steps we have come across so far in this chapter, applying them to something simple like her pet birds. With the completed raven I will also create multiple poses for use in the final renders. There's lots to cover so let's get started!

01 Developing the idea
I like to have a somewhat rough plan of where I want to go – especially with something as intricate as this that requires a lot of breakdown. So for starters, I'm going to go ahead and take some shots of the character as she is inside ZBrush and plan for the feathers, hair, ravens, and of course, the final composition of the render. By sketching very loosely over the renders, I can get a good idea of the visual flow I hope to enhance. Drawing quickly and gesturally will keep the energy high and the time spent to a minimum.

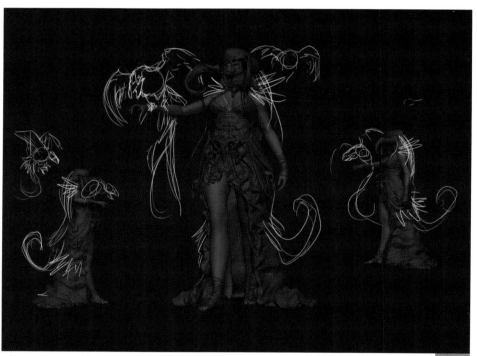

↑ Start out by sketching out some plans for the feathers and minion **01**

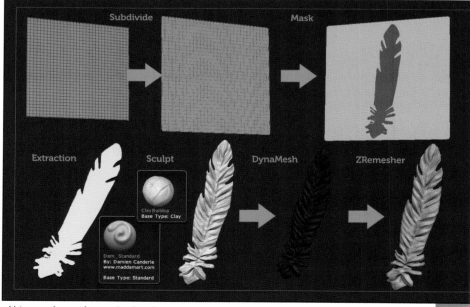

↑ Using a polygon plane, paint the silhouette of the feather; extract the shape for DynaMesh sculpting **02**

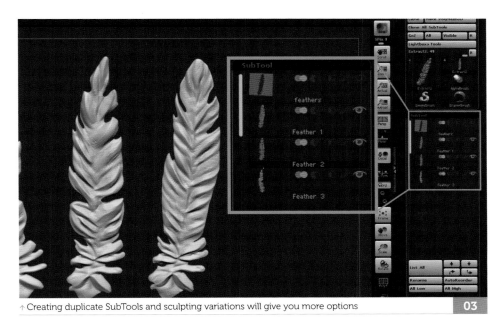

↑ Creating duplicate SubTools and sculpting variations will give you more options **03**

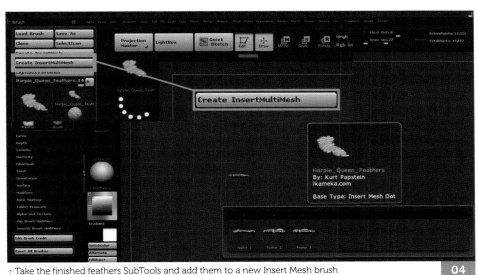

↑ Take the finished feathers SubTools and add them to a new Insert Mesh brush **04**

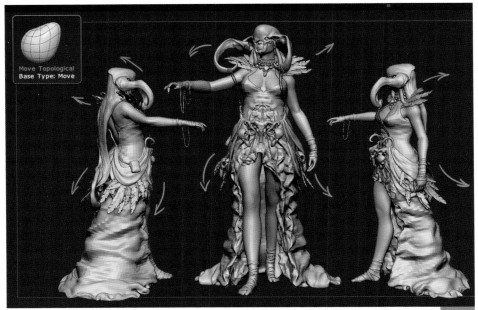

↑ Use the Move Topological brush to put a slight bend on the feathers to enhance the flow and gesture **05**

02 Sculpting feathers

With the plan laid out, I'm going to jump back into ZBrush and construct my needed parts. Using a plane in ZBrush, I start by sketching in a very clear silhouette of a feather. Ensure the plane has lots of subdivisions on it so you can be accurate with your shapes. Feel free to put in as much detail as you want. When finished, Extract the shape with some thickness, then begin sculpting on the extraction with DynaMesh and Symmetry on the Z axis to save you time sculpting the back.

03 Feather variations

With one feather complete, duplicate it a few times. With DynaMesh still activated for the SubTools, use the Move Elastic brush, SnakeHook brush, or something subtle such as the Nudge brush, to make some variations in the feathers. Try creating new lengths, and even reshape the silhouettes for further variation. It's okay if these are a little exaggerated.

Finally, you can choose to put in lots of high-poly details or ZRemesh them for later use as an InsertMultiMesh brush. Remember, with more polygons, the fewer instances you can use. This is okay though as these aren't going to be used to populate the character, just as large detail props.

04 Insert mesh

With all your feathers in one Tool, ensure that they are aligned and centered – use the Deformation > Unify button on each one to ensure unity. Also be sure you don't have any subdivisions, and that DynaMesh is deactivated for each. Looking down on the objects in the viewport with the floor plane as a guide, press the Create InsertMultiMesh button in the Brush menu. Note that however you are viewing the SubTools at the time that this is pressed will determine how it is drawn.

05 Gesture and detail

Using a dummy version of our character, we can place the InsertMultiMesh feathers. Click the Merge Visible button in the character's SubTool menu, which generates a new version of the character in a new Tool. Be sure you are working with the lowest subdivisions possible to make it easier.

Draw the feathers out in clumps; rotate them with the Transpose line; move them into place; then you can finish their shape with the Move Topological brush to adjust each one without masking. Putting a slight bend in the feather will feel more natural and have implied motion.

06 Hair cap

Moving on to the FiberMesh for our character, it's a good idea to begin by creating a new 'scalp' for the Fibers to be generated from. I start by duplicating the body or head SubTool, and hiding all but the scalp area.

With the hidden area deleted, you have a great starting point for your FiberMesh process. By creating this duplicate, you can be more certain you won't accidentally corrupt or damage the head and body SubTool. It is also setting us up for the following steps to run smoothly.

"If this is your first time exploring FiberMesh, cycle through the LightBox and view their settings to see what the big differences are in the values"

07 Polygroups for hair

Dividing the scalp SubTool into polygroups is pretty simple, and there are many ways to do it. I choose to hide parts of the mesh, and Group Visible under the Polygroups submenu. The polygroups give us more control over the Fibers of the head. Each polygroup will transfer to the FiberMesh generated from the SubTool, allowing us to hide, mask, and manipulate the Fibers in groups as opposed to one giant piece. Try to keep the polygroups to quadrants of the head. I plan for bangs, sideburns, and long hair.

08 FiberMesh hair

There are two ways you can get FiberMesh started. For both directions you need to open the FiberMesh submenu on the right in your Tool menu. You can click the LightBox > Fibers button to open LightBox and sample a collection of presets, or you can click the Preview button which will activate a simple FiberMesh cluster ready for tuning. I share the numbers I used at the start as an example of how you could match the look I was able to achieve. If this is your first time exploring FiberMesh, cycle through the LightBox and view their settings to see what the big differences are in the values.

09 Combing FiberMesh

This is where the Fibers start to take shape. First we have to get organized, which is what the polygroups will help us with. Work with one group at a time, and begin clumping it together with the GroomSpike brush. With the groups

↑ Duplicating the scalp of the character will allow us to easily create FiberMesh for her hair 06

↑ Create polygroups on the new duplicated scalp SubTool to control selection groups in the FiberMesh 07

↑ You can use the LightBox presets as a starting point, or build your own from scratch 08

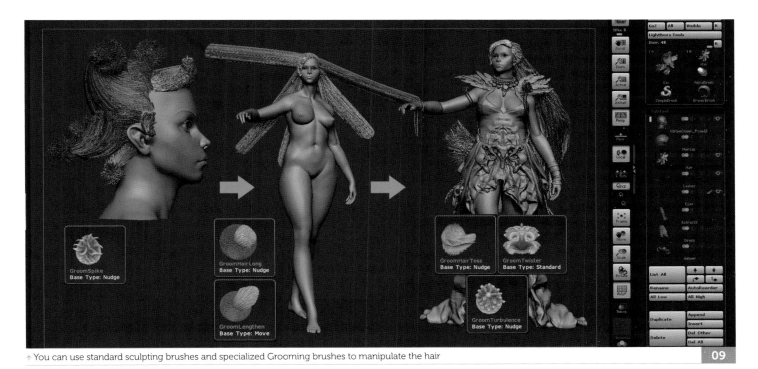

↑ You can use standard sculpting brushes and specialized Grooming brushes to manipulate the hair

09

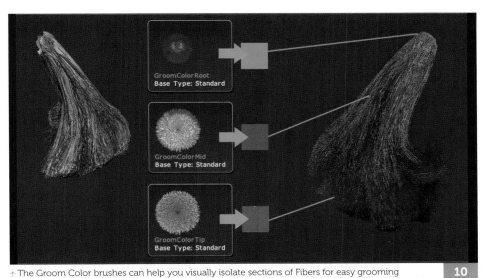

↑ The Groom Color brushes can help you visually isolate sections of Fibers for easy grooming

10

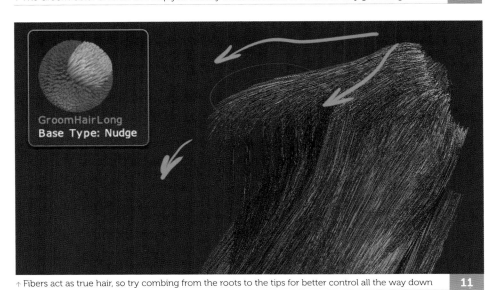

↑ Fibers act as true hair, so try combing from the roots to the tips for better control all the way down

11

pulled together, you can begin working each one individually with the GroomHairLong and GroomLengthen brushes. This helps you really pull the Fibers out into a nice long length. Finally, I begin to shape the Fibers with GroomHairToss, GroomTwister, and GroomTurbulence. With the polygroups it is easy to fix a section and start over.

10 Grooming with color

Sometimes it helps to have a visual guide to the Fibers. It can be a little confusing when it gets all tied up in itself, and you can't see where things are going. Using the Groom Color brushes, you can Polypaint the roots, tips, and mid-sections to all the Fibers. Using Rgb values makes it very clear and easy to see at first glance. You'll be surprised how some of the Fibers are too short, or in the wrong place! The Groom brushes can easily distort the look, and having a colored guide helps you straighten it out.

11 Grooming long hair

When it comes to long Fibers, it can be a little tricky. The reason the long Fibers are more difficult has to do with the lengths and segments on each Fiber. You'll probably notice that if you try to groom any of the long strands, you can easily accidentally move the roots or tips. Try to think of the Fibers like real hair; if you touch any part of it you will also adjust the rest. Using the GroomHairLong brush, you can make it simple by always starting at the roots. Treat the brush as a true hair comb, working down from the root to tip.

12 Tossing the hair

Tossing the FiberMesh with the GroomHairToss brush can be a lot of fun but it is also very destructive. Keep that in mind before you spend too long on grooming with your other brushes. It works very much like an intense Move brush or Move Elastic, but has a more realistic treatment with the Fibers. By moving an area, the tips of the Fibers are then pulled into motion in a whip-like effect – creating a very natural look. This can help enhance the overall flow and gesture of your sculpture with a very dynamic element.

13 Making it natural

Finishing up the shapes of my FiberMesh, I work each section in the polygroup at a time. FiberMesh can look very artificial when left alone, and it can be easy to spot. In order to

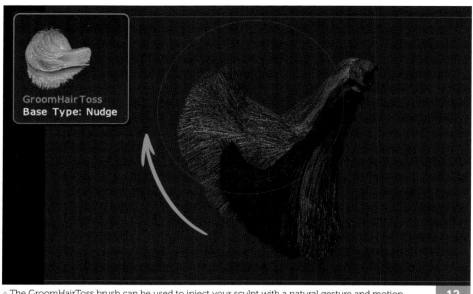

↑ The GroomHairToss brush can be used to inject your sculpt with a natural gesture and motion **12**

↑ Finishing the FiberMesh with brushes that will break up the predictable shapes and perfection **13**

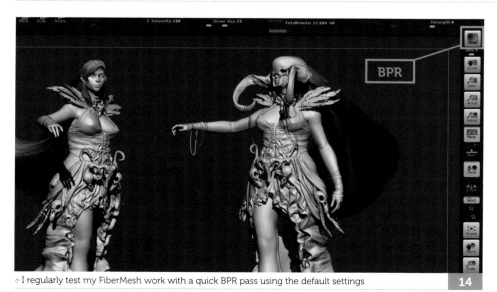

↑ I regularly test my FiberMesh work with a quick BPR pass using the default settings **14**

breathe some more life into the Fibers, and to make everything feel nicely tied together and unified, experiment with other Groom brushes.

I typically enjoy using the GroomTurbulence brush to sort of mix the Fibers together, creating a subtle criss-crossing look. The GroomBlower is perfect for the tips and also to put more volume in an area. GroomSpike is handy when you need to pull Fibers together.

"Do a quick BPR test to see how your FiberMesh is looking. I would recommend doing this throughout your process of working with FiberMesh"

14 BPR Fiber test

Without spending too much time in ZBrush's render settings, do a quick BPR test to see how your FiberMesh is looking. I would recommend doing this throughout your process of working with FiberMesh, so you don't get too far ahead of yourself. Simply clicking the BPR button should be enough to see how the final render pass might look in the end. Remember this isn't final, and we still have a way to go; but you should be looking for flipped Fibers, incorrect shadows, and it should feel natural.

> "I complete the feathers with ClayBuildup on Color Spray and low Z Intensity to fluff them up and create irregularities"

15 Minion armature

In my early sketch, I made plans for a minion of sorts. So let's get started on that by opening up a new 3DSphere in the Tool palette, converting it to PolyMesh 3D, and beginning sculpting with DynaMesh. Another great way to get started is with ZSpheres. Lots of people overlook them now, but they are still very useful for lots of projects.

When I'm designing, I normally start with the head or the torso. In this case, I begin with both and refine with a very limited choice of brushes. This helps me focus on the shapes and not the detail.

16 Sculpting the minion

Continuing in DynaMesh, the minion will be sculpted through to the medium shapes of the design. Try to shy away from putting in too much information and detail; we only want to get the idea out. The other thing I am focusing on is building out the future SubTools like the claws, eyes, and tongue. To achieve this, I have Groups turned on in my DynaMesh menu, and I place Insert Spheres for the different parts. Pulling their shapes around with SnakeHook and Move Topological, I keep them separate based on polygroups.

The beak and talons are pretty easy to sculpt. I use the Dam_Standard and ClayBuildup for the plating, cuts, wrinkles, and large shapes, and use the hPolish for the harder edges to the beak. Flakes is also helpful with a round Alpha and low Z Intensity, to bring out some of those hard edges. Finally, I sprinkle the surfaces with the Standard brush, a pin dot Alpha, and Color Spray, to pepper the surface with small bumps.

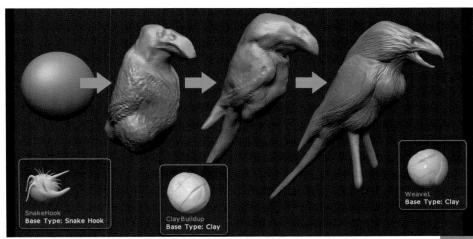

↑ ZSpheres or just a sphere with DynaMesh will help build out the basic volumes of the minion　**15**

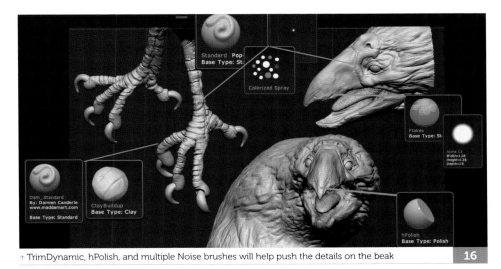

↑ TrimDynamic, hPolish, and multiple Noise brushes will help push the details on the beak　**16**

↑ Sketch the direction of the feathers; build up the volume; add texture with Weave and Clay brushes　**17**

17 Feather clumps

The feathers follow the standard sculpting method – big to small. Starting with Dam_Standard, I create my gestures and lines. I fill those lines in with volume using ClayBuildup and then planarize those shapes with hPolish. The Weave brush is used to create the fiber-like quality of the feathers. At this stage, I will sometimes go back to previous steps to change the look or pull a shape out. Finally, I complete the feathers with ClayBuildup on Color Spray and low Z Intensity to fluff them up and create irregularities.

18 Minion details

I end my time in DynaMesh by committing these shapes to ZRemesher for a clean and easily posed base mesh for all the different parts. Once ZRemeshed, I split the parts into their own SubTools for better control and detail through subdivisions. In total, all SubTools reach level 5 subdivisions, and I use brushes such as Dam_ Standard, ClayBuildup, and Standard to add detail and information to the minion. It's important to use ZRemesher because in the coming steps we will want to pose the minion with our Queen.

19 Merging characters

Now it is time to introduce our minion to his Queen. Let's begin by merging all the SubTools of the minion into one; be sure their subdivision levels are the same so you can maintain them in the new merge. This will make posing easy, and you won't lose detail.

Once merged by either MergeVisible or MergeDown, go back to the 'Harpie Queen' and click Append in the SubTool menu to select the minion. Once in the SubTool list, you can move him into position on her arm so he's ready to be posed into the scene.

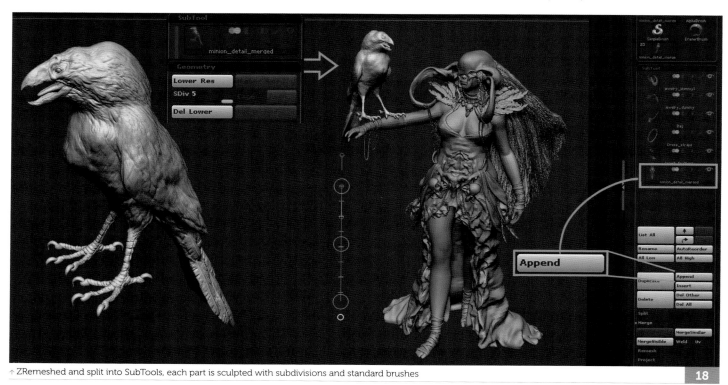

↑ ZRemeshed and split into SubTools, each part is sculpted with subdivisions and standard brushes

18

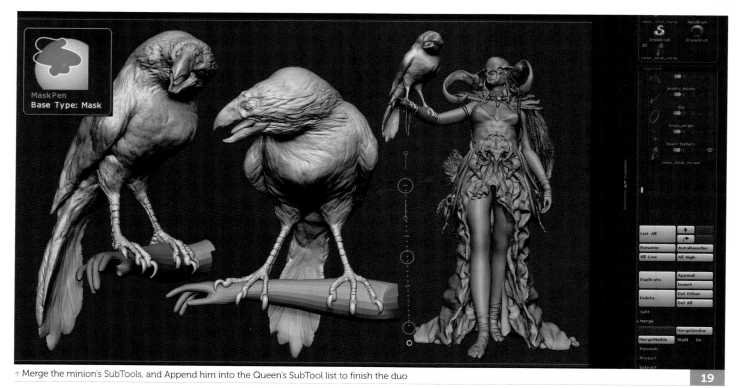

↑ Merge the minion's SubTools, and Append him into the Queen's SubTool list to finish the duo

19

"Make sure that you remember to consider her posture, her motion, and direction. These will factor into the minion's balance and posture as well; they also indicate the minion's own character"

20 Posing the minion

To pose this minion, I decide to hide all other SubTools excluding our Queen's arm where he is perched. Using the Transpose line with Move and Rotate, and the MaskPen brush to select areas to adjust, I am able to get a very quick pose out of the minion. It especially helps that his base mesh is pretty low. Make sure that you remember to consider her posture, her motion, and direction. These will factor into the minion's balance and posture as well; they also indicate the minion's own character. Finally check the composition at a distance.

21 Conclusion

We are now left with a completed sculpt. All of the meshes are present, FiberMesh included. We are far from done, however. From now, you can add materials, texturing, and of course, lighting.

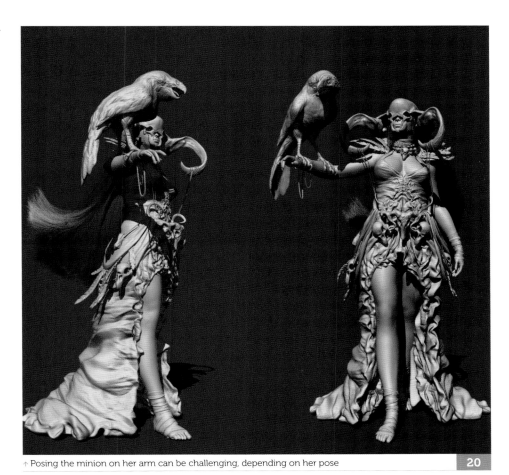

↑ Posing the minion on her arm can be challenging, depending on her pose

20

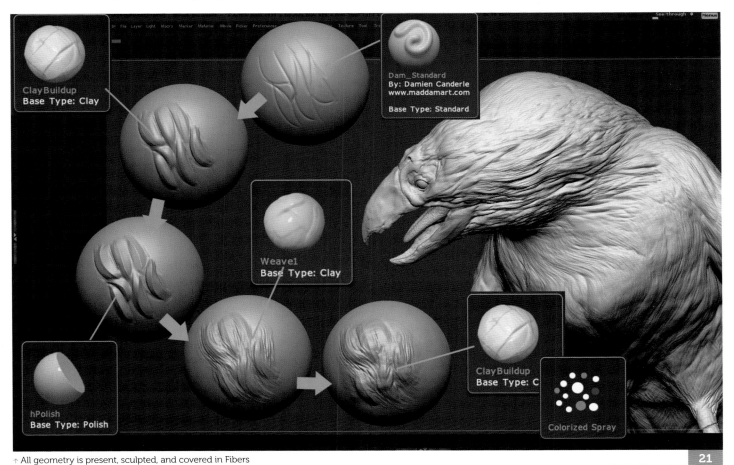

↑ All geometry is present, sculpted, and covered in Fibers

21

Chapter 05
Creating fantasy figures
Part 05: Texturing and Polypainting

By Kurt Papstein

Freelance Concept Artist at Bad Robot

In this tutorial, I will share how I go about using ZBrush to Polypaint our 'Harpie Queen' and her minion. I will share different techniques and tools to give you the most information about ZBrush, and maybe with this wide range of ideas you will come up with something totally new! I'm going to show you a bit about Spotlight, a very handy tool for using photos with your Polypainting. I also break down some of the basics with traditional dry-brushing and inking techniques you will find many model-makers using. These methods and more will be combined with layers inside ZBrush, to give us even more control with our textures.

Bonus content includes how I make some really quick and easy eyes, mostly as a placeholder but great for a quick sketch or bust work. This is followed up with another bit of information regarding masking and Polypainting over your photo texture work.

01 Color theory

To get started on texturing and Polypainting the character, we need to have a clear guide to where we are going. But first, let's talk a little about color theory. There are many rules and guides to follow when it comes to color choices. Complementary colors are a great direction to start with, giving you at least two colors to work with that complement each other from the opposite side of the spectrum. Using a Photoshop add-on named Kuler (**https://kuler.adobe.com**), you can spin the different handles on the color wheel to see what colors are complementary, triadic, compound, and more.

02 Mood and story

The colors you choose will set the mood of your piece, and even tell a little story along with it, such as how this character wishes to portray themselves, their demeanor, and their status. I usually try to pick one color that is the dominant

↑ Using the Photoshop add-on, Kuler, can help you plan out your color scheme easily and quickly **01**

↑ Make a collection of color themes – bright saturated themes induce a pleasant feeling and dark tones will be more ominous **02**

hue, with two minor colors, and maybe one additional trim color. This helps me focus my composition once we start throwing color down.

Bright and saturated colors are associated with happiness, optimism, and joy, while dark and desaturated hues give a feeling of sadness, dread, or gloom. Choosing your

colors is very important in telling your story, and describing who this character is.

03 Color composition

I've picked three or four color schemes that I like, that tell a similar story to our character with some slight differences. To prototype them, I work on top of a screenshot from ZBrush to paint over in

↑ With a select few themes, I paint over a duplicated screenshot of the character in Photoshop to previsualize the final look

03

Photoshop. I try adjusting Layer styles as well to get a different result! I paint in solid colors with no pressure sensitivity so the paint acts as a mask I can easily copy over to the other paintovers, and adjust their hues by selecting them and using a Hue adjustment. It makes the process very fast.

04 Planning the render

It is very important to keep your final composition in mind for your render. You need to keep your focal point clear, and remember what is there to support that focus. The 'golden spiral' is something you can find in nature, and almost every successful composition from the art world. It divides the image up into sections and shows the pleasing path our eyes like to travel. Taken from the world of math and geometry, artists use this guide to tap into something our human brains really enjoy. In every instance of my planning I make sure the 'golden spiral' works successfully.

05 Polypaint flats

Sometimes I skip the planning steps as previously mentioned, and dive right into painting on the ZTool in ZBrush. In this case, I do plan ahead with Photoshop, and I am able to just work from there.

By clicking the FillObject button in ZBrush's UI toolbar on the left, ZBrush will fill the selected SubTool with either color, material info, or both, depending on what you have activated for your brush settings (Rgb, M, Mrgb). I just make sure Rgb is active so when I fill the SubTool it only receives Polypaint. Seeing the colors on the model will help visualize your path.

↑ It's important to plan your focal points, and the 'golden spiral' is a great tool to explore the final composition again

04

↑ Transferring your paintover ideas to the ZBrush model is as easy as selecting your color, and clicking FillObject

05

↑ LightBox has a huge selection of photos in ZBrush that you can use for your texturing. You can easily preview your images as well

06

06 Using photos

Photos can provide a myriad of color and sculptural information when used properly! Opening LightBox and looking in the Texture tab will reveal the giant library of assets readily available to you in ZBrush. Just because a photo is unrelated to the subject matter I am Polypainting, does not mean it isn't useful. I begin loading multiple textures from here with the hope of using them in the coming steps. Double-clicking the texture will import it into ZBrush's Texture menu for later use.

07 Spotlight introduction

With your textures imported and loaded from LightBox or the Texture menu, you can begin loading them into Spotlight. Spotlight is a powerful widget-like tool that has image manipulation strengths, as well as the ability to float images over your work for Polypaint projection or sculptural projection.

In the Texture menu you will see a collection of Spotlight buttons to load images into Spotlight. With your image selected, click

that button, and you can begin using the Spotlight wheel to adjust the hue, saturation, intensity, and more, right in ZBrush.

08 Realistic feathers

I brought in a collection of raven photos I collected online for her minion pet. Some of them are taken of an emu, which has very pronounced feathers, that may prove to be useful.

Pressing Z will turn Spotlight's widget off, allowing you to paint from the photo directly

↑ The Spotlight widget is a mini image editor and organizer in ZBrush allowing you to add imported images to Spotlight from the Texture menu

07

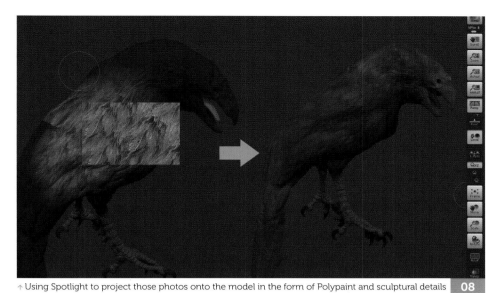

↑ Using Spotlight to project those photos onto the model in the form of Polypaint and sculptural details **08**

↑ Using photos of unrelated objects can still be very handy in breaking up the colors and giving life to a flat sculpt **09**

onto the model. The main goal with this technique is to cover your sculpt with photo information to break up the flat, airbrushed look that can be typical of Polypainted sculptures. Remember to use many photos, so you can mix them together in your texture.

09 Photos for variation

In image 09 you can see I'm using a photo that came with ZBrush. Planks of wood in this photo have some great color and pixel information to break up the smooth surfaces. Since we are just making a foundation to work on, it's okay that the photos don't completely match the subject matter. In fact, in many ways it's better because it will make everything harder to figure out on a technical level for your viewers. With the widget you can also adjust hue and saturation levels to get even more out of a photo.

10 Inking

The term 'inking' comes from the miniatures world, or model-making. It refers to the process of watering down your paint to an ink-like quality, so that when you paint it lightly onto your figure, it will seep down into the recessed areas. For this project, I want the recessed areas to be darker, with slightly more saturation. So I prepare to color sample from the flats of the sculpt to generate my next pass of colors. Using masking methods such as Cavity mask and Smoothness, ZBrush will protect surrounding areas we don't wish to paint on.

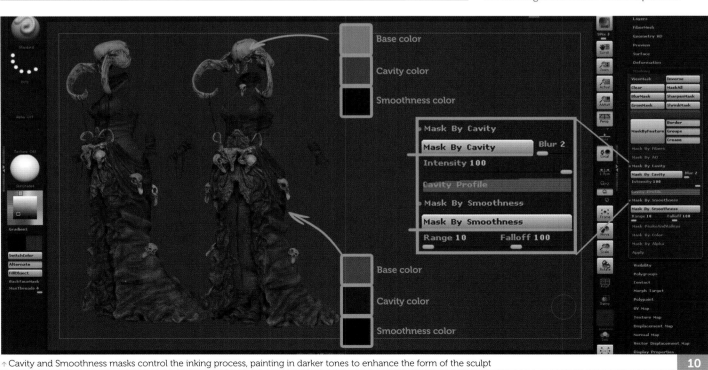

↑ Cavity and Smoothness masks control the inking process, painting in darker tones to enhance the form of the sculpt **10**

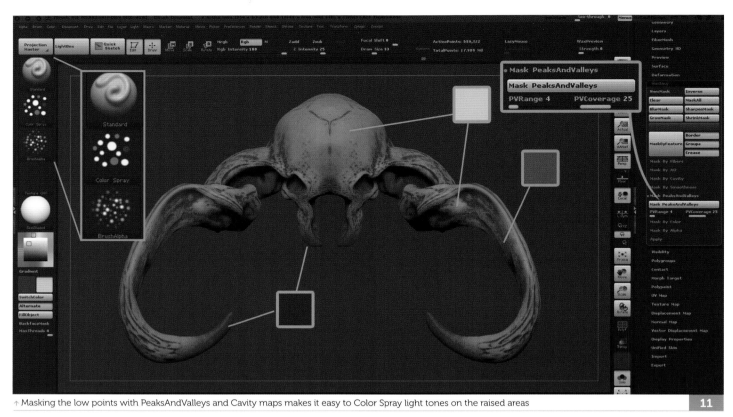

↑ Masking the low points with PeaksAndValleys and Cavity maps makes it easy to Color Spray light tones on the raised areas

11

"Taking a dirty Alpha with lots of noise in it to paint on the surface will give us the perfect dirt and grime layering"

11 Drybrushing

'Drybrushing' is a term also borrowed from the miniatures craft. It's about dipping your brush in paint and wiping it off on a paper towel until you see no more paint coming off. Then you can go ahead and paint on the miniature, which will catch the remaining light paint on your brush, lightening up the high points and highlighting the edges. The PeaksAndValleys mask works well for this, as well as Cavity masking again. Notice I'm also using Color Spray for my stroke, with a spotted Alpha to bring in more color variation.

12 Weathering

As I press onward, I continue to use those masking options to preserve areas of the sculpt while Polypaint resumes. To weather this character and make her feel more 'lived in', we need to go ahead and rough the surface up a little bit. Taking a dirty Alpha with lots of noise in it to paint on the surface will give us the perfect dirt and grime layering. Also the high points that would normally face the sun regularly should look a little worn and bright, with less saturation. This is the step that unifies the props and clothing to look more convincing.

☑ Top Tip
Photos and masking

A good combination of techniques is needed to create a successful texturing job. Starting with the Spotlight photo projection will break up the surface's airbrushed look and give lots of color information to sample. Using masks and a careful hand will unify the Polypaint with the sculpt again, creating a strong read and consistent form across the model.

Photos will only get you so far – in the end it takes an artist's touch to unify all the methods at work. I typically use Mask By Cavity at varying subdivision levels, as each one produces a different mask.

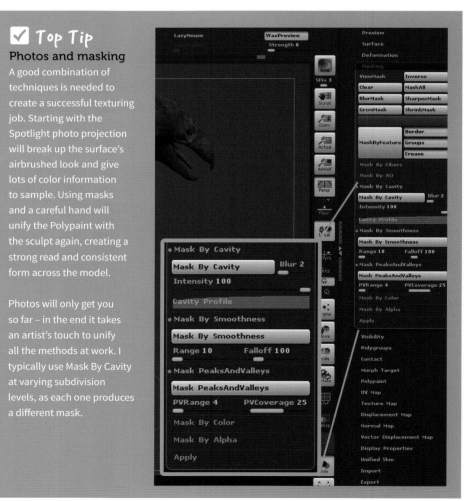

↑ Using masks to control where you Polypaint will preserve some of the Spotlight image work did

"I typically paint flesh with Color Spray, to make the color tone variation process go faster and make it way more believable. Nobody is a flat color; we have layers of transparent skin and some of that will shine through"

13 Setting up layers

I will use some different methods for her body. Let's begin with layers. Human skin is very tricky, and can be done in many ways. With layers you can control every aspect of human skin. You can see in image 13 that I have the pose layers on top, with three additional layers just created for Polypainting. I have it broken up like this: Human skin tones on top, blood vessels underneath

↑ Using DragRect and a grungy Alpha with the Standard brush, begin placing mud, stains, and other damage to areas of the character **12**

↑ Using a collection of layers in ZBrush, you can organize all of your Polypainting if you are unsure of the process **13**

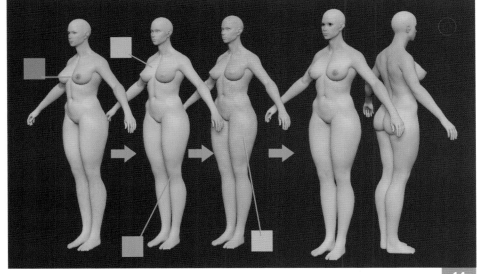

↑ Three layers and three Polypaint passes: Skin tones, blood vessels, and sub-dermal coloration with Color Spray **14**

that, and finally sub-dermal coloration which will give us that patchy flesh look. You can also use layers alongside Spotlight for photo projecting.

14 Realistic human skin

You can see the layering effect for the human skin in image 14. Normally I would say that you could manage this outcome by simply Polypainting over the model as is, but layers can help you fine-tune and adjust each step by adjusting the Layer strength slider. I typically paint flesh with Color Spray, to make the color tone variation process go faster and make it way more believable. Nobody is a flat color; we have layers of transparent skin and some of that will shine through. Don't be afraid to use a loud color like neon green. Remember the body is filled with warms and cools; treat it like an animal's color pattern, almost.

15 Photo texturing

Spotlight will come in handy again, allowing us to project from photos of the human body onto our character. Notice that none of them line up with the subject matter in ZBrush. I will use a man's palm wrinkle image if it has good coloration. You can put this into another layer, or you can just project it on the sculpt as is. For more control, decrease the Rgb Intensity of your brush to slowly watch it fade into the surface. You might only use these in a few locations – just always remember your focal points so you don't get carried away!

16 Unifying skin tones

Sunburns, freckles, and imperfections will unify the Polypaint and photo usage on the skin. Treat it like weathering the surface.

17 Additional color variations

I feel like the character is getting very monochromatic and needs something on the cool side to complement all the warm earth tones. So I choose a light blue, set my brush to Color Spray, and load a rough Alpha to break the airbrushed look up even further. I also do this to add more mud and dirt to the character's feet for believability and a little narration.

Notice the blue in the clothing (image 17) is only put in a limited number of places, mostly around the edges or large empty spaces. This creates a nice gradient of color and should help the composition a little more.

↑ As mentioned earlier, the photos you use don't need to match the sculpt exactly – extract what you need for color and detail

15

↑ Unifying the Polypaint using a series of imperfections such as freckles and sunburn

16

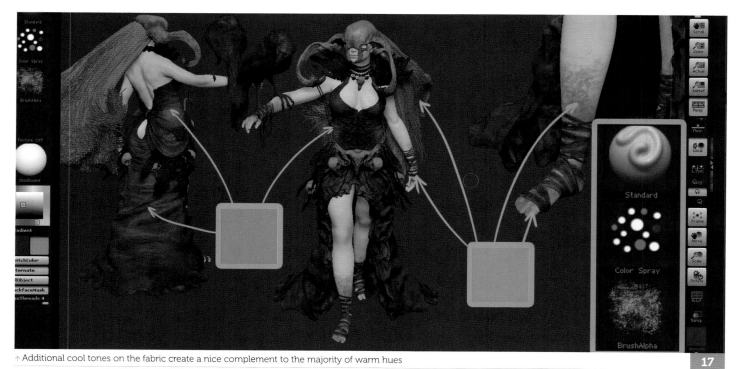

↑ Additional cool tones on the fabric create a nice complement to the majority of warm hues

17

"What I love about BPR Filters is that they are instant, so no need to render again! This saves me tons of time"

18 Render tests

With a majority of SubTools Polypainted, it's a good time to do some render tests in ZBrush. Whether or not ZBrush will be your final rendering tool, it's certainly fast, and makes seeing the final result faster. So in this case I do some slight adjusting to the top light, to better angle it based on my character's field of view. I also make some adjustments to the shadow render settings.

Increasing the shadow angle will spread the shadow out a little more instead of spending precious time blurring it in post production. If something stands out, or looks off with this simple lighting, then it might be a good idea to review your color work and get some opinions.

↑ Doing a render test will help us see if our Polypaint is in the right direction **18**

19 BPR filter testing

Using filters improves our basic render by a huge margin. You can see in image 19 that I used five in total: Saturation, Red, Orton, Sharpen, and Contrast Auto Color. They are pretty self-explanatory, and you can also do more adjusting in Photoshop if you wish. What I love about BPR Filters is that they are instant, so no need to render again! This saves me tons of time when working for clients and they want to see rapid adjustments.

Taking the BPR Filter tests into Photoshop to use additional tools, or even to paint over the render, is how we will wrap up this tutorial. It's been a fun stage and feels great to see it all come together in the end.

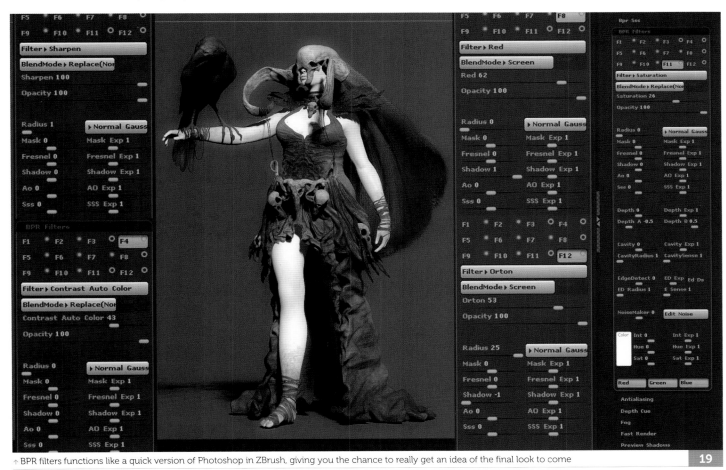

↑ BPR filters functions like a quick version of Photoshop in ZBrush, giving you the chance to really get an idea of the final look to come **19**

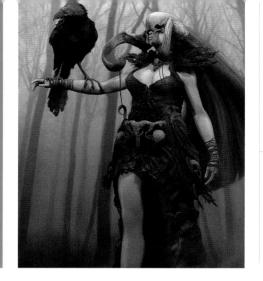

Chapter 05
Creating fantasy figures
Part 06: Lighting and post effects

By Kurt Papstein
Freelance Concept Artist at Bad Robot

Welcome to the final part of *The Harpie Queen*. This is where we take everything we've done and finish it up into one final shot.

In the last tutorial I covered texturing, specifically with ZBrush's Polypaint tools, and before that I covered the entire process starting from the conceptual stage, through sculpting the character, posing, and even FiberMesh. Moving forward, let's talk about the last bit of work we have on our plate. For the most part, we will still be doing our work in ZBrush.

Creating materials can be very easy; it is a matter of understanding the material and light relationships in the program to create

very convincing and realistic results. In order to simplify the process, I am going to share with you the way in which I create materials using only one starting shader. Having a simple yet versatile workflow is an important part of staying productive and not losing any valuable time.

Lighting in ZBrush is very hands-on, yet one of the most intuitive systems for an artist. If you like being able to tune the look of every aspect of a light, working it like an illustration, then you will enjoy this process. There are three major ways to build your lighting, and I'm going to walk you through the process.

Finally, I take you to Photoshop, where the final 10 percent of the work is done. This last little stage will either make or break your render, and many artists neglect this stage and call it quits before they really finish.

01 Material preparation
We need to prepare our ZBrush project for editing. Be sure to save any progress as a ZProject, by going to File > Save As. This saves out an instance of ZBrush, keeping your custom materials, lights, render settings, and sculpt, all in one big file. In the future, open your Project from the same menu.

For your materials, start by copying SkinShade4 from the Material menu, and pasting it over any

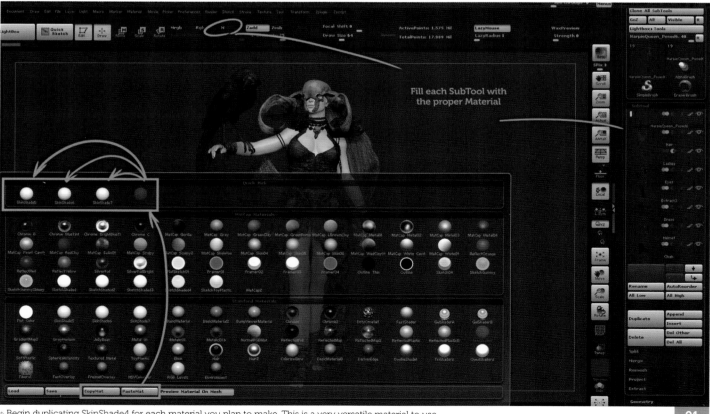

↑ Begin duplicating SkinShade4 for each material you plan to make. This is a very versatile material to use

01

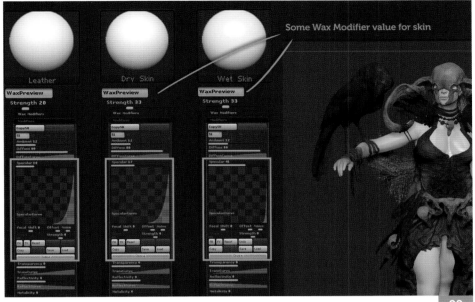

↑ Making some variations of wet and dry skin will give you flexibility. Also use some Wax Modifier for light translucency **02**

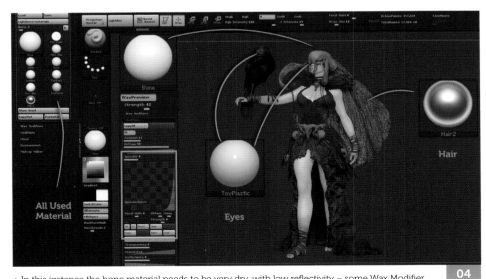

↑ Both material types require more of a soft velvet look, with the light scattering across the surface rather than reflecting **03**

↑ In this instance the bone material needs to be very dry, with low reflectivity – some Wax Modifier applied can help it feel organic **04**

"Most of my changes will be in the Specular options, making the reflections broad or tight, and increasing the intensity"

unused materials in the scene. I pasted mine six times, so I have five copies of the material. You can always make more later – be careful to not paste over materials you might want, though.

02 Skin and leather

Creating skin and leather is fairly simple. SkinShade4 is already set up to look like skin anyway, but I plan on doing some adjustments. Most of my changes will be in the Specular options, making the reflections broad or tight, and increasing the intensity.

I make a wet and dry skin material, as well as a leather. A steep curve and high intensity will yield reflective and wet results, while the opposite will look dry and less reflective. Each material uses some Wax Modifier, which can be activated in the Material menu, and the Render Properties submenu of the Render menu. A little goes a long way, so try to keep the value below 50.

03 Cloth and feathers

Like the leather material, I will have a very dry and low reflectivity material for the cloth and feathers. The fine fibers on the surface do not reflect light well, so we need to take the specularity in the shader and reduce the intensity, while at the same time reducing the curve in the specular graph. Only highly polished surfaces reflect light well, reducing the amount of friction the light particles come into contact with. Curving the graph upwards will spread the light across the surface more, making it much softer.

04 Bone

Creating the bone shouldn't be too difficult either. It should look rather dry and dusty; however, if you want to show off some more of the forms, there are some things we can do to keep it convincing without going too far. For example, using the specularity to highlight the high points is a good technique, so let's bring the value up a bit.

To reduce a very shiny feel, I'm going to increase the steepness of the curve so that it tightens the shine. Without it looking too wet, find a happy middle ground where you are just barely seeing the highlight. Remember none of this is final, we will come back to fine tune everything after lighting.

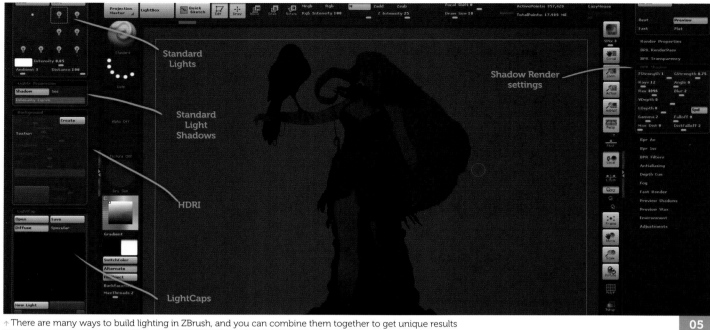

↑ There are many ways to build lighting in ZBrush, and you can combine them together to get unique results

`05`

05 Lighting in ZBrush

Lighting in ZBrush is really different to other software packages out there. Some engines use what is called 'physically-based rendering' (becoming more common with video games) and other engines use ray-tracing technology.

ZBrush uses a blend of techniques for lighting its unique 2.5-dimensional world. We are given a handful of tools and techniques to fine-tune the render into a realistic image. The important thing is to keep it simple at the start, so for now turn the light off by clicking the only light in the Light menu. You should have a dark scene now, ready for a new start.

06 Using HDR images

Using HDR images is a great way to build your lighting through LightCaps. Load your 2:1 ratio, 8000 × 4000 pixel image in the Light > Background submenu by clicking on the Texture button. Once an image is loaded, you can click Create LightCaps to build your lighting from the image. You don't need to use a 2:1 ratio image, any image will do. Even a painting! But if you wish to use the image as a background plate you need to avoid stretching by following the suggested dimensions. You can turn the image off from the same menu, by deselecting the On button.

07 LightCaps

With your newly created LightCaps, you can edit each light by selecting them in the LightCap submenu's preview window. Think

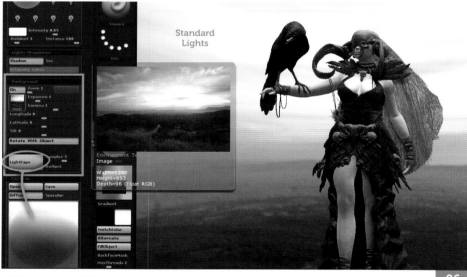

↑ Using an image, HDR or not, can give you a starting point for your lights. Any image can be sampled to create the desired effect

`06`

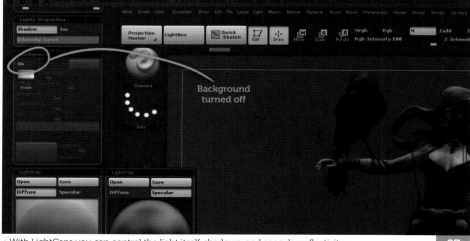

↑ With LightCaps you can control the light itself, shadows, and specular reflectivity

`07`

of this as a 2D representation of the lighting. You can also build them from scratch, clicking New and starting with a main light and a rim light. Click and drag it into position.

Each light has a Diffuse and Specular tab. The settings are fairly self-explanatory – a series of sliders are labeled in each tab to control the settings individually. You can even create a new HDR image by clicking Create Environment, so your background is in sync with the lights.

O8 Standard lighting

Your LightCaps might just be enough to light your scene, using a combination of HDRI and hand-adjusted lights. However, sometimes it needs a slight push. This is where I use a standard light.

Go back to the Light menu and reactivate the standard light by clicking its button. You can

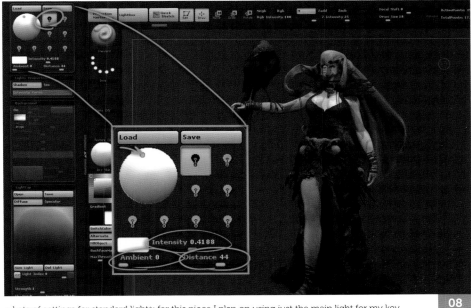

↑ Lots of settings for standard lights; for this piece I plan on using just the main light for my key lighting and shadows

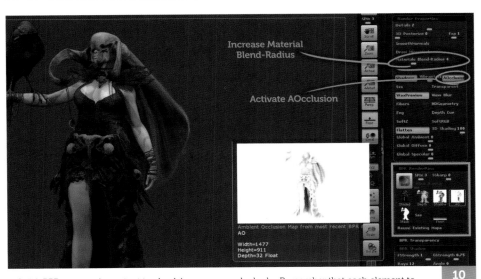

↑ Adjustments need to be made to your materials to work well with your new lights **09**

↑ Quick BPR tests are important to check how your render looks. Remember that each element to the render can be exported **10**

move the light just like in the LightCap menu, and adjust its intensity. Try to match the existing light's direction. You don't want this light to overpower the others, or blow out your model – it should just bring up the brightness a little bit.

O9 Specularity and material tuning

This is where we can start to control our Specular settings. By using LightCaps, you are sort of tied down to the light settings. You can control your material specularity settings a little in the Material > Modifiers submenu, but you are restricted to the Specular slider (this is the strength or intensity).

The sharpness of your specularity is determined by the LightCaps. Sometimes I will use multiple lights with Opacity set to zero in the diffuse tab, so they will only act as specular controls. Remember that less is more; I typically work with one specular light.

IO Render passes in ZBrush

With everything in control (for the most part), we can begin tuning our renders a little. Do some quick BPR tests (Shift+R) to see how the shot looks. Since our primary goal is to transfer these renders into Photoshop for final touches, we want to take advantage of ZBrush's BPR RenderPass submenu in the Render menu. Here you will see a list of all the different layers that are used together to produce the image that you see in the document. We can export each of these by clicking them and selecting their Save location. This can come in handy once in Photoshop.

11 Tuning the shadows

Shadows can be adjusted in a few different places. We can adjust the shadows of our lights, LightCaps, and our render settings. For our lights and LightCaps, you are essentially turning the shadow functions on or off.

For your standard light, look to the Lights Properties submenu under the Light menu to turn shadows on and off, while the LightCaps shadow settings are in the light's Modifiers. Global shadow settings can be found in the Render > BPR Shadow submenu. Angle will soften the light's spread in conjunction with Blur, and you have two strength options – one for the floor and one that is global.

12 Enhancing lights

The point of this workflow is to always move forward with simple additions, knowing you can enhance or change something very easily. Using BPR Filters under the Render menu, we can use filters such as Contrast Auto and Orton to enhance the lights. Activate any of the filter buttons by clicking the small button on the filter tab.

You can change the type of filter as well by clicking the Filter drop-down and selecting Orton, for example. The strength slider will increase the amount of filter use, and you can adjust the other sliders below in order to control where the filter is applied. In this case I can brighten the image, except for the shadows, to create more dynamic lighting.

13 Additional filters

You should play around with all the filters so you can see how they will affect your renders. I like to use Sharpen and Blur. Sharpen is a universal filter for me; I use default settings and increase the strength a little.

With Blur, I want to try to control it based on Depth, by putting the Depth slider to 1, and then adjusting the Depth A and B sliders to act as focus indicators. Click the sliders and drag to the closest point for Depth A, and desired out

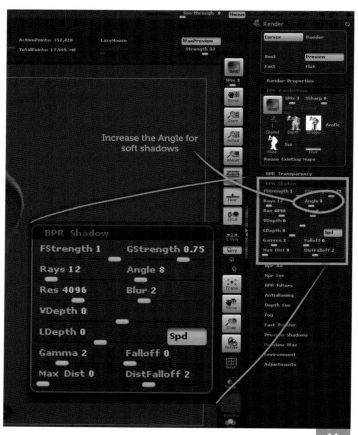

↑ Adjusting the shadows to your scene can drastically change the mood and quality of your render

11

↑ BPR Filters can be employed to boost your lighting, creating dramatic contrast, softer ambience, or overall brightness

12

↑ ZBrush is filled with BPR Filters that work much like Photoshop. You can adjust your colors, saturation, and even add effects

13

"Keep your character's lighting in mind when building the background; if you used an HDR image you could always just use that"

↑ Double your document size to work at a final resolution, and begin your renders. Save each element out for flexible compositing in Photoshop **14**

of focus point for Depth B. Remember we can also use Photoshop for these post effects.

14 Final renders

Before you complete your render, make sure you double your document size for good resolution. Go to Document > Double and accept the changes. You will need to redraw your character to the scene after holding Ctrl+N to clear the document.

Once your renders are done (Shift+R), you can export the render from Document > Export. Remember to export the different elements to the render from the BPR RenderPass submenu. Having all the elements will give you more to work with in Photoshop, though the main element I use the most is the Depth render for Lens Blur effects in Photoshop.

15 Compositing the final scene

The document in Photoshop should be well organized, with your character on its own layer ready for a background. For now I am only using the document export render with the other elements on backup, just in case. I do have the Depth render sitting in a new Channel, which will be used later.

We want to be as nondestructive as possible with our compositing, making new changes on new layers. Your Shadow and AO renders should sit on top as Multiply layers (currently not used, but just in case), and the mask should sit at the bottom for easy selections.

↑ Bring each exported element into Photoshop to be used in their respective layers. Keeping it modular allows for easy adjustments **15**

✓ Top Tip
Rgb masks

For added control in Photoshop, you can create what is called an Rgb mask. Go to Color > FillObject with Mrgb selected for your brush, and Flat material selected with a solid color.

Do this for each SubTool, without changing the angle of the camera of course, so it lines up with your actual renders. Turn off Shadows in the Render > Render Properties submenu. You can save your camera angle by clicking Cust1 or Cust2 under Document > ZAppLink Properties, so if you accidentally tumble the model, you can click that button again to snap the camera back to the proper location.

↑ Filling each SubTool with a Flat material and solid color will give you a mask for Photoshop

16 Background plate

For the background plate, I'm choosing to do some photo manipulation. Remember to get permission from the authors when borrowing images for your own art. Sometimes you can take pictures on your own well enough with just a phone, and with some image manipulation stitch them together into a new scene.

Keep your character's lighting in mind when building the background; if you used an HDR image you could always just use that. Organize your background edits into a Group in your Layers window to stay organized.

17 Rendering Photoshop lights

Working on a new merged copy layer, we can start to unify our image with a simple trick I use a lot in Photoshop. Go to Filter > Render > Lighting Effects to bring up the lighting tools. You can adjust the spotlights angle, which will create a vignette over your image and illuminate other parts. Less is more, so bring up that ambience and dull back the hotspot with the intensity so you don't over-expose your image. A little bit of this can do wonders, and you also have the ability to lower the layer's opacity to reveal the original before the filter was applied.

18 Hand-painting details

Now we have the image's basics down, we can start painting! Photo manipulation is acceptable if you wish to use more photos. Remember, the goal is to have a finished image that we are happy with, treating it as a multimedia piece.

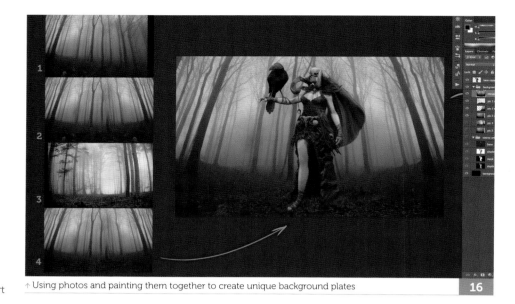

↑ Using photos and painting them together to create unique background plates 16

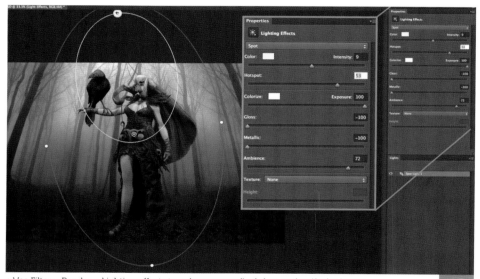

↑ Use Filter > Render > Lighting effects to enhance your final shot, and unify the image 17

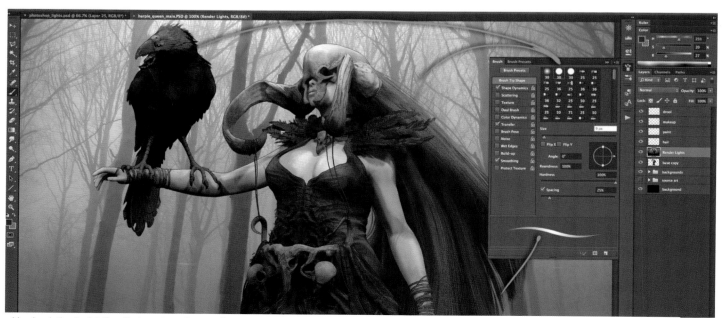

↑ Hand-painting in details, adjustments, and extra effects can take your image to the next level 18

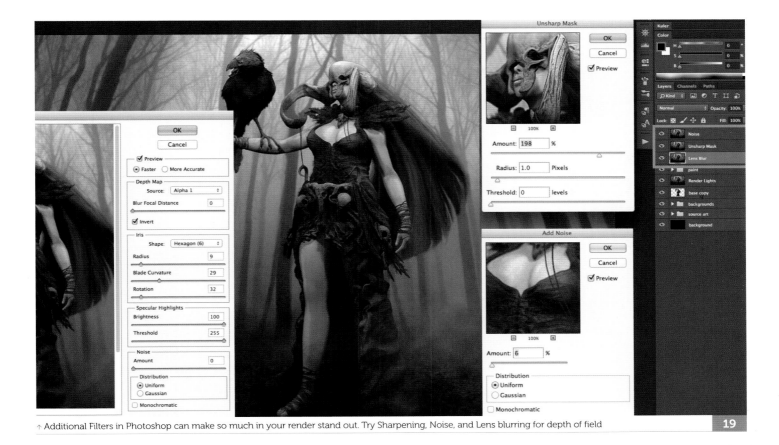

↑ Additional Filters in Photoshop can make so much in your render stand out. Try Sharpening, Noise, and Lens blurring for depth of field

19

I start by working on a new layer with a Hard Round brush, and begin color sampling around the area I wish to paint. In this image, I wanted to help push the feathers a bit more, make her hair more dynamic with some random strands, and also add more feathers to her minion.

19 Post effects

Just like we used BPR Filters, we will be using some more post effect work on our final flattened copy in Photoshop. So with a new merged copy in our layers, we can start melding all these elements together. Starting with Filter > Blur > Lens Blur, make sure you have Channel Alpha 1 selected – this is your Depth render. This will make things further away in your depth blurry, and so creating a realistic depth of field. Also click Filter > Sharpen > Unsharp Mask to pop the features out. Noise can be added in small degrees for a film grain effect as well.

20 Final presentation

When everything is complete, you are left with a well-polished image that was created using many different tools and techniques. You can repeat this process for additional renders of your character, and if planned properly, this process can be a very easy task of just copying settings and adjustment layers.

☑ Top Tip
Clouds and dust

In Photoshop, create some additional layers before your final post effects work (Lens Blur and Sharpen). Fill these layers with clouds by clicking Filter > Render > Clouds, and set the layer to Multiply, or Screen for different effects. Use a large soft round brush to erase areas you don't want covered. Having dust particle layers will add to the realism – you can hand-paint them in a new layer with a soft brush and scattering applied.

Having multiple cloud layers and dust layers can help you merge the scene together with the background, and create a lot of depth. Use your masking layers to remove the clouds from parts of the image, to put them behind the character.

↑ Adding layers of clouds and dust to your render can help it feel more real and tangible

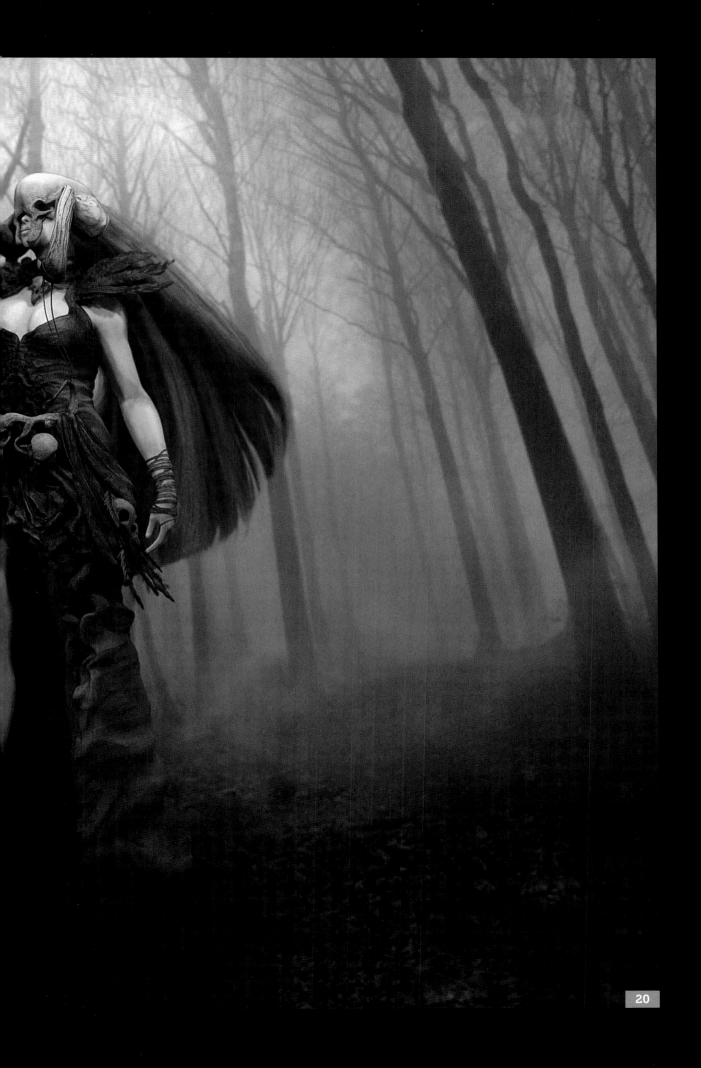

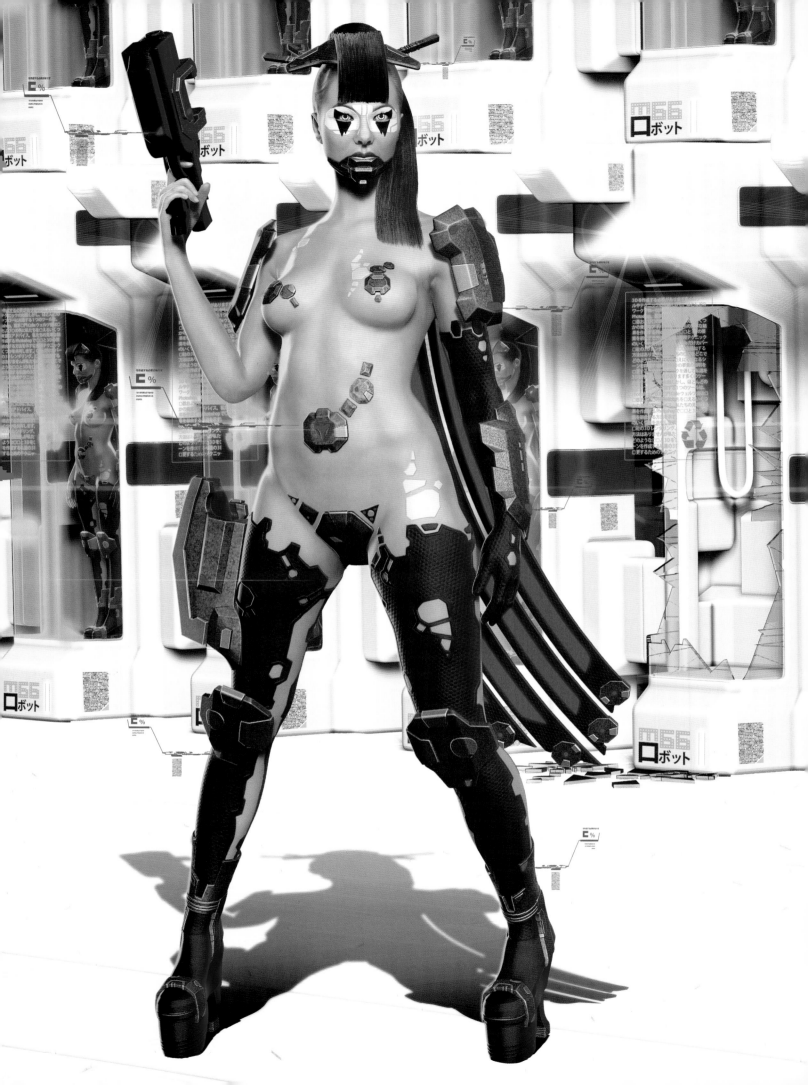

Sculpting a
sci-fi character

Encounter the ZBrush tools and techniques
involved in creating your own mech model

Following on from Kurt Papstein's inspired female fantasy figure, we now take
an in-depth look at creating a popular sci-fi icon – the cyborg soldier. Freelance
Character and Games Artist, Piotr Rusnarczyk, works through the complete process
of character creation, and reveals some of the more common tools and techniques
you can expect to encounter when working on your own ideas. Focusing on
creating a rough character to start, complete with detailing and Polypainting, Piotr
then explains how to incorporate a narrative into your image in order to hone the
final details and morph your mech warrior into something truly magnificent.

Chapter 06
Sculpting a sci-fi character
Part 01: Base model creation

By Piotr Rusnarczyk

Freelance Character and Games Artist

'Google is your best friend' is a phrase you'll be hearing a lot while working in digital art. I believe this is the best advice when starting out any new project. I suggest that you browse through renowned CG portals in search for inspiration, and then create a reference folder to store all the best pictures you can find in adequately titled subfolders.

For this particular brief, to create a female character, you can search for words associated with that topic for inspiration – for example, 'soldier woman' or 'futuristic female'. You can also search for accessories, such as 'cyberpunk gun' or 'futuristic armor'.

If you want your work to look realistic, browse through references that offer photos of human bodies taken from all possible angles – front, side, and three-quarter photos are the best.

The human brain works like a disk drive; you should therefore feed it with as much data as you can by observing paintings, movies, or fashion photography – even a historical weapons exhibition can be useful. The more references you pile up, the more knowledge about the objects in question you'll gain. You'll learn about their shape, color, and usage. From there, you can focus on the most interesting objects and try to modify or deform them using your imagination.

01 The base mesh
First, open the LightBox bookmark, then open the Tool bookmark and choose the model called 'Julie.ztl'. This is going to be our base model. I use this particular one a lot because it has a decent topology and good proportions, and it saves time I would have spent on creating a model from scratch. Remember to remove layers and subdivisions before starting.

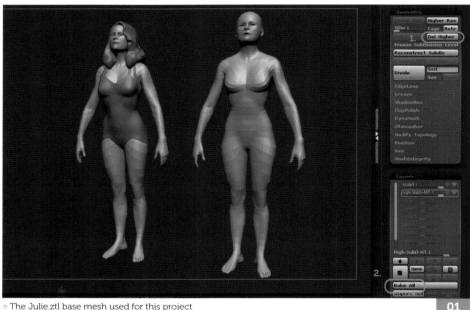

↑ The Julie.ztl base mesh used for this project
01

↑ Import reference image; use a grid to match the model proportions to it. Photo reference © 3D.SK
02

02 Proportion
Place the model according to your references and match its shape with a grid. Initially we will only use half of the model; every deformation will be done using Mirror in the X axis. Use the X shortcut constantly while sculpting – we're going to work on an android character so perfect symmetry of the body will help accentuate its artificiality. Our aim is simple – to model and paint the female model as a base for sci-fi armor and weapons.

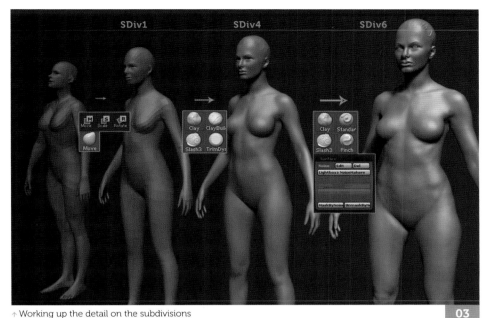
↑ Working up the detail on the subdivisions **03**

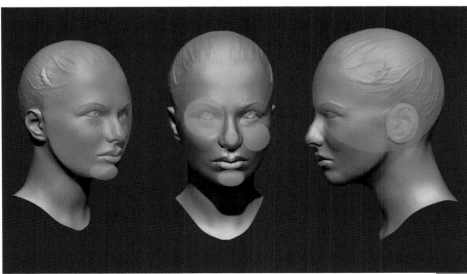
↑ Using the Mask to create polygroups **04**

↑ Using circles to create the female face **05**

The ZBrush interface is intuitive and flexible, so don't be a slave to default mode. Take some time to give your work spirit by using a variety of color and palette configurations. Use the ZBrush layers for sculpting. When your object starts taking the desired shape, use one of the layers for saving details – you can save different modifications and preview them at any point in the creation of your image.

03 Using subdivisions

We can now refine the model by working up the subdivisions to complicate the mesh. To start, use SDiv1–4. Here, concentrate on giving your model the right anatomical shapes. Use brushes like Clay, ClayBuildup for adding bulk to the shape, and Smooth for smoothing, as you would with real clay and your finger. Use TrimDynamic for trimming the excess of the 'clay', as you would do with a knife. Use Slash3 for defining cracks and nooks in the clay, as you would with a sharpened stick.

Then, moving to SDiv5, try to define the character and make it stand out on its own. Facial features such as the nose or lips should be defined by now. Use the SDiv6 layer for skin details – pores, lip skin detail, fingernails, and so on. Your main brushes at this stage will be Surface and Slash3.

04 Preparing your model

Divide your model into polygroups. You'll be able to work on a designated area and not see the others, which is useful for detail-work. Polygroups make managing the model parts easier.

05 Shaping the face

There are a few points that need you'll need to take into consideration when modeling a female face. Eyebrows, particularly their positioning against the center of the eye, are important to get right. In a man's face this area is much smaller and resembles a square; men's brows and eye shapes tend to be sharper.

Many sections of a female face may be drawn into a circle or into other oval shapes; if working on a male face we would use rectangular shapes. It may sound obvious, but these basic tips have helped me find proper proportions many a time.

There are also elements that build facial beauty: Big eyes, full lips, and a long neck. Everyone has their own preferences – I prefer the line of the neck, connecting the jaw with the collarbone. This line makes the model's neck look slim.

06 Shaping the body

Circular shapes are not only good for modeling the face, they also come in handy when modeling the rest of the body; breasts, tummy, buttocks, and thighs are all elliptical.

When it comes to breasts – contrary to the belief held strong by many men – it's not about the size, but about the shape. The direction in which they're pointing, nipple positioning, and the way the breasts are attached to the muscle mass of the ribcage are important factors, too.

Protruding hip bones are a desirable article among the ladies – fashion models have them, you see. I wouldn't exaggerate this feature, though; it's not about dress sizes but about the shape of a line connecting the beginning of the bone with the end of the thigh muscle.

The inner line of the thigh is an important detail, too. When done right, this showcases the model's femininity. This line shouldn't be a straight one. It should consist of three imbricate ellipses: Small, medium, and a big one.

Calves shouldn't be too protruding. The important section here is the line in the middle that connects the shin bone with the muscles. Our model will be wearing shoes so high-heeled women's legs would be a sensible reference – shaping the foot as if it's in a high-heeled shoe is crucial.

"Our character is going to be wearing a suit, so there is no point in us dabbling about in the details concerning the knees or the ankles. What we require is a base that we can paint over; we don't need the ultimate render"

07 Finishing the face: Eyes and eyelashes

Use a sphere for making the eyes. Make little nooks in the ball while rendering in the place where the iris will be. The edges will deflect the light, imitating the iris gleam.

Use Plane3D for the eyelashes. Increase the subdivisions as much as possible (6–7) and, using the Mask tool, paint a comb-like shape and extract it. Next click Unify in the Deformation drop-down menu, and use Gravity for bending the object so that it matches the upper eyelid.

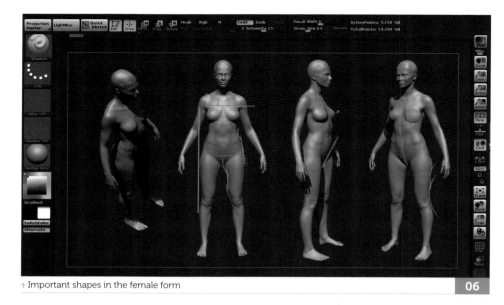
↑ Important shapes in the female form 06

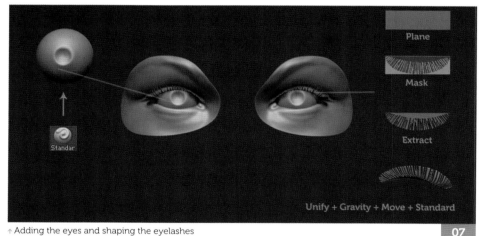
↑ Adding the eyes and shaping the eyelashes 07

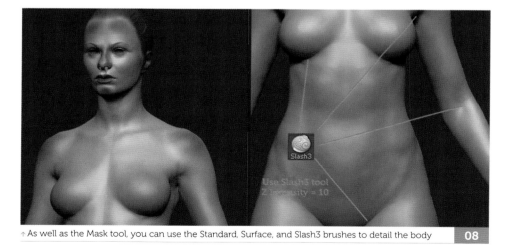
↑ As well as the Mask tool, you can use the Standard, Surface, and Slash3 brushes to detail the body 08

Gravity changes the eyelash size, so it has to be rescaled and molded for the eye.

Use the Move brush for details such as the shape of the lashes. Then finish by using the Standard brush for bending the lash upwards so it looks curved. Try to avoid making your task more difficult by wasting time – that is, don't tinker with the parts that won't be visible anyway. If you're producing a model or an illustration, the detailing may be left as only as good as the picture's definition. Remember, you can always redo certain parts of your model and give them higher detailing later in the process.

08 Detailing the body

Our character is going to be wearing a suit, so there is no point in us dabbling about in the details concerning the knees or the ankles. What we require is a base that we can paint over; we don't need the ultimate render. Note that both the Surface tool and Masking will be particularly useful to us at this stage in the process.

Let's begin with the entire character and paint the most protruding areas first – we need to remember to be subtle about it, though. Create a layer called, for example, 'Noise Global', and use Noise on default settings. Next click the 'Apply to surface' button. As you can see, the noise places itself evenly over the model parts, which simulates skin pores.

↑ Refining the detail on the eyes and lips **09**

↑ Changing the model skin material to skin shader. Photo reference © 3D.SK **10**

↑ Retouching areas of the image to create a more convincing texture **11**

09 Masking and painting

Remember those polygroups we had? Now's the time to use them. Hide the entire body, except the face and the neck. Next, paint the lips with Mask, reverse the Mask, and go to Surface and change the following settings: Scale to 3.7, Strength to 0.0003. You can do the same with the eyes, too – apply the following settings: Scale to 1, Strength to 0.0007.

Now some areas could benefit from being brought out by Slash3. Concentrate on the places under the breasts, armpits, and also the inner part of the wrist.

Spotlight is a comfortable and powerful tool when it comes to texturing detailed objects and base textures as well. Combine it with Polypaint From Texture for maximum effect. Check out the Spotlight options Hue Saturation or Contrast, too – they work almost as a Photoshop app inside ZBrush.

10 Skin texturing

I find that high-definition skin textures downloaded from professional sources work best. It's important to create your own reference kit. Get your textures from high-definition quality face and body photos or snap your own pictures if you can – just remember to use diffused light, as every shadow is a hindrance (you'll have to waste a lot of time removing it from your model later).

Change the model material to skin shader with the color palette swapped to white. Load the photo into the Textures window. Use Spotlight and the Standard tool (with the Zadd or Zsub option disabled). You can also leave only Mrgb on, and switch Rgb Intensity to 100%.

"Retouching is inevitable when using a texture taken from a photo"

11 Polypainting

Retouching is inevitable when using a texture taken from a photo. I use the Standard tool for it, with options as follows: Strokes: Color Spray, Alpha: 07, and Rgb Intensity: 10. For the hair, I use: Strokes: Dots, Alpha: 58, and Rgb Intensity: 40.

If you decide that you want the color of your brush to match the color of the applied texture perfectly, use Picker (C shortcut) when loading color from the texture.

12 Painting the eyes

You now have to decide what eye color your character will have – blue, brown, aqua, or maybe red? Browse the web for HD photos of the human iris or work on your personal model using Macro mode. It's good to create a few different color versions of the iris in Photoshop. You can do this using Hue/Saturation or Color Balance as well.

Load your texture into ZBrush and then apply it to the surface.

13 Posing

The Transpose Master works in a similar way to bones in other 3D programs. You'll find it useful if you have any experience with rigging. Difficult areas, such as wrists or ankles, will need extra bones to help control the bends.

After loading the model from Pose to SubTool, you'll have to carry out further corrections. Set SDiv on 4 and use the Move tool to touch up areas that might get deformed while positioning the model.

14 Rendering

Focus on the face and the whole body of your model while designing. Create a render of the face and cleavage first. Set shadows to soft, so as to make under-painting the uniform and weapon elements easier and fit better with the body. Don't worry about light – the default one in ZBrush will do just fine. In the Document bookmark you'll find a switch to send your render to PaintStop.

"Silhouette is a great way of starting to concept our model – you can create a general shape using a few quick brushes; use your imagination and express yourself!"

15 Silhouettes

Silhouette is a great way of starting to concept our model – you can create a general shape using a few quick brushes; use your imagination and express yourself! Use a Flat Color material and change its hue to black, then set the document background and click BPR. Next move the document to PaintStop and work on it until something interesting emerges.

16 Over-painting in PaintStop

You can complete this stage in a 2D program of your choice; however, I think getting the

↑ Deciding on an eye color and loading into ZBrush 12

↑ Positioning the model with Transpose Master 13

↑ Setting a Soft shadow to the model, with Rays of 100 and an Angle of 100 14

hang of PaintStop is a good idea. It's very comfortable to use, and most importantly, it is at hand. Its layer edition may not be as sophisticated as Photoshop but it still helps to make decisions about the character's design.

My personal favorite brushes are the Pencil, Felt pen, and Air Brush. Brush editions resemble the tool edition in ZBrush as well – you can change them quickly by punching the space bar on the keyboard.

In order to create the silhouette, I sketch the character's draft using the Pencil brush, then fill in the color using the Air Brush, and apply light and shadow using the Marker. I don't tend to use the Eraser for corrections – I prefer using the Felt pen set to correcting mode instead.

↑ A range of potential silhouettes for the character 15

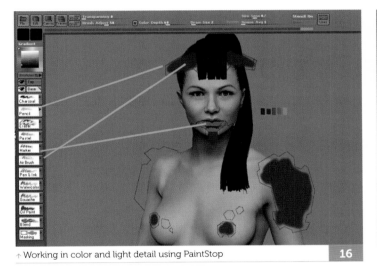
↑ Working in color and light detail using PaintStop 16

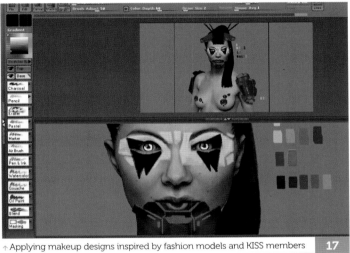
↑ Applying makeup designs inspired by fashion models and KISS members 17

↑ Improving pose and finishing effects in Photoshop 18

17 Makeup in PaintStop

Inspiration for this character's makeup comes from fashion photos and traditional Asian aesthetics. KISS-style (the band) makeup also enhances the character's bad-assery – she's supposed to be intimidating, she's a gunslinger after all.

I give the armor only a cursory treatment as I intend to detail it further in ZBrush in the future. I want this character to be aggressively sexy so I give her as little clothing as possible.

18 Final model

Sooner or later all pictures end up in Photoshop. I use a Quick Mask for editing one of the legs' poses then repose it using the Transform tool. I merge two over-paintings into one, over-paint flashes on the red lights with Vignette and voilà, it's finished! We now have a base model with basic textures that we can develop on in the next stage.

Chapter 06
Sculpting a sci-fi character
Part 02: Detailing the character

By Piotr Rusnarczyk
Freelance Character and Games Artist

So we commence another stage of our work. I'm sorry to say that this part won't be as much about creative as about technical thinking. Naturally, a pinch of creativity is allowed at every stage – we can still smuggle small reinterpretations of the concept in. Small is the name of the game here, though. The whole retopology process and model detailing is, in my opinion, the dullest part of the job. Unfortunately it's also the most time-consuming.

However, after hours tediously spent on perfecting our model, it finally starts taking shape. The surfaces are smooth like they should be, while layered details please the eye, and our co-worker, who was just passing by, stops midway and says in awe: 'Dude… you've got skill.' So – put your earphones on (an appropriate soundtrack really helps!), grab your graphics tablet, and get to work!

01 Modeling the hair
We start with the head. Hide the rest using polygroups – it will make matching and modeling all the elements of the face easier.

Pick the Cylinder tool and remove the upper and the lower part, along with some polygons, from the circle. Adjust the element according to the concept so that it is shaped as hair covering the forehead. This element is going to be our base for posing the hair in FiberMesh, but we'll get to that part later.

Use Extract with Thick option set to 0.005. Treat all those settings as general, though; the thickness of the object (that is, the bangs) should mirror the thickness of its real-life counterpart – say, 2cm or 3cm thick.

We use the same proportions for the ponytail. Next we create a bun of hair on the top of the

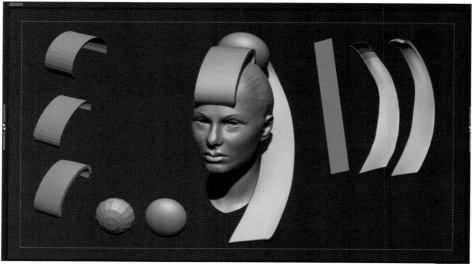
↑ Drafting the first models of the hair　01

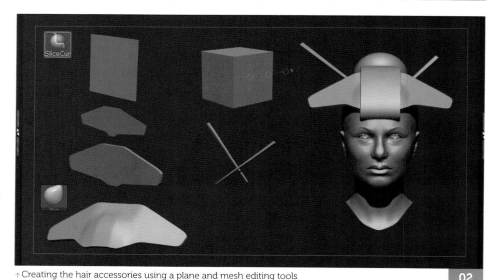
↑ Creating the hair accessories using a plane and mesh editing tools　02

head using a sphere, and the first draft of the hair is done and ready for further work.

02 Head armor
We shall start the mechanical parts of her head armor using a simple plane. Using a Slice Curve tool (hold Ctrl+Shift to use), cut out the shape we

outlined at the concept stage. Next, click the Tool icon, and an additional tool menu will appear. Click Draw Polyframe so you have a good preview of the cut. When using Curve tools, double-clicking Alt during editions will result in breaking the curve. Make sure you master this technique because it will become handy in the future.

As soon as you get the right shape, use Extract to give the model's head a proper sense of mass. Use the Wings selection and carefully bind them downwards, using the Rotate and Mirror (X) options. Next, pull the mesh using the Move brush so that it shapes itself to the curve of the head. Create hair sticks from a box using the Scale and Move mesh editing tools.

03 The jaw piece

We create the jaw using mainly the Topology tool and Crease. But first, let's make a quick draft so we know exactly how the grid should look. I will describe the whole process here step-by-step – this will be repeated a lot later on, so you may want to come back to this section of the tutorial.

1. Use the Mask tool for distinguishing a part of the jaw. Next, use the Group Mask option in the Polygroups menu.

2. Hide and delete the unneeded part of the mesh by clicking Del Hidden in the Modify Topology menu.

3. Next, shape the 'chin' using the Clay brush, Standard brush, Slash brush and TrimDynamic brush. Keep an eye on the concept, but don't worry about making it perfect – we'll smooth it perfectly later using a simple trick.

4. Download the ZSphere to a SubTool and activate the Edit Topology options in the Topology menu. When creating model topology from scratch, try to use the simplest divisions possible – this will be helpful in obtaining simple planes later.

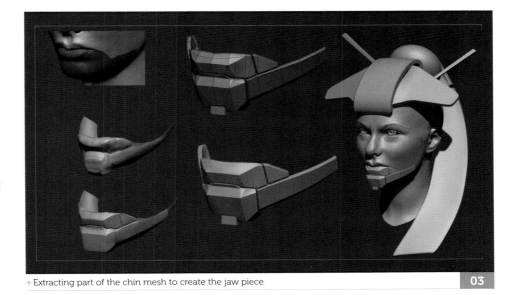

↑ Extracting part of the chin mesh to create the jaw piece 03

5. Thicken the grid using Skin Thickness. You can check on this by clicking Preview in the Adaptive Skin menu.

6. Use Crease for adding divisions at the edges of the mesh so that the grid looks smoother after adding subdivisions.

04 Retopology

Sharpening the edges of the model using the Topology tool and Crease is one of the best ways to create a perfect base for hard-surface modeling. As a reminder for you, this is how the workflow goes…

1. We retopologize using the Topology tool. Make sure that the grid is set the simplest way possible, as it's easier to edit later.

2. Use Skin Thickness for thickening the mesh. We can preview the walls of our model by using, well… Preview.

3. Create a new SubTool by clicking Make Adaptive Skin and Append in the SubTool menu.

4. Use the Select Lasso tool for distinguishing parts we want to harden.

5. We can preview the hardening of the grid using shortcuts D and Ctrl+Z. Don't worry about the areas where the grid sticks out a bit. This happens mostly where the subdivisions are laid over triangles. We can make those places smooth by using the Move tool or, after thickening using the Thick Dynamic tool, by setting its strength to between 5 and 10.

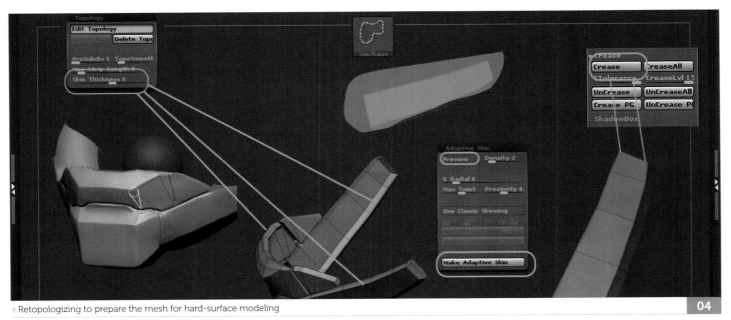

↑ Retopologizing to prepare the mesh for hard-surface modeling 04

05 Body armor

We use a similar workflow as before (see steps 03 and 04), but we can skip modeling the base, and retopologize instead. We use the body modeled before as a base to create the various bits of armor.

06 Armor on the arms

This time we start with a plane. Use the Topology tool to create the shape, then set the thickness of the walls – this is armor so it should be pretty thick. Next we use Mask and lift the center of the mesh, making it protrude outward slightly. Use Crease for hardening the edges.

Next, we go to the Deformation drop-down list and click Unify to center the object. Then use Gravity for bending the object so that it fits the hand more. Finally, we layer the last two elements by putting them on the arm.

07 Armor on the legs

Separate the grid from the arms and legs and put it on a separate SubTool. Now paint the mask around the armored areas, according to the concept. To make painting easier, you can use MaskCurve and MaskRectangle. When you get the desired shape use the Group Masked option and remove the non-important parts of the mesh.

Then use Extract to thicken the mesh and use Crease to harden the edges. Now we have acquired a solid base for further modeling.

08 Posing the foot

Separate the lower part of the leg and place it on a separate layer. Go to the ZPlugin drop-down list and choose TPoseMesh with the StoreTM Rig option on. Next, place the bones so you can edit the foot, then shape the foot as if it is in a high-heeled shoe. Click on TPoseMesh to SubTool. You can use a DynaMesh made from a sphere and spread and deform the object as you please. Using ShadowBox before DynaMesh will make your job easier.

> "For details, I use the Clay brush, Smooth, and TrimDynamic; and finally, I work on the topology, polygroups, and hardening the edges with Crease"

09 Modeling the shoes

The workflow for modeling the shoe is as follows: First, I select a ShadowBox DynaMesh and add simple objects to the mesh – for example, I use a simple box and a general draft of the clog for modeling the buckles; for details, I use the Clay brush, Smooth, and TrimDynamic; and finally, I work on the topology, polygroups, and hardening the edges with Crease.

10 Knee protectors

To create the knee protectors, first add a plane as a SubTool. Use the Topology tools to create a shape based on the original concept, then use Extract and set an appropriate thickness to the model. Now use the wings mask and bend them down as before; then use Crease to create the peak in the mesh.

Use simple shapes, such as a plane for creating the back strips – don't forget to remove the unimportant divisions by clicking Extract+Crease. You can also use a cylinder set with eight

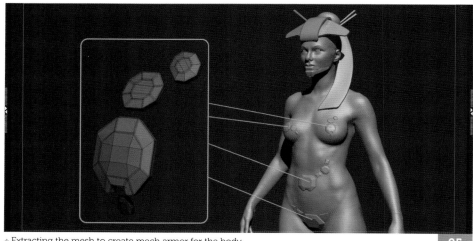

↑ Extracting the mesh to create mech armor for the body **05**

↑ Creating the armor for the arms using plane topology **06**

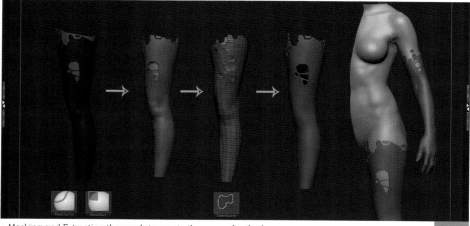

↑ Masking and Extracting the mesh to create the armor for the leg **07**

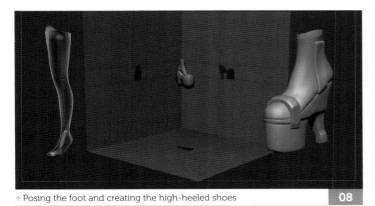

↑ Posing the foot and creating the high-heeled shoes 08

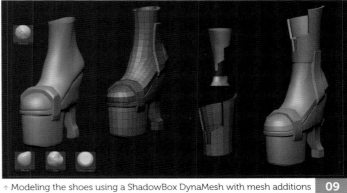

↑ Modeling the shoes using a ShadowBox DynaMesh with mesh additions 09

walls (you can set the thickness later). Finally, use Crease on the edges of these and you have accomplished a texture-ready base.

Refining the hair

Creating the hair is the hardest part of modeling people in my opinion. Therefore every moment spent on determining the shape of the hair will be useful to us in the long run. Ultimately, we will make the hair using FiberMesh at the texturing stage. For now though, as a placeholder, we can use a polygonal model to create a high-poly model of the hair.

↑ Modeling the knee protectors and strips on the back 10

First, change the hair model to DynaMesh – this will make it easier to shape. Model the shape of the top knot so it looks more realistic, and use the Slash brush to create some variation in the base of the hair. Now divide the model and use the Rake brush to create texture. To create fluid movements, open the Stroke menu and mark the LazyMouse button or use the shortcut L.

Detailing the head armor

Changing every element of the head armor to DynaMesh will make it easier to edit the mesh – particularly the edges of the models.

↑ Convert the hair to DynaMesh to make it easier to refine 11

We'll start with the wings element. Use the TrimDynamic brush, with the LazyMouse option switched on, to flatten the edges of the models. Then on the left side of the wing, cut out a rectangular shape using the SliceCurve brush. Now hide the rest of the mesh and use Inflate with the parameter: 1 (you can find this option in the Deformation menu). Use Mask and paint additional elements as outlined in your original concept. Finally, use the Smooth brush to soften any hard edges.

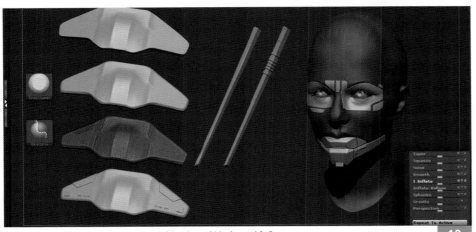

↑ Shaping the head armor using a combination of Masks and Inflate 12

Create the sticks plugged into the hair in the same way, using Masks and Inflate with a parameter of 1.

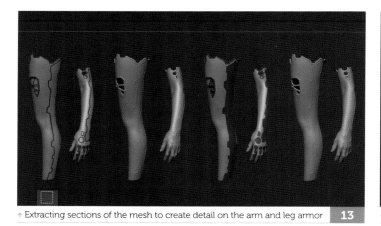

↑ Extracting sections of the mesh to create detail on the arm and leg armor **13**

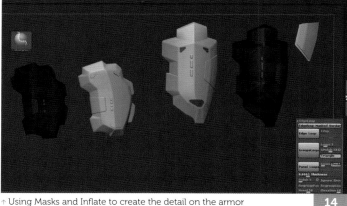

↑ Using Masks and Inflate to create the detail on the armor **14**

"I invented a set of body armor accessories to protect our character. There are two types: One that adheres to the skin; one made of metal"

13 Refining the arm and leg armor
This section will involve a long period of time spent painting masks, so make yourself a cup of tea and we'll get started…

First, paint a line around the sections of the model and extract the selected areas (to mask a more precise shape, use the Select Rectangle option). Then use Inflate. Now paint over the contours, as seen in image 13. Go to the Surface menu and click on the LightBox button, select a sliced-effect pattern and use it on the model. I choose this pattern because it is quite often used with a cyberpunk or tech style, but you can experiment with the parameters here to make the pattern appear as you like it.

Now click on the Apply To Mesh button, and you have a great armored uniform.

14 Detailing the armor
To create detail on the armor we will use the same tools as used to detail the head armor, plus a new one – the EdgeLoop tool. First, as usual, use DynaMesh. Now use the SliceCurve tool and cut a rectangle shape into one of the armor plates. Go to the EdgeLoop menu and set the number of loops to 2, then click GroupsLoops. Next, set the Thickness to 0.0003 and click on the Panel Loops button. As you can see, we've created gaps between our element and the rest of the grid.

Now hide the rest of the mesh, with the exception of that rectangle shape, and use Inflate. The detail has now been well integrated into the model.

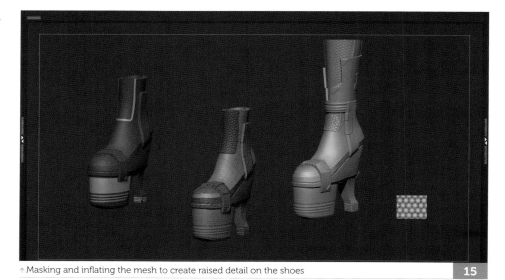

↑ Masking and inflating the mesh to create raised detail on the shoes **15**

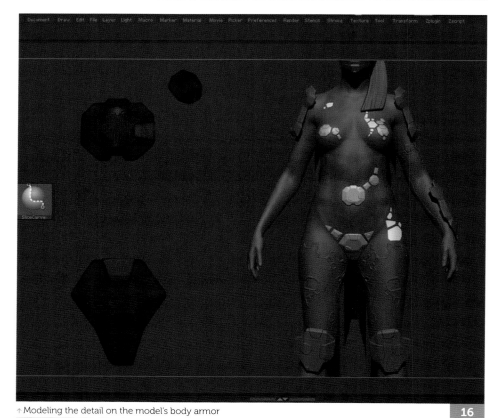

↑ Modeling the detail on the model's body armor **16**

To create simple stripes along the model, use this same process of masking and inflating.

15 Detailing the shoes
To create detail on the shoes, again, you can use a simple combination of Masks and Inflate to deform the mesh.

16 Detailing the body armor
I invented a set of body armor accessories to protect our character. There are two types: One that adheres to the skin; one made of metal. Create the first using a mask and extracting the mesh. Use TrimCurve to cut off the rounded edge. Experiment with this brush to really get the hang of it because it is extremely useful when working on square shapes. Detail the metal parts in the same manner.

17 Knee pads
Once again, use the same workflow as before to create the detail on the knee pads.

1. DynaMesh: Use Del Lower and set the resolution to 2048.

2. Use SliceCurve and SliceCirc to cut shapes into the mesh as per the concept.

↑ Creating the detail on the knee pads using the same workflow as before　　17

3. Use EdgeLoops.

4. Mask the mesh.

5. Use Inflate to inflate the mesh.

See image 17 for the detail produced.

18 Prepare for texturing
So at this point we have the model completely detailed. Now we'll need to refine the additional elements of the model, equip it with a weapon, prepare it for texturing, and create a few simple elements which we will use to lay the scene for our female warrior.

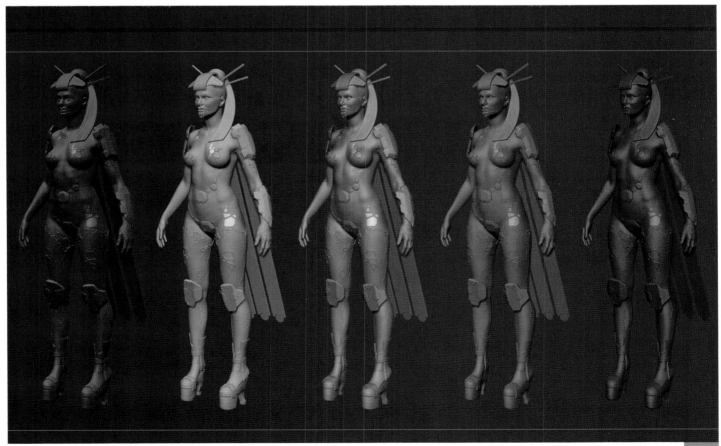

↑ The detail on the model ready for the next stage　　18

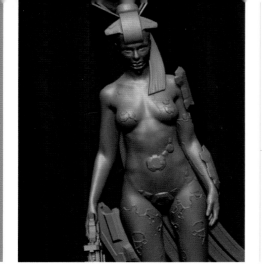

Chapter 06
Sculpting a sci-fi character
Part 03: Creating a narrative

By Piotr Rusnarczyk
Freelance Character and Games Artist

I remember when the head of our studio once ordered a group trip to the shooting range. We were researching weapons for our game and everyone, from coder to designer, could try out different weapon types to see how they work and, more importantly, how to handle them safely.

Personally, I've always been fascinated by the image of the gun. I think there is something mysterious and inspirational in the image of a woman holding a gun in her hand – an object of power.

In this tutorial, we will be modeling weapons for our warrior, the rear part of the costume, and several elements to the background image. I have a specific idea of the illustration I want to place in my background, but feel free to apply your own background elements if you have another scene you'd like to use.

01 Shaping the strip detail
We will begin by adding detail to the strips we created in Part 02. First, change the object to DynaMesh and trim the ends so that the strips form a triangular shape. This is a task best suited for the TrimCurve tool. Using the SliceCurve tool, cut a trapezoidal shape as shown in image 01. Fill the holes in the mesh by clicking the Close Holes option (found under the Geometry > Modify Topology). Then use the mask as shown in image 01. Remember, to paint simple and precise shapes easily you can use MaskRect, alternating it with the Shift key or Shift+Alt to cut the appropriate shapes.

"I shaped and pointed these strips to the right on the concept art in order to make them look more dynamic. You can do this now on the actual model, or later"

02 Strip surface texture
Now to achieve the strip surface texture, use Inflate to decrease the value of the sides in order to get a cavity in the mesh. I choose to use the value of –1 because it is sufficient to obtain a clear outline of the cavity.

Next, invert the mask by holding down Ctrl and clicking on the area outside of the geometry. Paint stripes to mask around elements of the geometry; then open the surface and click LightBox. Select Noise 11 – Honeycombs, as this is the same as I used to create the uniform and shoes.

↑ Creating the basic strip shapes and adjusting the detail
`01`

↑ Adding a light texture over the surface to match the uniform
`02`

03 Tech detail

First create a simple object-based octagon using a tube as a base, and make it a little bit thicker than the strips. Then use our favorite DynaMesh tool. Now use the SliceCurve again to cut trapezoidal shapes into the element.

On the Geometry tab, click on the EdgeLoop option and use it with the following settings: GroupsLoops > Loops: 2; Panel Loops > Thickness: 0.0003. Now use Inflate with a setting of 2. Then use Clay in order to implement the element in the middle of the object. We now have strips ready for the uniform.

04 Posing the strips

I shaped and pointed these strips to the right on the concept art in order to make them look more dynamic. You can do this now on the actual model, or later when you pose her.

Theoretically, there are two ways to arrange the strips in this way; however, at this stage when the model is just a fine mesh, we have to use Deformations. I use SBend with the value +/–11. When we get to the stage of texturing the model, we will use the Topology tool, as our mesh will be light enough to freely execute this deformation using the Transpose Master.

05 Making the holster

Now it's time for a little carving. First, create a simple box using a mask and the Move tool, and try to extract a simple object like the one

↑ Creating the tech detail on the strips of the uniform **03**

↑ Deforming and bending the uniform strips to match the concept **04**

↑ Carving the holster for the gun from a simple box **05**

shown in image 05. This will be the base for the holster. Then, alternating the Clay and Smooth brushes, model a more precise shape.

You can make holes in the holster by using the Mask and Move tools. In order to make flat shapes quickly, you can use the ClayPolish tool that you can find in the Geometry menu. Remember that after using this tool you have to clear the mask on the object, though it is very delicate and difficult to spot, and later the deformation of the object can cause us many problems.

Now use the Topology tool. You need to make sure that you are careful when creating the topology of a grid. This is because when you create hard edges, sometimes hard-to-smooth spots appear, and we definitely want to avoid that. Of course, there will be some small amendments on the grid, but they should be cosmetic.

06 Modeling the gun

I don't see the point of describing the exact process of modeling each part of the weapon, because each element is created in the same way. I present the step-by-step workflow I use for each part below. Image 06 shows the screenshots of each item I created joined together to make the entire gun model.

1. Each of the elements is based on a simple geometric solid. For example, when modeling the barrel and rounded elements, I use a tube; when modeling the handle and the main part of the weapon, I use a box.

2. I use DynaMesh to keep the object dense. This way I can create accurate shapes, bevels, and so on.

3. In order to create deep cuts I use Mask and Move, then once again DynaMesh the model.

4. I use ClayPolish to smooth the grid.

5. I use DynaMesh once again and repeat it as many times as needed.

6. I then use the TrimCurve tool to cut complex shapes and trim corners.

7. I modify the topology to straighten the plane of square elements.

8. I use Crease to sharpen the edges of the model to create the perfect shape.

9. Decimation helps combine all the elements into one object.

10. I use Topology or ZRemesher to create a roofing grid.

11. I use UV Master to burn the textures of Polypaint.

12. Finally, I use the Project tool to burn the entire model for a new, less dense, grid.

"We are slowly approaching my favorite part of working on the illustration – the render. If you've not yet been tempted to see how your model will look, then it's time to push the render button and find out!"

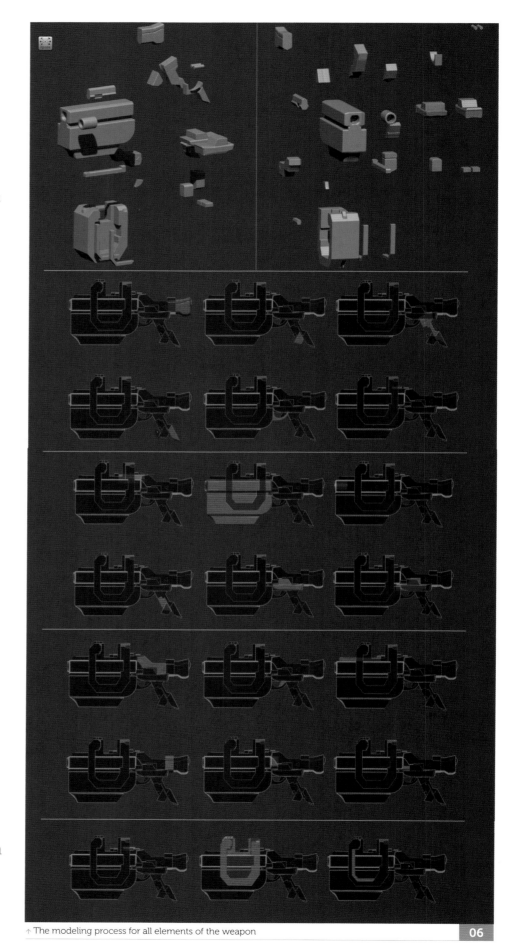

↑ The modeling process for all elements of the weapon

06

07 Notes on rendering

As a quick note: We are slowly approaching my favorite part of working on the illustration – the render. If you've not yet been tempted to see how your model will look, then it's time to push the render button and find out! Here is a brief description of how the various rendering options in ZBrush work.

1. Flat: I often use this option when I need to quickly mask individual parts of the model. Later you can use the Magic Wand tools in Photoshop to select your chosen element. If you use the BPR (Best Preview Render) option with the Flat option, the render of the entire scene will be black with the exception of the background. It will potentially be useful if you need a quick picture of the silhouette and then use it for over-painting in PaintStop.

2. Best: I haven't used this option in a long time because it has basically been replaced by BPR. All in all, Best render is quite well suited to the solid model rendering, when the model is not yet painted, as it bypasses most of the resources and settings and is therefore fast and easy to use.

3. Fast: As the name suggests, this is the fastest preview option for our model. This is because ZBrush does not use any shadow in the preview. It's usually useful when the model becomes too complicated to navigate easily in the viewport.

4. Preview: This is our basic view in ZBrush. It shows us a full view of the model with the lights and color, and an outline of the shadows.

5. BPR (Best Preview Render): This is the magic button that causes our model to come to life. We will use this option again in Part 05 of this chapter, when we discuss the preparation of the model, the rendering, and the pass rendering for the finished model.

> "In ZBrush, we have a large library of ready-to-use MatCaps. I use them often when I want to build a base for a color on my model"

08 Simple gun render

It is nice to see the whole work on a render. For an even better look you should choose the right MatCap. I choose a simple metal MatCap for the gun because I want to make the final texture look like a real gun.

In ZBrush, we have a large library of ready-to-use MatCaps. I use them often when I want to build a base for a color on my model. The

Pixologic website (**www.pixologic.com**) has many more very useful MatCaps, too – plus, you can preview each of them on a basic 3D model. You can also create your own unique MatCap, but we will deal with this issue in more detail later in the texturing phase of our model.

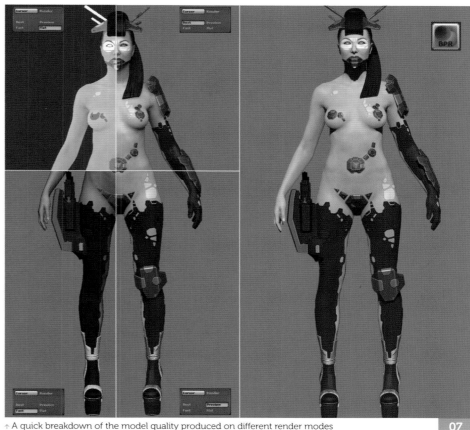

↑ A quick breakdown of the model quality produced on different render modes　07

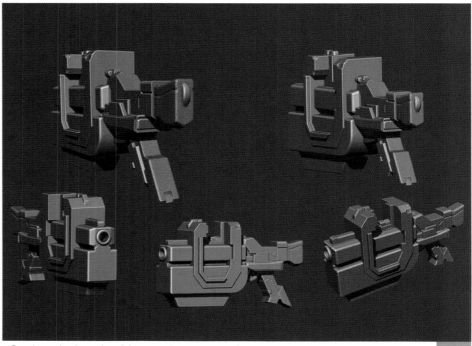

↑ Creating a simple render of the gun using a metal MatCap　08

"Now I have the background set up, I want to put our character into the scene so I can figure out poses"

09 The capsule

I choose to create a capsule as an element of the background in order to continue the cyberpunk theme. In the final render I will create a background from the capsules and place as many of them as possible in it to create a narrative involving futuristic stored cyberbodies. As the main theme, I want to show the rebellion of one of the cybersoldiers, who after accidental activation, climbed out of her capsule.

To start, I use a simple box and with the Mask and Move tools, I draw the basic shape. Then I use SliceCurve to extract the glass and elements of the panels on the sides of the capsule. Next I use EdgeLoop with the following settings: Loops: 2; Thickness: 0.0003; Inflate: 2; and the rest as default options. I also use Polish: 5 and the Bevel Profile in the same form. This way, when I extrude the loops, all sharp edges on the model are smoothed.

10 Broken glass

While looping, ZBrush automatically splits my objects into groups so that I can extract individual elements and move them to another SubTool. This way I can work on the glass on the capsule. I copy one of the capsules and cut it using SliceCurve to remove the glass panel, then bring out the shape of broken glass.

I keep some of these elements and put them together to create extra detail such as the glass on the floor. To get the gap between the pieces, I just use the Loops panel then remove the mesh between them. Finally, extracting them creates a thick piece of glass.

For the additional elements of the capsule, I make simple boxes that I scale to size. I make the pipe using the CurveTube brush. I use Masks and the Resize tool to create the terminals. The floor is a combination of the Move tool and Mask. Finally, I also use Inflat.

11 Placeholder models

Now I have the background set up, I want to put our character into the scene so I can figure out poses. This is not the final pose, it's just a placeholder that I will later replace with the finished texture model.

↑ Modeling the capsule to create a more convincing narrative 09

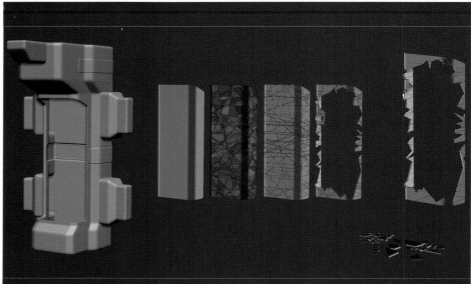
↑ Adding the broken glass to the capsule to unify the narrative 10

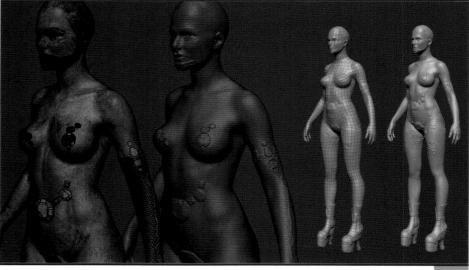
↑ Creating placeholder character model to add to scene: DynaMesh, ZRemesh, Projecting the mesh 11

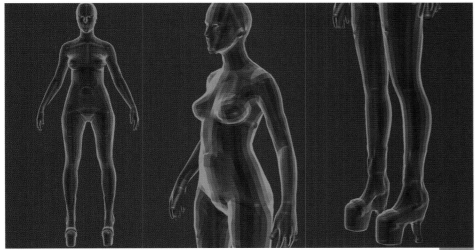

↑ Using Transpose Master to create a skeleton rig **12**

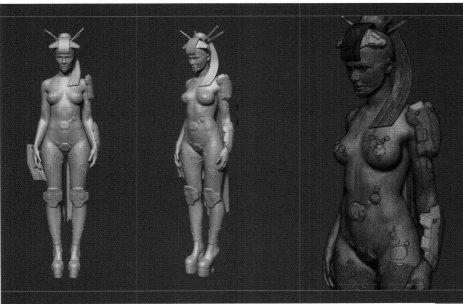

↑ Decimating the model to fit the scene **13**

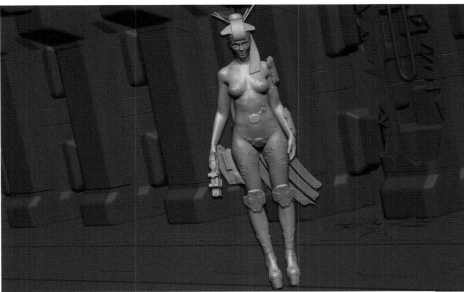

↑ The scene so far, ready for texturing **14**

First, I join all the non-animated body together (i.e. hair). Next I use DynaMesh, copy the model on a separate SubTool, and use ZRemesher – I don't think about creating a correct topology because I want to have things done as quickly as possible, and a sketch like this is sufficient for this purpose. Finally, we need to project the old mesh onto the new one.

"We set the rig so that the skeleton's range of movement works correctly with deformation of the grid. The tools are pretty intuitive so I think everyone should be able to choose the right rig for their model"

12 Transpose Master

Now that we have a lighter mesh, we can safely use the Transpose Master. Remember to turn off the ZSphere Rig option while exporting. We set the rig so that the skeleton's range of movement works correctly with deformation of the grid. The tools are pretty intuitive so I think everyone should be able to choose the right rig for their model.

13 Decimation

Decimate the model in such way that you can put a few additional clones into the scene. Keep in mind that it will take a little time to set the appropriate camera, so the more detailed our scene is, the more time our workstation will need.

14 The scene

And now we've created a simple scene in which to showcase the character. Next, we'll prepare our model for texturing with vertex paint and some interesting MatCaps.

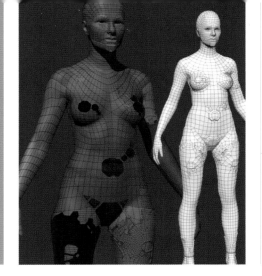

Chapter 06
Sculpting a sci-fi character
Part 04: Starting to texture

By Piotr Rusnarczyk
Freelance Character and Games Artist

I remember being a student in a painting class. Before each lesson, I would pack my art toolbox, putting in a range of different-sized brushes, different kinds of paint, a bottle of turpentine, rag cloths, and a wooden palette. I'd put my box in a backpack and march off to class. I could never believe how, after only a few classes, the inside of my backpack looked like a Jackson Pollock painting, and also how much it cost me to clean it. I've lost count of how many jeans I've had to throw away because they've been stained with intense (and permanent) blackberry dye, or splattered with colorful paints.

I'm very thankful for the invention of the computer. Don't get me wrong, I love the smell of turpentine, the contact with the canvas, and the colorful mud from which various interesting colors arise; but now my tools are always clean and my backpack is in perfect condition. Admittedly, my favorite jeans are in the closet waiting to be washed – but that's another story.

In this tutorial, we will begin to texture our model using MatCaps and brushes, and use Spotlight to apply textures to the objects in the scene. To make the texturing workflow easier, you should equip yourself with the textures you'll need, or take any necessary photos before you start this phase. You'll need textures for the following: Metal/armor, texture of the skin, face, hair, and body. So load up a playlist with your favorite music and let's get to work!

01 Prepare for texturing
To make it easier to work on the texturing, you can split your ZTool objects into the following groups:

1. Hair: You can throw all three elements of the hair here (the bangs, the circular top, and the pony-tail), and we can work with the base meshes for

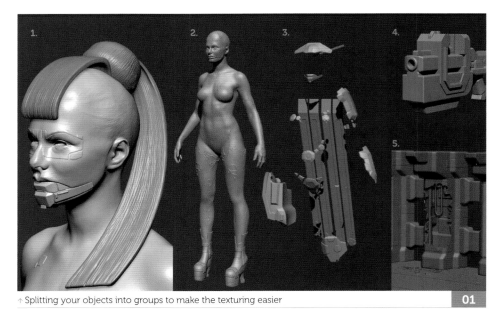

↑ Splitting your objects into groups to make the texturing easier
01

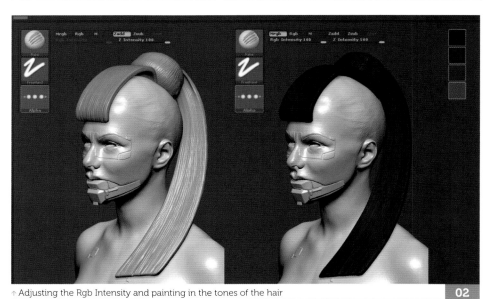

↑ Adjusting the Rgb Intensity and painting in the tones of the hair
02

rendering the supporting characters in sections. You can create new ones using FiberMesh.

2. Body: This group of ZTool objects should include only the body and eyes, in

addition to some of the elements of the uniform and shoes that will be used.

3. Armor: This includes all metal components and the straps on the back of the model.

4. Gun: This should only include the gun model.

5. Environment: The environment ZTool will be the base we will use when rendering the background for our model. Objects will have the same sort of texture as the warriors because they are clones of the model, but their capsules and other items will include simple materials using the ZBrush library. In contrast, for the last pass we will add detail using textures in Photoshop, which will be a good exercise in matte painting.

> "Remember that you can combine this finished hair texture with hand-painting if you prefer – it is very important that you are satisfied with the end result"

02 Hair texturing

The first thing we do before modeling using FiberMesh hair is paint the base mesh. I find that the Rake brush is best suited to this because it already has a set Alpha that imitates tufts of hair very nicely. We used the same brush earlier (Chapter 06, Part 02), set to Zadd, to detail hair texture – now we can turn this option off while adjusting the Mrgb options. Rgb Intensity moves from 80 in the first phase of painting, to 100, and we can use the color picker to select hair that we painted on the head model in the first tutorial of this chapter.

Generally for body and hair, and elements such as lights, you can apply a standard MatCap skin shader and simply change its color alone depending on the element. If it comes to hair, and you paint the long strands using the LazyMouse, you can then experiment with the options. Like layers, paint the darkest hair underneath, and the brightest on the top.

We will not use this object on the foreground model, only the figures standing in capsules, so you do not need to exaggerate with accuracy here. Also remember that you can combine this finished hair texture with hand-painting if you prefer – it is very important that you are satisfied with the end result.

03 FiberMeshing the hair

Firstly, create a selection using the Select Rectangle tool – this is how we shape a cross-section of the hair. Then open the FiberMesh tab and use the settings seen in image 03.

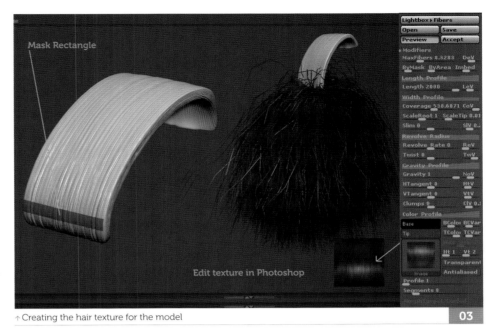
↑ Creating the hair texture for the model **03**

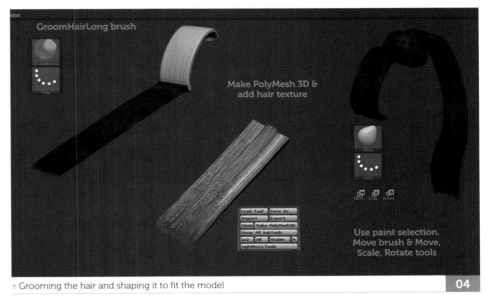
↑ Grooming the hair and shaping it to fit the model **04**

On the bottom of the palette you will find a window showing the texture. Export it to Photoshop, and using the Color Balance tool by adding red and yellow halftones, try to calibrate the colors to the ZBrush window. Then Accept.

Don't worry about the hair looking a bit crazy at the moment, we just need to comb it. Go to the Brush tab and select the GroomHairLong brush. Then use fluid movements to create a simple hair shape.

04 Refining the hair

Now click on Tool > Make Polymesh3D, and we can edit our hair as an ordinary mesh. Go to Display Properties and turn the Double option on to make sure it displays all the walls, then go to Map

Textures and upload the texture of hair that you have edited in Photoshop. Add two subdivisions in order to avoid the hard kinks in the mesh during deformation. To adapt it to the shape of our base model, use a mask and the Move and Rotate tools.

Finally, use the Move brush to add the finishing touches. The workflow for the other ponytail section is almost identical, with the difference that you have to put more work into the arrangement of the hair to ensure it fits nicely on the body of the model.

I'd keep the ponytail in its own SubTool without the deformation, even after it's become part of the hairdo, at the moment. This will help when we pose the model and change the hair.

05 Face makeup

We already started a little of the body painting in the first tutorial, so I won't repeat this entire stage here. As a recap, I used only the finished texture of the face, hair, and body to paint the model using Spotlight. Then I used a Standard brush to retouch areas, and then applied makeup, uniform, body parts, and eyes.

To create the makeup, we will use a simple Standard brush with the Zadd option enabled on the Mrgb and white and black color. You can color the areas closest and thus save time on selecting colors using the color palette. You can also use the mask and tools to sharpen or blur painted edges. Holding the Ctrl key while painting the mask allows you to enjoy a variety of shapes.

You may already know about this technique, but I wanted to mention it here anyway because using these shortcuts frequently allows you to become used to them and therefore use them more fluidly in your workflow.

"MatCaps are one of the many things I love about ZBrush, as they remind me a little of cooking. I use a variety of ready-made ingredients, but every time I can create a brand-new dish!"

06 Body paint

Now, change the brushstroke setting to Color Spray and apply Alpha no. 07 set at 1.5 intensity, to get a soft transition between skin tones.

Now we can paint in elements of the uniform. Return to the previous brush settings and choose a dark gray color palette. This is the color that most often appears on cables or rubber fenders. To further emphasize this material, use the Invert Mask By Cavity mask and a lighter gray paint on the mesh. You can create the effect of dirt in the crevices or of stretched rubber.

07 Armor MatCap

For the base of the armor, I use a modified metal MatCap called 'antique bronze', which is dragged from the library of materials in ZBrush. You can also build your own material in a very simple way. MatCaps are one of the many things I love about ZBrush, as they remind me a little of cooking. I use a variety of ready-made ingredients, but every time I can create a brand new dish!

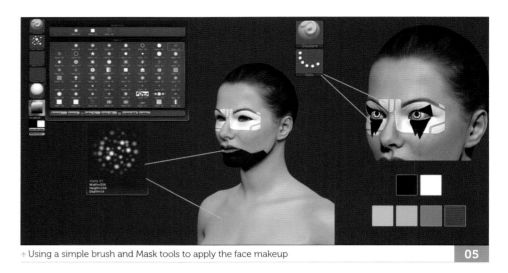

↑ Using a simple brush and Mask tools to apply the face makeup 05

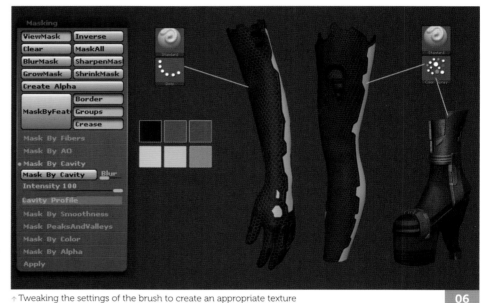

↑ Tweaking the settings of the brush to create an appropriate texture 06

↑ Some of the material textures used as a base for the metal armor 07

↑ Adding a galvanized look and highlighted edges to create more flavor

08

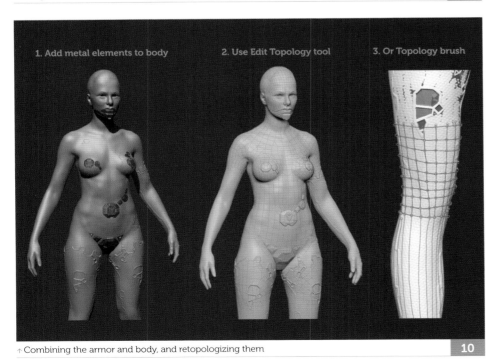

↑ Using MatCaps, skin shaders, galvanized metal textures, and Spotlight to create the gun texture

09

↑ Combining the armor and body, and retopologizing them

10

Regarding elements of the lights, I decide to use SkinShade4 to keep an appropriate intensity of color. We will need it when generating strips of lights. I'll mention more about this in Part 05 of this chapter.

08 Painting armor textures

The metal MatCap we have got so far is not really enough for me. I therefore add a little extra texture to the material so that it matches the look I want to create.

First, I choose the color of the area, as you can see in the screenshot materials in image 08; these can be divided in a simple way into various shades of gray. Then, in place of using a gentle edge, I increase the intensity of the brush from 5%.

Next I apply a galvanized metal texture (using a texture from **www.cgtextures.com**); feel free to add other details such as scratches at your own discretion, too. I then use Spotlight in one or two choice places on the model – exposing the edges will add a little extra flavor to the whole piece.

09 Painting gun textures

The workflow for creating the gun texture is identical to texturing the armor, with one exception – joining a dark metal color to the whole. I use this color to isolate or highlight the targeting system from the rest of the weapon.

> "Use symmetry wherever you can, and use the Topology brush in simple places, too"

10 Retopologizing the body model I

The first thing to do before retopologizing is to make a complete ZTool of the painted flesh with elements of armor that adhere to the body model. When done, select ZSphere > Topology > Edit Topology. Try to distribute EdgeLoops on the model so you can easily edit the grid when we pose the model later. Also, take care to arrange the topology to fit the protruding elements perfectly to their shape.

Use symmetry wherever you can, and use the Topology brush in simple places, too. Combining these two methods has both good and bad points: the good news is you can save time now; the bad news is that you have to combine the two generated meshes at the end, which sometimes has to be done using an external program such as MODO.

"As a general rule, you don't need to worry about things that won't be seen in the final posed image"

II Retopologizing the body model II

When your mesh is ready, you can redesign the painted texture and make the object high-poly. Concentrate the new mesh to six subdivisions, then set the Project Distance to 0.08 and press the Project All button. Unfortunately, it often happens that with this action, as in this case, you'll also need to consider two additional steps:

1. On the Deformation tab, after you set the mesh density, inflate at 0.5 or 1.

2. When using the Move brush, you have to manually drag it to places where the mesh is very intertwined. Sometimes three points on the mesh are attracted to the grid to form stretched triangles, then, not considering options like the Mrg Smooth brush, we need to relax the mesh. We may also need to improve the mesh using the Clay brush.

Generally, what we need most is a good redesigned texture. Don't worry that some of the edges don't look like the base model at this point. Remember that if you have very close shots of the model using the camera, then you would be focused solely on one angle of the mesh in the render. As a general rule, you don't need to worry about things that won't be seen in the final posed image. However, you still have to add high levels of details to areas such as the face.

I2 UV mapping

We can now prepare the model for the UV mapping phase. Although the assumption that I do not want to use Photoshop to paint textures is reasonable, it is important to prepare the model as such because the decimation keeps the texture on the model, and it doesn't make sense to impose 15 million grids in ZBrush.

Go to the ZPlugin menu and open the UV Master tab. You will find that there are many options, but the one that interests us most is the ability to set which side of the model the UV map cut will run through. Unfortunately, we cannot use this option when our object has subdivisions, but there is a way to work on a clone. If you use the options, you can easily work on the mesh without subdivisions then export it as an OBJ to a disk and import the

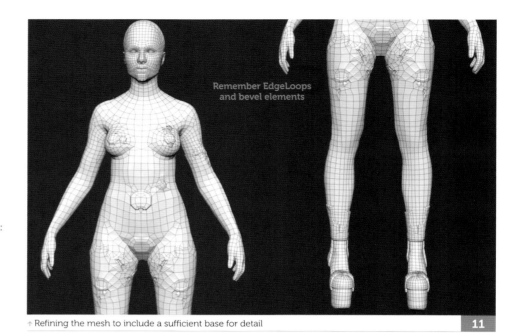

↑ Refining the mesh to include a sufficient base for detail

11

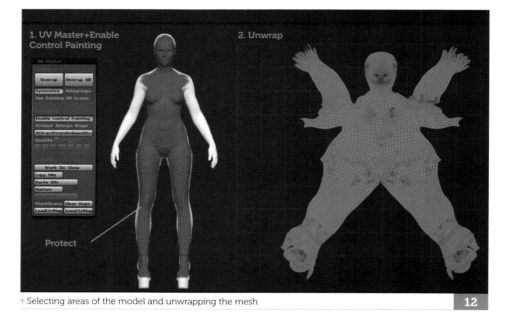

↑ Selecting areas of the model and unwrapping the mesh

12

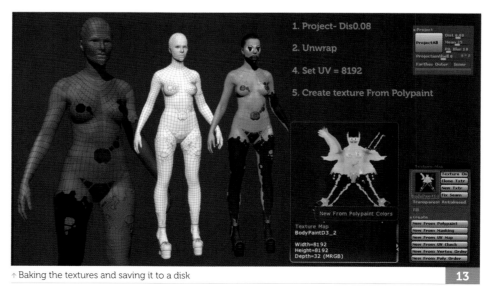

↑ Baking the textures and saving it to a disk

13

Use Edit Topology

Make clean mesh

1. Project- Dis0.08

Remember bevel elements

↑ Working through the same UV mapping workflow to texture the metal elements **14**

original in place of the mesh. In this way, we will have the ability to create a complete UV map.

Click on Enable Control Painting then Protect. ZBrush automatically chooses the red color for you to select the location where you don't want the UV Master to cut. Normally you need to blank out the front of the model, because if you want to edit the texture later in Photoshop, it will be easier to paint. Also, note that places where it will be reattached (i.e. the seams) should not be visible from the front of the model.

13 Baking textures

Now we can bake the textures. Go to the UV Map, select and drag the slider to the end to generate the texture size 8K, and press the Create New From Masking button. The texture will be generated and allow you to save it to disk. Click on Clone Texture, then select the texture and press Export.

Make sure you remember that in order to keep the texture on the model, you need to keep

the MatCap Texture On button selected. When you upload the texture back off the drive and apply it to the ZBrush model, it will remove information about the MatCap and will simply replace it with a color from the texture.

Of course, there is the possibility of some MatCap burnout on the texture, but this object renders well in ZBrush so it makes no sense to add a job in unless this occurs.

14 The armor and gun

The workflow for retopologizing and UV mapping the gun and armor is identical to the one that we used for the body. Make sure that you remember the beveled element on the edges of the armor pieces, though.

Now you can combine all of the ZTools into one and we're done with this stage of the project. In the next tutorial, we will pose our model, prepare the stage for rendering, and prepare materials for the composition of the image in Photoshop.

✅ Top Tip
Use a mirror to save time
My experience with retopology is that it is unfortunately one of the most time-consuming parts of the model creation process. Of course, you can use ZRemesher to speed up these processes, but you'll still often need to manage or control every element of the mesh by hand.

Here's a simple tip to save time when retopologizing. Find a space on the object in which the mesh is identical on both sides of the x-axis, and in these places use symmetry. If you find a place that is a bit different, don't worry – you can always retopologize using the Project button or adjust the grid records with the Move brush.

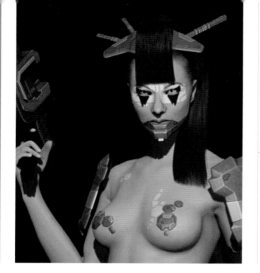

Chapter 06
Sculpting a sci-fi character
Part 05: Posing and rendering the model

By Piotr Rusnarczyk

Freelance Character and Games Artist

Now comes the long-awaited moment where we set the scene and model, crop areas, and repeatedly press the render button.

I like to think that we live in a gender-equal society, so I'll admit that a few times as a child, I felt the need to steal one of my sister's dolls. On one occasion, with the help of a pair of scissors, I'd apparently tried to change her rather plain hairstyle into something more elaborate. Personally, I don't recall much about it, but I do remember a lot of yelling, and then having a restraining order of at least one meter's distance from my sister's dolls as a result.

Now I'm designing a doll in a 3D context. I'm laying the hairstyles, modeling clothes, and designing her environment. Sometimes it's a lot of fun and sometimes it's exhausting work – not physically, but exhausting in terms of concentration.

I would like to stress that while you're working this intensely, it's important that you take a break. In this case, I devote part of the time to watching movies where the main character is a female warrior, such as *Barbarella*, *Ghost in the Shell*, *Sucker Punch*, or even the classic cyberpunk anime, *Armitage*. From these, I decide that the best pose for our model will be a static pose – inspired by the pulp posters from movies of this genre.

01 Prepare for rigging

For our illustration we will need two kinds of poses: The first is the main model; the second will be for the models in the background.

We'll start with the main model. To make it easier to pose, as well as to avoid the problem of having the evil deformed mesh, make sure that you remove any unnecessary SubTools on the model.

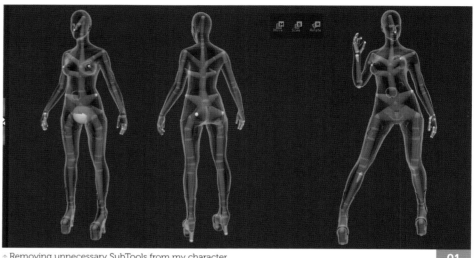

↑ Removing unnecessary SubTools from my character
01

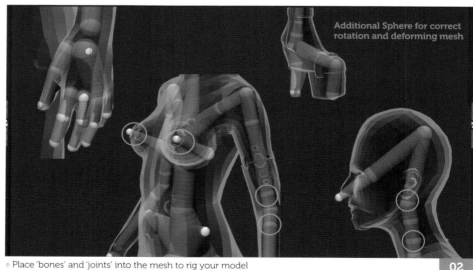

↑ Place 'bones' and 'joints' into the mesh to rig your model
02

02 Rigging the main model

Now go to ZPlugin > Transpose Master. Make sure that the ZSphere Rig option is enabled. Then follow the skeletal structure of the model, as shown in image 02.

The last time we used this tool, precision wasn't as high a priority. This time, however, we'll need to keep the 'bones' in the correct place, or risk poor deformation of the mesh, for example in the breast area. Add additional spheres at each of the joints, too. This will make it easier for us when we move and position the bones.

To quickly test the skeleton works, use the Bind Mesh option. When you disable this option,

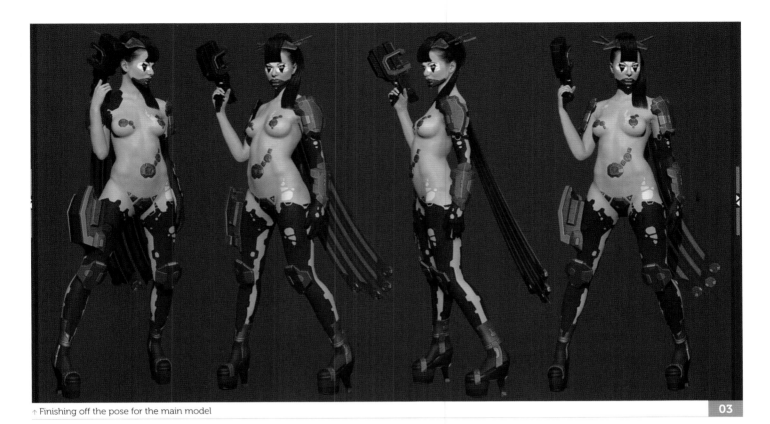

↑ Finishing off the pose for the main model

03

place the model back into the T-pose and you
will be able to further improve the skeleton.

03 Posing the main model

When you have set the pose of the model, return to
the Transpose Master and press TPose > SubT. Add
the pieces of armor and hair; set these elements
to fit the pose using the Move and Rotate tools.

04 Posing the background model

The background model pose should show
the model standing in a capsule, waiting for
activation. She should have her hands lowered,
legs set close together, and her head pointed
downwards so she is looking at the floor.
There should be no problem with the posing,
because it is very similar to the T-pose.

Once you have achieved a ready pose, complete
the model by adding the elements of her armor.

For her hair, use the hair previously modeled in
the mesh. Because this model is a background
model that will be standing behind the
glass, it doesn't make sense to invest more
polygons than are necessary here.

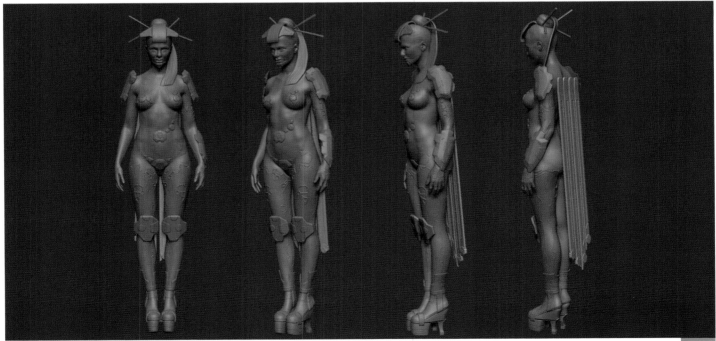

↑ Using a static pose for the encapsulated background models

04

237

05 Defining the background models

When you have completed the model by adding all the armor and hair elements (remember to Enable UVs in the Merged SubTools), load all the textures into Photoshop. In Photoshop, isolate the red lights on the model and replace the color red with a vivid green using the Hue/Saturation tools.

Models standing in the back will be in stasis, and are not likely to be dangerous, so I think the color green will emphasize the placid nature of their character. In addition to defining the two active and inactive states, we're working with two opposing lights – cold and warm – which is quite often used to visualize spatiality.

Now extract the character models in the scene and use the Decimation Master to reduce the polygons to 300,000. Remember to keep the UVs enabled.

06 Preparing the ZTools

We need to split the SubTool into two groups: The first one will be the placeholder model; the second will be the main model.

Use the Decimation Master to reduce the polygon count – 500,000 faces will be fine for our placeholder. Don't worry that our model has lost a little painted definition. We need a model without an assigned MatCap that allows us to impose various materials upon its surface. This way we will be able to generate different passes, which we need to create our final illustration.

07 Experiment with different textures

At this point I would like to draw your attention to the various possibilities this raw form

↑ Defining the active and inactive models by changing the light color in Photoshop | 05

↑ Defining the two SubTools – the placeholder and the main model | 06

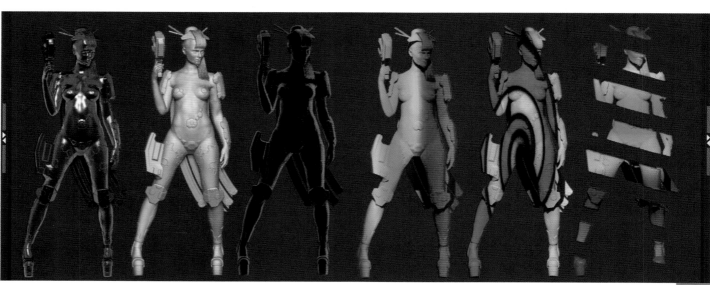

↑ Experiment! There are many possibilities for creating interesting effects | 07

holds. We can peruse the ready-made MatCap library and use rendering to mix them later in Photoshop. In this case, we use the simple skin shader material to generate different pass lights and attach them to the model.

You can also experiment and apply different textures to the model. You can put the render passes into Photoshop later on, and use the Eraser to remove any unwanted areas. You can texture on the object and apply different UV mapping. You can also apply textures with Alphas, although this means only some elements of the model will be rendered.

08 Background SubTools

When rendering, don't burden the scene with models that aren't visible in the frame. Decide the composition of your image in advance and set the elements to fill the largest area of the frame. Modern PCs are equipped with a lot of RAM and fast CPUs, but it's easy to blame them when it becomes tricky to navigate an overcrowded scene. As previously stated, we'll do the greater part of the work in Photoshop; but we need a good base for compositing and over-painting to start us off. So to prepare for rendering, group the following:

1. The capsule with the broken window and internal elements of the capsule, within a single SubTool.

2. The glass from a broken capsule.

3. On the floor, clone elements so as to cover the whole of the lower part of the frame. You can do this in two ways: Using the duplicate SubTool option or using the Move tool while pressing Ctrl and holding the middle wheel controls. Using the same method, clone the next scene elements.

4. The first row of capsules: Create a SubTool of capsules split into polygroups, so that the blue strip is in one polygroup and the rest of the capsule is in a second polygroup. This will help us later on, when we assign specific materials to our model.

5. Capsules: Second row.
6. Windows: First row.
7. Windows: Second row.
8. Character models: First row.
9. Character models: Second row.

By preparing the SubTools this way, you'll be able to render different passes for our scene later on.

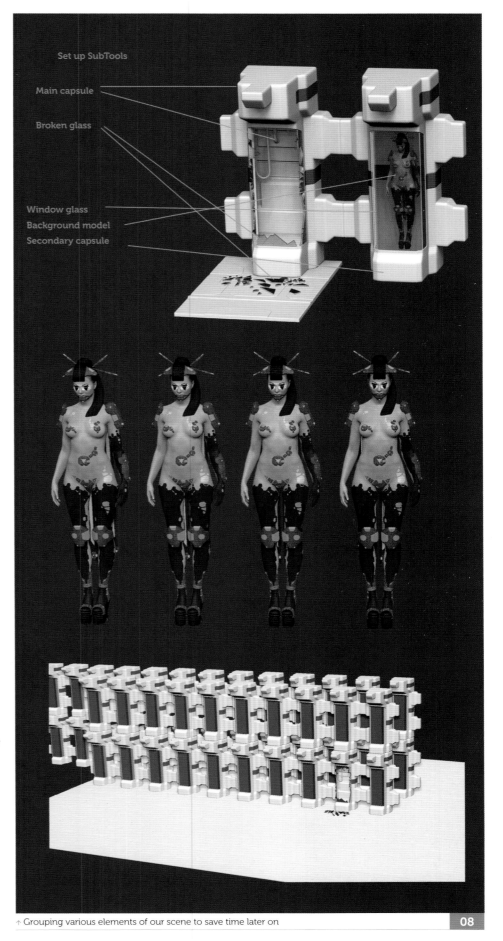

Set up SubTools

Main capsule

Broken glass

Window glass
Background model
Secondary capsule

↑ Grouping various elements of our scene to save time later on

08

09 Image setup

Setting the size of the picture at first glance may seem a little twisted at this stage, but the longer you work on 3D modeling, the more you'll find this way makes sense in the long run.

So, to set the size of your final image, go to Tool > Load Tool, and load the Tool with the main model. Then open a new document, go to the Document menu and set a New Picture with the following dimensions: Width 4961; height 3508 (A3). Set the resolution and click Resize. Go to the File menu and save the canvas under an appropriate name, for example 'Canvas_A3'.

Now confirm the settings for the frame in the scene (you can also set options for rendering and shadows), and save the file under an appropriate name, for example 'Main_Model_Default'. Later, you'll be able to modify the scene and save out more complex versions, but for now this will be our base scene. Now we can load the scene settings for the A3 size. First load a canvas (File > Canvas > Open), then the ZPR file (File > Open).

10 MatCaps for the model

We're going to use the material SkinShade4 for our character model. To set this up, go to the Material menu and open the Modifiers panel. Adjust the following parameters: Ambient = 0; Specular = 0.

Now we can adjust the lighting. Open the Light menu and apply the following settings: Intensity = 0; Ambient = 0.

Now you can use the LightCap to render a light pass.

11 MatCaps for the background

For the MatCaps in the background scene, we are going to use two different materials. For the capsule, we'll use the SkinShader4 and apply two colors: White over the entire capsule and blue -stripes on the side. I think blue stripes emphasize the idea that it's from a clinical laboratory.

For the windows, I use Chrome BrightBlueTint. I set these with a combination of blue and green, to make a more realistic glass window effect. Paste these materials onto the objects by using the following file path: ZPlugin > SubTool Master > Fill > Color and Material. You can also render the window using Transparency – open Display Properties > BPR Settings and turn on BPR Transparent Shading.

↑ The process for saving and opening your image 09

↑ Setting up the MatCaps for our character model 10

↑ Applying a blue and white MatCap to the scene to create a clinical mood

11

"Experiment with these settings in order to see what effects you can get. Remember that you can save the light and LightCap settings and create your own library of lights to use again and again"

12 Lighting setup

Moving on, we will now concentrate on tweaking the light settings in order to create our desired effect.

To set the lights, we'll use a LightCap. Open the project with the main model, activate the SubTool with the placeholder model and hide the others. Next, open Light > LightCap and create a new light. You can set any number of lights, depending on the concept and the final look you're after.

If you want to create a pass from the lights or speculars, set the Shadow to zero. There are two main parameters that are responsible for this effect: Strength and Aperture. You can set the Specular parameters at narrow or wide, depending on the effect you want to create. For example, some elements such as the eyes or mouth will need a narrow specular while the body or metal should be much wider.

Experiment with these settings in order to see what effects you can get. Remember that you can save the light and LightCap settings and create your own library of lights to use again and again.

↑ The light in my basic library for this scene

12

"Play with the other parameters too, but remember not to overdo it with the result, because it could make our model look like a wax figure"

13 Render properties

I will describe the most important parameters I use in the render setup, but you can also test and experiment with options that will be more convenient for you.

Select BPR Shadow under the Render tab. There are two main options that are responsible for the appearance of our shadows: Rays and Angle. You will find that if you use a high setting for the rays, your shadows will be smoother and uniform. If you use a higher setting for the angle, your shadows will be softer, as if you had used an area light. GSStrength is a parameter that sets the density of the shadow. The Resolution

✅ Top Tip
Folder organization

Honestly, I'm not particularly organized. For me, maintaining order was always associated with a large amount of work. Of course, I'm not collecting pizza boxes under my desk, and don't keep my used socks in the refrigerator, but I sometimes think that our world could be so much better if we could just arrange things like the folders on a computer.

Our project requires order. At the moment, we're starting to arrange the composition and need to have a bright and clear view of the files. I'd suggest using a structure like the one shown here, though of course you can upgrade this system depending on what you'll be using the files for, or just create your own.

↑ Making sure all the files are organized

↑ Adding BPR Shadows and Wax Modifiers to the model

of the shadow should be left at 4096. I think that should be sufficient for our image.

To create a wax effect, select the WaxPreview option in the Render Properties window, and in the pop-up window, select Material > Wax Modifiers. You can set these up depending on how you want the final 'power' effect to look.

Play with the other parameters too, but remember not to overdo it with the result, because it could make our model look like a wax figure.

"Passes are actually a brilliant technique that give us the opportunity to modify each of the light, color, and shadow settings already in the 2D scene"

14 Render passes

You may be asking, what's with the passes? Surely we could set it all up in one scene, click the Render button, and have a complete image? Passes are actually a brilliant technique that give us the opportunity to modify each of the light, color, and shadow settings already in the 2D scene.

Imagine how much time you would have to spend rendering the image every time you changed the strength of the light or the color. How much time would it take you to extract the shadows on a flat picture and manually change their color, because the one you have now doesn't fit the whole? The easy way to skip all that wasted time is to use passes – they give greater opportunities and save time.

Even better, ZBrush generates additional passes in just one rendering. You can just go to Render > BPR RenderPass, and when you click on the selected pass you can save it to your drive.

You can also set the render passes you want to generate – it's always better to have more than less for image composition. I will explain more about the purpose of all these passes in the next and final part of the chapter, but for the moment, we'll just collect all the files and group them. The entire workflow is set so that if you would like to change the settings for any of the passes you can do it at any time.

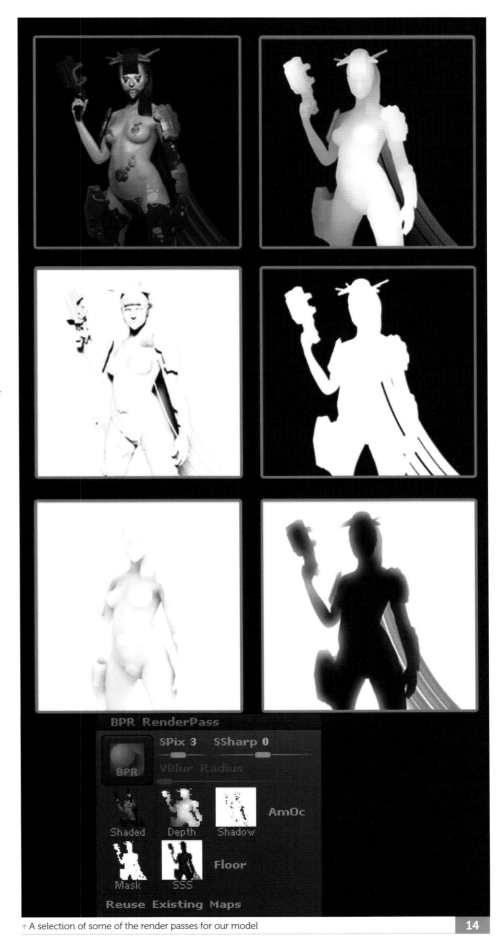

↑ A selection of some of the render passes for our model

14

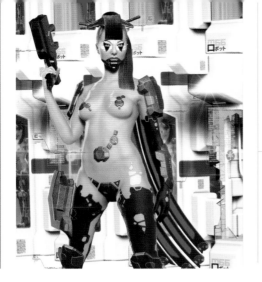

Sculpting a sci-fi character

Part 06: Compositing the final scene

By Piotr Rusnarczyk

Freelance Character and Games Artist

This is the moment we put together all the work we've done so far into Photoshop, and combine it all to create a beautiful illustration.

I remember when I first started my adventures with a computer – my first programs were Photoshop, LightWave 3D, and ZBrush 2.5. At first, I was very skeptical about these tools; however, with time I began to love them. My first medium was photography, and when I discovered that all the effects that had previously taken me so long to capture could be achieved with a single 'click' on my computer, I said goodbye to classic photography, painting, and drawing, and focused on exploring the possibilities presented by the digital world.

Now this might provoke a discussion on the superiority of classical techniques versus computer graphics, but I'd argue that the work of today's artists shows that technique is not restricted to specific genres or mediums in art. In no way do I discriminate against classic art, I simply support the idea that an artist will find inspiration from his imagination, regardless of the medium he or she uses. For example, would Salvador Dalí not have created his amazing surrealistic images if he had had the latest version of Photoshop to work with, rather than paint brushes? I don't think that he, or any other artist, would have had a problem. I think the fundamental idea of imagination in artwork is indisputable.

Okay, we can return to the tutorial now and pick up where we'd gathered all our models into one file. We will create two documents: On one we will apply the background passes and add various effects, logos, and lights; on a second document we will deposit our character and add details such as blooms or speculars and side lights. Then we will combine these two documents into one illustration at the end.

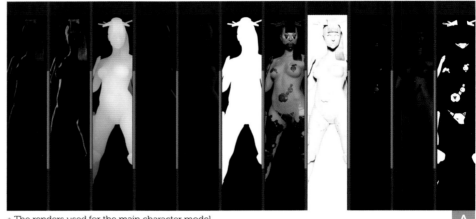

↑ The renders used for the main character model

A

↑ The renders used for the background scene

B

I've provided a brief list of the materials we should have gathered in preparation for the next stage:

Main model (image A):

• Render_blue_light: This emphasizes the model's profile and integrates it with the background.

• Render_blue_light2: Used as in the point above, and also to enhance the lighting effect.

• Render_depth: This pass is used to lighten the rear side of the model, and has the added option of Blur and creating a depth of field.

• Render_red_light: This pass can be used against the blue light, to emphasize the natural enemies of our character. It also connects to the red indicator lights glowing on the armor model.

• Render_red_light2: Used as in the point above, and optionally to smooth and add light force.

• Render_mask: Used to cut out the silhouette of our model, and also when applying adjustments.

• Render_mask_metal: An Alpha to select the metal areas in the armor and weaponry (not in image A).

- Render_color: This is the colorful heart, the most important element in our scene.

- Render_shadow: This pass is responsible for the appearance and strength of our shadows.

- Render_specular_armor: Used to generate the specular on the armor.

- Render_specular_body: Used to extract a delicate sheen on the artificial skin of our model.

- Render_mask_armor: I created this mask by rendering pieces of armor in ZBrush, but you can use this mask optionally for selection of armor.

Background (image B):
- Bg_render_depth pass: This pass can be used to lighten the furthest set of capsules and create a sense of space.

- Bg_render_floor_alpha: Used to edit the floor and add adjustments to the floor layer.

- Bg_render_windows_blue_light: Used to create a window with an inner blue light.

- Bg_render_windows_alpha: This pass is used to select windows or make adjustments.

- Bg_render_shadow: This pass controls shadows.

- Bg_render_color: Used for the floor base, rendering shadows, or no shadows, as you prefer.

- Bg_render_stripes_alpha: This pass can be used to change the color stripes on the capsules.

You can place most of the layers in the main image by holding Shift and dragging and dropping the files into Photoshop. For those that don't appear in the Alpha window, you'll have to select (Ctrl+A) and then copy the files (Ctrl+C). Then select the main document, go to the window to create a new Alpha, and then paste the files in (Ctrl+V). This sounds complicated but trust me, it's really simple.

Make adjustments by pressing Ctrl and clicking on a layer – a new selection will appear. In the palette at the bottom of the Adjustments screen, you can add Adjustments such as Levels or Contrast. If we don't have a layer with a cut element, select the image you want to create an Alpha from, copy it, and click on the Adjustments window. From there, go to the Alpha panel; select and paste the image.

↑ Setting the right file size to begin and organizing the files into color-coordinated groups **01**

↑ Using the Color Range window to sample and apply the color tones **02**

01 Starting our file
You can start to compile your final file by throwing passes into it. Drag and drop the Render_color file into the main image, and save it in a 'Compositing' folder. Note that you should only save composites here. At the end of the work you will create a 'Finished' folder, where you can put your final complex files.

When it comes to the size, we're going to adopt the A3 landscape as our output size. I know from experience that this will render at 4000 pixels and we can easily increase this by 25% in Photoshop without much loss of quality. If you find you need a larger image, don't hesitate to enlarge the size. This is best done after throwing all the passes into the main image and using the Image Size window with edge sharpening.

I recommend that you try to keep layers in order in the correct files. You can also assign colors to folders that contain certain types of information, which you will find very useful when working on many layers. You can place various adjustments, masks, and graphic elements on the layers in these folders.

02 Working on the base image
Create the capsule window illuminated by a blue light using an Alpha. Open the Color Range window (Select > Color Range) and use the Eyedropper tool to choose a blue color; click OK. Then copy and paste – we now have light on the layer. To refine that further, use Filter > Blur > Gaussian Blur, and we will have a bloom effect.

To create the glowing floor, use the Bg_render_floor_alpha. Create a layer from the floor, then, similar to what we did for the blue lights, create a selection of only the brightest spots in the floor using the Color Range window Eyedropper tool. Now copy and paste and add a Gaussian Blur filter. Then choose Screen mode, and apply Level adjustments to regulate the contrast and brightness on the floor using the Bg_render_floor_alpha.

↑ Applying adjustments to the Alpha channel **03**

↑ Creating the text and logo for the capsule **04**

↑ Cloning and placing the logos on the capsules **05**

03 Adjustments

Using the Bg_render_stripes_alpha, create a Hue/Saturation adjustment and change the color and brightness of the stripe on the capsule. Now use the Bg_render_shadow pass and change the color of the shadow to a more blue hue. You can use the Global adjustment according to your needs.

04 The text

Now we can create the text to go on the capsules. Here I leave you with the opportunity to demonstrate your own initiative, and give you a completely free hand to create at will, depending on your own artistic preferences.

↑ Adding a light and glow to the capsule text **06**

I decide to use the Japanese language for my text. Each letter in the Japanese alphabet can be seen as a sign or symbol for Europeans, and we often perceive some of these symbols in the form of logos. In addition to that, we often tend to associate Japan with technological advances. I think that this might be one of the reasons why William Gibson books often use modern Japanese architecture as the background for cyberpunk stories.

The content of the text is irrelevant because it won't be visible in the final illustration; I'm just looking for a nice set of shapes. At this point, I'd like to apologize to anyone who is Japanese and reading this tutorial – I hope that I haven't offended you in using your beautiful alphabet as a graphic element in my scene!

To create the logo, I use the word 'robot' from a Japanese dictionary. I'm not sure if by chance it may translate as another word or curse. At this point, I'm reminded of the *Monty Python* sketch about a Hungarian–English dictionary, and wonder if I've unwittingly created a humorous hidden theme in the scene…

After I have created and styled the text, I add a layer and give it a blue color and glow. You can also add some other elements with random colors. Don't forget to think about the fonts you use, too. If you use publicly available fonts, you'll need to verify that they are not covered by copyright. Many sites offer free fronts; however you'll need to be well-acquainted with the license for use in your work.

05 Logos
Place the logos in a 'Logo' folder specifically created for them, clone them, and set them to match the perspective using the Transform tools (Ctrl+T). I also join a layer of light this way, to save time on editing an additional 16 layers.

06 Lights
For the lights, use a rectangular shape with rounded corners, select the Stroke style, and add a 2–3 pixel outer glow.

07 Depth pass
Now we can use the Depth pass, not as an Alpha, but this time on top of the layer stack with a Screen blend mode. Use the level to determine its strength and use the transparency slider on top of the Layers panel to set it.

↑ Adding Depth passes to create the illusion of depth in the image 07

↑ Creating light flares for the background scene 08

08 Flares
To create a flare you can use the plug-in in Photoshop, or simply make one yourself. Flares can be created on a black background, and after cloning all the elements using a Screen blend mode.

Our background is now ready. Flatten all the layers and go to the Filter > Lens Correction window. There, with the help of sliders, just add those last effects to your image. I use Remove

Distortion to obtain the effect of lines on the perspective of the capsule and move some channels to get the effect of chromatic aberration.

09 Compositing the main model
In the model file, we'll gather all the rendered passes and add some effects to the character. I'll describe all the folders in random order but you should remember to keep the files in a specific order in your own work – it will help you find files quickly and speed up your overall process.

↑ Gathering all the rendered passes and ordering the files 09

"Use the Screen blend mode and use Levels to calibrate the fog covering the stripes"

10 ZBrush passes

First, drag and drop the Render_color and Render_mask files into the document. Now open a new window. Select and load Alpha 1 and copy and paste the content of your selection. This way, you've created the base layer of the main model. Now duplicate it and add a Level adjustment between those layers, and a Screen blend mode on the first layer. This will make a lighter and more vivid image, and yet you won't lose any detail.

Now activate the levels and set the value so that the character looks good. I adjust the hue and saturation a little because I like to have control over the color saturation. Put the passes with blue and red color lights into the document and use the Screen blend mode. Now you can add specular.

Next you should drag and drop the specular passes into the main document. Now it's time for a little trick. Open the Filter > Noise window and add a little grain to the specular of the body; then do the same thing with the metal specular. Use the Filter Gallery > Poster Edge so that our grain becomes thicker and resembles the shape of little groundnuts. Now our noise has an irregular shape and looks more real.

Finally, we can tweak the layer depth. Use the Screen blend mode and use Levels to calibrate the fog covering the stripes.

↑ Working with ZBrush passes on the model

10

↑ Using a Gradient Overlay to create the shadow on the model

11

✅ Top Tip
Composition

I've created a lot of studies, formulae, canons, and so on, on the subject of composition. It makes no sense to discuss this topic too much here, as artists have already developed the proven formulae and so we can just use them as a base to compose our frame.

For me, the most important element in choosing a composition is taste and personal preference. In this case, I used a static composition, which I decided was the best way to present this model. In the horizontal frame I used a movie-style composition, and the portrait frame had the style of a pulp poster. I encourage you to develop your own knowledge about composition; I believe this will help to create variety in your work.

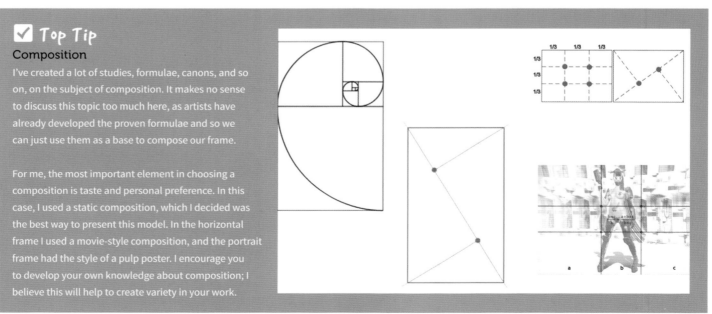

↑ Various composition formats for the model

11 Shadow

To create the shadow of the model, I use a trick as old as the hills. I duplicate a layer of the main model and apply a black color into the shape. I then use a layer style with the Gradient Overlay option, setting black on one end of the scale, and blue on the other. Next I use the sample picker to pick color from the light on the capsule, and finally use a mask to blur the edges of the shadow. I choose to create the shadow this way because it's handier and spares me the time it would have taken to render another version of the shadow pass.

12 Control lights

For the control lights, I'll leave you to tweak all the settings as you would prefer. I've not got any tips here, except to familiarize yourself with the custom shape and line tools.

13 Lens effect

The lens effect is actually the image damage arising from the photography process and various aberrations. Light reflections offer the impression that there are elements in the room that are looked at through a glass pane, or camera lens. You can create this effect in your own scene by using some images containing proper glass elements to begin with, and then by adding Photoshop's Gaussian Blur and Motion Blur filters to your files.

↑ Apply your own settings to create your desired control light effect

12

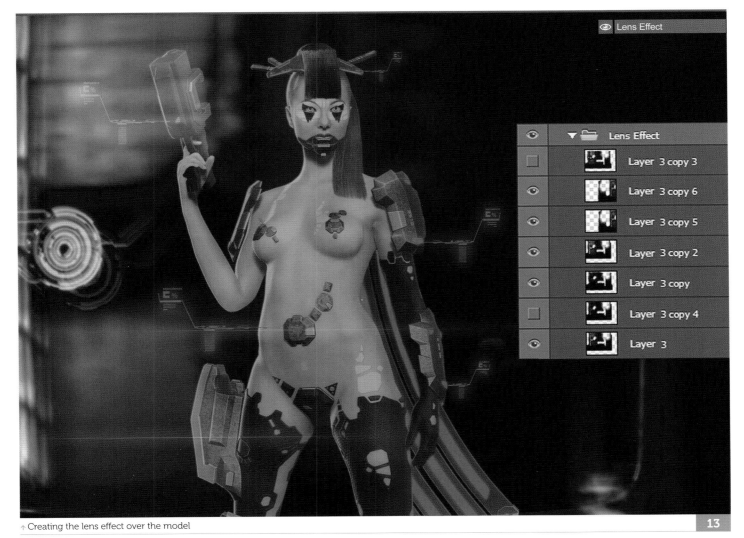

↑ Creating the lens effect over the model

13

14 Environment light

Adding a couple of laser lights won't hurt. You can always disable this layer later if you don't like the effect. To create these, I used the Line tool, plus Motion Blur and the Warp tool (Transform > Warp).

15 The background

Put all the flattened layers of the background in a 'Background' folder. You can also use some adjustments to calibrate this background to the main model images.

16 Global adjustments

On top of all these folders, just add the folder with all the adjustments. Finally, you can decide what hue will be right for your scene, and compile your own lab colors.

17 Completing the illustration

Now we can combine the two layers (character and background) and decide what aspects to choose for the purposes of our illustration. I make two images, one landscape and one portrait, to experiment with the ways the renders from a single session can be used. I use the portrait frame to crop the image and see how the composition looks when I change the background setting.

18 The final image

Finally, if need be, you can add any over-painting. We haven't really used over-painting

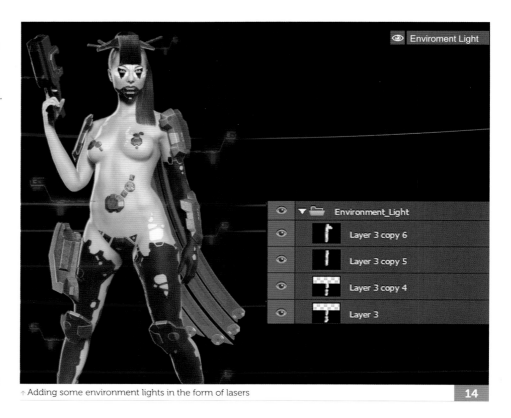

↑ Adding some environment lights in the form of lasers

14

throughout the creation of our illustration. Whether you employ effects such as these depends on how you want your image to look.

Here, I wanted a sterile-looking image, so I kept the painterly effects to a minimum. If, for example, we decided to show a messy,

abandoned, post-nuclear-war scene, we'd certainly be blunting our pen stylus.

As you can see overleaf, our image is now finished! I really hope that this chapter helps you when sculpting sci-fi characters and creating your own illustrations.

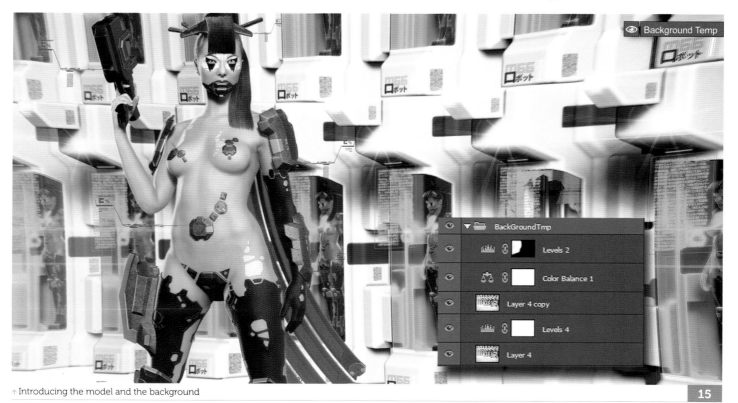

↑ Introducing the model and the background

15

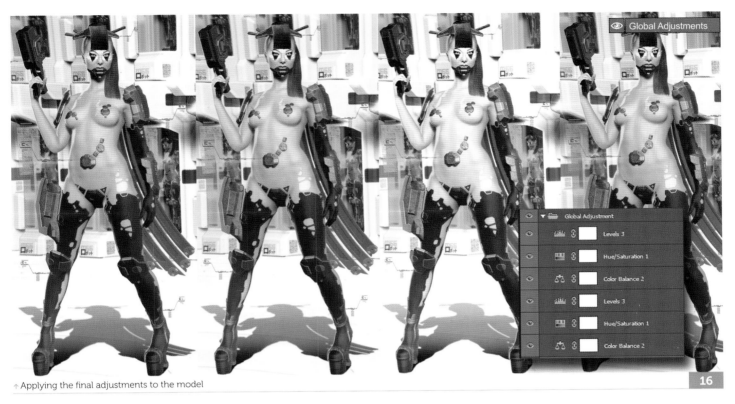

↑ Applying the final adjustments to the model

16

↑ Using the portrait form to crop the picture and create a nice composition for the final scene

17

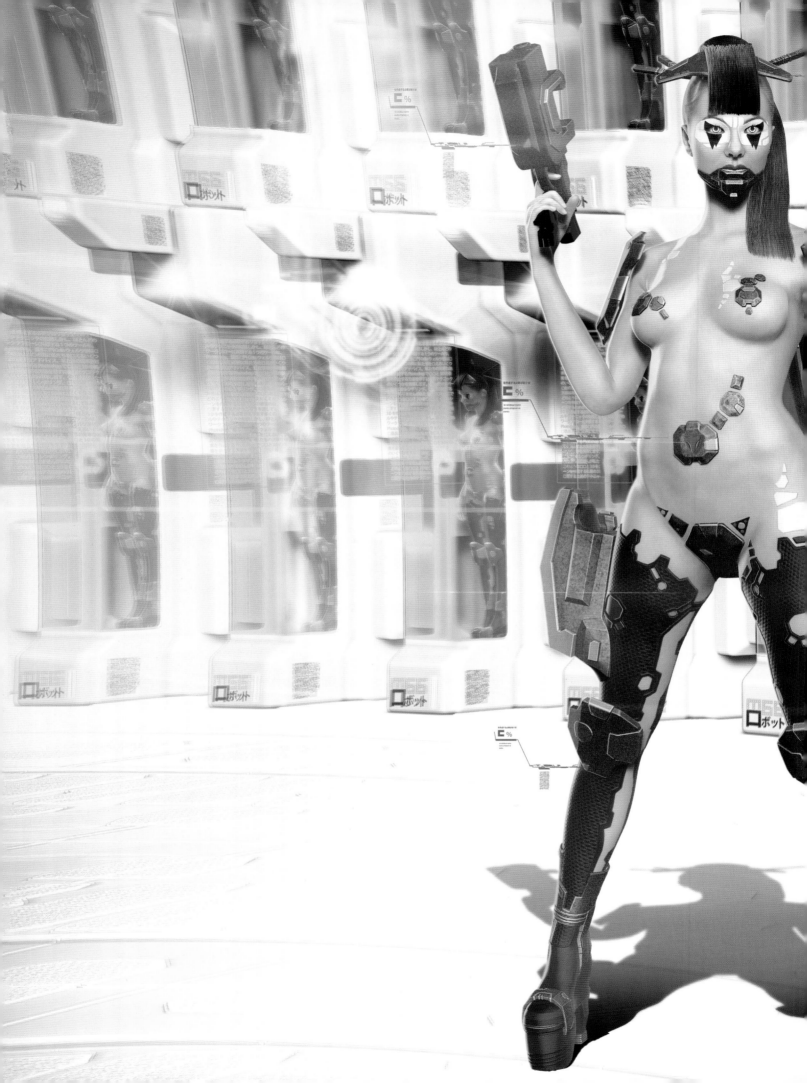

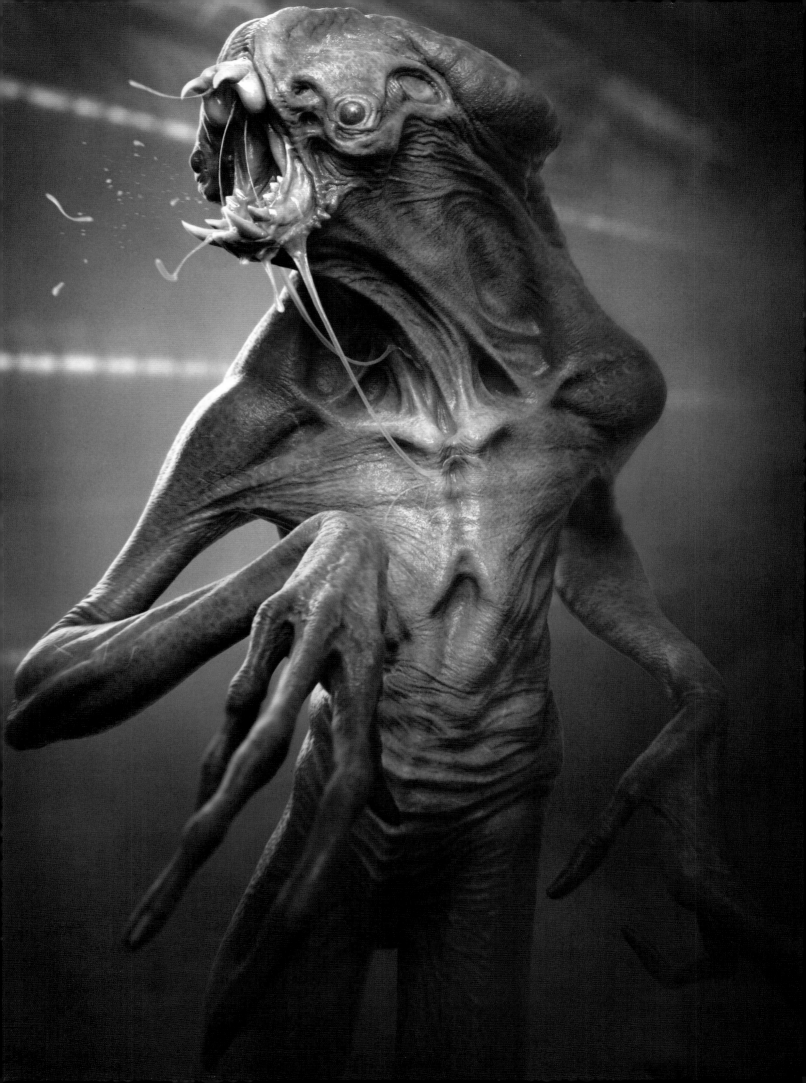

Gallery

Discover some of the latest and greatest ZBrush creations...

Finally, to round off, we bring together some of the greatest images to grace the face of top CG sites from all over the world. Explore some of the best models that started life in ZBrush. Not only will you encounter final, high-gloss, portfolio pieces, but our artists have also provided some smaller, yet no less fascinating sketchbook speedsculpts, as well as listing some of the tools that are part of their typical ZBrush workflow. So in addition to enjoying the high quality craftsmanship of these top-notch treats, you can also take a sneaky glance into the ZBrush tools and modeling techniques behind their creation. What more could you need to inspire and fuel your own ZBrush creations?

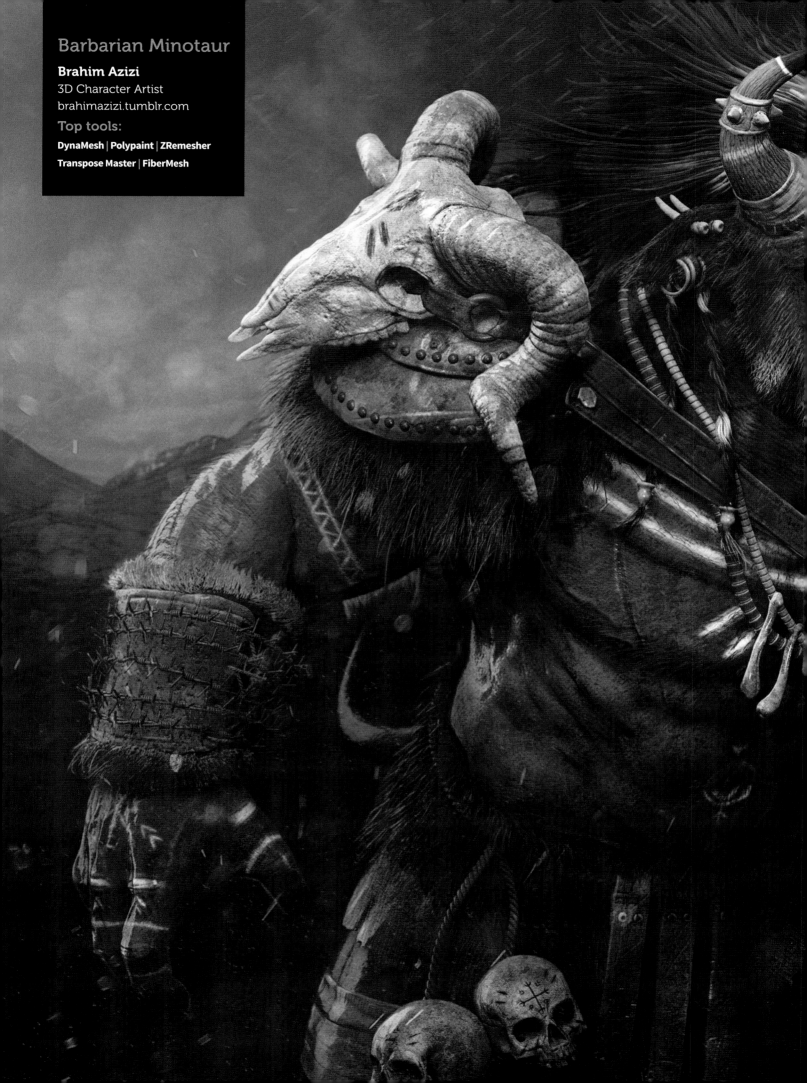

Barbarian Minotaur

Brahim Azizi
3D Character Artist
brahimazizi.tumblr.com

Top tools:

DynaMesh | Polypaint | ZRemesher
Transpose Master | FiberMesh

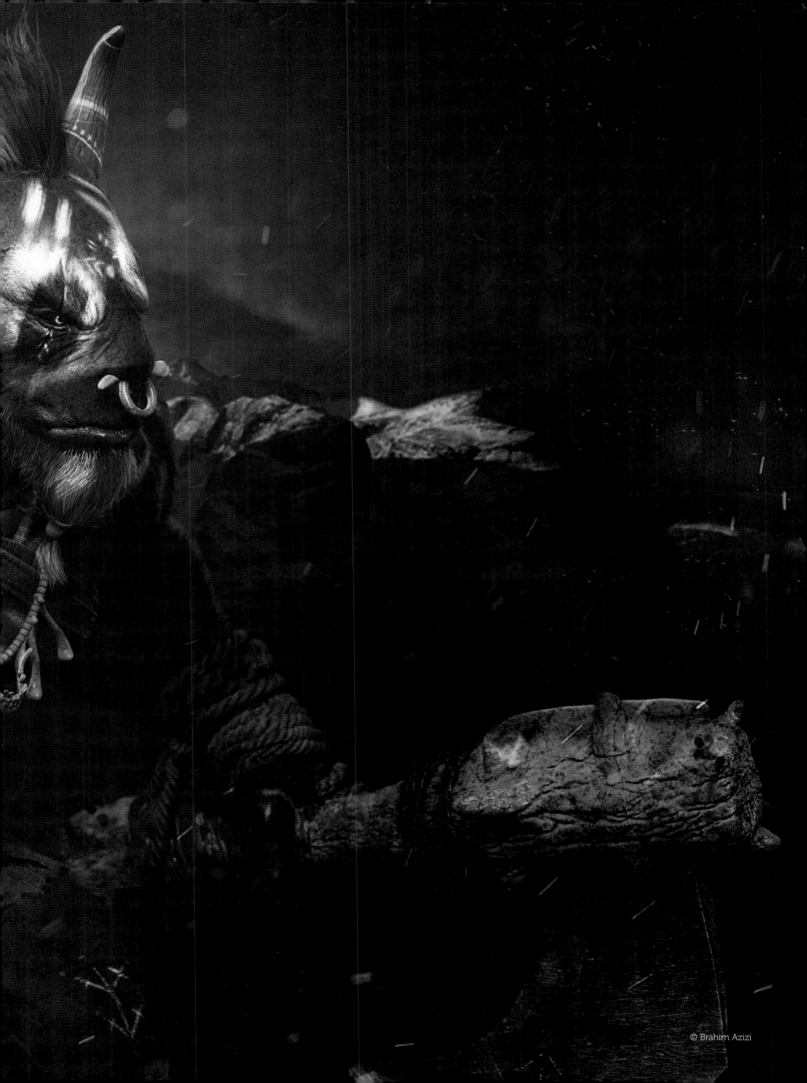

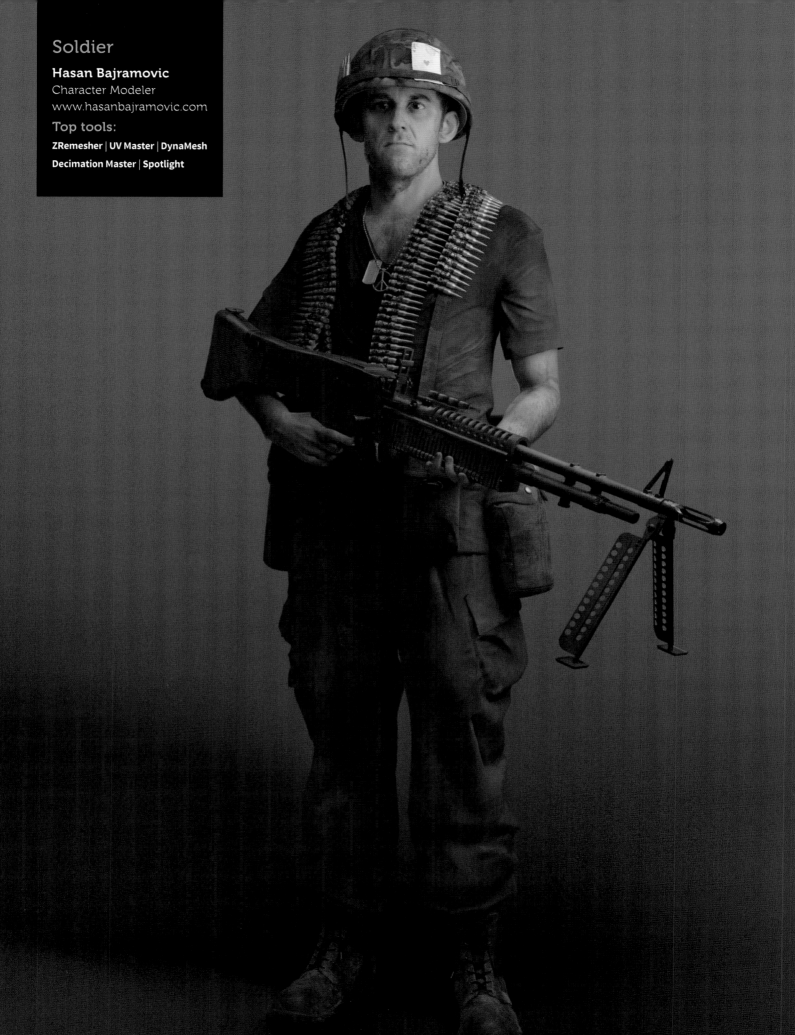

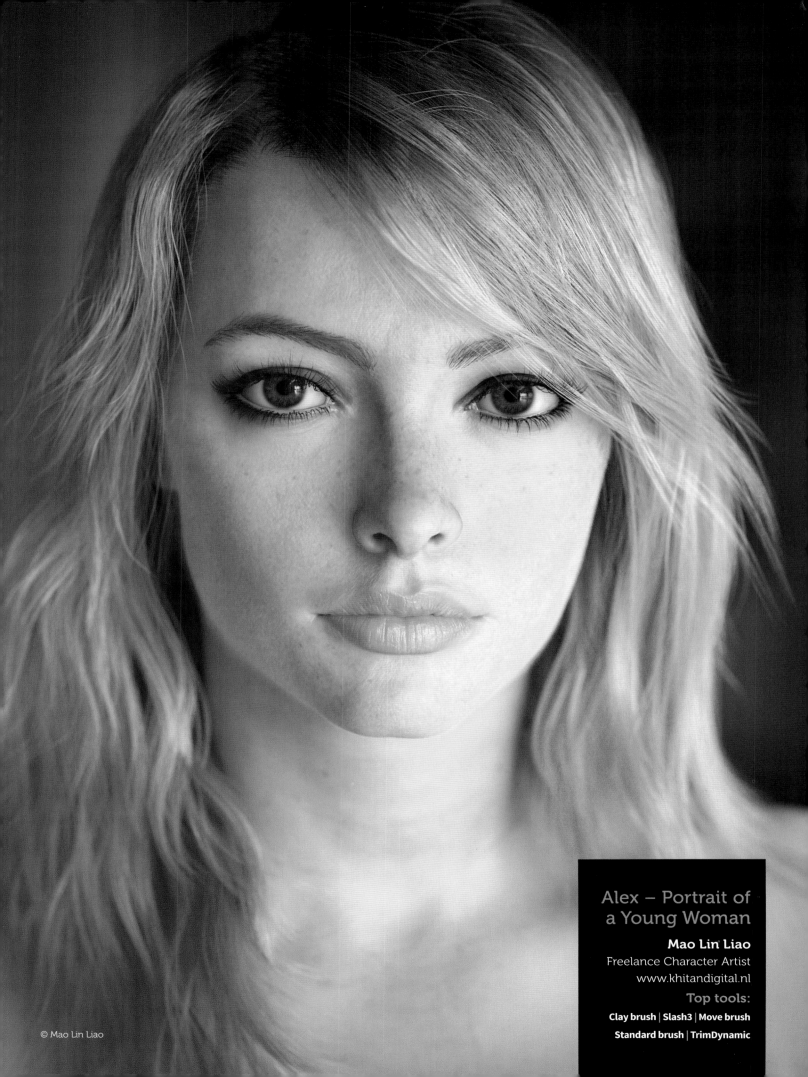

Alex – Portrait of
a Young Woman

Mao Lin Liao
Freelance Character Artist
www.khitandigital.nl

Top tools:

Clay brush | Slash3 | Move brush
Standard brush | TrimDynamic

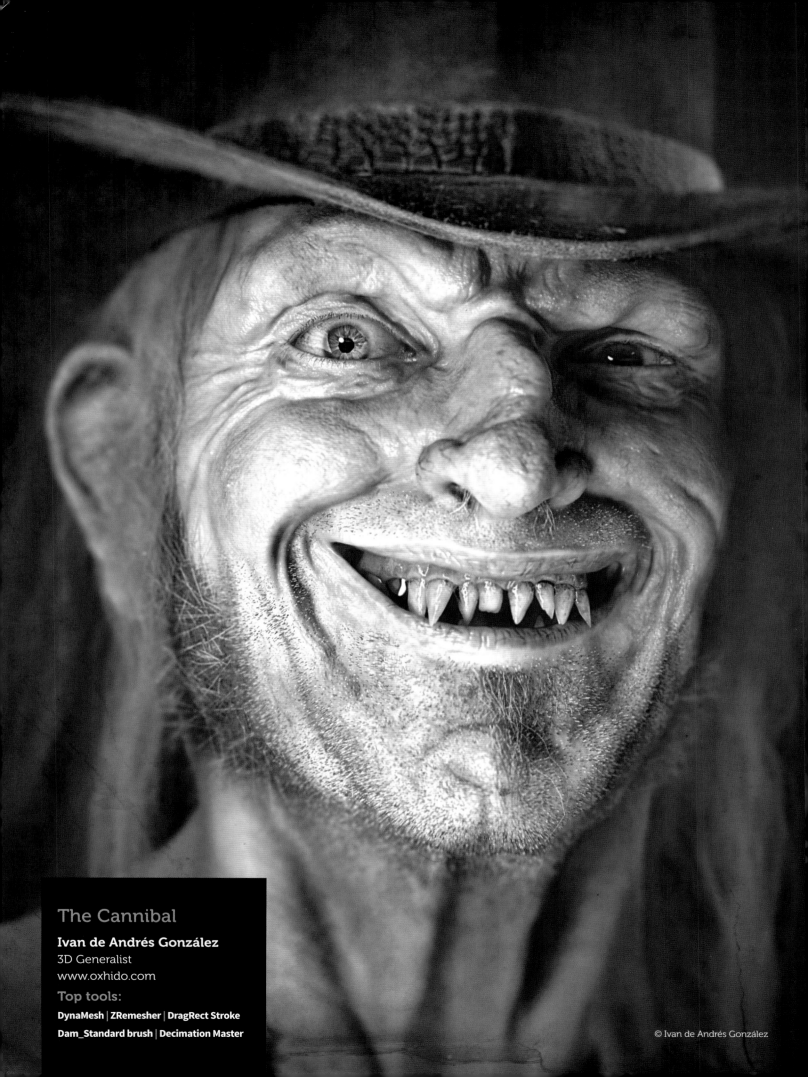

The Cannibal

Ivan de Andrés González

3D Generalist

www.oxhido.com

Top tools:

DynaMesh | ZRemesher | DragRect Stroke

Dam_Standard brush | Decimation Master

© Ivan de Andrés González

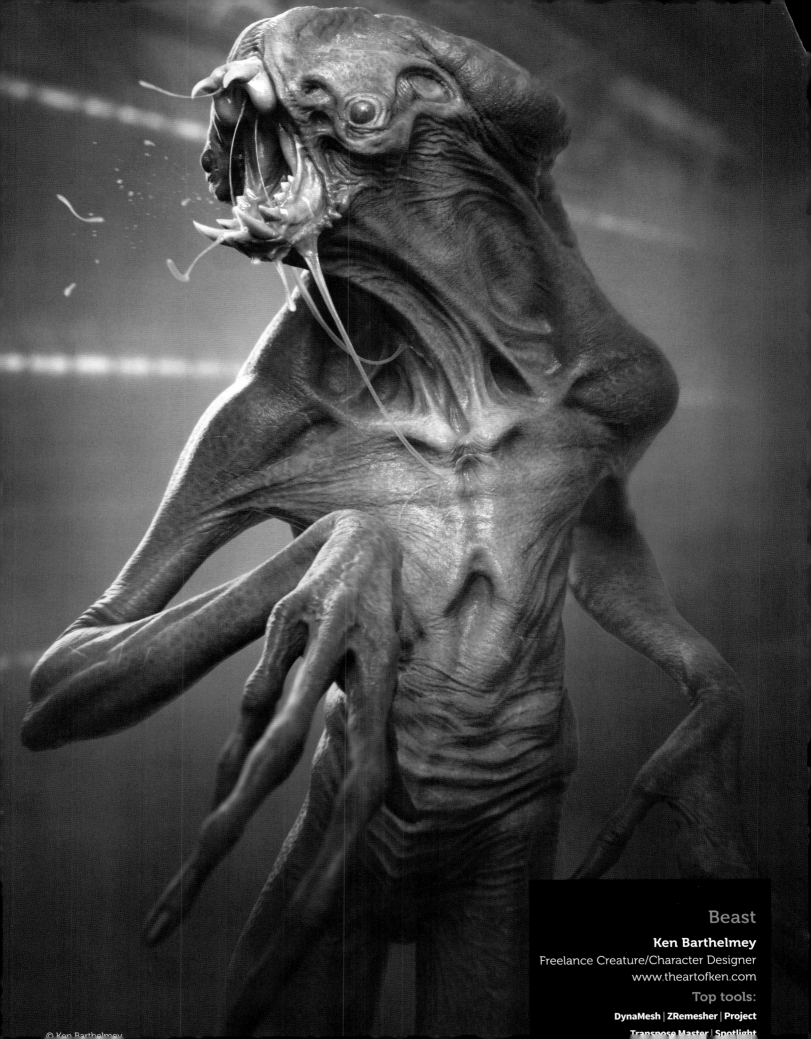

Beast

Ken Barthelmey
Freelance Creature/Character Designer
www.theartofken.com

Top tools:

**DynaMesh | ZRemesher | Project
Transpose Master | Spotlight**

© Ken Barthelmey

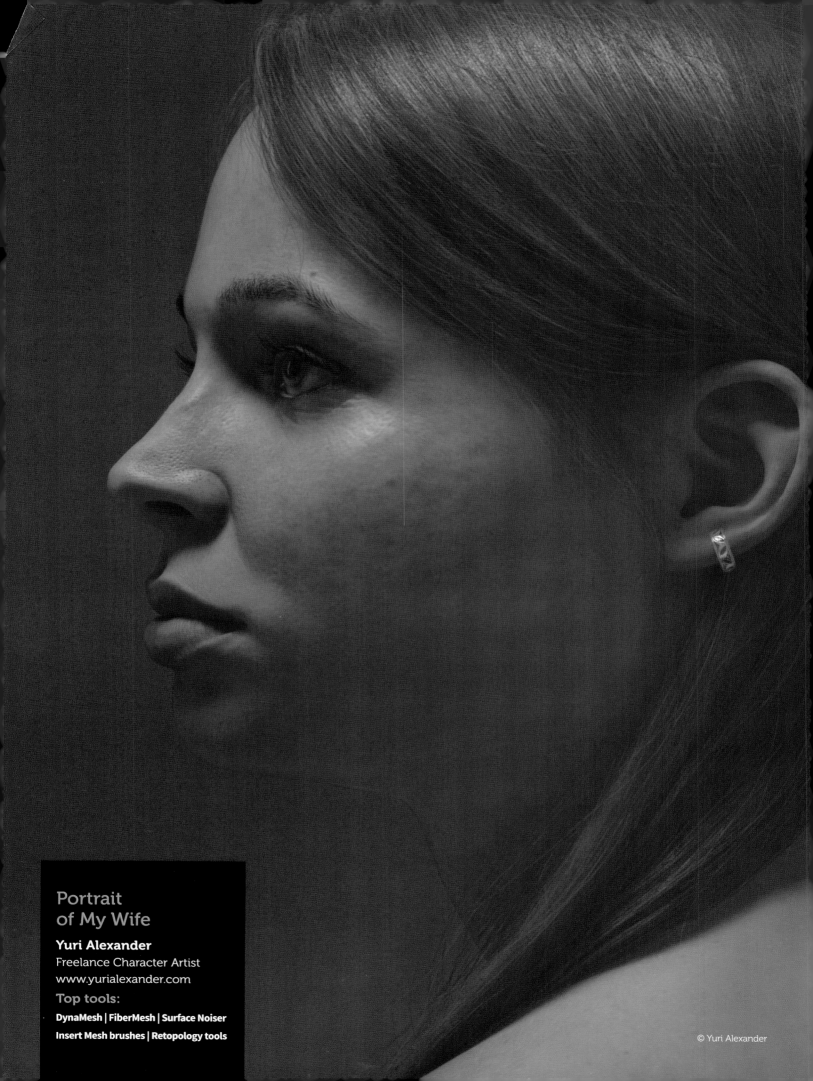

Portrait
of My Wife

Yuri Alexander
Freelance Character Artist
www.yurialexander.com

Top tools:

DynaMesh | FiberMesh | Surface Noiser

Insert Mesh brushes | Retopology tools

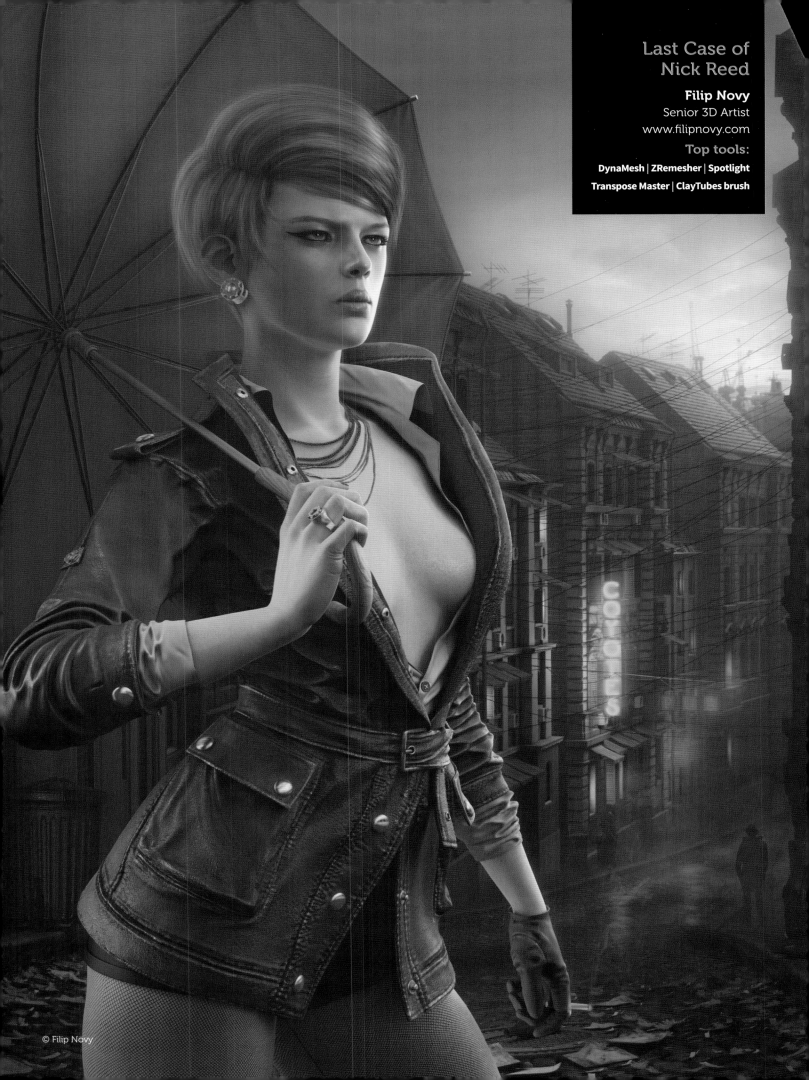

Last Case of
Nick Reed

Filip Novy
Senior 3D Artist
www.filipnovy.com

Top tools:

DynaMesh | ZRemesher | Spotlight
Transpose Master | ClayTubes brush

Flamenco

Borhan Chou
Art Director

Top tools:

DynaMesh | ZRemesher | ZSphere

Micro Mesh | Panel Loops

Pure

Cézar Brandão

3D Artist

www.drawcrowd.com/branduarte

Top tools:

Polypaint | ClayBuildup brush | Transpose

Dam_Standard brush | TrimDynamic brush

Combat Suit

Patryk Olejniczak
Freelance Concept Artist
www.patrykolejniczak.com
Top tools:

DynaMesh | ClipCurve | LazyMouse
CurveTube brush/Curve mode | ZSphere

© Patryk Olejniczak

Pablo Muñoz Gomez

Lead Animator at MedAdvisor

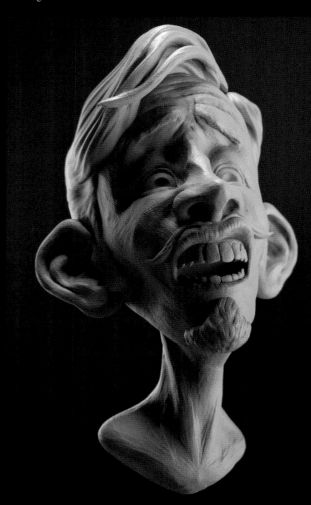

01

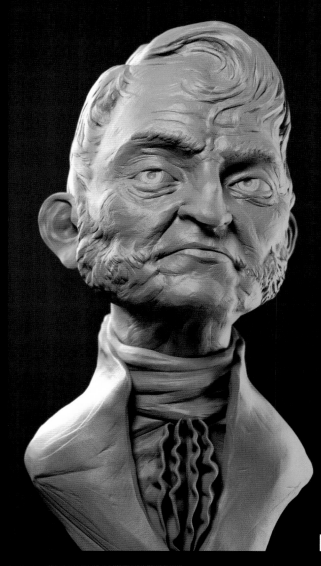

02

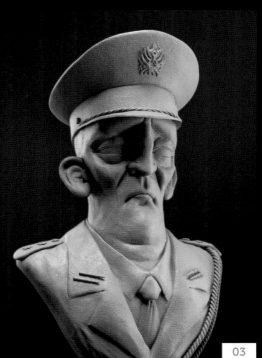

03

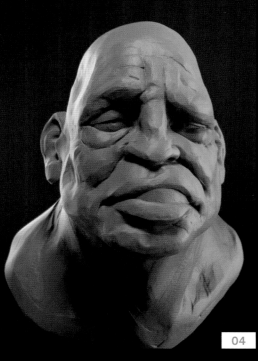

04

01 This guy is scared of life so he performs his drama.

02 This is one of those occasions where I started with no ideas, and then the DynaMesh sphere evolved to be a writer. You can see 'the making of' here: **www.pablander.com/ website/?p=1190**

03 I started this guy to explore a bit more of a caricature style.

04 I made this guy just for fun after watching the great movie, *The Fighter*.

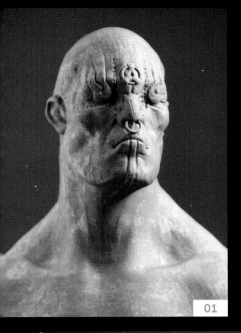

01

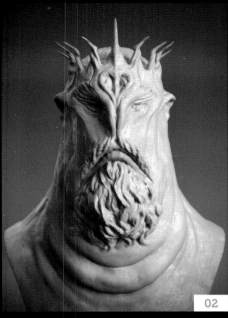

02

04

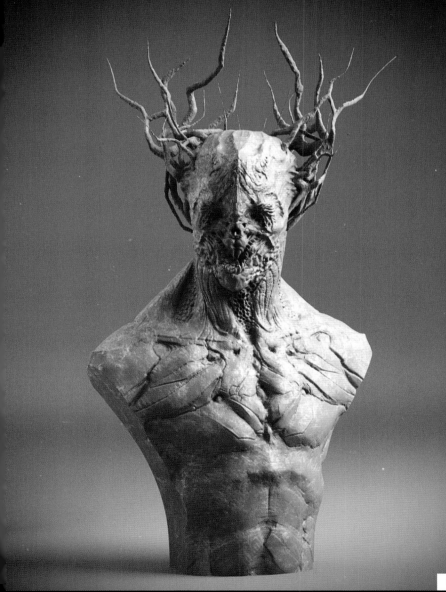

03

Federico Scarbini
Modeler and Textures Artist at MPC

All images © Federico Scarbini

01 The first cyclops. This monk-creature's eye is a symbol of the 'spiritual eye' and was sealed as part of a ceremony.

02 A king – his look reminds me of a tower: Safe and sturdy.

03 This creature reminds me of Hellraiser's 'Cenobites', but this one definitely has nothing that is reminiscent of a human...

04 This sketch was inspired by macro references of flowers and diagrams of mathematical formulae in nature.

Damir G. Martin

Freelance CG Artist and Illustrator

01 This one is one of the first dragons made for a series. The neck is covered with large sets of scales made with the Track brush and a custom Alpha.

02 This design was a practice in asymmetry, with no greater depth to it.

03 This was a brutish dragon with an intricate horn structure. The story of an evil wizard who trapped a princess in the interlocking horns grew from the sketch.

04 This was inspired by a praying mantis. The appendages on its head should be brightly colored to make it look like a flower.

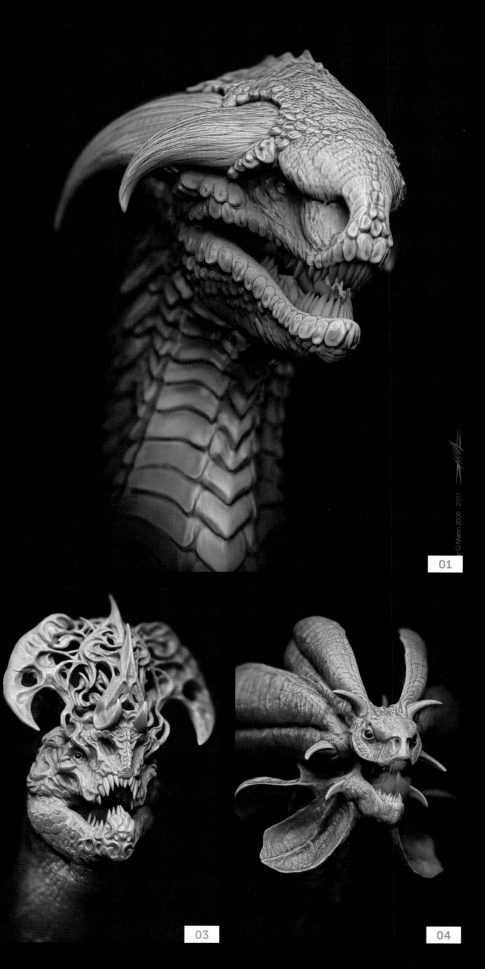

01

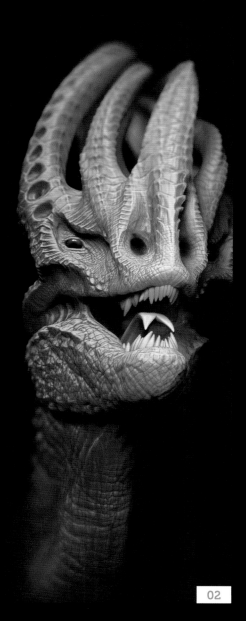

02

03

04

01

02

Magdalena Dadela
Character Artist

All images © Magdalena Dadela

01 Trying out different features and playing around with ZSpheres during ZBrush beta testing.

02 A quick sketch of William Shakespeare.

03 I saw a historical miniature of a Polish lancer on the internet and this guy popped into my head.

04 *The Satyr* – a quick sketch I created as a concept for a traditional sculpture project.

05 A lunch-crunch sketch created from a sphere with the use of DynaMesh.

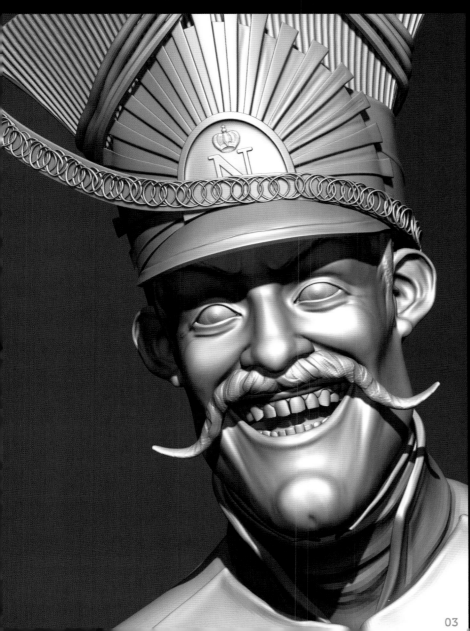

03

04

05

Cézar Brandão

3D Artist

All images © Cézar Brandão

01

02

03

04

01 This piece was created with the memory of a Californian girl in mind, from when I lived there.

02 This is an old sketch of a girl – I was trying to achieve the look of a top model.

03 This piece is about a cold-hearted girl, who thinks she's at the top of everything, like a queen.

04 Sometimes it's easier to just give away your whole life and quit everything, but with patience you can have your reward later.

Ben Mauro

Freelance Artist

All images © Ben Mauro

01 This crab-inspired creature was created as a demo in a class that I was teaching.

02 Another in-class demo showing the students how to learn from nature – in this case, Orangutans.

03 A preliminary concept model.

01

02

03

INDEX

ARTIST BIO

Kurt Papstein
Freelance Concept Artist at Bad Robot
www.ikameka.com

Ali Zafati
Freelance 3D Character Artist
www.zaliti.cgsociety.org/gallery

Maarten Verhoeven
Freelance CG Sculptor and Designer
www.verhoevenmaarten.blogspot.co.uk

Borislav Kechashki
3D Character Artist at Ubisoft
www.b_kechashki.artstation.com

Mariano Steiner
3D Character Artist and Digital Sculptor
www.marianosteiner.com

Bruno Jiménez
Freelance CG Artist
www.brunopia.com

Mathieu Aerni
Lead Character Artist at Blur Studio
www.mataerni.com

Bryan Wynia
Senior Character Artist at
Sony Santa Monica
www.bryanwynia.blogspot.com

Pavel Terekhov
3D Generalist
www.goodatom.blogspot.ru

Caio César
Freelance Character Artist
www.caiofantini.blogspot.co.uk

Piotr Rusnarczyk
Freelance Character and Games Artist
www.sexy-polygons.com

Daniel Bystedt
Lead Modeler and Project Manager
at Milford Film & Animation
www.dbystedt.wordpress.com

Tanoo Choorat
Freelance Character Artist
www.facebook.com/tanoonoi.choorat

Glauco Longhi
Freelance Character Artist, Sculptor,
and Creature Designer
www.glaucolonghi.com

Tudor Fat
Freelance 3D Character Artist
www.tudorfat.weebly.com

Justin 'Goby' Fields
Concept Artist, Illustrator, Graphic
Designer, and Owner of IronKlad Studios
www.justinfields.com

Zsolt Vida
Character Modeler at DIGIC Pictures
www.zsoltvida.carbonmade.com

ZBrush Character Sculpting V1
Projects, Tips & Techniques from the Masters

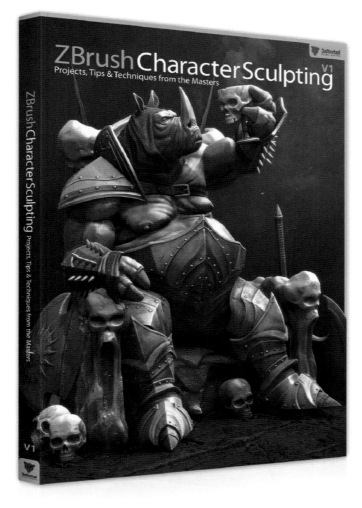

"Often you find a little information here or there about how an image was created, but rarely does someone take the time to really go into depth and show what they do, and more importantly why. This book contains clear illustrations and step-by-step breakdowns that bring to light the power of concepting directly in ZBrush, using it for full-on production work and using the software with other programs to achieve great new results"

Ian Joyner | Freelance Character Artist
www.ianjoyner.com

ZBrush has quickly become an integral part of the 3D modeling industry. *ZBrush Character Sculpting: Volume 1* explores the features and tools on offer in this ground-breaking software, as well as presenting complete projects and discussing how ZSpheres make a great starting point for modeling. Drawing on the traditional roots of classical sculpture, this book also investigates how these time-honored teachings can be successfully applied to the 3D medium to create jaw-dropping sculpts. Featuring the likes of **Rafael Grassetti**, **Michael Jensen**, and **Cédric Seaut**, *ZBrush Character Sculpting: Volume 1* is brimming with in-depth tutorials that will benefit aspiring and veteran modelers alike.

This book is a priceless resource for:
- Newcomers to ZBrush and digital sculpting in general
- Artists looking to switch from a traditional medium
- Lecturers or students teaching/studying both traditional and digital modeling courses
- Hobbyists who want to learn useful tips and tricks from the best artists in the industry

Soft cover: 220 x 297 mm I 240 pages
ISBN: 978-0-9551530-8-2